City of Play

City of Play

An Architectural and Urban History of Recreation and Leisure

RODRIGO PÉREZ DE ARCE

BLOOMSBURY VISUAL ARTS
LONDON • NEW YORK • OXFORD • NEW DELHI • SYDNEY

BLOOMSBURY VISUAL ARTS
Bloomsbury Publishing Plc
50 Bedford Square, London, WC1B 3DP, UK

BLOOMSBURY, BLOOMSBURY VISUAL ARTS and the Diana logo are trademarks of
Bloomsbury Publishing Plc

First published 2018

© Rodrigo Pérez de Arce, 2018

Rodrigo Pérez de Arce has asserted his right under the Copyright, Designs and
Patents Act, 1988, to be identified as Author of this work.

Cover design: Eleanor Rose
Cover image © Mark Cowlin / EyeEm / Getty Images

All rights reserved. No part of this publication may be reproduced or transmitted
in any form or by any means, electronic or mechanical, including photocopying,
recording, or any information storage or retrieval system, without prior permission
in writing from the publishers.

Bloomsbury Publishing Plc does not have any control over, or responsibility for, any
third-party websites referred to or in this book. All internet addresses given in
this book were correct at the time of going to press. The author and publisher
regret any inconvenience caused if addresses have changed or sites have
ceased to exist, but can accept no responsibility for any such changes.

A catalogue record for this book is available from the British Library.

A catalog record for this book is available from the Library of Congress.

ISBN: HB: 978-1-3500-3217-0
 PB: 978-1-3500-3216-3
 ePDF: 978-1-3500-3214-9
 ePub: 978-1-3500-3215-6

Typeset by RefineCatch Limited, Bungay, Suffolk

To find out more about our authors and books visit www.bloomsbury.com
and sign up for our newsletters.

To Pilar, Rodrigo and Beatriz

With a massive hauling of sand on the backs of a disused ball court ('Beti Jai' which translates into 'always festive') in Madrid, Andres Carretero and Carolina Clocker transformed a derelict space into a playground (2014). See Figure 31(b) for the view of the Basque ball court interior. Image courtesy of Carretero and Clocker; copyright by the authors.

Table of Contents

List of Illustrations x
Preface xviii

Introduction 1
 Elusive imprints 7

PART ONE The field 19

1 The whereabouts of play 21

 Everywhere 21
 Spheres of action 26
 Field and stage 27
 The Canon 28
 The primeval 32
 Field and square 39
 Skin and precincts 52

2 Formal and relational traits 63

 Scale 63
 Topology 68
 Topography 69
 Symmetry 73
 Perspectival alignments 78
 The informal and the formless 79

3 Material 81

 The lawn 82
 Sand and snow 83
 Water 85

4 Locational attributes 97

Orientation 97
Adaptations 101
Clustering: couplings and mosaics 114
The near formal 120
Site specific 123

5 Park and amusement park 125

PART TWO Players 129

6 The athlete 131

Introduction 131
Cells and arenas 140
Bucolic deportments 153

7 The child 157

Introduction 157
The sky 160
The street 164
Anywhere 172
Tumuli 176
Displacements 182
Ludic cores 184
Future imperfect 186
Stillness and the miniature 191
Statuary: action and the immobile 193

8 Back to order 201

The school 201
The campus 212

9 The citizen 219

The return of *Homo Ludens* 219
Paideia's revenge 220

Final Remarks 231

Notes 237
Bibliography 253
Index 263

Illustrations

1	A legacy of objects we admire whose dimension and presence are an unfailing source of joy	1
2	High altitude field near Uyuni, Bolivia	3
3	Ansart plan showing: (1) Embedded race course; (2) formal race course (Turf Club, Club Hípico). Santiago, Chile in 1875	8
4	Excelsior Hotel, Lido, Venice, c. 1910: a palace stranded on sand	9
5	Embedded fields, Guerra dei Pugni, Venice	11
6	Ur Spiele Greek miniature displayed in Kinder Spiel Zug, a catalogue much appreciated by Walter Benjamin	12
7	Three temporary arenas in the Roman forum, according to Catherine Welch. (3) and (4) Wooden bleachers accommodating ludic arenas between (1) the Aemilia basilica and (2) Julia (Sempronal) basilica in the Roman forum, 2nd century BC	13–14
8	Early conceptions about sport in the city. After le Corbusier's sketch of Unwis Garden City, c. 1910, and his 1925 lotissements a alveoles	16
9	Rooftop cricket in Jaisalabad	20
10	A racecourse on the Agora, Athens, 400 BC	29
11	'Good design' in tools and sport implements	31
12	Colliding field patterns for work and leisure in the Forêt de Compiegne, from a hunting charter of the Ile de France	34
13	Chasing stags in the Tabladillo Aranjuez	35
14	(a) Landscapes and hazards: coursing in Stonehenge, 1845; (b) limestone walls in Derbyshire	36
15	Square as arena at Santa Croce, Florence, 1688	39
16	Independent field and square in Visviri, Atacama Desert plateau, Chile	40
17	Spianada cricket ground, Kerkira, Corfu	41
18	Bullring at Campo de Santana, Rio de Janeiro, early 19th century	42
19	Embedded and formal types: (a) impromptu bullring in Chinchon; (b) octagonal pattern in Almaden; (c) canonical form in Almeria	42

ILLUSTRATIONS

20	Rings and squares: (*top row*) Plaza Mayor Madrid, Plaza del Coso Peñafiel, Plaza Mayor Chinchon, Plaza de Toros Freguenal; (*bottom row*) Mijas, Aranjuez and San Roque	43
21	Rural patterns in the metropolis and the colonies: (a) Alaraz; (b) Atienza in Spain; (c) Ollantaytambo, Peru	44
22	The demountable bullring over a football pitch for the Corraleja, Sincelejo, Colombia	45
23	Houses and the arena: (a) Aguilar de la Frontera, 1806; (b) demountable bleachers in Riaza, Spain	46
24	Evolution of bullrings: (*left to right*) informal; open country; informal urban; semiformal with temporary array; geometric phase; canonical type	46
25	The Colosseum rubbing shoulders with civic building	47
26	Discrete arenas: an 18th-century cockpit within a building in Buenos Aires	48
27	Elementary formats: holding the ring, Argentina	49
28	(a) Royal Circus and Crescent, Bath; (b) Piazza del Anfiteatro, Lucca	50
29	Scale contrasts and typological inversions in the Roman amphitheatre and Bath's Royal Crescent	51
30	Frontón (Basque ball) at Segura, Spain, with the playing arena across the square from the atrium	54
31	Pattern and variations of frontónes in (a) 'Nacional de Buenos Aires'; (b) Beti Jai ('always festive'), Madrid	55
32	Torroja and Suazo Frontón Recoletos Madrid, 1935	56
33	Luiggi Moretti fencing hall, in Accademia de Scherma, Foro Italico, Rome	57
34	Irish handball alley attached to Buncrana Castle, County Donegal	57
35	A billiard room	59
36	Children's playroom and billiard room at the Robie House. Chicago: Ground floor plan, Frank Lloyd Wright, 1910	60
37	Outdoor Play in a 1970's Chinese commune	61
38	Comparative field plans	63
39	Manuel Casanueva: a 3-metre diameter ball becomes the playing field. Teams take turns launching a player towards the ball	64
40	Comparative track and racecourse plans	65
41	Large ludic imprints: racecourse in Rio de Janeiro	66
42	Bois de Boulogne: (a) before and (b) after transformation by Adolphe Alphand, executed 1882.	67

43	Ludic patterns: (a) Maze at Hampton Court, (b) Go kart race track	68
44	Movement protocols in (a) Ludic and (b) pedestrian practices	69
45	Man-made hazard	70
46	(a) Holmenkollen ski jump, Oslo; (b) plan of Gramisch Paterkirchen ski jump stadium, Bayern	71
47	Displacements: (a) Oberstdorf (168 metre); (b) Wembley Stadium wooden ski-jumping hill, 1961; (c) Ski jump diagram: note that higher profile and elevation correspond to Obertsdorf	72
48	Araucanian games: (a) Guiseppe Erba, Odescalchi, Odescalchi et al. *Indians Playing Chueca*; (b) Claudio Gay, contrasting view in 1854	73
49	Rodchenko chess table and chairs: one half black the other red, for a workers' club, 1925	74
50	(a) The sport arena and the axis of symmetry in Leonidov's Cultural Palace for Moscow, 1930; (b) Corbusier with Pierre Jeanneret Mundaneum in Lake Geneve, 1929	76
51	Symmetrical rigours: lawn and playgrounds in Jean Nicholas' Forestier Parque, Saavedra, Buenos Aires, 1924	77
52	Classical hippodromes integrated to larger ensembles: (a) a college by Durand; (b) a royal palace over the Acropolis by Karl Friedrich Schinkel, 1834	77
53	Henry Barnard's 1848 school desk with a sand tray	83
54	Piazza Navona flooded, Rome, 1827	85
55	Ludic mutations in the urban arena. Three identities of Piazza Navona: (a) as a racecourse (Campus Agonis); (b) the flooded square; (c) in its current shape	86
56	Confined swimming in the sea-water pool at Miami, Florida, *c.* 1920	88
57	Ludus and paideia in Corbusier's binary pool scheme	89
58	Tony Garnier's (a) civic and (b) ludic ensemble at the Cité Industrielle	90
59	Atelier Nikolsky, 1928, swimming pool, Leningrad	91
60	H. A. Brown: Weston-super-Mare springboard, 1937	91
61	(a) Castel Fusano, Ostia, diving board designed by Nervi; (b) Icarai Board in Niteroi, Rio de Janeiro	93
62	Swimming overloaded with ancillary programmes as recommended in Ortner's manual	94
63	Baroque scale in the rowing pool, Bos Park, Amsterdam (Corneus van Eesteren). (1) Rowing pool; (2) sports field.	95

ILLUSTRATIONS

64	(a) Instructions for orientation in football pitches; (b) the conception of a quadrangular pattern	97
65	(a) Metaphysical and secular alignments of churches after the fire of London; (b) Le Corbusier master plan for Meaux, 1956	98
66	Principles of disorientation in a labyrinth, Pompeii	99
67	Mediations: (a) alternative seating arrangements on stadia according to Ortner; (b) Le Corbusier's conception of a versatile stadium for 100,000 people	103
68	Training at the golf driving ranges on Pier 66, Manhattan	105
69	Domestic training in Maria Montessori's exercises on personal care	106
70	Training pontoons	107
71	Augusta National Golf Club, Georgia: (a) the field as a sequential entanglement of fairways, (b) evolving patterns 1934–present	109
72	Patterns of minigolf	110
73	The barren golf course in the Atacama Desert, Chile	111
74	Pezo von Ellrichshausen's '120 Doors': a bewildering set of paths based upon the utmost rational layout	112
75	Soft and hard surfaces meet at Soldiers' Field, Harvard University, over the winter season.	114
76	The function of boundaries in a striated field pattern at Leonidov's new town of Magnitogorsk, USSR, 1930	116
77	Sport mosaics: (a) 23 tennis courts in Hansen's sport park, Copenhagen; (b) in Ortner's scheme for Munich	117
78	Playing with the boundary: an overused net in Casanueva's *Despelote*	118
79	Organic flow and orthogonal frame: (a) Burle Marx's roof terrace at the Ministry of Education, Rio de Janeiro; (b) the dilemmas of flow vis-à-vis the field	118
80	Reidy and Burle Marx playing fields at the Aterro de Flamengo, Rio de Janeiro	119
81	Informal fields in Brazil, Joachim Schmid 'O Campo', 2010	120
82	The baseball arena as a public square	121
83	Manhattan adaptations	122
84	Flatten the site. Sewell company town, Chile	122
85	Site-specific slide on a hillside, Valparaiso	123
86	Field and topography colliding	125
87	Sert and GATEPAC City of Leisure, Catalonia, 1934	133
88	Leonidov's 1930 house of industry: typical floor plan with gymnasia and working stations side by side	134

89	Recreational needs classified and quantified: (a) Dutch CIAM age chart; (b) Ortner sport needs per inhabitant (adult male 3.5 m^2 plus 1 m^2; middle bathing area 1 m^2 per head with 0.1 m^2 water surface; playground 0.5 m^2)	136
90	(a) Stepanova, 1923 Soviet sport attire; (b) athletes, Malevich, 1932	137
91	Frederick Kiesler, space house. Interior view with photomural 'determination (labour and play)'; modern-age furniture company, New York, 1933	138
92	Luigi Moretti's so-called parametric stadium with optimized viewing angles for spectators, 1960	139
93	The form and its vestiges: (a) Roman amphitheatre remains in Housestead's England; (b) Roman Colosseum	140
94	Apartments and arenas: (a) Porte Molitor, Corb's own apartment as seen from the stadium; (b) Ilote Insalubre n° 6, Paris	142
95	Le Corbusier's marble villa with communal tennis courts, and hanging gardens facing outwards	143
96	Le Corbusier's Alveoles condominium, with alternating strips for 'play', 'garden' and 'allotments'	144
97	Football, tennis and swimming in the collective grounds of Corbusier's Ville Verte	145
98	Le Corbusier's the Mourondins, provisional housing for war refugees, 1944. Overall plan with the devastated city on the right, emergency dwellings around courts with lawns indicated as children's play areas and extensive sport facilities in front park	146
99	(a) Le Corbusier's Firmini Vert sport ensemble with church swimming pool, stadium youth centre (miracle box); (b) secondary field	147
100	Le Corbusier's stadium complex in Baghdad, including swimming pools, gymnasia, tennis and football	148
101	Louis I. Kahn's Market Street East, Philadelphia, 1961, with arena near the town hall	149
102	The stadium at the core of the Citadel. Louis I. Kahn, Dacca, 1964	150
103	Louis I. Kahn's Fort Wayne fine arts centre, Indiana, 1961, 64 with stadium across railway line	150
104	Coliseum and debating chamber in Louis I. Kahn's, Dacca, (penultimate scheme): *left* Citadel of the Institutions; *right* Citadel of the Assembly, 1964	151

ILLUSTRATIONS xv

105	Ludic arenas and civic spaces in Abbas Abad, Teheran, 1974: oval square and rectangular maidan with stadium embedded on the hills on the left	152
106	Alison and Peter Smithson, Kuwait old city, Orangerie Maidan 1969	153
107	The urbanism of golf: ludic and residential tissues at islands. *Right* compact golf course detail. Florida, John Nolen	154
108	Size dilemmas: (a) Prouve's 1936 miniature desk; (b) Rietveld helps the child to reach the adults' table	158
109	Play-oriented traits in the post-war house: (a) Marcel Breuer's Moma House, 1949, with playroom next to children's bedroom and children's court with sand pit in the garden; (b) Louis I. Kahn's sun house with tennis court	159
110	Play on decks: (a) a school in Islington, London, photo by the author; (b) the Empress of Britain tennis deck 'here in the middle of the ocean, tennis and swimming pool, sunbathing . . . and enjoying the boat's girth . . . dimensions apply to the ville radieuse' (Corbusier)	161
111	Unité Berlin grounds and rooftops for play and leisure	162
112	Tennis court above the Centrosoyus building in Moscow by Le Corbusier	164
113	Ludic counterpoints, sunshine and urban misery, according to Corbusier's, Jeux Eugenisme, *c.* 1940	166
114	Play facilities at street level in Smithson's Golden Lane scheme	167
115	Playing among ruins at Seville, 1933	168
116	19th-century horse stampede in Roman streets	169
117	Plastic sensibility and crass insensibility according to Rudofsky: (a) the wonderful imagination of Ethiopian children against (b) Froebel's passion for cubes	170
118	(a) Play supplants traffic in Copenhagen 'play streets'; (b) traffic playground at Lords' recreation ground, London	171
119	Aldo Van Eyck sand pits with modular concrete sets	174
120	Isamu Noguchi's topographic playscape in Yokohama	175
121	Isamu Noguchi's slide mantra, preliminary study, *c.* 1940	178
122	Louis I. Kahn's community centre and adjoining playground, Mill Creek housing, Philadelphia, 1953	178
123	Louis I. Kahn's ludic patterns at the Jewish Community Centre in Trenton, NJ, 1954–1959	179
124	Louis I. Kahn and Isamu Noguchi's Adele Levy Memorial Playground in Riverside Drive, New York, 1960–65, third proposal	180

ILLUSTRATIONS

125	Alison and Peter Smithson, Robin Hood Gardens scheme with mounds and sport yard	182
126	Ludic counterpoints; (a) horizontal grounds for games in the Ville Verte; (b) mounds as arenas for Paideia in the Robin Hood Gardens	184
127	Urban leisure cores carved out of the grid: (a) Chicago market park, Hilberseimer, *c.* 1950; (b) European housing blocks before and after intervention	185
128	An odd landscape: Sorensen's inaugural adventure playground in Copenhagen; a barren site sheltered behind mounds and foliage	187
129	Heuried recreational centre, Zurich; overall view with adventure playground against cultural centre	188
130	(a) Memories of underdevelopment: a counterpoint of formal systems in Copenhagen's adventure playground; (b) the informal surrounds the formal field in Buenos Aires Villa 31	189
131	Dimitri Pikionis's playground in Philotei, Athens	191
132	Thrills of the miniature in: (a) Aldo Rossi's *Le Cabine dell Elba* and (b) Giorgio Chirico's *Evocations about Life by the Italian Seaside*	193
133	Play sculpture by Julliette de Jeckel	195
134	Gulio Minoletti's submerged sculpture	196
135	Oscar Niemeyer, 1983, Zambodromo, Rio de Janeiro	199
136	A stern approach to school, hard-paved yard in Camden Town, London	201
137	A Scout leader explains the Murondins to his companions in Le Corbusier's conception about the reconstruction	202
138	An elementary ensemble: an aexedra, classrooms and the playground in Wilson's Primary School, England, 1825	204
139	Contrasting technologies and traditional patterns of twin stools: (a) Jean Prouve, 1951; (b) high school, Providence (19th century)	206
140	Swimming and field games at Le Corbusier and Prouve's 'portable schools for refugees', 1939–1940; note the binary pool	207
141	Two settings for play at the new town of Nagele: (a) football by the edge of town; (b) playgrounds sheltered within thick groves	208
142	Hunstanton School, East Anglia: the main block flanked by symmetrical sport fields that mediate between school and the rural hinterland	209
143	Stadium and orphanage in Amsterdam	210
144	Bauhaus blocks and sport fields, Dessau	213

145	Athematical gambits at the Illinois Institute of Technology by Mies van der Rohe (intermediate scheme)	214
146	Smithson and Stirling's competing visions about a Cambridge college in its relation to its grounds	215
147	Topographic devices for wind control in a sport cluster at the Naval Academy, Valparaiso. Competition entry by architects of the Valparaiso School	216
148	Epic scale and pre-Columbian associations at Alberto Taray's 1952 Hai Jalay play courts in Mexico's university city	216
149	A pleasure machine: Cedric Price and Joan Littlewood's fun palace, Lea Valley, London. Worm's eye perspective, 1964	221
150	The old in the new: Yonna Friedmann's Ville Spatialle, collated to a Mediterranean village	223
151	Friedmann's bid for the Paris Olympics 2004, with a demountable stadium at Place de la Concorde	225
152	The play board as a sculpture constant. Neienhuis's Ambiance de Jeu, 1956	226
153	Strenuous efforts: a late Victorian gymnastic apparatus	227
154	A field of ludic objects: John Hedjuk's memorial for the Gestapo victims, Berlin. Completion stage with 67 items	229
155	Leisure ensembles at Chantilly le Notre's garden with hunting grounds, the hippodrome and a golf course	233
156	Fields and squares	233
157	Mapping the body for food or leisure: Chilean beef chart 28 cuts; American Angus 9 cuts; Argentinean 22 cuts; Chilean rodeo points 4 sections	234
158	A lexicon of urban spaces	235

Preface

This research would not have happened if it wasn't for time spent teaching at the Architectural Association, later at Bath and various universities in North and South America. My hosts, the Pringle family, introduced me to English life. Chairman Boyarsky trusted me to teach at the AA, whilst Williams and Winkley supplied me with much needed job opportunities. Through Patrick Hodkinson I got to meet Peter Smithson, as we taught at Bath. The spirit of play was present in diverse ways in the aforementioned settings as it also was in Guillaume Jullian, the late Corbusier's assistant whom I was lucky to befriend. As will become evident, the way ludic inventions interweave with a particular landscape culture in Britain left a lasting impression on me. My long-standing interest in the so-called Valparaiso School resulted in an encounter with Manuel Casanueva who was then forging fascinating links between ludic practice and design inventions. I greatly benefited from seminars held at my alma mater, Universidad Catolica, Santiago, also at Universidad Central Caracas, Cornell, and Harvard GSD. Dean Mostafavi at Cornell, (later at the GSD), and Professors Azier Calvo and Jose Rosas in Caracas opened up invaluable teaching opportunities that led to my Doctoral study entitled *Materia Ludica*. I am also indebted to Jose Rosas for his generous advice. The students and collaborators are too numerous to mention, but my thanks are due to them all.

Teaching assignments at Penn, Porto Alegre, Tucson, Arizona, University of East London and Yokohama, allowed me insights into diverse ludic cultures. Carlos Comas, David Leatherbarrow and Thomas Weaver offered invaluable critical support. My thanks to Professors Frampton and Cohen for their generosity. Also to Emilio De la Cerda, Daniel Taliesnik and Felipe de Ferrari and Ivan Gonzales Viso. Even if they do not know, Alan and Marina Morris helped in great measure and so did Alberto Sato. Paloma Gonzales and Rodrigo Camadros made a decisive contribution with the illustrations. Special thanks to Agustina Labarca for her help in drawing and for her critical insights, whilst Mauricio Pezo, Christian Juica, Eduardo Castillo lent valuable images: my thanks to them all. Finally my thanks to the editors and proof readers.

Introduction

War had been raging all over Europe when Le Corbusier envisioned fusing the contours of Place Vendôme, the Court of the Louvre and Place de la Concorde (. . . 'a legacy of objects we admire whose dimensions and presence are an unfailing source of joy' . . .) in a linear pattern of slab blocks (Le Corbusier, 1946, 154). His diagram was of course validating the notion of the 'redénts', their apartment blocks folding about open courts. Where the squares would have formerly hosted sculptures or obelisks, he emplaced a football pitch. By 1953, the Smithsons substituted the CIAM charter's 'four functions' (as conceived by Le Corbusier) with 'forms of association' that were lavishly illustrated with vignettes of children at play. Embodied in their Golden Lane scheme, the patterns intimated spontaneity and chance. Later still, and inebriated with the idea of *Homo Ludens* as

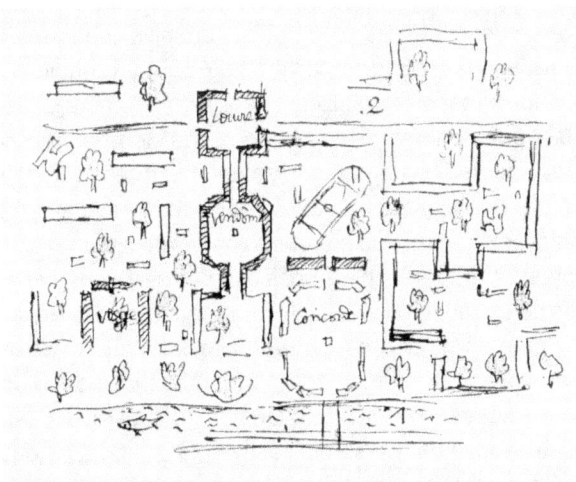

FIGURE 1 *A legacy of objects we admire whose dimension and presence are an unfailing source of joy. Corbusier. Copyright Fondation Le Corbusier Copyright: FLC / ADAGP Paris and DACS London, 2017.*

the true twentieth-century citizen, Constant Nieuwenhuys (who abhorred Le Corbusier's 'captive nature'), conceived a city of improvisation, chance and play. By 1972, Robert Venturi incited his peers to 'learn from Las Vegas', the Mecca of gambling where the 'non-judgmental observer' could learn as much as from Rome. The ludic agendas of athletes, children and assorted citizens became prioritized, whilst play was reckoned as significant as programme and concept. Its entry in the twentieth-century architectural agendas was simply unprecedented, and so were the shifting meanings attached to the subject by architects, planners and landscape architects.

Play fills our early years with an intensity that cannot be easily matched. Ushering our minds away from mundane concerns, its praxis and spirit *as recreation* (to differentiate it from *performance* (theatrical or musical)) accompanies us through life . . . 'The child is father to the man' said Wordsworth. . . . 'Genius is childhood recovered at will' added Baudelaire. More often than not, modern artists yearned to share the child's enchanted vision: play, we reckon, is by no means solely a childhood affair.

Fascinated with its explorative nature, twentieth-century culture valued its creative and formative potentials. Moreover, it greatly enhanced its visibility through the conception of novel spaces for its deportment. Indoors, the playroom superseded the aristocratic nursery. Outdoors, playing fields sprouted all around. Indeed, play was so highly valued by the fathers of modern urbanism as to endow the modern city with that holiday air that we associate with a superabundance of sunshine and greenery. Play time summoned freedom. An expanded leisure society embraced all. Spare time became a statutory right; *Homo Ludens* beckoned everyone.

Play has been described as a mirror of 'ordinary life'. Huizinga, Ortega, Caillois and Duvignaud recognized in play a prime cultural engine: 'all primordial human occupations', asserted Huizinga, 'are already impregnated with play'. Indeed the 1938 publication of *Homo Ludens, the element of play in culture* in a Europe overshadowed by imminent disaster, heightened the subject, whilst giving it its proper due (Huizinga 1938).[1] Yet on the whole, the significance of its setting as essential to the ludic proposition remained unexplored. Huizinga opens up, however, a far-reaching possibility: if play is as central to human endeavours as he stated, why was so little attention paid to its tangible signs? If indeed play creates its alternative world, what kinds of artefacts does it engender? And how are the urban contours of the playground defined?

This enquiry is above all about the *play-ground*, a particular space released from productive ends in the pursuit of festive plans; about its emplacements, configurations, material description, and equipment. The issue is not so much one of 'frameworks', 'scenarios' or 'backdrops', as one of interplays and entanglement with place, space and matter. It involves, therefore, the unveiling of the singular – perhaps privileged – rapport that binds play as action with

FIGURE 2 *High altitude field near Uyuni, Bolivia. Image courtesy Christian Juica © C. Juica.*

architecture as 'support'; it enquires about how these are forged, and about how these may become embedded in ludic practices to such a degree as to render it futile to extricate one from the other. It emphasizes how play manifests itself through artefacts and space.

The subject has been extensively explored from such focused perspectives as 'child play' or 'sport'. In surveying the developments on the playground, Ledermann and Traschel delineated fundamental ideas about its structure and spatial requirements only that focused upon children; Hertzberger grounded his ideas about play in evocative architectural descriptions, whilst claiming an uncommon urban primacy to it, yet again his interest was unstructured play. Both Bale and Teyssot looked into sport's cultural, political and spatial dimensions, whilst Cranz described the conflictual inscription of playgrounds (for all ages) in the North American park, embracing thus a broader range of ludic expressions, but with a prime concern for the politics. A body of technical manuals offered detailed advice on ludic 'infrastructures'. Recent exhibits at MOMA ('The century of childhood'), Zurich ('The Playground Project'), Reina Sofia, Madrid ('Playgrounds') made substantial contributions to the subject. All these delineate a fascinating landscape of ideas, events and forms; yet without, on the whole, delving in the urban impact of play.

Ours is a broad appraisal, for its scope in time, as much as in geographic range, seeks to disclose the effect of play upon architecture in its manifold

expressions, whilst outlining a comprehensive vision (in contrast with specialized ones such as 'sport', 'indoor games', 'child's play'). In doing so it aspires to bring into architectural consideration the range of ludic concerns raised by the likes of Huizinga, Caillois and Duvignaud.

Why review it now? Considering the subject from within a historic framework may help reinvigorate notions about the public sphere, whilst adding lessons about its rich ascendancy of forms, grounds, and occasions. Play adumbrates public space memorably, charging it with cultural significance, whilst displaying it as freer, its inherent gratuitousness counteracting the excessive bearing of economics in our lives and outlooks. Moreover, cities always knew how to accommodate it: why not look at its settings anew? Our modern forebears procured to extend ludic rights to everyone; is it not worthwhile to resume their quest?

No doubt, play and architecture imbricate. Within its modern understanding, however, one can hazard just four – material or conceptual – links.

Play was understood as a rhetorical trope, a recurrent one within the architect's discourse: an example is Le Corbusier's famed 1923 definition of architecture as . . . 'the masterly, correct and magnificent play of masses brought together in light' (play, that is, as expression of the fleeting, unpredictable engagement of form, matter, and light). It was also conceived as a creative tool, a procedural instrument that legitimized the creative function of chance (as with the Surrealists, Dada, and the notion of the *objet trouvé*).

Play was alternatively understood as a kind of a cradle, laboratory or template of social organisms (a point highlighted by Huizinga, Ortega and Caillois), and finally, it was simply assumed as an architectural programme.

Several interesting traits are attached to each of the above, but the singularity of the latter –which is also the most conventional link – calls for attention, for play had never been so comprehensively understood as an architectural issue before.

This particular architectural programme reckons a binary mode, as represented by *play* and *game*, the spontaneous and the structured which accounts for the extraordinary twentieth-century ludic universe. Because 'play' embraces 'game', however, Roger Caillois coined the more precise terms, *Paideia* (borrowed from the Greek) for 'play' and *Ludus* (from the Latin) for 'game', whilst also probing their mutual transactions.[2]

Paideia is spontaneous. In the absence of established rules, it rests upon the shared assumption of the illusory 'as if': hence upon provisional armatures. *Illusion* – Huizinga reminds us – derives from '*in ludere*', meaning 'to be in the game'. *Ludus* appeals to a priori agreements and therefore rests upon legal constructs. Both share arbitrary and imaginary assumptions; whoever dispels the enchantment spoils the game and must be expelled; but only in *Ludus* do rules become explicit and stable (Caillois, 1986, 1967).

Implicit to his analysis, there are spatial matters which he does not delve into, but it follows from his reasoning that *Paideia* – which is eminently tactical – simply snatches ludic opportunities from any given place; whereas, being rooted in experience, *Ludus* issues mandatory norms and spatial criteria thus defining its highly singularized fields. Hence, one infers that the relationship between *Ludus* and architecture is straightforward, whereas it can only be oblique with *Paideia*. One can also assume that the former is prone to long-term bonds, whereas the latter eschews long-standing rapports. Clubs and global bodies attest to *Ludus* institutional projections. *Paideia* might forge strong memories but only *Ludus* makes proper history.

The submission to the rule bespeaks a social order forged upon shared agreement, hence *Ludus* also becomes an index of social organization; moreover, only *Ludus* offers the springboard toward a veritable architecture of play.

Relationships are seamless, however, for *Paideia*, in any of its forms, may evolve into *Ludus* and conversely any expression of *Ludus* may degrade into *Paideia*. The former's transit operates through the acquisition of rules, the latter from sheer degradation, when the cohesion of a determined game's formal armature loosens up. However, *Paideia* is, for Caillois, the cradle of play.

These fundamental strands of the spontaneous and the organized together with the way in which they calibrate the relationships between chance and the rule become prime ludic topics. Principles and norms ease the institutional life of play whilst also become critical to the definition of a play-*ground*.

Considerations about the city, the field and the player will structure our argument. The city – the theatre of human comedy and drama – is arguably the ultimate ludic space with the square its prime symbolic locus.[3] We will, however, examine the public dimensions of play in a variety of urban settings.

The first part looks into the field as the concrete embodiment of play, examining form, identity and relational properties, its temporal and material foundations, as well as its symbolic and factual severing from the grounds of 'everyday life'. It also enquires as to how 'fields' embody specific ludic principles; hence also how ludic agendas coalesce with architecture. With a certain emphasis on structure and typology, the interfaces forged between rule, form, matter and space will reveal manifold expressions.

Players are fundamental to any ludic proposition: the second part will review modern ludic settings through the perceived urban agendas of three main characters: the athlete, the child, and the citizen. The sequence is by no means gratuitous, for epochal predilections roughly followed broad sensibilities, such as the pre-war cult of the new man (predominantly male and adult), a post-war enchantment with childhood, and certain countercultural propositions that reacted to – amongst other things – the welfare state and the emergent

affluent society, opened the field to everyone. Rather than 'the player' in the abstract, what emerges from this analysis is a characterization of a certain type of player who embodies certain modes of play. The manner in which their requirements become embedded in particular projects discloses the highly specific responses that leading architects gave to this matter, as well as the distinctive urban status they attached to it.

This generous perspective seems necessary to outline ludic space as conceived between the early decades of the twentieth century, and the crisis of the modern movement, broadly occurring in the 1970s. However uncommon may be the idea about embracing all play types under a single approach, the choice is quite in line with Huizinga, Caillois, and others who thus charted the ludic territory, a fundamental framework to ensure the subject's integrity.

Play forms reveal social prejudices no less than other social mores, yet one aspect that makes the twentieth century special is its commitment to universal access to leisure, an expanded agenda upon which the so-called leisure industry eventually came to rest, as much as the society of the spectacle. Besides the social distribution of leisure, changing sensibilities about ethics also affect the ludic landscape. Blood sports increasingly encounter public revulsion. Gambling is controlled by law. Statutory limits regulate boxing. No doubt these merit full exposure, but they are not essential to this argument for its focus is instead charting ludic space in modern culture: how the activity takes hold of space; which are the salient arenas and what is the urban incidence. Clearly volatile, this scenario also exposes abandoned playgrounds and disused fields. We will attempt to chart some of these changes, and their urban impact too.[4]

Much like laughter, play is jovial and unselfish. It thus embodies an idea of freedom. Coercion is simply alien to its light spirit. Freedom and the democratic ideal are at the heart of the leading twentieth-century urban projects; no wonder play finds a prominent place in it. Its gregarious nature renders it congenial to urban space. Its atavistic traits which often embody simple, seemingly immemorial formulations, ease its reproduction.

Just like art, this occupation is lodged somewhere beyond utilitarian experience. Like ornament, play does not fulfil any practical purpose. It neither adds practical elements to the world, nor does it contribute to its progress; at its best it only embellishes human experience. One does not play in order to be useful; one plays in order to move from one level of experience into another, somewhat distant from ordinary experience.

Yet play is often spectacular. Its reiterated practices inform the architectural project which in its turn gives shape to its predominantly urban arenas. It embodies the interfaces between chance and the rule, between the indeterminate and the predetermined that so fascinated modern creative minds. It becomes a sensitive, dynamic and self-renovating index of cultural moods.

Much like laughter, its expression is often fleeting and unexpected. Insofar as it represents gratuitous pursuits, it can easily be dismissed as something futile; however, its impact in the formation of our contemporary habitat is considerable. An infinite number of fabrications attest to its tangible presence, but the presence of its grounds which is for us self-evident, was not always so.

Elusive imprints

One readily recognizes the contours of a soccer field or a baseball diamond, even if in thoroughly unfamiliar localities, but this kind of intelligibility of the play-ground was not always nearly as evident. With the exception of classical Greek and Roman arenas (and here one would need to reckon with the remoteness of ancient ludic practices in relation to modern conceptions) right until the dawn of the twentieth century, proper playgrounds were rare in the West. Until the late nineteenth century playing fields were seldom fabricated, because play unfolded for the most part in shared grounds, thus leaving no significant traces. Even when fields were established, these followed no precise standards. Venice – a city that encapsulates like no other the notion of artifice – exemplifies the case, as seen in the remarkable 1845 Combatti's plan,[5] a detailed account of the city that roughly follows from Nolli's famous rendering of Rome where such urban interiors as churches or monumental spaces were shown together with the open spaces. The survey does not give away any clues about the subject; perhaps as yet outdoor play did not cast durable imprints. It portrays, however, a singular expanse suggestive of physical deportment, namely, its *Campo di Marte*. Although clearly not a *campiello,* nor a forecourt, it vaguely resembled a sports field. Devoted to military drill, it recalled a not uncommon agonistic convergence of military training and playing, but aside from it no formal playing grounds appeared. Did citizens play in every single *campo* and *campiello*? If so, one can safely infer that in 1845 Venice, outdoor play did not become as yet an architectural programme; that is to say, it did not call for exclusive configurations. These practices were simply embedded in its ordinary structure.

Realized some three decades later by French engineer Ernesto Ansart, the 1875 *Plan of Santiago de Chile* depicts instead two distinct ludic settings: an extensive hippodrome, and the denominated *Yungay* race course. The former is a roughly oval circuit that accords with conventional outlines for race tracks. The latter is an *alee*, with the equestrian field inscribed within the road, a dual identity which is also evident in London's *Pall Mall*, Cajamarca de la Cruz's *Paseo de la Corredera*, Murcia's *Explanada de España*, and San Juan Puerto Rico's *Calle de Cristo*, probably too in the French *Carrières* and Italian *Corsos* whose names betray equestrian use. Today, these would be termed hybrid spaces.

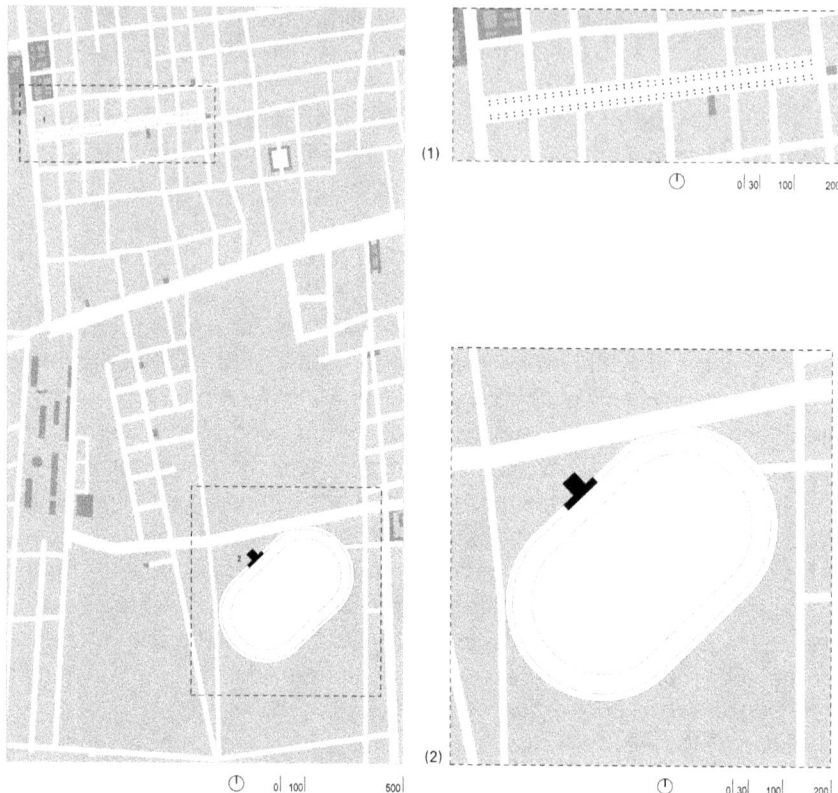

FIGURE 3 *Ansart plan showing: (1) Embedded race course; (2) formal race course (Turf Club, Club Hípico). Santiago, Chile in 1875. Drawings by the author after Ansart 1875.*

The early presence of the formal field in a minor capital city is nonetheless remarkable. Santiago was thus equipped with alternative ludic enclaves, the *club*, essentially an exclusive association devoted to recreation, and the *shared space*, a public ground accessible to all. Henceforth, whether public or private, the sports field – a space of order, harmonic confrontation and social interaction – became a benchmark.

Just like Venice, Santiago also possessed a Field of Mars, but by 1875 its parade was engulfed in pleasure grounds. It was laid just one block away from the race course, so that together these added up to the largest expanse of greenery in town.

Indeed, the public park, a nineteenth-century invention, was to become a main locus for play. Thus, Santiago's extraordinary pairing of park and racecourse embodied competing visions about contemplation and action, with their contrasting demands increasingly affecting the evolution of urban

parks. Neither of a bucolic nor of a georgic disposition, lacking in compositional or productive goals, the playing field supplied another nature, one that gradually, and not without resistance, forced its way into the park.

Featuring a vastly enlarged cartographic frame, the *Blue Guide, Northern Italy and the Alps* (1978) embraced an amplified notion of leisure. Besides Venice, its map featured the lagoon. Venice hosted at this juncture at least one football pitch, but day to day outdoor play remained otherwise embedded in its venerable fabric. The outstanding novelty was the inclusion of the Lido – Venice's renowned resort – and as such its prime *modern* attraction. It was also a byword for resorts, open air swimming pools, and cruise ship recreational decks.

The nineteenth-century resort represents a decisive landmark in the pursuit of play, a veritable alter ego of the industrial company town, except that where one sponsored production, the other was entirely devoted to 'recreation' (Sica 1981). Just as optimized outputs determined the company town's layouts, the rational deployment of 'spare' time organized the resort's structure, with the beach unfolding as its ultimate arena. Forged around the encounter of sea and land, the sea resort beckoned site-specific modes of recreation: the farther the emplacement from the shoreline, the lesser its significance. The shore

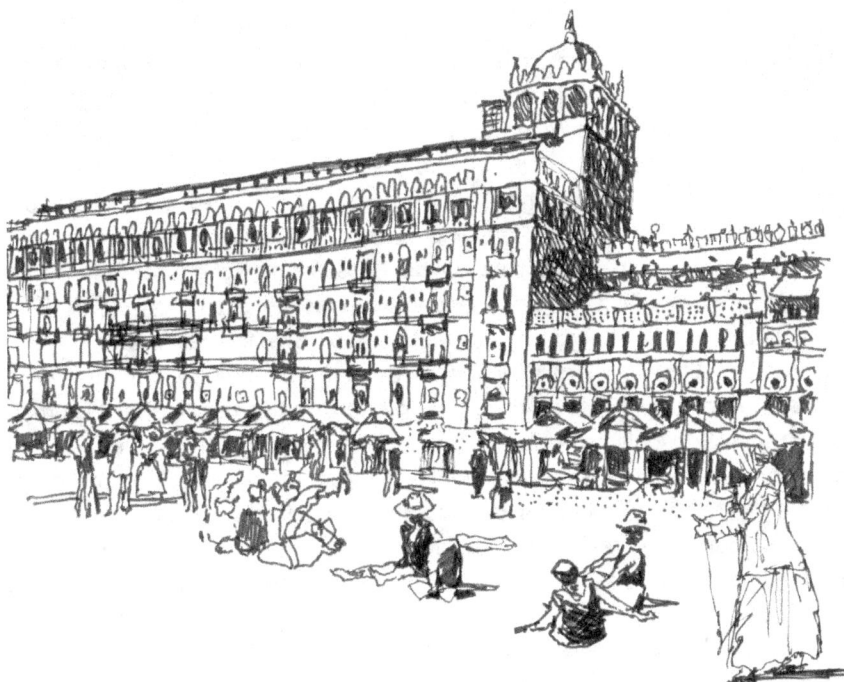

FIGURE 4 *Excelsior Hotel, Lido Venice, c. 1910: a palace stranded on sand. Drawing by the author after postcard.*

gathered tennis courts and gambling rooms – that is to say formal, indoor and outdoor arenas, as if it was an overloaded playing field. (In Spanish, 'arena' denotes sand, thus betraying the relationship between place, tactile material, and play, a kind of complicity between the ludic spirit and its material instruments that will be examined later.)

In its prime location, the Excelsior Hotel aped a palace, although with an expanse of sand in lieu of the expected forecourt, as if crude nature had replaced craftsmanship.[6] Moreover, the casual demeanours of holidaymakers on the beach contradicted stately manners, not to speak of the utterly subverted dress codes and unprecedented bodily exposure. In the daytime, day guests were encouraged to morph into noble savages, gentlefolk behaving as children or 'primitives', only to regain their comportment (and formal attire) by dusk.

Whilst retaining a privileged place in the public imagination, the beach encapsulated a primeval play spirit. In consecrating a particular rapport of nature and city the resort delivered templates for the modern outdoors. It is not by chance that the May 1968 revolutionary claim '*dessus le pavement, la plage*', unwittingly appealed to this (bourgeois) leisure paradise. Impregnated with an idea of play, this profoundly anti-urban utterance adhered nevertheless to that strand of play that seeks fulfilment in nature. Its implication was none other than the dismantling of the urban crust in the pursuit of leisure, play, and untrammelled freedom.

The unlikely agenda about recasting the beach inland was embraced by Le Corbusier in his 1930s Ville Radieuse roof tops where a sequence of synthetic beaches would have brought the spirit of the resort to the urban heart, enshrining a cult of heliotherapy that conjoined informal leisure modes with the beneficial effects of the sanatoria, whilst sponsoring sport-like trends which would become conventional in the ensuing decades. Some seventy years later, through a massive hauling of sand, the *Paris plages* scheme softened the Seine's masonry quays, bringing the resort into the city once every summer. In order to attain these objectives, sand was strewn over the pavements.

The deposition of sand over the hard-urban surface and the alternative uncovering of the primeval (ludic) soil through the dismantling of the urban crust described polar strategies. One operated through material accretion and programmatic densification; whilst inspired by *Rus in Urbe*, the other made it through subtraction. Beyond these topographic strategies, urban playing grounds also revealed formal and material identities. The modern ones subscribed to an idea of zoning which sponsored the disaggregation of practices that once had shared spaces and facilities. Urban play was largely made to conform to this *technique of separation* (thus Guy Debord decried its deleterious effects). Zoning was enforced by planners upon urban play, yet players often favoured taking over spaces by stealth: nurtured from spontaneity and self-organization, informality also became a ludic objective. The

counterpoint between consolidation of the playing grounds and the ludic recourse to the city at large was innate to modern ludic horizons.

Countering the 1845 Venice plan for opacity as regards the whereabouts of playgrounds, Giacomo Franco's slightly earlier vignettes clarify the particular ludic advantages attained by Venetians in the *Guerra dei Pugni* (battle of the

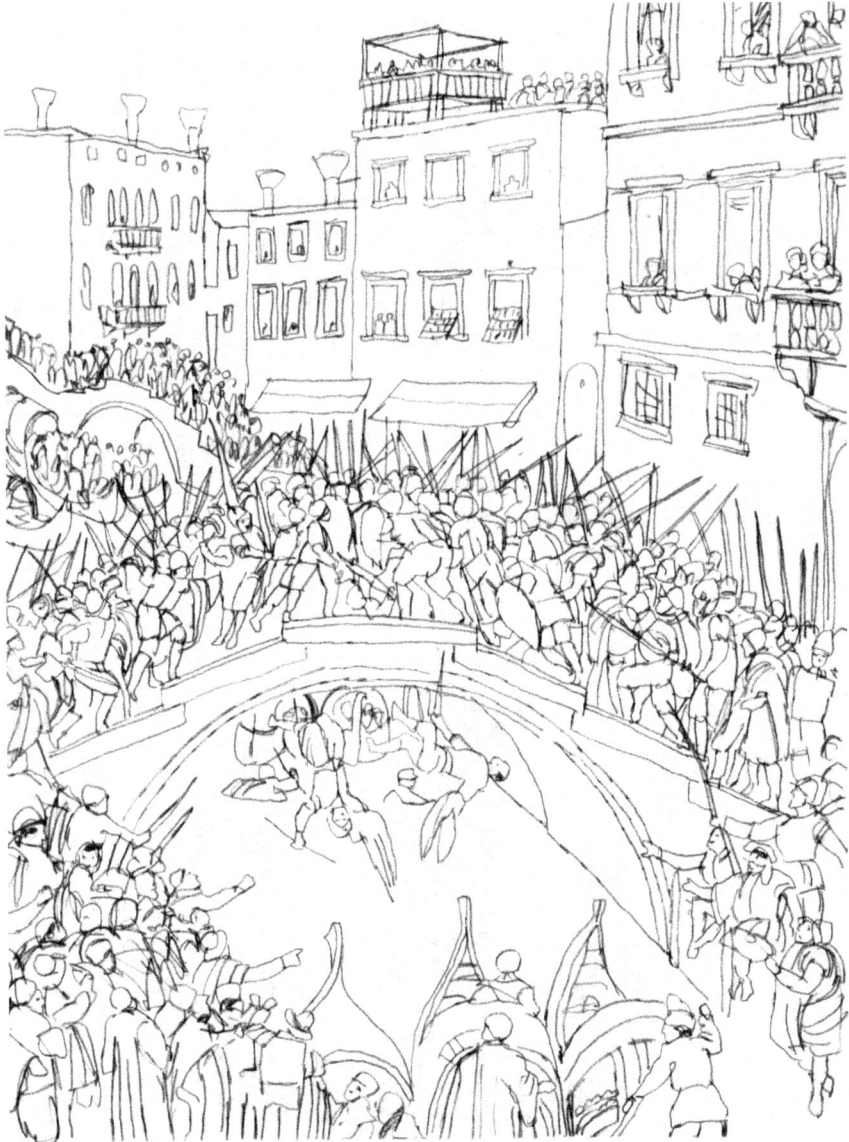

FIGURE 5 *Embedded fields, Guerra dei Pugni, Venice. Drawing by the author after Giaccommo Franco.*

punches), a fist-fight contest fought between rival factions over a bridge.[7] It unfolded within ordinary spaces. It did not create urban spaces; quite to the contrary, it dislodged routine activities. Nurtured from a certain degree of spontaneity, the game was rendered invisible in maps. Yet it would be equivocal to assume its indifference with respect to its settings for *Guerra dei Pugni* seems to calibrate Venice's ludic potential with the utmost finesse whilst deriving its ludic principle from such salient traits as Venice's structure of canals and bridges. Thus, the keystone demarcated the limit between the warring factions, supplying that element of symmetry in the field common to so many competitive pursuits; its elevation enhancing the drama; it supplied the agonistic frontier, whilst, endowed with the quality of an urban theatre, the bridge framed the free falling dejected parties.

Hence, *Guerra dei Pugni* nurtured from Venice's salient traits. Conversely, it celebrated Venice's material construction highlighting its dramatic potential. Such reciprocity between play requirements and urban form can best be described as a form of complicity, for it is the case that, whilst players play against each other, they simultaneously play *with* and *against* architectonic configurations.

Two ludic templates issue from the above. The first one extracts from the rules of the game such cues as are required for the configuration of the field, and belongs to the domain of *Ludus*; the other scans the urban field for its ludic potentials, and belongs to *Paideia*. Such are the possible grounds in which play and architecture reciprocate.

FIGURE 6 *Ur Spiele Greek miniature displayed in Kinder Spiel Zug, a catalogue much appreciated by Walter Benjamin. Drawing by the author after Kinder Spiel Zug.*

A symbol of urbanity, the square was often a privileged locus for play. The colonial Latin American 'Plazas de Armas' were typically characterized as voids within the chessboard plan; they were as indeterminate as regards use, as precise in outline. Together with other colonial enterprises these revealed systemic traits. The Law of the Indies (a set of instructions which counselled orientation, urban layout, and choice of terrain) also betrayed an interest in urban play, counselling a rectangular plan, bearing a one-and-a-half-to-one ratio that was deemed suitable for equestrian contests.[8] Even though the format was seldom applied, some authors perceive in the dirt floor that characterized these squares a deliberate ludic choice (hard paved European squares were often strewn with compacted earth for similar ludic purposes).

Conjoining ludic and civic goals, these codes followed Vitruvius who had recommended a three-to-two ratio for the plan of the Fora, as convenient for

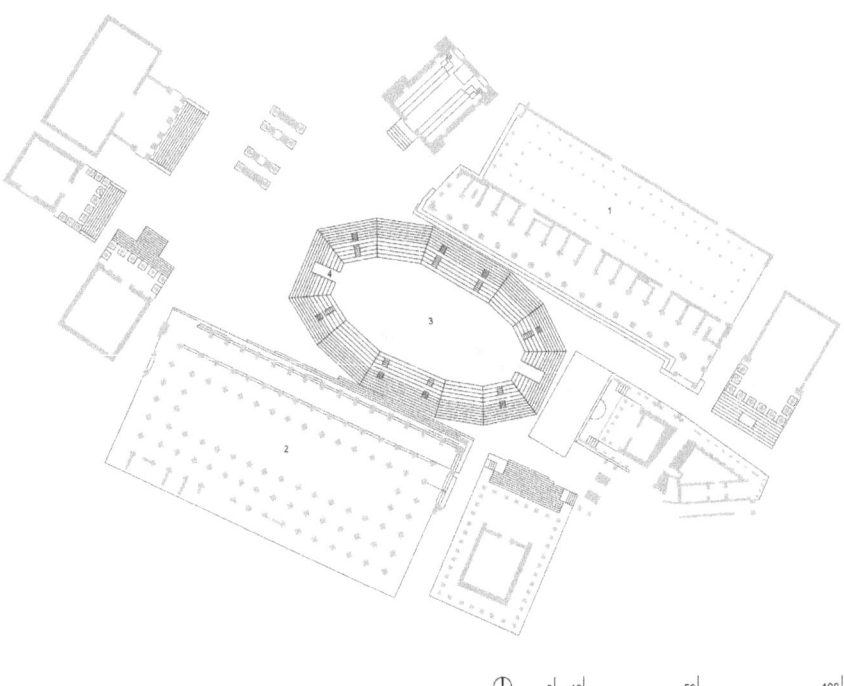

FIGURE 7 *Three temporary arenas in the Roman forum, according to Catherine Welch. (3) and (4) Wooden bleachers accommodating ludic arenas between (1) the Aemilia basilica and (2) Julia (Sempronal) basilica in the Roman forum, 2nd century* BC. *Catherine Welch,* The Roman Amphitheatre from its Origins to the Colosseum, *Cambridge University Press. Drawing by the author after Welch.*

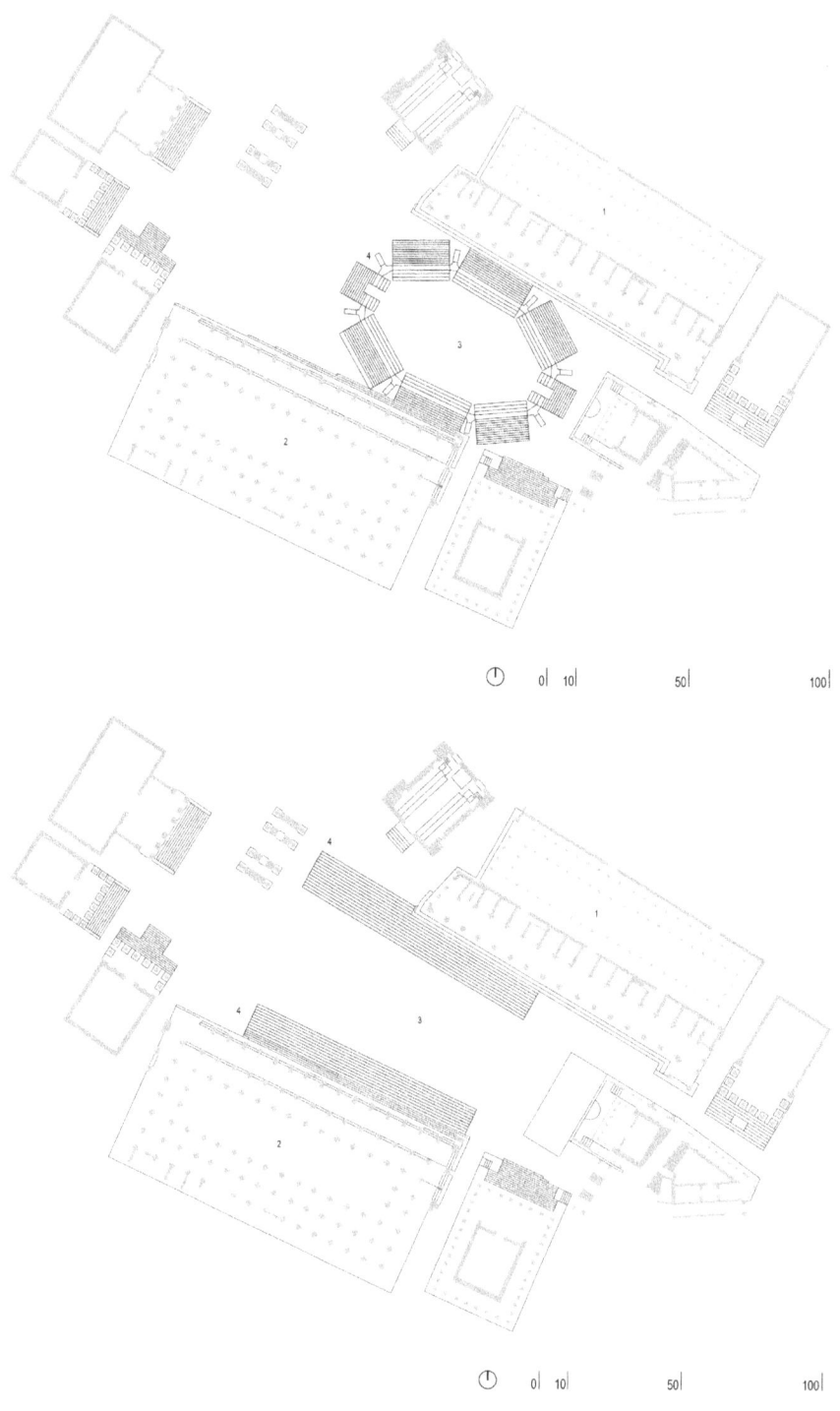

FIGURE 7 *Continued*

gladiators' contests, together with the provision of colonnades for spectators. Conceived as theatres, these spaces indeed accommodated ludic functions[9] (Welch, 2007).

Whether strictly followed or not, these conceptual frames reveal the metric properties inherent to so many playing fields. Yet besides hosting a plethora of ceremonial functions, the spaces reverted to daily routine, so that a concept of indeterminacy fits them better than exclusive ludic usage. No significant playing fields were implemented in such South American localities until the introduction of the bullring, a building type that evoked memories of the ancient coliseum.[10] Otherwise, with minor exceptions, it was not until the nineteenth century that playgrounds acquired the generalized status of proper fabrications, but then the dissemination of ludic arenas became contagious.

Urban space furnishes play with arenas, whilst, through obstinate reiteration, play inscribes its contours in the urban field. Latent in the city there are endless potentials for play, just as latent in ludic practices there are potential field forms. Reciprocity characterizes the interchanges between play and its grounds (which need not be hard: Anglo-Saxon 'commons' and 'greens' anticipated sports grounds whilst embracing an enduring relationship between public space and cultivation). Soft or hard, cultivated or constructed, fields infiltrated the urban scene, decisively. Play is anything but indifferent to form: more often than not, whether on the board or in the field, it prescribes configurations together with the rules of engagement: contours often contain and prescribe its performance. Such attachment of play to form was prolific in the making of urban spaces, and yet as one can see, urban experts were slow in perceiving its evident impact.

Originally published in 1922, Hegemann and Peets' *The American Vitruvius, an architect's handbook on civic art* paid scant attention to urban play, no doubt because of the subject's conceptual remoteness from the authors' perception of the civic, but probably too because the programme did not exude as yet the required pedigree. The handbook just portrayed a few fields in university campus and housing estates. Admittedly the authors' traditional outlook betrayed their indifference towards play (Hegemann and Peets 1988–1922).

It was not just a question of consciousness, however, for just over three decades earlier, their mentor Camillo Sitte had recalled – although just in passing – how certain Viennese districts contemplated 'public grounds, children's playgrounds and athletic grounds'[11] (Sitte 1965, 1900). He emphasized 'sanitary greenery', as a foil to the 'decorative' (i.e. ornamental), hence his sponsorship of the urban park as an institution mainly devoted to hygiene. However, his extensive portfolio of squares did not illuminate ludic usages.

FIGURE 8 *Early conceptions about sport in the city. After Le Corbusier's sketch of Unwis Garden City, c. 1910, and his 1925* lotissements a alveoles *Drawings by the author after Le Corbusier.*

Not much else was mentioned about the subject in Raymond Unwin's 1906 *Town Planning in Practice* either, except for some attention lavished upon the need for safe playgrounds for children and a recommendation about setting parks and playing fields by the edge of towns. He did, however, conceive tennis courts for certain residential schemes, foregrounding Le Corbusier (who sketched up Unwin's proposition), but overall the ludic subject was alien to his otherwise broad and extensive review of planning options (Unwin, 1994, 1909). As with Sitte, his selected playing fields had little public incidence.

The topicality of play was to take a sharp turn, however, in Le Corbusier's 1933 *Radiant City* where play, especially sport, was hailed as a prime subject. Sport, as he put it, was there to be played *au pied de Maison,* always at hand, and in full visibility. His predicament was congenial to Sitte's health driven green agenda. His recreational spaces were intended to cater to the hours of idleness guaranteed by social legislation. In view of later developments, his clairvoyance as regards the subject seems remarkable. Implicit in his agenda was the acknowledgement of the playground as a significant urban arena. Similar trends informed Soviet urban conceptions as displayed by Leonidov.

In the course of time, formal playgrounds were either incorporated in cities or else embedded in new urban quarters eventually becoming standard amenities. The countless aspects to be considered about their incorporation would largely exceed the scope of this enquiry, but allowing for some simplification, certain landmarks may be noted.

First, there were 'bottom up' institutional sponsors like the club. These commanded the governance of collective events and the planning of new fields. Indoor urban clubs housed sedentary games, sometimes sport, whereas 'country' clubs hosted outdoor sports.

Secondly, top-down initiatives percolated from the political establishment that gradually assumed the public recreation agenda within its conceptual and instrumental horizons: 'the cultural, physical and moral improvement of the race would be a primordial and basic preoccupation of the State' proclaimed the Spanish Republic in its 1938 *Statement of Principles*. States devised such administrative figures as a 'ministry of culture and youth' (sport, health and education were often allied) targeting site planning, leisure infrastructures, and also vacation colonies where recreation, social welfare and a certain measure of indoctrination converged. Public parks increasingly embraced 'active' recreation whilst public housing incorporated playgrounds for both children and adults.

Thirdly, there were the educational establishment fields that aided the cultural propagation of ludic agendas.

Finally, it was the market, that is to say a medley of agents large and small, who, embracing the ludic programme as commodity, promoted leisure in resorts, fairs and a host of establishments orchestrated around play and recreation. The consideration of leisure never again lost momentum as it became evident in the emergent 'leisure industry' and the 'sport and leisure' sections increasingly featured in newspapers and broadcasts.

A vast network of events surrounded the incorporation of the playground into the city. By 1972, Le Corbusier's former assistant Georges Candilis was pleading for 'Planning and design for leisure', only that following a quantum leap, his concerns were then territorial, because leisure's onslaught upon the landscape had become at that stage simply massive (Candilis, 1972).[12]

As observed by Cranz, early attempts at situating large sport arenas in cities were difficult: some of these were banished to liminal areas; others were grafted – not without resistance – on to parks (the institutions had gone public precisely when sport became recognized as an important mode of recreation). Others were squeezed into available sites. Suburbs became fertile ludic grounds as they expanded in tandem with increased sport demands (Cranz 1989). Fields were sometimes skilfully fitted atop buildings. These adaptive tactics came to characterize urban play facilities.

Thus, playgrounds became urban late-comers, for they were primarily grafted on cities, but their significant potential as incubators must also be acknowledged, for eventually whole districts also surged around play arenas. Thus, conceived as foundational elements, these usurped, so to speak, the function of squares, with the club house somewhat substituting the parish church. The transit from the grafted on to the foundational status of the urban field describes the ludic agenda's urban success story.

PART ONE

The field

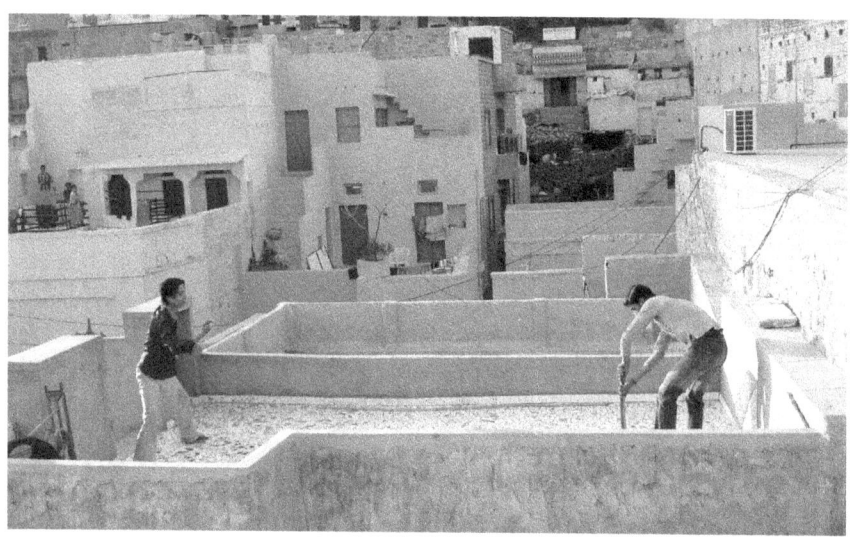

FIGURE 9 *Rooftop cricket in Jaisalabad. Courtesy Christian Juica, © C. Juica.*

1

The whereabouts of play

Everywhere

Once upon a time, all places were ready for play; the issue was just how to seize their unique ludic opportunities, whether embedded in water, ice, snow, sand or rock, forest or clearance, meadows, gorges or plains, mountain slopes or frozen ponds. But play also engaged scenic, atmospheric and acoustic conditions. One played with full visual command or in visually occluded fields; one could play with sounds as much as with eerie silence. In blindfolding oneself for the sake of fun, one could interfere with visual perceptions. One could also meddle to the same avail with one's motor functions or ramble against pitch darkness. None of these actions could be disallowed by nature with its latent ludic potential. But this also meant that the fulfilment of play could do without architectural support. In architectural terms, play would be barren, infertile.

Far from it however, the instinct of play furnished prodigious ranks of fabrications, ranging, in decreasing scale, from landscapes, fields, precincts, to tools, garments and toys, thus fostering a vast manufactured universe. Moreover, disused artefacts, even over-scaled ones, joined its ranks, as recalled in Paul Virilio's affectionate memories of playing in abandoned German bunkers by the Normandy coast, for the ludic universe also embraces the paraphernalia left behind by society in its relentless march to progress.

It was in the city however where the ludic instinct delivered its most impressive fabrications and it was also there where each type was assigned an idiosyncratic setting, and a purposefully defined vessel.

The drama of active play rests upon spatial foundations. One only plays within determined spatial and temporal limits. Huizinga points to the Greek *Temenos*, where 'portions of land (were) set apart . . .' within which special regulations of behaviour had to be observed' (Tzonis & Giannissi 2004, 160) for the reasoning behind this. Although fields often appear denuded, these are highly charged, observes Huizinga: . . .' within (fields) reigns an absolute order; play embodies order' . . .; these are . . . 'arbitrary and only relevant to a

determined form of play, but also absolute, since . . . every game is played within a material or ideal field which either expressly or implicitly is defined beforehand' (Huizinga 1972). Be it within the confines of the play board or the expanse of the field, each play embodies spatial or configurational traits. In play, order rules space and time, particularly so with structured games. A distinctive geometry charges ludic space with values.

Once in the field, the player submits to rules, whilst he (or she) becomes entangled with space, a host of instruments, adversaries and team mates; all with a heightened sense of urgency, for the action is bound by time. Physical prowess, cunning, energy, and a sense of *arête* converge with material, topographic, dimensional and visual factors. The trial's ultimate outcome leads to either victory or defeat. Once games pass, fields revert to a mute existence.

Cult 'inscribed itself in play', affirmed Huizinga, because play – a base impulse shared with animals – was there already, as a sort of a cradle of culture. Cult and play coalesced in early times: it was only later that play, when divested of metaphysical goals, became just a pastime. Primitive cultures acknowledged no difference between playing and being, he asserted; consecrated places were no less than playing fields, where celebrants followed arbitrary choreographies charged with significance, so that spatial arrays gradually accrued hierarchical values. Play emancipated in the course of time, albeit with lingering ritual associations. There is a modicum of ritual in play – conceded Agamben – as there is also a modicum of play in ritual[1] (Agamben 1998, 2001).

These analogies suggest relevant architectonic projections. After all, is it not so that major buildings – the temple, the courthouse, parliament, surged from ritual? Yet significant gulfs become evident when the player's tactical interface with space engages the space for its challenge, such as, for example, its extension that bears so heavily upon physical stamina. Likewise, the field's material and textural complexion provoke the player's discernment accordingly, as it augments the ludic appeal, (this is quite evident in children's play). One plays *with* snow and sand, highlighting the physicality of things in ways that cannot be matched in ritual. Therefore, ludic space intensifies bodily rapport with respect to ritual space, hence one significant difference. The other, which is more obvious, impinges on symbolism. Here values reverse. Unlike ritual space where iconography and structure embody fundamental social values, modern play-grounds contain no higher order of symbolism.

If play qualifies its settings in particular ways, what is then the value of landscape in it? Whatever the magnificence of the prospect, the player, like the soldier, will scan the field attentively, searching for topographic nuances or whatever advantageous properties, for the very enterprise depends upon a correct assessment. Their gaze is instrumental, it leaves no room for aesthetic rapture. As in warfare, field conditions must be mastered, for in ludic terms a landscape primarily represents a challenge. The domain of play is as extensive

as it is complex as it encapsulates a myriad of practices whilst embracing the recreational agendas of all ages and moods. Rather than distinguishing its formal and informal practices as Caillois did, Huizinga discriminated *Agon* from *Dromenon*, whereby *Agon* encapsulates the competitive drive and *Dromenon* relates play to cult, with all its implied reverberations; but his enquiry just triggered further ones such as Caillois with his focus upon *Paideia* and *Ludus*.

Caillois discriminated four archetypes within the vast ludic horizon, all based on 'irreducible impulses', namely *Agon*, for contests, which appealed to sagacity and skill; *Mimicry*, for imitation, which, like Huizinga's *Dromenon*, sponsored disguise and concealment; *Ilinx* (from the Greek *Ilingos*, vertigo) related to the loss of control and stability; and *Alea* which nurtured from chance. In his view, play modes furnished social templates, so that *Agon* and *Mimicry* belonged to the domain of the rule, in contrast to the irrational *Alea* and *Ilinx*; the former exercising the will, the latter drawing from the sacred; one culturally fertile, (he exemplified it with the fate of Athens), the other, ultimately self-destructive, (as in doomed Babylon). Highlighting their institutional projections, he pondered how the domain of masks and ecstasies that characterized earlier societies was gradually supplanted by merit and chance. He discriminated a dominant and a recessive term in each pair, thus *Agon* and *Mimicry* superseded *Alea* and *Ilinx* in cementing durable institutions with a somewhat linear substitution of the Dionysian for the Apollonian. As we will examine later, these paradigms correlate with specific ludic settings, but one must first examine the allegiance of play to reason.

Jean Duvignaud, who was close to George Perec, and a witness to the Paris 1968 events, highlighted certain outbursts – admixtures of *Ilinx, Alea* and *Mimicry* – as supreme ludic expressions. Counter to Caillois, he sponsored the spirit of *Paideia* at its most Dionysian, whilst decrying the puritanical ethos of capitalism (for it proposed *mere accumulation without joy*). He amplified the ludic scope to embrace style, in particular the baroque, which he saw as an expression of unbridled freedom, a veritable metaphor of excess, which he favourably contrasted with the puritan submission of play into highly contrived forms.

He was fascinated by heterogeneous scenarios – some not easily framed within ludic horizons – such as wastelands, monasteries,[2] palaces and *terrains vagues*, but above all it was the city that fascinated him, with its functions and hierarchies duly subverted by the carnival. All in all, Duvignaud despised parks and bucolic settings as much as purpose-made playgrounds. Along with the Surrealists and Situationists he abhorred organized leisure and sport (Duvignaud, 1997, 1980).

Sport is, nevertheless, the prime expression of the *Agon* in modern societies. It acquired its profile, as is well known, by the first half of the nineteenth century, with Thomas Arnold. The English cleric and public school

headmaster was credited for sport's configuration into a highly-tuned activity, and an instrument for the betterment of body and mind through the formation of character. Arnold's sponsorship of *Muscular Christianity* placed his efforts within a broader sphere, yet sports soon loosened up such aristocratic grip and moral overtones, to align with the domain of *Ludus*.

Norbert Elias reminds us about the domestication of vernacular games into sport. He describes how rather chaotic ball games were brought by the British into form, in a trial that he characterizes as an evolution of pastimes into sport. Everything evolved in the process; typically, the crowd gave way to the team, rough terrains to smooth geometric fields, random timing to measured time, common agreement to the verdict of the referee, ordinary costumes to play attires. These changes belonged to what he termed a civilizing process, whereby European societies progressively excised physical violence from the political and recreational arenas, concurrently with the implementation of an evolving body of gestures, etiquette, protocols and a sense of decorum that regulated affections and conducts. These were . . . 'either tacit or expressed agreements conductive to the reduction of violence amongst men and to the resolution of conflict through shared agreement' . . . (Elias and Dunning, 1995, 1986). The implantation of rules revealed an institutional status. Sport bodies assumed the governance of rules. Needless to say, the club became indispensable.

Despite the contribution of European and non-European traditions, Britain has been largely credited with the emergence of modern sports, as availed by the adoption of English as its lingua franca.[3] Of a northern European import, gymnastics also spread worldwide, but in being mainly instrumental to the betterment of the body it did not easily foster a ludic spirit. Skiing spread southwards from Scandinavia and Polo westwards from the Indian subcontinent. Aside from a myriad of vernacular games, countless inflections of sport engendered local styles that often improved upon the originals, modifying styles, yet retaining certain original traits.

Asking himself why was it that the British, of all people, converted well established pastimes into sports, Elias concluded that their society seemed to be ready to master these changes better, simply because its social and political organizations were experiencing parallel adjustments. Just like sport rules prevented physical injury, mutually agreed behavioural constraints in Parliament, ameliorated violence. Physical integrity became a shared assumption. But cultural and geographic sources also had repercussions in the early English conception of the resort as it migrated from the Arcadian inland spa towards the seaside. Moreover (as highlighted by diverse authors) relevant parallels about the value of efficiency in the shop floor and the field highlight the relation of sports and the industrial revolution[4] (Mumford 1934, 303–307).

In the course of time, games acquired precise structures. The old-time melange – a chaotic clustering of opposing factions in dispute – and the

choreographic encounters between teams illustrate the schism that separates pre-modern games from sports. Players were assigned precise roles. Injuries were effectively prevented. An element of elasticity in bodily performance was introduced together with a calibrated management of ground surfaces, the evolution of playing implements, all aided by the introduction of rubber as we will examine in following chapters; but we must first look into the unfolding of ludic practices in time.

The narrative is not linear however, for play may be at the origin of social organization, but the universe of play often becomes a repository of social and cultural mores. Children indistinctively play with bows, arrows and primitive huts. Troy games vaguely recall the Homeric siege. 'Everything that is old or discarded can be revitalized by their agency in the domain of play' (Agamben 2001). Either as anticipation or as memory, play turns time into a subject. A 'vertical history' accounts for the universe of conventions upon which societies evolve, whilst a linear narrative reveals the ludic potential of disused objects . . . 'the structures of playfulness and the structures of usefulness' . . . says Caillois . . . 'are often identical but the activities ordained by them cannot be interchanged in a determined moment or place' . . . moreover they can only be realized in incompatible domains.

Field patterns evolve too: Bale discriminates four distinct evolutionary phases in the English football arenas, namely, *environment, enclosure, partitioning and surveillance* (Bale 2001).

Originally football unfolded in the open landscape, featuring weak rules of exclusion and permeable boundaries. *Enclosure* stood for the first act of formal and symbolic severing of the field also demarcating the spectators' ranks which were often accommodated on grass banks. Raised to the status of symbolic enclaves, fields were mostly open to the landscape. In the *partitioning* stage, grandstands and bleachers clustered around the arena, eventually enclosing it, whilst consolidating hierarchical domains. Arenas became visually severed from the landscape. At this stage charges were imposed upon admission. *Surveillance* signalled the full detachment of the field from its environs, higher levels of behavioural control with the athletes, the public and broadcasters converging through the media. Bale's model charts the political and spatial coordinates of a graduated process, despite the fact that under different circumstances, and mainly in the European continent, the construction of all-round coliseums short-circuited the process.[5] But rural sports also drifted into civic spaces, adding to the manifold expressions of *Rus en Urbe* (Elias 1995). Moreover, as Bale points out, it was frequent for urban sports grounds to become incubators of new practices such as, for example, equestrian fields that hosted the early practices of soccer, cricket, or even airborne trials, before migrating to tailored-made arenas. Here the sequence described by Elias reversed, for it was from within the city, instead of the

rough country, whence practices disseminated. Conducted by officers with their distinct attires, and characterized by certain rhythms, timing, and neat spatial contours, these veritable liturgies bequeathed lasting social organizations through the agency of the club.

Ludus squarely belongs with that sphere of play that tends toward the absolute standard of form. Modern architects held extraordinary expectations, however, about coaxing *Paideia* into prescribed grounds. In doing so they were effectively overriding its unstable praxis. These attempts were funnelled through the creation of children's playgrounds, usually as adjuncts to parks, squares, schools and housing estates. In the course of time these became just as ubiquitous as the sports field, for the harnessing of child's play into prescribed grounds was simultaneous with the harnessing of organized play into ever-so-formal fields. Whilst fully acknowledging the primacy of play as a right, as a release from the burdens of industry and bureaucracy, as a vehicle for the acquisition of convivial tools, and a pedagogic device, design professionals perceived the need to fit it according to zoning. Such were Le Corbusier, El Lissitsky, Sert and Van Eesteren's views. Amongst others, these favoured the overall orchestration of ludic space as an epic task, consonant with the recasting of the modern habitat.

Such aims were not universally endorsed however. Jane Jacobs, Rudofsky, Duvignaud, Constant Nieuwenhuys and Jackson decried the functional criteria as exercises of institutional coercion, whilst others, such as Rasmussen, Lady Allen, Van Eyck, and the Smithson held ambivalent positions. These contradictory conceptions about playgrounds coloured the designer's views over most of the century.

Spheres of action

Aerial, territorial and water-born games ultimately draw their definitions from the limitless natural environment. A lesser entity, the field, stands for a configured space. Precincts represent a one-step reduction of the field, whereby scale becomes critical. Playing tables and boards represent in decreasing scale its transfiguration into objects. Although the transit from field to board is oblique, boards often embody a kind of territorial abstraction. Fields reach their highest status within the sphere of *Ludus*, for in *Paideia* – as we have seen – these are just a matter of appropriation.[6]

Fields summon the player's body to particular challenges, with the rules proscribing time limits, areas of exclusion, roles, the recourse to implements, or the way objects may be handled, together with assorted constraints. Under certain circumstances the three-dimensional fabric of precincts becomes integral to deportment, whist surface properties such as density, viscosity,

ruggedness, abrasiveness also fuel ludic inventiveness. Likewise, with optical and acoustic attributes, such as transparency, opacity, reverberation or muteness. Notwithstanding the fact that each game privileges just some, all physical attributes simultaneously concur in characterizing a determined form of play.

There are exceptions: in so-called 'X games' players eschew the field in favour of unbounded and often formidable domains. Their lonely action does not easily favour onlookers. Gilles Deleuze observes:

> we got by for a long time with an energetic conception of movement, which presumes a point of contact or that we are the source of movement. Running, throwing a javelin, and so on. . . . But nowadays we see movement defined less and less in relation to a point of leverage. Many of the new sports – surfing, windsurfing, hang gliding – take the form of entry into an existing wave. There is no longer . . . a starting point, but a sort of putting in orbit. The basic thing is how to . . . *come between* rather than to be the origin of an effort.
> <div align="right">DELEUZE 2002, 281</div>

Field conditions associated with form and demarcation are rendered useless on the face of these ludic principles. In the absence of the field, the public – if there is such – becomes distant, decentred, atomized. Following from Deleuze, Kwinter adds certain 'cousin' sports such as skating and snowboarding, where fluidity, intuition and innovation are valued highly (as in surfing), although these unfold over a 'solid landscape' orchestrated to 'pulse, flow and brake'. Like Deleuze, he signals a new paradigm:

> The extension of the streaming ethos to landscapes and motor fields of solids becomes the prime engine of transformation of both technique and style in all sports of the last thirty years.
> <div align="right">KWINTER 2002</div>

Fields evolve then, into landscapes, or disappear altogether in the practices of X games, and this suggests affinities with contemporary buzzwords such as *fluidity*, but as for the period concerned in this enquiry, fields reigned supreme.

Field and stage

As seen before, the textural, topographic, visual, or seasonal nuances suggested as many ludic inflections. Always sharp and vital, the instinct of play attained ever so particular conjunctions through the agency of the field.

Bereft of prescribed rules, the fields of *Paideia* staked nonetheless temporary symbolic terrains settled by common consent.

Field conditions relate practices to norms. But because of play's gregarious nature, these often define the conditions for its public appreciation, thus with the exception of games that require opacity and seclusion, fields transform into theatres.

Much like a military victor, the agonistic 'champion' (whose denomination derives from the Roman *Campo Marzio* originally *Campum*), commands the field. 'Breaking ground' signifies setting new standards of achievement. A good player ought to know the field, and in modern sport, which is laden with spatial and temporal coordinates, organized fields constitute hierarchical sets, where just a few accrue the value of ultimate destinations, so that in straddling the path from lesser to main venues, players ascend to the highest honours. Thus, as if localities stood for personal triumphs, Wimbledon, Rolland Garros or Maracanã crown selected careers.

Entrapped in this invisible network, fields are classed 'informal' or 'official'. Meaningless to the sport establishment, but quite significant to the life of sports in cities, informal fields proliferate; the sheer vivacity of impromptu games in their imperfect grounds often attracting the photographer's gaze. These represent a significant corpus of, largely uncharted, public space.

As previously reviewed, fields also betray transactions between rural and urban domains. So, for example, *campo*, the Spanish equivalent to *Campum,* alludes to the countryside, a 'country' primarily understood as domesticated. Lingering rural associations become evident in the denominated 'country clubs', which hosted outdoor play (just as urban clubs hosted indoor ones, each setting embodies particular play modes, be it in spotless lawns or lush interiors). In its broad semantic range, however, the country extends its reach towards the wilderness, with Spanish philosopher Ortega singling out the hunting grounds as *the* authentic field. (Ortega 1962, 1960).[7] Etymology supports his claim about the 'campo' as 'outside', somewhat beyond customary reach, but this usage may be just archaic. However, the urban square (an ultimate artifice) was of common ludic usage until the nineteenth century, and as we will see, the conception of the field oscillated between these poles.

The Canon

According to Tzonis and Giannissi, the classical Greek Canon embraced a wide range of ludic, athletic, military, as well as artistic dimensions. Derived from 'the institution of contest', it meant 'rod or stick and by extension measuring rod', also encompassing a standard of the highest quality, 'a first-class group

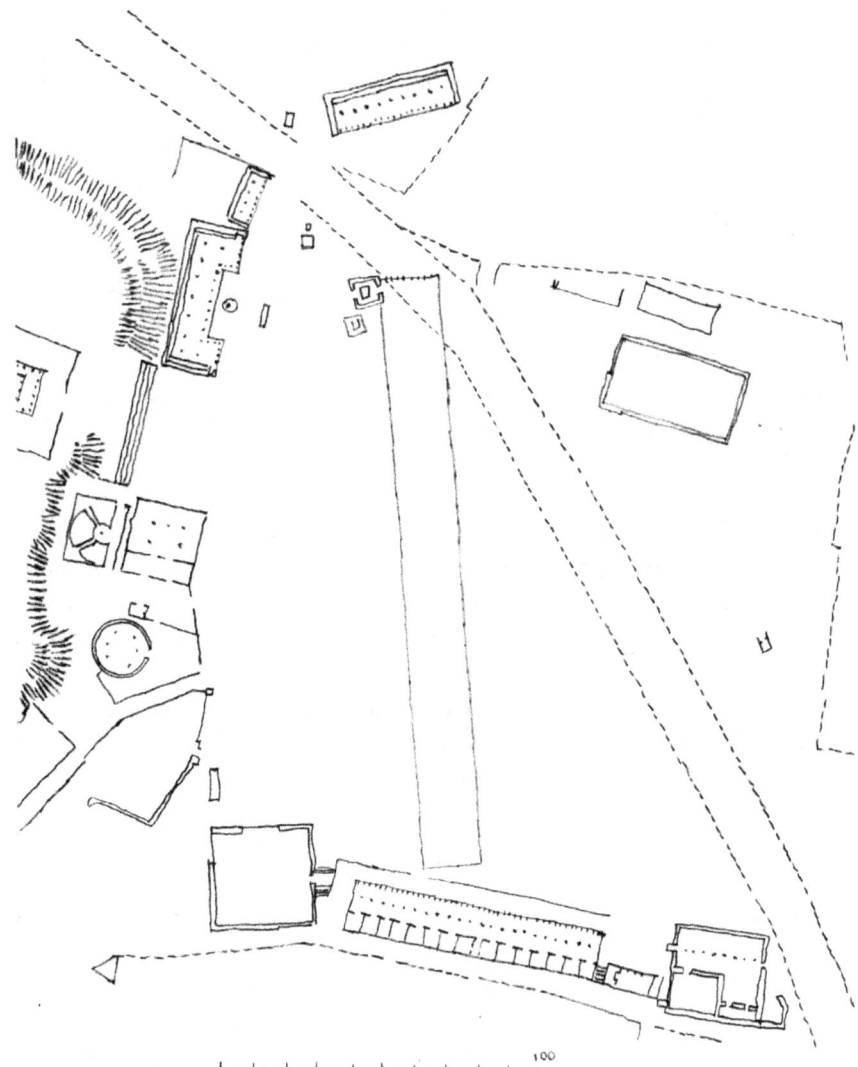

FIGURE 10 *A racecourse on the Agora, Athens, 400 BC. Drawing by the author.*

of objects thus "classical", to be used as a model to derive rules for further practice'. The notion was forged by a society imbued with an agonistic mindset. Self-control became then one criterion of relation between behaviour, space, play and *arête*, the acquisition of excellence.

The Canon was grounded in space mainly through the agency of the *stadion*:

originally understood by the Greeks as a unit of measure of 600 ancient feet (it was) later used to designate the footrace that was a stadion long; a sprint, down the length of the track, and ultimately the place where the race was held.

<div align="right">TZONIS, GIANNISSI, 2004, 239–240</div>

The word came to signify both an arena and a unit of measure where athletes conquered space and time. Measure accrued thus an enhanced ludic significance, for it was through its control – through bodily effort – that competitions were construed.

Such an atavistic link was not uncommon to *Homo Faber*, for it was customary to bring measure in line with productivity, for example in the archaic *furlong*, (212 metres) that originally represented the distance a team of oxen could plough in one go. Still in use in the sphere of horse-racing in the UK and the USA, its presence confirms a ludic propensity for the archaic, as well as a mathematical foundation. Measure, physical toil and efficacy concur in informing the sports field, a 'camp' or encrypted terrain that relates objects, action and space (Halley, 2009), as in Santiago's 1870s embedded race course, where block measures matched ludic requirements; likewise, New York's Fifth Avenue Mile – a race track between East 80th and East 60th Streets (Ballon, 2011). This brings up the issue of the standard, for just in parallel to the homologating efforts propelled by international trade, ludic rules and settings became statutory when contests went global.

The ludic principle of reiteration, reasoned Huizinga, followed two trends: the ability to re-enact play over and over, and also a rhythmical propensity akin to the musical refrain. The former guaranteed the inscription of play in custom. The latter suggested linkages to rhythm and cadence, to the pleasure of movement qua movement, a quality highly appreciated by Gadamer.

Because they were relentlessly played, many games, especially sport, secured a fertile ground for experience, where fields, together with the full gamut of implements, were calibrated through trial and error. Frederick Winslow Taylor, a keen golf player who valued efficiency in production as in leisure, considered ludic improvements to be quite consonant with the optimizing of output. Notwithstanding the paradox inherent to sports' wasted energy, players' movements were subjected to scientific probing whilst rankings (a modern cult) increasingly relied upon sensors.

Caillois recognized in *Paideia* a prelude for *Ludus*, spontaneity, a prelude to the establishment of the rule. Seen this way, each ludic proposition gave material expression to an unstable equilibrium. Optimized performances and records converged in delineating the 'official' field. Elias observed how the emergent nineteenth-century national leagues propelled shared rules with the register of time, thus aiding the trend toward globalization.

FIGURE 11 *'Good design' in tools and sport implements. J. M. Richards in* Architectural Review, *1935. Courtesy Paul Finch editor director. Copyright the* Architectural Review.

The iterations between rules, performance and action that stimulated improvements in sport attire, play implements and sports grounds, also mobilized considerable technical intelligence. No wonder that the suppleness and elegance of these design objects – which embodied the spirit of the outdoors – awoke such keen interest amongst early modern architects. So too with athletic motions: it was just natural for a dance impresario like Diaghilev to draw inspiration from tennis for his *cubist ballet* where . . . everything *turned around sport, the geometry of the body and . . . tennis. . . .*[8] He was attracted to the games rhythms and figurations; could these values extend to the field?

Play implements embodied no aesthetic goals, but their fitness to function was often understood as a token of functionalism. Such was J M Richards's argument about 'a rational aesthetic', when pairing exacting tools and (essentially unproductive) sport implements (Richards 1935, 225).[9] The same was perceived by Rasmussen years later, when displaying tennis racquets and sport balls together with fine samples of clay pottery (Rasmussen [1949] 1965).[10]

Theorems can be safely replicated but play demands drama. Once undue physical risks were excised from performance, what had to be safeguarded was an adequate balance between safety and boredom. Too much safety engenders slack, causing drama to dilute whilst its lack degrades play into a bloody contest. Together with rules and implements, fields consecrated this balance. It sufficed to alter one component to obliterate the game, whilst inadvertently leading to a new one. Not without irony, Dutch artist Asger John equipped his *triadic football* pitch with three goal posts. The introduction of rubber in sports increased speeds and ranges, affecting playing rhythms, field sizes, configurations, and ultimately their evolution.

The relationships between norm, form, and performance must admit enough interplay such as to allow the uncertainty that belongs to the very foundation of agonistic games. A sophisticated product, the field embodies these relationships, even when devoid of visual interest; in fact, the exclusion of visual cues favours effectiveness. Its evolution often betrays an idea of emptying out, or maybe abstracting. Rasmussen observed:

> A Victorian approaching a tennis court with racket in hand must have felt he was entering a new world. He had indeed left behind . . . that world where nothing was allowed to appear in its naked form. To enter the unadorned rectangle of the tennis court must have been like diving into bracing salt water in spring . . . [There] everything was mathematically determined with not the slightest decorative touch.
>
> RASMUSSEN 1965, 186, 187

This plain aesthetic was not just an expression of *physical culture,* a term that he linked to the German *turnen* and the Scandinavian *gymnastics*, for *sport* fused the physical with the spiritual: if the German idea could be stated as to how *to grow strong*, the English one, he reasoned, was more like how *to keep fit*. However, sports fields were derided by landscape architects as *green deserts*, for, much like empty stages, these demeaned the landscape experience. These abstract field patterns seemed to empathize with the depurated language of early modern buildings as if building and grounds shared a new aesthetic (a good example is the Villa Rosenberg by Van Doesburg, Van Eesteren and Rietveld where the tennis court fits into an orthogonal pattern of fields against the background of the villa). Wit, agility, dexterity, atmosphere, formal, dimensional, material and spatial properties, all converged in the ludic experience. Constricted scale heightened psychological challenges, whilst an expanded one stalked serious physical ones. Also with prospects: when open, they challenged visual command. When occluded, they awakened all other senses. Unfolding between the vast wilderness, and bounded urban domains, ludic actions oscillated between the primeval and the urbane.

The primeval

Of all games, the hunt – which is likely to be the most archaic – is often invoked as a primeval instinct that turned into sport for, as perceived by Elias, it only became a sport when it relinquished utility: only when alternative means of subsistence were secured did hunting become a pastime, but it was Ortega who unravelled its ludic status. Moreover, he firmly believed that play structures, their agreed rules, and the ensuing community of players

cemented social organization; play preceded organized labour, he said, hence its primacy over production.

What was fundamental to the hunt was the confrontation of man and beast: play, the animal and human kingdoms, and sacrifice concurring in its drama. Consistent with his patrician worldview, Ortega associated with the courtesan hunter such embodied values as courage, cunning, stamina and chivalry. His ethos (for he was usually male) invoked rules analogous to the monastic and military.

Typical of the play apparatus, constraints ensure the required balance between contenders. As weapons became ever more sophisticated, observed Ortega, man saw the need to . . . 'not unduly alter the balance between the hunter and his prey'. It became fundamental to restore the equivalence between the parties because 'in trespassing the limits, hunters obliterated the hunt's essential character, [thus] degrading it into carnage and sheer destruction' (Ortega 1962). This accorded with the principles of self-control detected by Elias. The hunter's relinquishment of supremacy guaranteed enough play-space to the beast. But this contest was particular for in the hunt, observed Ortega, 'man must be humble as he descends into the base domains of the beast'. Each player's move was provoked by the actions of its counterpart. An abyss may separate these competitive species, but as long as they played the game, they submitted to a perfect exercise of reciprocity. In the archetypal hunt the field was quite simply the wild where the mood was always elegiac.

Hunting grounds are necessarily extensive. The setting apart and subsequent enclosure of these vast domains for the pleasure of a few, constituted a feudal trait often challenged by communities dependent on forests for their sustenance. Even outside the feudal orbit, the establishment of extensive hunting grounds did call for similar exercises of resistance.

Hunting forests eventually nurtured a certain imagination about the *other*. J. B. Jackson pointed to the unforeseen effect of the hunt in the fostering of the National Reservations in the USA (they served as model for the rest of the world). As befitted a democratic society, the USA possessed no hereditary game forests. Despite an abundance of sylvan grounds, the provision of lumber and game became highly contested. The conception of forests as pleasure hunting grounds led on to the idea of conservation – nominally because of their natural beauty. Thus, the forest (Jackson reminds us that the word evolves from the Latin *fores*, meaning 'outside' or 'out of reach') did not welcome husbandry, nor productive pursuits. Hence it was through the agency and stimulus of play that National Parks were first conceived (Jackson 1994).[11]

Of all sports, the hunt is the only one that – in Ortega's terms – retroacts the player to the Palaeolithic. Needless to say, this demand cannot be easily fulfilled. Thus, the divestment of accrued cultural habit for the sake of play – such as occurs in the game reservation – paradoxically thrived on privilege.

Hunting embraces a range of practices, settings and objects of prey. It strongly evokes the wild, yet its grounds are not immune to organization and plan. No doubt the element of chance becomes as important as the notion of the field (itself a hazard) for both belong to that particular contest between man and beast. Hence any effort conducive to rationalizing the hunting ground may seem fruitless, as it seemingly betrays the natural status, but this was not an impediment to the creation of highly manipulated grounds. The comparison between English and French practices illuminates the case.

Against all odds, the French evolved a highly stylized format. With an abundant supply of forests, they envisioned a synthesis of geometric control, density, spontaneity and free growth. In carving radial clearances within the forest, they attained linear prospects that improved its intelligibility. Crossings were usually configured as Etoiles such as to ease such abrupt turns as dictated by the prey's erratic itineraries. This figure-ground pattern of radial paths and *round-points* came to characterize countless grounds in the Ile de France until becoming a territorial trait. Subtle design constraints were involved: voids were narrow, thus preserving depth and the predominant 'wilderness'. As stipulated in courtesan practice, the hunting party gathered large formations. Music added a striking aural dimension. Situated along the visual corridors, ladies followed the spectacle from a discreet distance. Dark

FIGURE 12 *Colliding field patterns for work and leisure in the Forêt de Compiegne, from a hunting charter of the Ile de France. Drawing by the author after Charte de Chasse, Foret de Compiegne.*

foliage made a barrier to the formal gardens creating a measure of separation of the exclusive domains of the hunt and the leisurely promenade. Thus, in the outer fringes of the park, coarse male rituals disported a distinctive pace, in blatant contrast to the suave demeanours expected in the garden proper, the expansive ludic field enfolding the geometric and highly stylized gardens.

Although resonating with the aura of the wild, hunting forests were often planted: in *Vaux, le Vicomte* Fouquet removed three entire villages for this purpose. These were emblematic of a noble ancestry, and indispensable for the exercising of 'manly virtue and warlike arts' (Scully 1991).[12] Moreover, the structure of the French hunting forest supplied the template for the renovation of Paris: it was this particular system of pleasure grounds that inspired Abbé Laugier's dictum about the park as the source of urban form (Pannerai, 1988). Regardless of their assumed potentials, be it as crowd control devices, corridors for the efficient movement of goods, parade grounds or representations of centralized power, the radial boulevards and etoiles that made the renovated structure of Paris were derived from hunting practices. The transposition of a ludic into an urban schema offers so many possibilities and confirms the inherent versatility attached to vigorous spatial conceptions. Likewise, as if aping the function of density in the hunting ground, the labyrinthine remnants of medieval Paris afforded shelter to those threatened

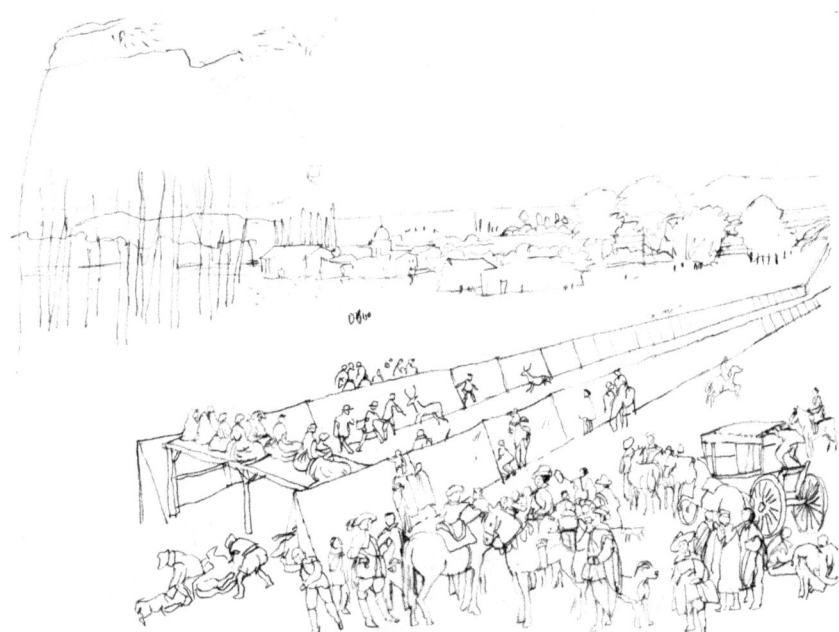

FIGURE 13 *Chasing stags in the Tabladillo Aranjuez. Drawing by the author after Martinez del Mazo, 1640.*

by the authority: embedded in the city, a similar contrast of panoptic control and concealment emerged. The transference of the matrix of the playing field into the structure of Paris is perhaps the most vehement demonstration of Caillois' thesis about play forms as templates of 'everyday' events.[13]

Temporary hunt rides were also construed: demountable enclosures were erected in the royal grounds of Aranjuez where in Juan Bautista Martinez del Mazo's *la caceria del tabladillo* stags were coaxed inside to be slaughtered in a dead-end passage, their corpses were then dragged out underneath the wooden platform, from where the ladies of the court watched the procedures

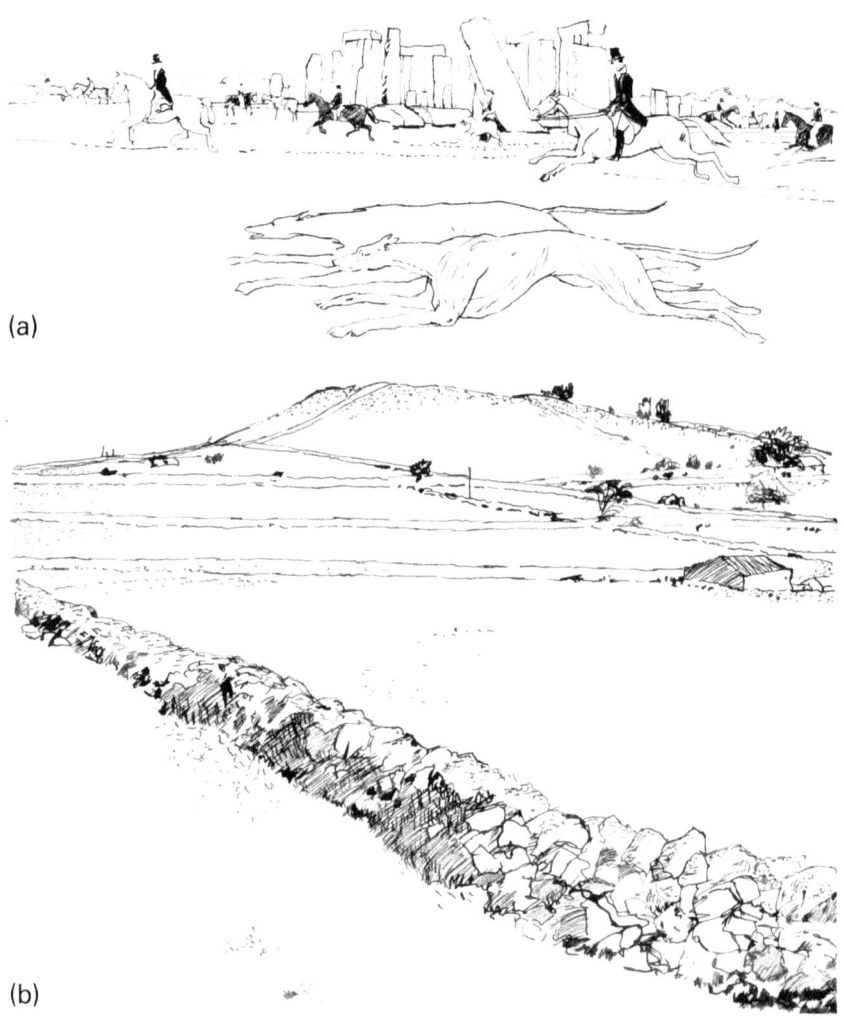

FIGURE 14 *(a) Landscapes and hazards: coursing in Stonehenge, 1845; (b) limestone walls in Derbyshire. Drawings by the author.*

in safety. This landscape apparatus created different conditions to the French hunting forest, however, for here the quality of the spectacle was attained by a diminished agonistic element and a lesser scope for chance. Temporary fabrications often accommodated ludic arenas within ordinary urban spaces thus accounting for the 'invisibility' of ludic practices in so many pre-industrial settings. In their landscape effects, we might even liken them to the contemporary fabrications of Christo and Jean Claude.

The situation in England was different. Faced with a countryside depleted of large forests, the upper classes were forced to seek alternative hunting fields. Their semi feudal framework inhibited absolute power. Big game was scarce; humbled by these considerations, they settled for vermin as quarry. In the absence of large forests, a scheme was devised that was as expansive in territorial terms as any. Rather than being confined to single estates it embraced large swathes of open country, trespassing whenever required, over private holdings. Here, as in *Paideia*, fields were tactically appropriated, yet considerable power was exerted to ensure indiscriminate trampling. The apparent naturalness of the chase embodied such privileges as the ones vehemently denounced by Veblen as inherent to the 'Leisure Class'. If the French had cast the hunting field through a forthwith intervention upon the wild growth of the forest, the English settled for a tactical use of the available grounds. Every accident added interest to the trial. As in *détournement*s, everything botanical, topographical and manmade, such as ponds, dry stone walls and hedges, fallen trees and crevices became instrumental to the ludic objective.

Referring to the transformations brought about to the English countryside by field enclosures, landscape historian Hoskins pondered how these fragmented fields increased the difficulty of the hunt, yet he acknowledged its collateral benefits in the acquisition of 'new and exciting skills' (Hoskins 1955: 278–300).[14] He also observed how fox hunting stimulated a measure of landscape transformation, since artificial fox coverts – of a size which he estimated between two and twenty acres – were constructed in landscapes that were depleted of forests and grouse patches. Coverts – essential to the survival of foxes – were distributed by landlords in well-chosen spots, sometimes on commoners' land upon payment. Thus 'clumping' – in Capability Brown's parlance – became an instrument in the field's conception.

As in France, the hunting pack gathered significant numbers, including a master, paid huntsmen, servants (known as whippers), and also numerous hounds. The absence of the purpose-made field is somewhat delusionary, for each hunt involved a large expenditure in respect of staff, kennels, stables, and assorted items. Despite it being played upon a vast open landscape, each hunt delimited a territory called a 'country', each one ideally covered within a season comprised between November and March. But there is more to it than just using the land for pleasure. Howe claims that the imposition of hunting

territories on the landscape thus makes a strong symbolic claim to territorial dominion[15] (Howe, 1981, 278–300). Using space extensively thus became a way of asserting power. In Howe's view the substitution of big game as hunting prey for the relative insignificance of the fox was countered, at least partially, by the recourse to 'noble creatures' such as horses and hounds: all in all, it appears as if the English hunt was a sophisticated fabrication that enabled its practitioners to claim equal, if not superior, status to their continental peers even though it made do with the space 'as found'.

Magnificent stallions, a massive display of hounds, colourful attire, brass instruments and the sheer number of participants highlighted the event. The contrast of green fields with the crimson, white and black attire was attractive, as was the mix of pageantry and roughness. Liturgical dress codes were subservient to aesthetic goals; together with the equestrian apparel, the horses, hounds and instruments betrayed conspicuous expenditure, but much in the way children appropriated streets as playgrounds, manoeuvring through the landscape of the everyday, no evident design could be discerned in the English hunting field. Once gone, the event left no durable imprints, with the exception of the damage inflicted here and there to the fields. It was quite at home in the picturesque: geometry played no role in its grounds as it did so vehemently in the French ones. Echoing some of its features, modern equestrian jumping courses recast country walls and hedges into stylized objects: wooden 'walls' that easily collapse thus averting injury and the 'triple bar', a country fence.

If all this looks somewhat obsolete, it is good to reflect upon its massive appeal: in Spain for example, aside from the official hunting grounds, an estimated million participants are alleged to turn about 80 per cent of the rural landscape into playgrounds albeit without partaking in the expensive liturgy of the aristocratic hunt (Lopez Olivero 1944:11–130). These experiences are most probably not at all spectacular, but they account nevertheless for a significant territorial dimension of play. One can only imagine the landscape impact, a subject worth considering even though, as described before, it is in the hunt where the visual, aural and haptic rapport between player and nature is likely to turn intimate.

Common sports, observed Elias, conjured up rational measures destined to excise undue violence. Rules invoked limits. Limits acquired various practical connotations: regulating player numbers, behaviours, gestures, roles, hierarchies, age, complexion, gender, or time; but these also settled the field's extent and shape, as well as its internal zones.

Sport trials were famously described as 'the transit between equal beginnings and unequal outcomes' for the level field (a recurrent metaphor) allows every game to unfold until splitting the parties into victors and vanquished. Each game embodies an idea that supplies a tempo, style

FIGURE 15 *Square as arena at Santa Croce, Florence, 1688. Drawing by the author.*

and drama, consequently diversifying the rapports between form, norm and action. From this primeval game with intimations of the wild, we will turn our attention to the ludic usages of urban squares where the notion of the limit is always relevant.[16]

Field and square

Spielplatz and 'playground' equally denote 'playing field'. *Plaza* and *place*, the Spanish and French for 'square', derive from the Greek *platea*, a levelled terrain, with its ground surface usually firmly hemmed between facades.[17]

Sensitive to political and cultural factors, play practices negotiate adequate settings; they are, says Caillois, 'innumerable and ever changing'; they 'emigrate and acclimatize'. Preindustrial uses of squares as playgrounds were frequent, sometimes iterative, as if the square that first hosted the activity excised it, to welcome it again, perhaps under different conditions.

The issue of adaptations will be reviewed later. Colonial Santiago for example, celebrated most ludic activities in its Plaza de Armas. Gradually *displaced* (literally 'turned away from the square'), these emigrated, one by one, to particular settings.

Following Spanish custom, and until late in the eighteenth century, bullfights were hosted in squares. Purpose-made coliseums became representative tokens of the ludic function, but Santiago never obtained a proper one, partly because after independence, bullfights became illegal. Moreover, Romantic fashion ushered the substitution of the empty grounds

FIGURE 16 *Independent field and square in Visviri, Atacama Desert plateau, Chile. Drawing by the author.*

for exotic gardens, a mid-nineteenth century development that led to the wholesale greening of urban squares in the continent, with the substitution of play for the gentle promenade, staking the primacy of contemplation above action, with a de-facto migration of active play. Yet although the relationship between play and the park was riddled with conflict, extensive lawns eventually became 'natural' habitats for sport. As seen, modern sport first arrived to Santiago's hippodrome, inaugurating a vital trend. Its unprecedented landscape in no way looked like a token of the local landscape (the semiarid climate prevented this kind of greenery). Bemused locals must have regarded the extensive lawn rather as a very alien import. A similar ecological displacement characterizes Kerkira's Spianada in Corfu, turned into a lush Anglo-Saxon green that hosts a cricket ground edged on two sides by a dense rank of buildings, in a configuration better attuned to the Mediterranean temperament.[18]

Colonial South American squares delivered a panoptic visual command over the arena. Flat and barren as a soccer ground, except perhaps not so level, these were prime locations, while the not too distant outskirts offered rough alternative grounds, so that ludic opportunities veered between the bounded urban core and the broad rural (or wild) hinterlands. Equally, the emergence of sport eventually engendered urban and 'country' clubs. But the geometric based fields yielded really interesting architectural dilemmas for, as aforementioned, liminal instruments are essential to their conception. Architects eventually controlled the interfaces around the surgical and increasingly sophisticated geometries that defined the field proper and their commonplace surroundings.

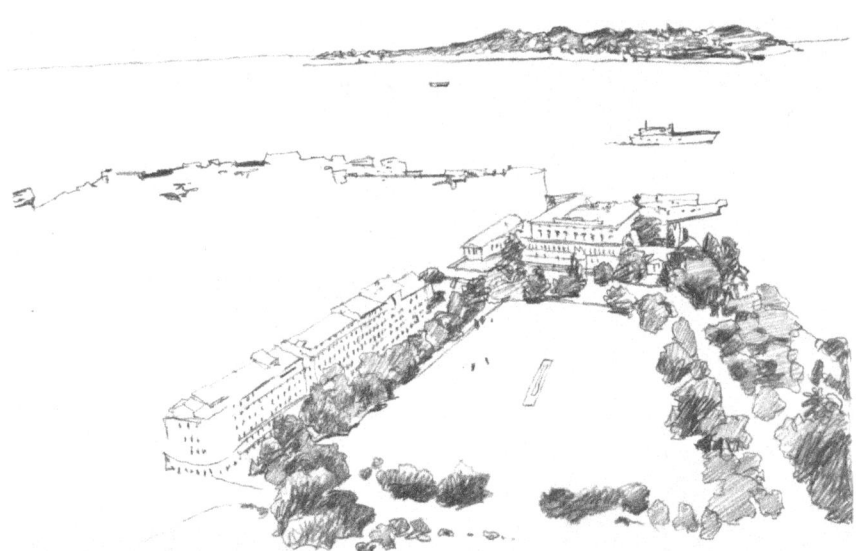

FIGURE 17 *Spianada cricket ground, Kerkira, Corfu. Drawing by the author.*

In stark contrast with the primeval wilderness, *the square*, reasoned Ortega, was:

> a lesser rebellious field which secedes from the limitless one, and keeps to itself . . . a place *sui generis* of the most novel kind, in which man frees himself of the community of the plant and the animal . . . and creates an enclosure apart which is purely human, a civic space.[19]

Yet, as if contradicting that notion, 'plaza de toros', the Spanish bullring, literally translates into 'bull (fight) square', denoting the beast's radical displacement from its rural estrangement on to the ultimate civic space. Hunts and bullfights represent thus extreme field conditions for the agonistic encounter of man and beast, with the hunter's sortie into the wild, and the beast dragged into the cultured environment. These centrifugal and centripetal displacements lead to widely varied scenarios; the former, extensive, often fuzzy; the latter, compact and geometrically precise. As aforesaid, the former is often refractory to visual command, whereas the panoptic quality of the latter gathers all sights upon its perfectly delineated sacrificial arena. Play confronts an indomitable milieu in one, whereas it encounters a finely calibrated one in the other. Often lonely and patient, the ordinary hunt also differs from the bullfight in the absence of a massive body of witnesses, reflecting the distinction between pastime and a spectacle.

Notwithstanding these differences, the actual qualities of the field became critical to both.

FIGURE 18 *Bullring at Campo de Santana, Rio de Janeiro, early 19th century. Drawing by the author.*

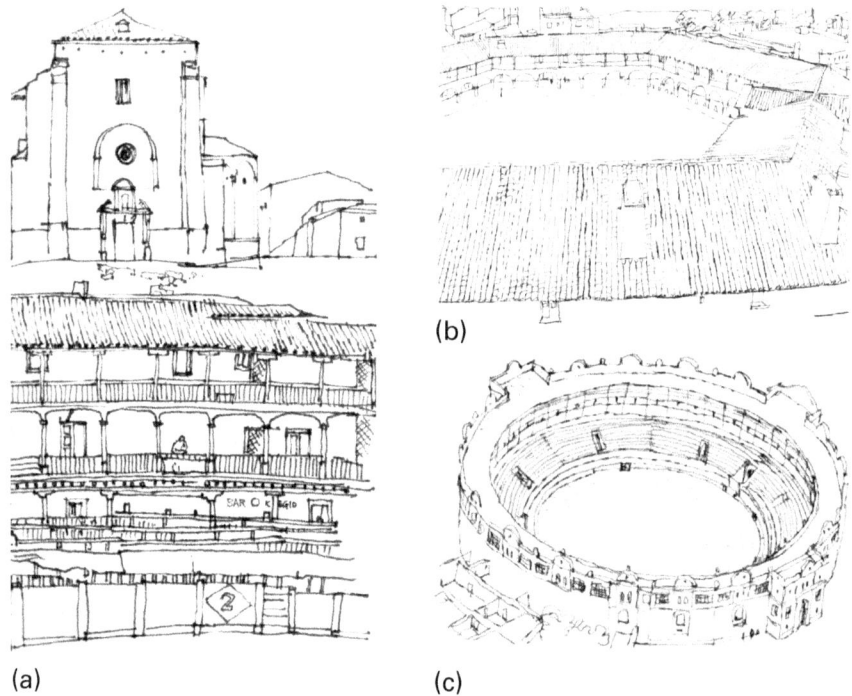

FIGURE 19 *Embedded and formal types: (a) impromptu bullring in Chinchon; (b) octagonal pattern in Almaden; (c) canonical form in Almeria. Drawings by the author.*

The formal consolidation of the bullring proceeded in parallel to the evolution in sporting styles. As with other ludic experiences, the archaic expression of the contest verged on chaotic formations. Charting the emergence of the type, Bonet perceived distinct phases: in a primitive one the fight was staged in the open country. Remarkably, this was followed by drifting the arena right into

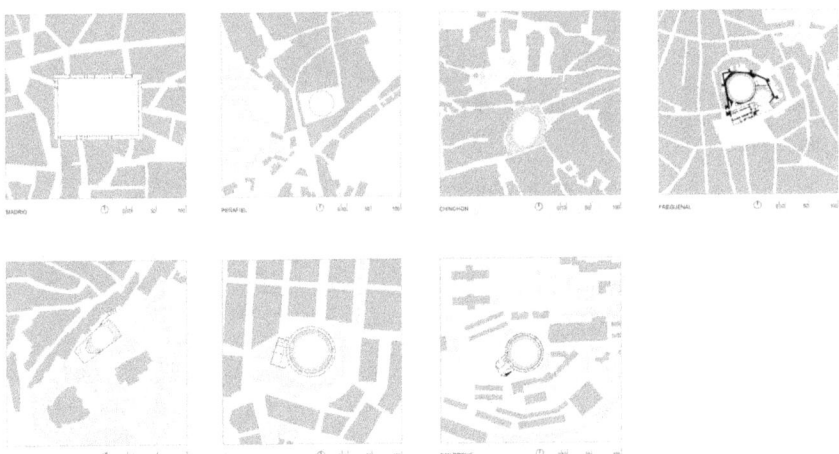

FIGURE 20 *Rings and squares:* (top row) *Plaza Mayor Madrid, Plaza del Coso Peñafiel, Plaza Mayor Chinchon, Plaza de Toros Freguenal;* (bottom row) *Mijas, Aranjuez and San Roque. Drawings by the author after Dias y Recasens, 1992.*

main squares, that is to say, seizing the most significant place in town, if only temporarily, as if claiming undisputed urban credentials. Portable elements of considerable size were mobilized for adapting the field to the square, just as in the Roman *Ludi* when staged in the Fora prior to the building of the Coliseum. Bullfighting was then a gentleman's occupation. The ensuing eradication of the spectacle from the main square onto purpose-made coliseums was stimulated by the substitution of the main actors; the gentleman on horseback for rank and file, bullfighters on foot, the latter giving rise to the modern practice (the Portuguese held to the earlier model) (Bonet 1990, 141–175, Welch 2007). By 1794, protocols and responsibilities were issued, together with the formalization of the ceremonial: Ortega characterizes the instance as an ordered liturgy that summoned particular officers. Instruction books (under the heading of *Tauromaquia)* crowned the institutional process.[20]

Purpose-made arenas were usually detached. Of course, some of the older emplacements remained, but the course of events led on to new patterns. On the whole the sequence follows Bale's observation about the evolution of football pitches. Demountable bleachers and enclosures aided the accommodation of bullfights in urban squares; battered earth (or sand) strewn over the paving delineated the arena. Palisades were extensively used. An increased interest awoken by the spectacle led balconies to be prized as prime localities, their festive use regulated by the authorities, as in Chinchon, Castile. These became theatres, with the public crowded all around (Diaz y Recasens 1992). Even in far off Santiago, an arrangement of balconies edging the main square was justified primarily for this purpose.

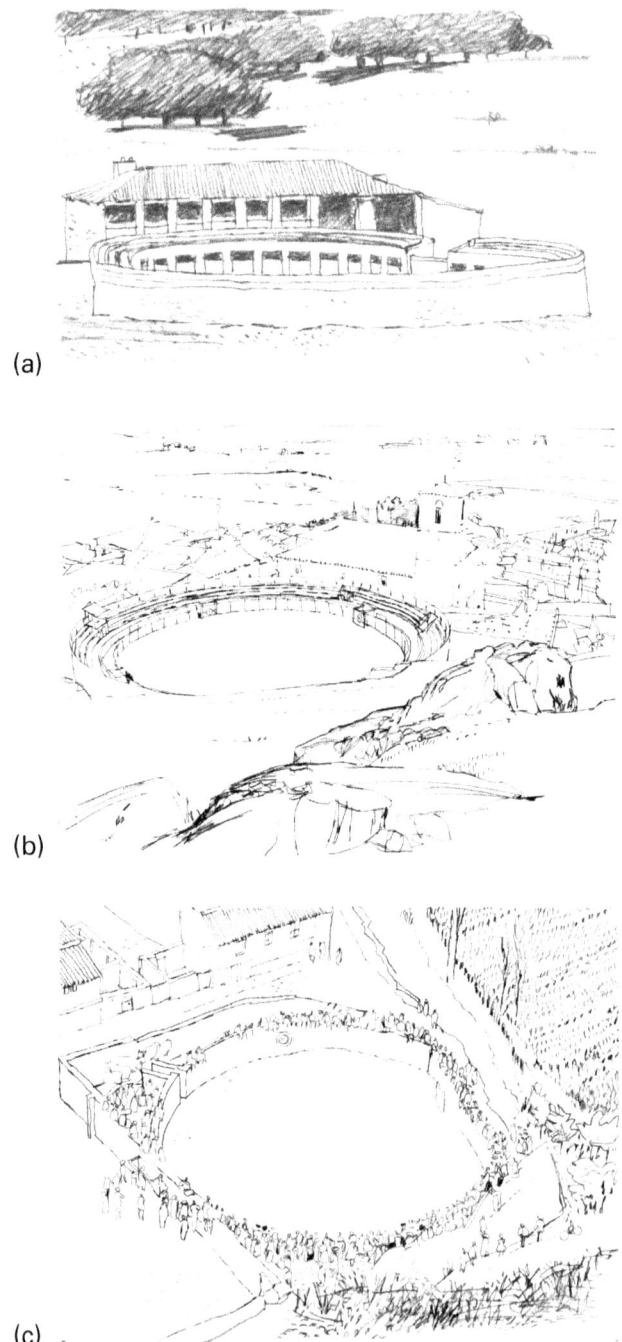

FIGURE 21 *Rural patterns in the metropolis and the colonies: (a) Alaraz; (b) Atienza in Spain; (c) Ollantaytambo, Peru. Drawings by the author.*

Arenas diverged in size and shape. Strange as it may seem, it took time for the circular format to be universally applied. It took time too for the *Plaza de Toros* to be excised from the *Plaza Mayor*. Formalization and emplacement became significant issues. Nevertheless, once the cycle was closed, the arena's civic ascendancy was reasserted in its denomination as 'square', its geometric rigour, and its urbane credentials.

Bullfights are designated as feasts (*fiesta de toros*) somewhat amplifying the significance of the event beyond technical mastery. There is something distinctive about this Dionysian encounter (Dionysius was the god of the hunt) that does not quite fit the puritanical sport ethos. The attire and ceremonial attest to old usages. Music enlivens the event. Motions recall courtesan etiquette. The performance culminates in bloody sacrifice. Despite these archaic traits, however, in modern times artists like Picasso and film director Orson Welles became obsessed by the drama. Picasso went as far as to plan a small arena in his own grounds at Vauvenargues. Moreover; by 1962 he sponsored Antonio Bonet's innovative design of a covered arena in Madrid.[21] The figure of the Minotaur also became obsessive to Le Corbusier (Moore 1980, 19–20).

Demountable outfits persist, however, like the remarkable case of *La Petatera*, a full-bodied bullring, assembled yearly in the state of Colima, Mexico, with Guadua cane, rope moorings and Petate matting.[22] It holds up

FIGURE 22 *The demountable bullring over a football pitch for the Corraleja, Sincelejo, Colombia. Drawing by the author.*

FIGURE 23 *Houses and the arena: (a) Aguilar de la Frontera, 1806; (b) demountable bleachers in Riaza, Spain. Drawings by the author.*

FIGURE 24 *Evolution of bullrings: (left to right) informal; open country; informal urban; semiformal with temporary array; geometric phase; canonical type. Drawings by the author.*

to 5000 spectators and its fragile format replicates the classic circular plan, of a disengaged object. Similar impromptu constructions characterize the Corralejas in Sincelejo, Colombia, their wooden fabrications hosting a bastardized bullfight, with the arena sometimes implanted upon a football pitch, sometimes over a square. In diverse settings these manifestations of 'non-pedigree architecture' aided the realization of ludic events.

The gradual delineation of the arena followed trial and error: originally fields were formless, or rectangular, sometimes ovoid or octagonal. Once the geometric pattern was settled, certain purpose-made arenas were ringed with apartments as if retaining that peculiar relation of house to arena so prevalent in compact European towns, with the residences embedded in the coliseum so to speak, facing head-on to the ring. We see this similarly today, with modern apartments that enjoy prospects over sports fields. Even Le Corbusier assumed this affiliation of apartment to arena, but earlier iterations on the subject were mostly confined to southern Latin cultures. A myriad of variations reflected upon layout, materiality, context and durability. Nonetheless, as from a certain stage formal stability was attained, as if the interplay of action and container had reached perfection. Likewise, the gradual substitution of timber for masonry structures crowned with slender cast iron pillars engendered a neo-

Moorish aesthetic. Following eclectic fashion, the Roman Coliseum was also summoned, although adjusted to a circular plan, its matrix attaining a canonical thus 'classical' status. It was also understood as a sort of solar instrument, with its localities designated as 'sun and shade'. The symbolic passage of the fighter through its formal exit into the city crowned his urban triumph.

In its avoidance of deadly corners, the circular format seems obvious, 'a geometrical theorem 'in Ortega's words, where the player scans the field for critical spots (denominated *terrenos* or *terrains*). 'To fight properly, means avoiding every source of waste in the bull's charge', noticed Ortega; the *matador* manoeuvring the strength of the beast to his own advantage (Ortega 1962). And yet, as we have seen, the circular arena was slow to come. The format greatly enhanced both visibility and safety, but its counter form – the external facade – confronted serious dilemmas with the accommodation of bullpens, horse stables and ancillary facilities, whose combined effect conspired against the ideal form. However, despite its overwhelming rationale, the geometric choice was not primarily aesthetic but functional.

The emphatic urban presence of these unassailable bastions recalls the 1450 Urbino panel sometimes attributed to Luciano de Laurana, where the coliseum rubs shoulders with palazzi and other significant edifices whilst concealing its inner secret.[23] Concealment was eventually challenged by high-rise blocks, whose visual command over the arena somewhat recaptured older traditions about the event staged in public squares.[24] Circular arenas were not exclusive to bullrings, however. As observed by Bonet, cockfight pits, circuses and other establishments followed the pattern. Latin American cockfight pits, of Iberian provenance, were often inscribed within courtyards sometimes recalling renaissance operating theatres, in their minute size, the circular layout, the concentric seats, the intense focus upon the arena and one can imagine too, the very charged atmosphere. This theatre of animal fury banished human intervention. (Bonet 1990).

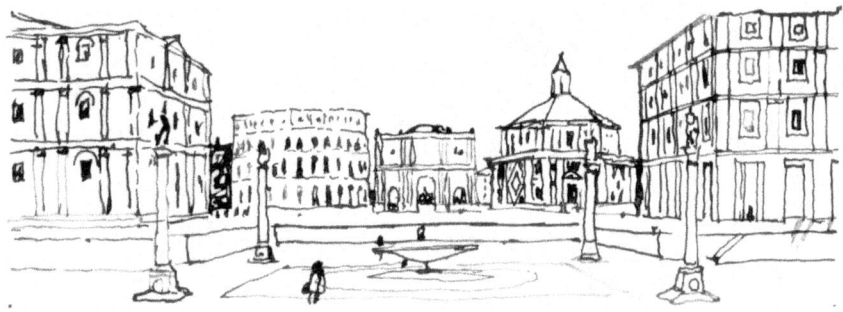

FIGURE 25 *The Colosseum rubbing shoulders with civic building. Drawing by the author after painting attributed to Luciano da Laurana.*

Pits were to be found in eighteenth-century Santiago, Buenos Aires and Cordoba, hidden behind civic facades, their restrained presence perhaps revelatory of social caution about blood spectacle and chance games. In contrast to their urban neutrality, propinquity, if not downright promiscuity, increased the psychological drama enacted within their minute rings.

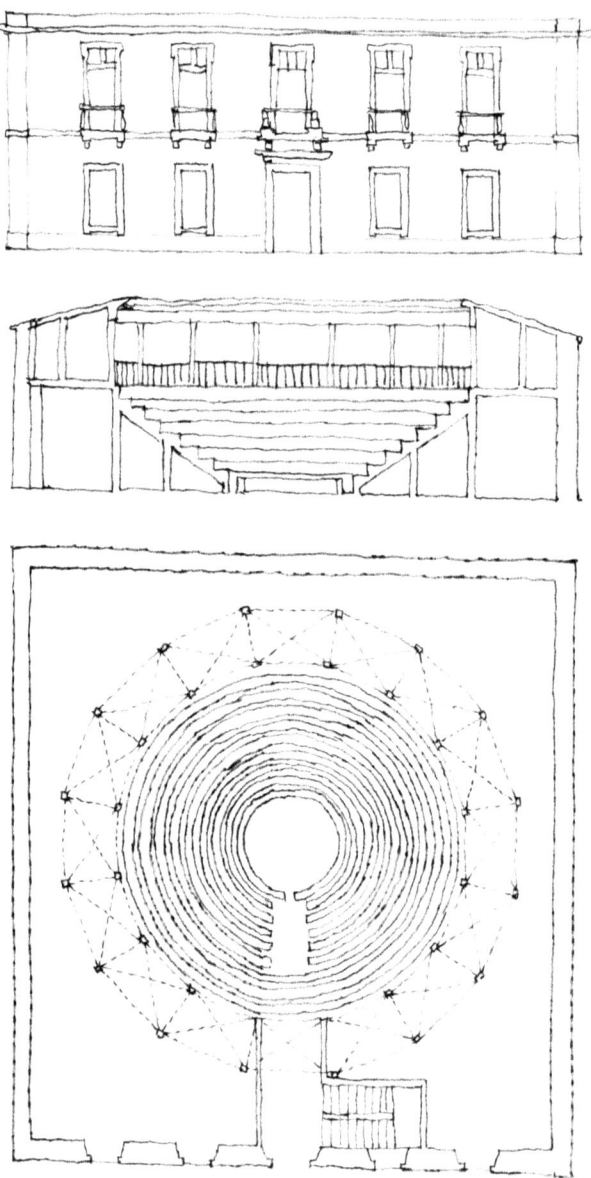

FIGURE 26 *Discrete arenas: an 18th-century cockpit within a building in Buenos Aires. Drawing by the author.*

Circuses also adopted the format. Conceived as a theatre in the round, and displaying wild animals as prime attractions, these are often credited as harbingers of pre-industrial pastimes.[25] Earlier ludic tastes were just too gruesome to fit modern expectations, nonetheless the circus kept memories of old menageries. Picasso, Calder, and their fellow artists detected in these rough popular venues a vitality which was then lacking in formal scenarios. The characters were also memorable. Le Corbusier admired the tight roper's defiance of risk, and courage. The circus personae contributed to a certain modern imagination.

Elliptical and circular outlines became predominant, for the action is often in the round, with cavalcades stomping at full speed to the exhilaration of the public. Yet unlike other ludic scenarios, circuses activated multiple foci as if the geometries described by their diverse trials accounted for all spatial options, with some performances on the ground, some up in the air, some between ground and airspace. Aerial appurtenances drew the public attention expanding it in multiple directions, for its arena was a domain of *Alea Mimicry and Ilinx*. Up against a backdrop of canvas, tiny figures tested their balance on the tightrope, while acrobats slid down poles, or tested their balance skills. The canvas tents evinced an expression of the nomadic spirit; hence they rarely made lasting urban landmarks. As with the bullfight, music accompanied the drama, for the spirit was festive.

Court jesters, menageries, popular entertainers, the baroque carousel and other sources converged in the crystallization of the modern circus with its assorted ingredients: the equestrian elements, wild fauna, clowns, acrobats, freaks, all performing in or around the arena, each bearing a particular lineage.

FIGURE 27 *Elementary formats: holding the ring, Argentina. Drawing by the author.*

But performance is by no means indifferent to the arena's geometric format. The circle illustrates a response to all round viewing conditions and the endless track. It reacts to form in more specific ways, so that it suffices to increase the acceleration of the body around a circular path for the edges to be activated by the outward pull. Cambered velodromes respond to this effect, but when acceleration is increased as with high speed bicycle tracks, the edge substitutes the floor, with spectators reaching its upper rim for optimal views. Acceleration turns the plan into a bowl, so construed that its perimeter becomes actively used, its depleted horizontal core becoming to all effects redundant. How the fields figure is used squarely depends on *interplay*.

But *circus* also denotes an English urban format that follows from the Royal Circus in Bath, the royal spa. This classic ensemble of thirty-three terraced houses surrounded a circular paved arena (it was landscaped later). Its three access roads preclude axial views, highlighting the rotational effect. Together with the Royal Crescent this much-quoted urban sequence related contrasting arenas, with the crescent opening its residential quarters into pastoral nature, an extraordinary invention at a time when it was customary for urban houses to face each other across streets. Much like the aforementioned bullrings where residential buildings contoured the arena, the houses circumscribed the space of action with windows opening ajar towards the spectacle, except that the action was gentler and more leisurely than the agonistic quests one would expect in such ludic scenarios. Arcadia and etiquette substituted active play. The analogy with the Roman arena was beautifully captured by John Soane who superimposed the section of the Royal Circus to that of the

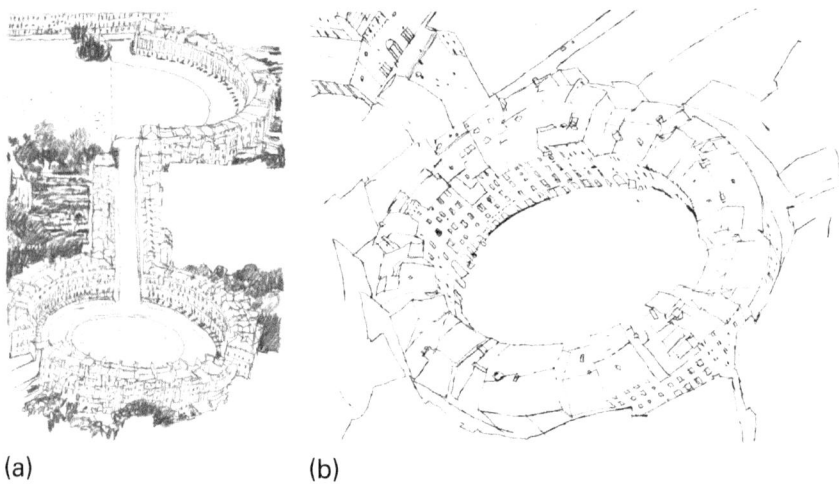

(a) (b)

FIGURE 28 *(a) Royal Circus and Crescent, Bath; (b) Piazza del Anfiteatro, Lucca. Drawings by the author.*

Coliseum (although he aimed at the Crescent's lack of proportion in relation to its model).

No wonder then that the Royal Circus came to resemble the transformed Roman Amphitheatre in Lucca, where, oblivious to its former function, common houses nested over antique ranks of seats, whilst substituting former agonistic usages for commonplace activities.[26] In the face of these analogies Woods' apparent inhibition about sportive uses is extraordinary. This becomes even more paradoxical once one considers the incidence of the spa upon the city of Bath, and the key role this remarkable resort played in instilling a modern consciousness about leisure.

Fully conscious about the memories of the Roman spa, John Wood the Elder highlighted the inherent ambiguities:

> In each of the projects, I proposed building a grand place of assembly to be called the Royal Forum of Bath; another no less magnificent for the exhibition of sports to be called the Grand Circus, and a place or square, for the practise of medicinal exercises, to be called the Imperial Gymnasium, from a work of that kind taking its rise at first in Bath during the time of the Roman emperors.
>
> <div align="right">WOOD, 1749[27]</div>

When describing imperial gymnasia and medicinal exercises he intimated sport affinities, but these seem to hold just as metaphors.

Be that as it may, some decades into the twentieth century, the notion of houses facing on to something like a 'people's gymnasium' seemed fresh and highly desirable: it engendered robust urban agendas espoused amongst others by Giedion. In *Space, Time and Architecture, the growth of a new tradition*, he seized Georgian circuses and crescents to illustrate the potentials of sports fields as residential foci, thus confirming the desirability of easy access to parks and sport venues (Giedion 1941). By then, many of London's crescents hosted tennis lawns (Rasmussen 1983 (1934), 92–93).[28]

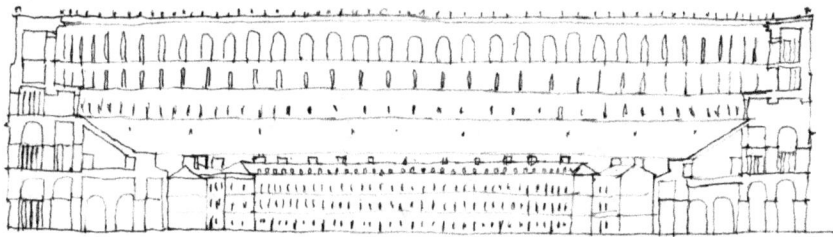

FIGURE 29 *Scale contrasts and typological inversions in the Roman amphitheatre and Bath's Royal Crescent. After John Soane. Drawing by the author after Soane.*

And yet a consciousness about health (if not sport) seems to have been congenial to these (originally) treeless voids, for, according to an 1851 guidebook, they represented a 'sacrifice of building ground, not to the purpose of ornament and architectural beauty but to the pure necessity of ventilation'. Sport and leisure just increased their significance.

Betraying an equestrian memory, the denomination of the 'circus' derives from a dispositive reserved for the *circenses*, the Roman chariot courses. As with other practices, horsemanship only became a *sport* once its practical functions had vanished.

Whether inspired by Hardouin Mansard's 1685 Place des Victoires, or John Wood the Elder's 1764 Royal Circus, or some other sources, circular riding tracks were often inscribed within theatres in a nineteenth-century process that validates Bale's conception about the alternation of confinement and release in the crafting of sport venues. London's Ashley amphitheatre is credited with the inauguration of this trend. In it the riding space supplanted the lower galleries, and so it was too in the 1821 *Cirque du Fabourg du Temple* in Paris, where the public was confined to the edges, its core cleared for the spectacle. Sheltered within urbane settings, these equestrian venues often fused the riding circus with a backdrop of forced perspectives. Frenetic cavalcades must have felt like odd intrusions into such gentle domains. One must also imagine the auditorium filled with roaring sounds and a pungent odour. Dupavillon charts the reverse evolutionary line that led from the aforementioned solid constructs to portable ones, eventually culminating in the modern tent (Dupavillon, 2001).

Portability is typical of the seasonal apparel that accompanies outdoor lifestyles. Le Corbusier's 1925 enquiry into modern equipment made the linkages quite explicit when juxtaposing 'sport cars', easy chairs, tubular furniture, travel apparel, and sporting implements to top-heavy Victorian items. *Le style camping* was Eileen Gray's term for portable furniture. Just like Giedion who had visualized in the matrix of row houses, gardens and tennis courts a suitable modern urban pattern, the suppler fabric of the circus inspired Constant Nieuwenhuys, Archigram and others by the latter half of the century, in their search for the transient, the nomadic and a certain lightness of touch.

Skin and precincts

In *Ludus* the quadrangular platform predominates. Its format suits the patio: certain accounts describe how football was played in London's Charterhouse School cloister. The tennis 'court' recalls the link, also its courtesan background. The game was played both indoors and outdoors. The transit from hall, to

court, to open field, shaped its rules and character, assigning precise ludic functions to selected features such as the building's bulk, configuration and skin. The ludic mutations that followed the transit from the two-dimensional field to the precinct were complemented by ludic interplays with selected architectural elements, a common enough trait in *Paideia*. In *Parkour*, for example, the high-risk game played against urban hazards, the field is quite simply a challenging and complex fragment of the urban skin. This interplay is exceptional to the domain of *Ludus*, however, for, as we have seen, in it, architectural resources must first accord with the rules of the game. Furthermore, as pointed by Elias, rules usually consecrate moderation.

Walls became integral to the ludic ground. Always observant of human behaviour, Rasmussen followed the ways of children playing balls against the apse of Santa Maria Maggiore. The building concave and convex surfaces and the cascading steps were activated in play. In playing, children learned something fundamental about architecture: they also learned how to turn the architectonic ensemble into a field, as they found a way of measuring distance, estimating trajectories and physical prowess. Such was the argument, where play correlated with building form. Rome became a playground thus equipped with ludic features derived from its salient traits (Rasmussen 1962 (1959) 16, 17). In playing with walls, Roman children highlighted certain configurations. Staged in the very heart of the city, their play just added a brief spark of life and happiness yet leaving no trace behind.

The most common interaction between a game and the building skin occurs through the bouncing effect of walls, an action critical to that broad ludic range based on ballistics.

In royal tennis, which was one such indoor game:

> Architecture was part of the game itself: walls and roof became playing surfaces. The trajectory of balls described a kind of a three-dimensional billiard. High and low walls became offensive and defensive surfaces. They contained hazards to which balls could be directed in order to gain scores. The spatial configuration . . . was further highlighted by the contrast of the white ball against black walls. Space structure itself was then integral to the game.
>
> EICHBERG 1986, 92–121

One should add to all these, the reverberation, caused by the impact against hard surfaces. Here the field was truly three dimensional.

Although spartan, and truly 'without rhetoric', there was some grandeur in the royal tennis court, and its French derivation, the *jeu de paume*, that was largely due to proportion and natural lighting. Jacques Louis David's *Oath of*

the Tennis Court captured that momentous event when the court, located near the Versailles palace, became the theatre of a revolutionary proclamation. The public had invaded the field; prominent figures occupied the floor, whilst commoners cheered from the tribunes. This ludic space was prototypical. More like a template than a singular creation, it was endlessly cloned, so that with slight variations it was embedded in urban blocks, as in Versailles, or released as a garden pavilion as in the Tuileries. Architectural nuances countered; in the words of Eichberg 'all venues reproduced the subtle irregularities of the original container'. Cloning took account of layout, building textures, proportions and material. Exterior appearances diverged but interiors were fundamentally alike.[29] Likewise, diverse variations of squash courts, jai alai, Irish handball, and the Spanish fronton (or Basque ball) utilize floors and walls as bouncing surfaces. Relationships between tectonic form and ballistics liken these settings to fortresses, for their mastering of geometry, trajectories, impact, resilience, and the incidence of form and materials upon the behaviour of missiles, with building form equally critical to performance.

Eton fives surged from the interplay with particular elements found at Eton College: an ensemble of steps, ledges, walls, buttresses, and a slightly inclined floor. Its cloned fields hosted the game irrespective of latitude or local culture.

A more significant example, the Spanish *fronton*, or Basque ball, surged from the practice of bouncing balls against urban walls. Blind walls supplied play surfaces; church atria ensured enough clearance and steps accommodated spectators. Their settings, never residual or marginal, guaranteed an active urban presence. The widespread supply of suitable walls ensured ample possibilities for performance: a good example is Segura, Guipuzcoa where the church side porch and raised plinth parallel to the principal bouncing wall almost predated the pattern followed by formal courts. Games were played in

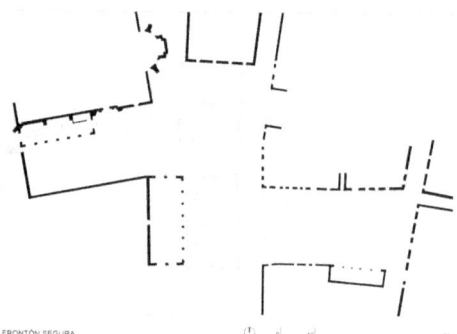

FIGURE 30 *Frontón (Basque ball) at Segura, Spain, with the playing arena across the square from the atrium. Drawing by the author.*

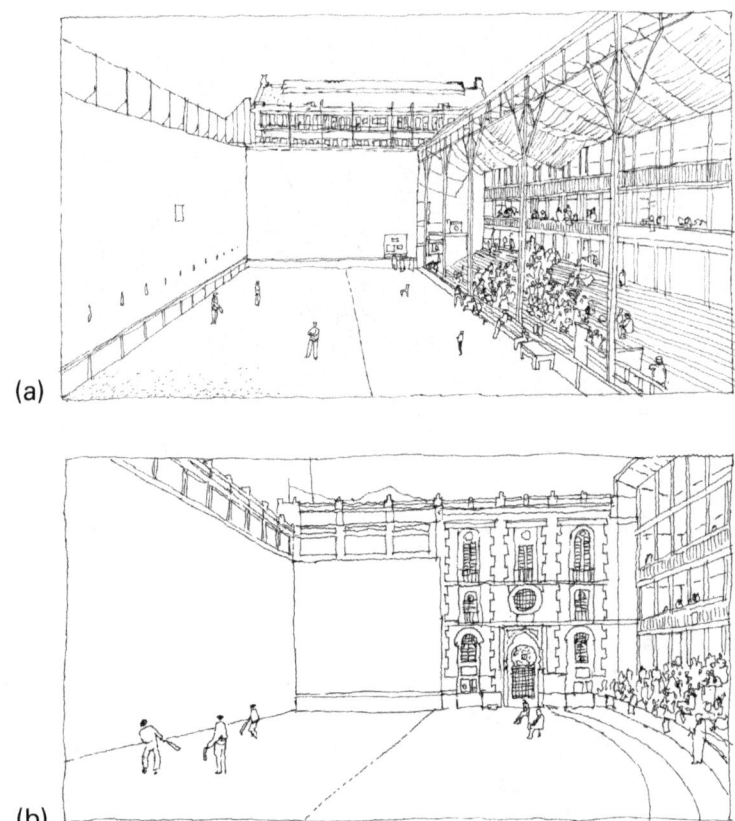

FIGURE 31 *Pattern and variations of frontónes in (a) 'Nacional de Buenos Aires'; (b) Beti Jai ('always festive'), Madrid. Drawings by the author.*

full visibility. Moreover, as if interchanging urban centrality for dimensional and geometric tolerance their arenas accommodated variations.

Purpose-made facilities gradually supplanted the impromptu arenas with their stylistically purged idiom. Typological characterization ensued, and with it, the facility for homologating play conditions, the procedures dispensing nevertheless with the heaviness found in the original squares: thus, despite the substantial differences, a massive Basque masonry wall and a flimsy court in Buenos Aires held the game indistinctly, with spectators accommodated parallel to the arena's long axis as customary to this particular sport.

When transferred indoors, lighting and atmosphere became architectural issues, such as in the no longer extant 1935 *Fronton Recoletos* in Madrid. In characterizing this modern theatre of suspense, Torroja and Suazo devised a magnificent double-vaulted nave whilst the interior geometries and finishes magnified the acoustics, thus augmenting the drama. Following the axis and

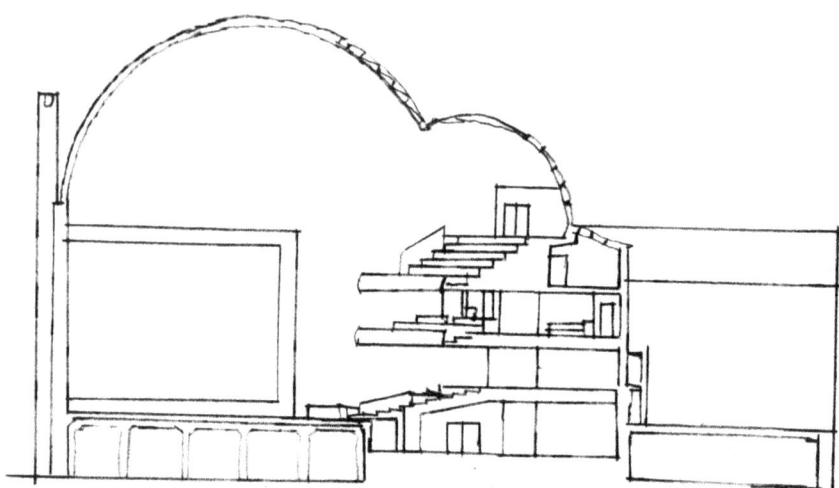

FIGURE 32 *Torroja and Suazo Frontón Recoletos Madrid, 1935. Drawing by the author.*

keeping close to the action, slightly inflected ranks of seats accommodated the spectators. Lighting was subdued. 'Skin against stone', a documentary devoted to the Basque Country encapsulated its fundamentals; the encounter of soft and hard, of hand to wall, of the organic to the mineral (Medem, 2003).

In most games the recourse to the indoors is just an insurance about the vagaries of the weather. When performative qualities are not at stake, the transit from outdoors to indoors may proceed smoothly, but even then, how not to affect the atmosphere? Architectural elements may easily get in the way of a proper concentration. Suazo eased out the effects of immurement through the management of light, texture and atmosphere. Moretti set his aims in similar directions.

Fencing, that inheritor of the duel, used to distinguish a *jeu de sale* from a *jeu de terrain*, summing up the indoors and outdoors. How to create a fencing hall where architecture did not overpower or inhibit the action was the question Luiggi Moretti addressed in his 1934–36 *Accademia de Scherma* in Mussolini's *Foro Italico*, Rome.[30] Recurring to a subdued light, and softening the geometries, he tuned-up the fencing hall into a solemn arena. Soft lighting, a restrained palette of materials, subtle hues, the homogeneity of the skin, the scale and serenity of the space concur in endowing it with a quasi-religious quality. The restful atmosphere contributed to its calmness, yet play was at the centre of attention.

As with all games there are variants in the idea of striking balls against walls. Three-sided Irish handball alleys followed simpler patterns than the Basque court. Courts were rectangular with one side open, like elongated

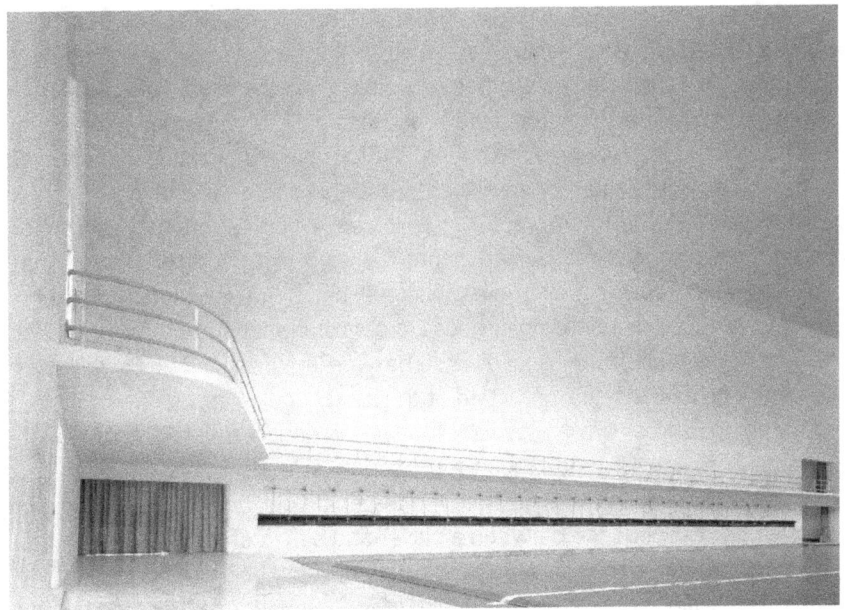

FIGURE 33 *Luiggi Moretti fencing hall, in Accademia de Scherma, Foro Italico, Rome. Photo Alessandro Vasari. Copyright Fotostudio Fotografico Vasari, Rome.*

FIGURE 34 *Irish handball alley attached to Buncrana Castle, County Donegal. Drawing by the author.*

buttresses, their flanking walls often attached to a building's blank face. The formula accommodated diverse urban and rural scenarios but – just like the fate of Basque ball – in the course of time these became increasingly confined indoors, thus missing out the communion with the landscape, daily routines and people at large.

The above-mentioned cases draw their performative quality from masonry. How about then if skins became soft?

In the 1960s, inflatables embraced ludic agendas: people could walk into balloons, and further, they could make balloons walk, glide or move, even over water. The usual shape was the spheroid. Sloterdijkt reminds us that spheres bring us back onto the human placenta, thus adding a subconscious appeal (Sloterdijkt 2011). Furthermore, their translucency modified ordinary perception so that players gazed from within onto altered prospects of reality. They interacted by pressing their bodies on the skins. Large scale inflatables were sometimes used as bouncing surfaces, a sort of responsive field that yielded to human pressure, forging an alliance between the domain of *Paideia*, pure spontaneity, no hard rule, and state of the art technologies.

Climbing offers similar levels of physical engagement, although with unyielding matter. In both cases the player's attitude is one of caressing, grasping, grabbing and holding on to the material skin. One can hardly imagine a closer correspondence between a player and a field of action.

The domestic hall can be seen to denote the indoor field's minor expression. It may occasionally charge the ludic action with drama, for, aside from shelter, it supplies a propitious ambiance for the table, its prime arena. In setting a common visual horizon, a range of physical contact and a geometric order or positions, tables also regulate human interfaces, just like fields. Of course, table games are often played outdoors and certain board games may omit the use of tables altogether, yet the nineteenth century saw a nurturing of sports, and fostered ludic trials in the bourgeois salon, the public bar, the gambling casino, and the grand hotel whence 'game rooms' were introduced.

Tables define a play format and a genre. The format accommodates varied arrays, but it generally sets face-to-face encounters that test the players' psychological resilience. The genre distinguishes between portable and immobile items, between the impromptu and the monumental. Although tables denote sedentary activity, billiards and table tennis sponsor motion.

Just as with the circus, chess did elicit the passion of the *avant gardes*. Be it for its mysterious origins, the magnetic evocation of the miniature players, its mathematical base or intellectual challenge, the game was perceived as unique, and so were its implements. Staged in 1944 at New York's Julien Levy gallery, Duchamp's blindfold chess event launched a range of tables and sets, whilst characteristically manipulating the conditions for its realization: drifting from board to board, a blindfolded player executed just one move at a time, based solely upon memory, thus reckoning with an unacknowledged hazard. Chess designs by Calder, Xenia Cage, Noguchi, Ernst, and a host of artists betrayed the game's formal allowance (just for its pieces, not so with the board, its unchangeable battlefield) (List, 2005). Game sets inspired Le Corbusier's

Dom-ino scheme, its modular plan somewhat recalling the domino piece, and its associative patterns that coupled building units into orthogonal ensembles derived from the game the interplay of chance and the rule.

Portable tables became popular. Depending on the game, table tops either circumscribe fields, or simply afford support. Singled out as symbolic demarcations (Auciello 1997), carpets dampen sound whilst offering a friendly texture. Noise often augments the excitement: if a hush is about the strongest utterance expected in Bridge, Mah-jong seems to thrive on boisterous exchanges, the pieces banged about as the game gains momentum, each ludic theatre following its own protocols and etiquettes.

Purposefully bulky, the billiard table sets the action with the players just caressing its rim. Casting their sights low, they attain a visual command akin to the foreshortened views of players over extensive fields. The game requires it; often classed as a precision sport, it beckons fine geometric theorems that link impacts to trajectories. The player's cue is similar in size to field implements like the golf club, except that the prescribed gestures avert physical strain. The terse green surface apes a lawn. All these affinities suggest a microcosm whilst also confirming the game's historical displacement from field to table, and its migration into precincts. Artificial lighting seems to have accompanied it from early stages as attested by seventeenth-century depictions, where the halo of light bathes the theatre of action. Van Gogh and Degas captured

FIGURE 35 *A billiard room. Drawing by the author after Degas, 1892.*

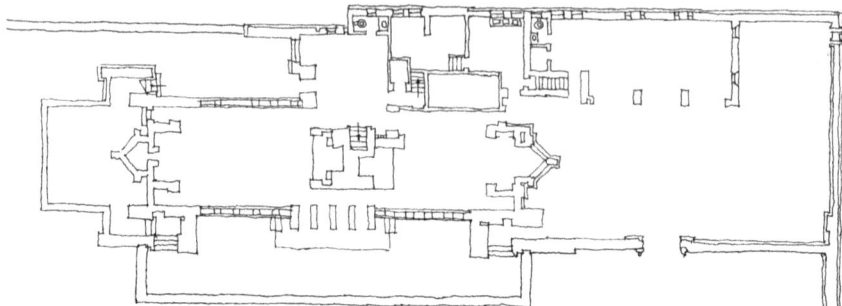

FIGURE 36 *Children's playroom and billiard room at the Robie House. Chicago: Ground floor plan, Frank Lloyd Wright, 1910. Drawing by the author.*

singular billiard rooms in their works, one at a coffee house, and the other within a stately home. Adolph Loos attached a billiard area to a coffee house, as if adding a ludic wing, an adjunct that became conventional. In time the billiard hall was frequented by the lesser ranks of society: featured in gangster movies, always charged, seemingly ready for violence.

As if matching piano rooms, billiard rooms became customary in stately homes, each one evoking particular moods and veering to specific constituencies: the former a female scenario, the latter a male one, the former an auditorium, the latter an arena, one suave and polite, the other coarse, most certainly clouded with smoke. What they shared was the status of the object as definer of usage, its virtual immobility somewhat closer to building than furniture, and the focus upon performance. Following from well-established conventions Frank Lloyd Wright's 1911 Robbie House featured a massive double-sided fireplace separating the billiard room from the children's playroom. It thus conformed to the ludic component in North American residential agendas. Neatly discriminating male adults from children, the scheme assigned to each a precise setting: a prime space to the former, a lesser one to the latter whose contiguity to the service court betrayed an acceptance of clutter. The table was the billiard room's structuring device, whereas a denuded floor was essential to the de-centred playroom. Echoing zoning principles that were eventually made extensive to the city, play in the Robbie House was orchestrated according to age, gender and behaviour. Play rooms – and later play yards – be they at home or school, became domestic equivalents to the urban playground.

Roughly similar in dimension to the billiard table (3.05 x 1.52 metres), the table tennis table (2.74 x 1.52 metres) is usually portable. Mostly played outdoors (in mild climates), and quite removed from the sedate conventions of the salon, its agitated performance evolves over the table top: its denomination as table tennis clarifies the transference of the game from the ground onto a furniture piece.[31]

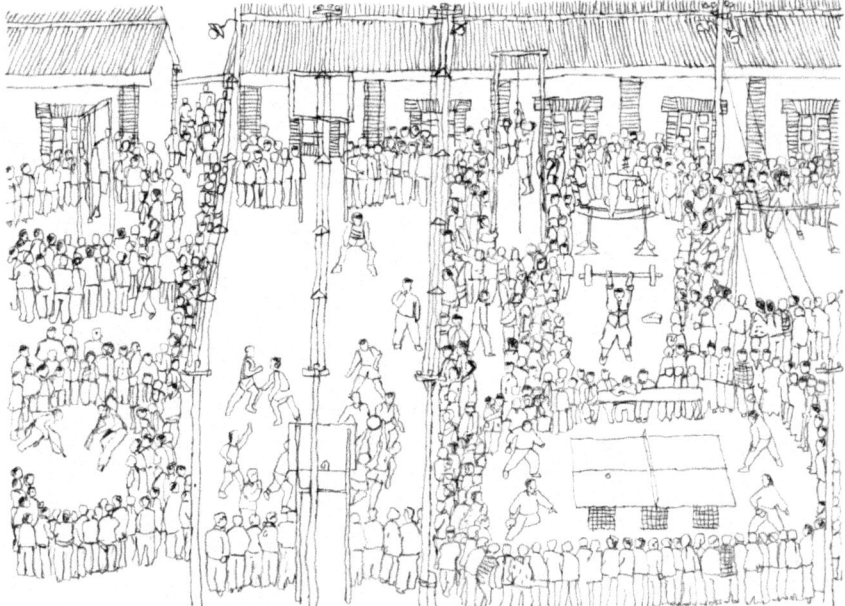

FIGURE 37 *Outdoor Play in a 1970's Chinese commune. Drawing by the author after Iu Kuang Chen, 1976.*

Each ludic proposition issues formal, material and relational clues: the following survey displays salient ones, described one by one for a better comprehension, although they always converge. Bearing this in mind, each topic can be examined independently for a better grasp of the architectonic considerations embedded in the ludic grounds.

2

Formal and relational traits

Scale

'**B**oard', 'table' and 'field' suggest almost infinite gradations in scale, yet they all share the notion of the 'space apart' as required by structured games. One also finds formal traits relating certain boards to fields, yet, notwithstanding the common ground, there are significant qualities attached to each.

Firstly, epistemological and experiential frontiers distinguish objects, fields and geographic events; for rather than a continuum, space concatenates distinctive conditions. Secondly, certain formats are embedded between ranges of scale: the graspable board is associated with the hand, and the field is related to bodies in action. Formats clash against dimensional thresholds; fields become unpractical beyond certain dimensions, whereas tracks are conceptually unlimited. Critical thresholds in scale determine the substitution

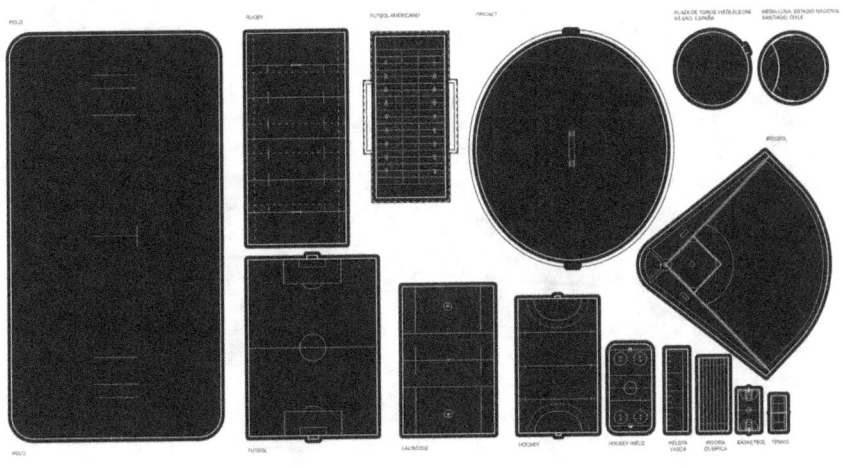

FIGURE 38 *Comparative field plans. Drawing by the author.*

of board games with field games. The same holds true of field games being substituted with track games, with a concomitant replacement of surfaces for lines, complex motions for single directions, converging lines of sight for single ones. The scale in fields is loaded with specificity.

In sport, orthogonal fields predominate, albeit with significant exceptions; their typical format ensures panoptic control. Each one holds the key to a certain performance: Polo derives its extensive grounds from horse power. The circular arenas of the Chilean rodeo – a contest between horsemen and calf – and the Iberian bullring, betray unmarked field patterns. But there is more to it than mere geometry for each one incarnates a practice in all its possible dimensions. Certain prescribed choreographies, the composition and roles of a team, a rhythm measured in time or scores, cadences, a tempo, and the use of specific implements, all eventually define its contours. Moreover, encrypted notations characterize the modern field, qualifying its areas, discriminating actions and penalties, accentuating its complex, albeit often subdued, topological structures.

As if pertaining to a secondary order of considerations, fields also prescribe the spectators' perceptual patterns, leading on to specific configurations of grandstands and bleachers. Moreover, the active, even boisterous behaviours that result from partisanship, contrast with the acquiescence to silence that came to characterize the modern theatre. Each score resounds with a roaring acclaim; a reciprocal voice sometimes likened to the Greek choir, for its

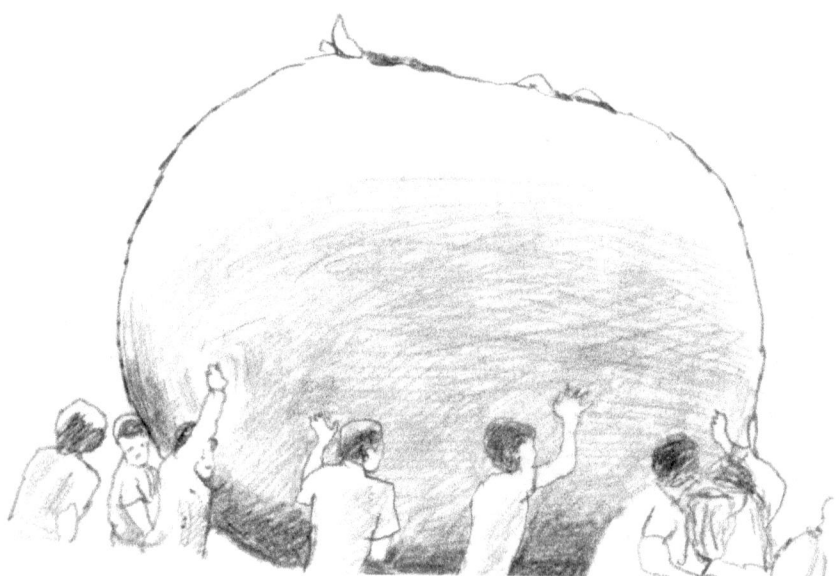

FIGURE 39 *Manuel Casanueva: a 3-metre diameter ball becomes the playing field. Teams take turns launching a player towards the ball. Drawing by the author after Casanueva.*

complicity with the action. But stands also depend on scale and format. Stands can eventually embrace fields, following the concentric patterns of the coliseum, but this relationship is only tenable within a certain range of scales. Upwards from football (in its original and North American variants) it becomes unfeasible to encircle fields with stands. Upwards from polo grounds there are no fields, just tracks, and their stands – whenever provided – are conceived as discrete episodes.

Scale rules not only the field but also the implements that must respond to the unique formula devised for each game: balls, for example, may be easily handled. A subversion of scales throws ludic conceptions into utter disarray, as proven by Casanueva's attempt to re-enchant sport through the manipulation of its formulae.[1] Some of his ludic experiments included holding up an excessively large balloon in the air, and throwing players onto the surface of a heavy balloon rendered immobile by virtue of its excessive weight.

Beyond a certain dimensional threshold, the track becomes the only tenable arena. Closed circuits follow different layouts: sprint race tracks describe the smallest range, the horse race a mid-scale, whilst motor race tracks represent the largest purpose-made ludic itineraries.[2] Beyond a certain range, equestrian, mechanical and motorized energies substitute human effort. Moreover, layouts are specific to ludic principles and their associated dynamics. Motor courses

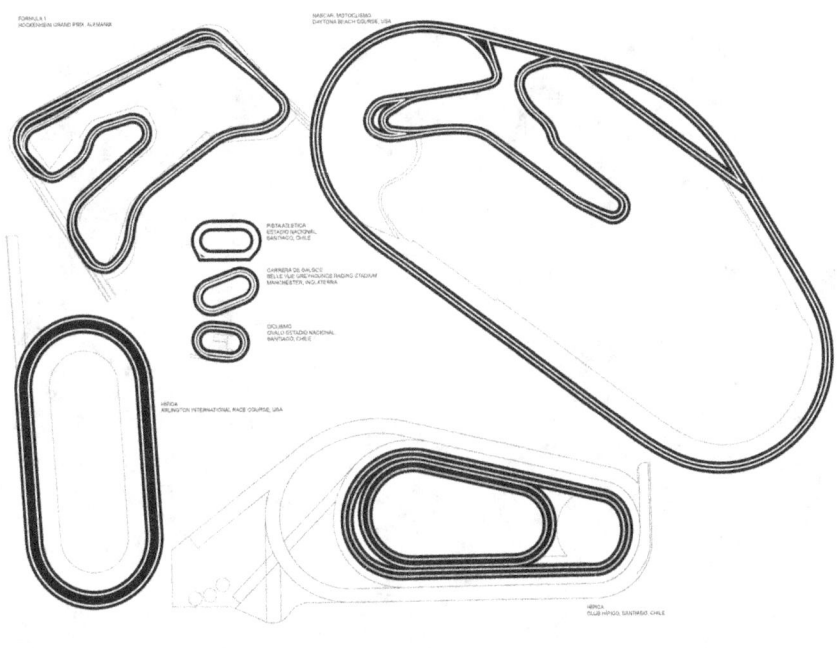

FIGURE 40 *Comparative track and racecourse plans. Drawing by the author.*

admit acute bends. Turf settles for generous bends, in contrast with its ancient precedents where the expectation about chariots negotiating around the *spina* – its median division (often furnished with obelisks and ornamental statuary) – was climactic. The rationale of modern courses becomes evident in the subtle road cambers that counteract the outward pull caused by high speeds, or in the pronounced banking that is common to cycling tracks.

Hippodromes count amongst the largest purpose-made fields. Airports are perhaps the only urban establishments to compete in scale. No wonder, disused airfields were sometimes converted to this effect.

Upwards in length, circuits turn geographical, appropriating road networks, or else opting for the off-circuit, a blurred maze of tracks negotiated over rough terrains. The *Tour de France* epitomizes the former, the *Dakar* rally the latter; one embodies the national space; the other is emblematic of the 'exotic'; both reach epic dimensions. Roland Barthes states:

> The French are said to be uninterested in geography . . . their geography is not that of the books but that of the Tour de France . . . each year the tour reunifies the country and makes an inventory of its frontiers and products . . . the combat scenery is the whole of France.
>
> BARTHES 2008

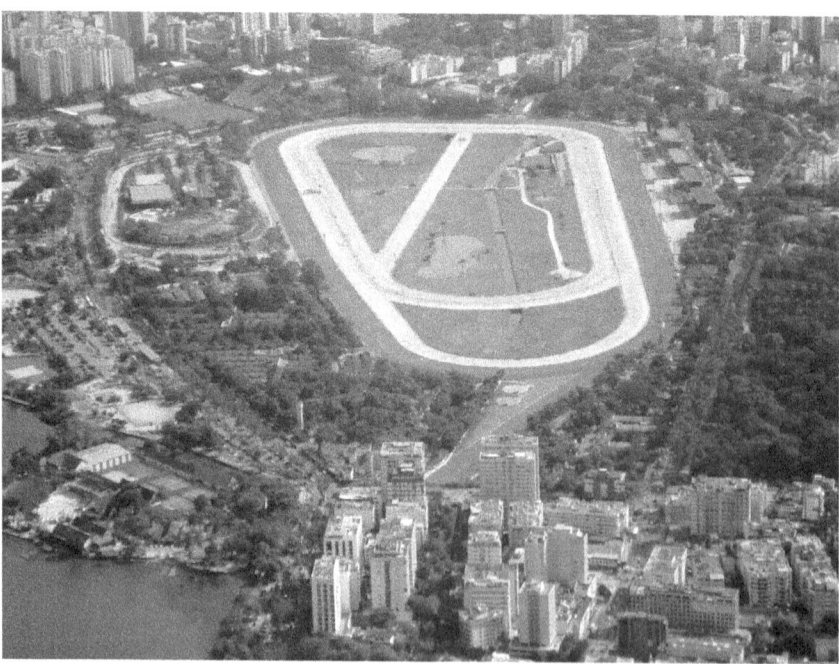

FIGURE 41 *Large ludic imprints: racecourse in Rio de Janeiro. Photo by the author.*

This concurs with *Paideia*: through a tactical appropriation of infrastructures, the nation is recast as a ludic field.

These dimensional ranges also affect localization, for they discriminate between that which is inscribed in the urban tissue, and that which can only be construed off city limits. Board, table, and field belong to the domain of design, architecture and landscape, whereas continental rallies exceed design scope.

Quite in line with the agonistic principle, scale also discriminates relational properties. Lacking in spatial depth, the closeness or even promiscuity of the smaller range underscores body language, increasing the psychological confrontation, whereas the panoptic field of 'active sports' sets the scene for a whole range of physical rather than psychological rapports, where body contact may or may not be allowed.

Denoting a large scale, parks evolved in parallel to play practices; the former acquiring a public profile (Olmsted 'people's parks'), the latter beckoning education and recreation, as was the case with Alphand's substitution of the Bois de Boulogne's hunt rides by a sinusoidal array of promenades, when recasting the former royal grounds into a mixed-use park. Assorted agendas about contemplation and action informed his changes. Lodged within, the Longchamp racing track substituted the former hunt rides for one circuit, thus aligning the equestrian element with modern sport.[3] Other fields were incrementally added, until it construed vast mosaics of stadia and courts that eventually covered the southern areas. Lured by the celebration of the outdoors and the festive spectacle, Manet and Degas vividly described its equestrian theatre. Decades later, Le Corbusier fixed his own domicile by the southern edge.

FIGURE 42 *Bois de Boulogne: (a) before and (b) after transformation by Adolphe Alphand, executed 1882. Drawing by the author after Adolphe Alphand's 'Promenades de Paris', 1867–73.*

Topology

The esplanade, the track and the discontinuous field are recurrent topologies. The former comprises a great variety of materials. Besides size and layout and following ludic requirements, these may beckon such diverse surfaces as ice, grass or hard paving. From a topological perspective, fields that exhibit topographic inflections count within this family.

Defined by a course rather than a surface, tracks describe linear patterns. Although these may range from geometric ones to arabesques, from traces to circuits, a golf course and a toboggan run equally belong to this family, also the maze, except that its course splits into alternative paths and dead ends. Tracks can be assembled in networks, as with the French hunting rides or may assume three dimensional entanglements as with roller coasters.

Connectivity is a topological concern. Certain fields are purposefully discontinuous, heterogeneous and hazardous. Such may be the case with the hunting forest for example, or the aerial fabric of trapezes and bars in the circus. Auciello singles out this trait as one that distinguishes field from board games, for continuity prevails in the former, whereas discontinuities often prevail in the latter where the norm rather than the field regulates motion. However, prescriptions and prohibitions embedded in graphic markings (as with traffic signals) turn fields into heterogeneous entities whilst regulating the scope of performance. Thus, the chess board is made complex through norms that sanction discontinuities within the otherwise homogenous gridded surface; likewise, with fields where graphic markings turn the continuous surface into a highly differentiated patchwork of field conditions.

 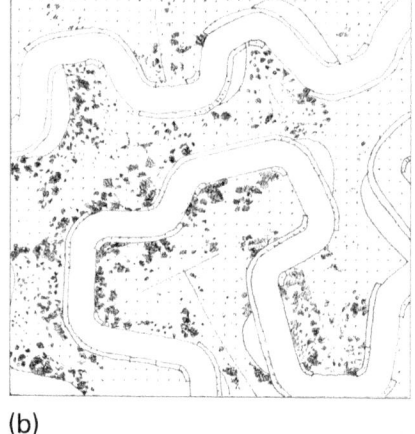

(a) (b)

FIGURE 43 *Ludic patterns: (a) Maze at Hampton Court, (b) Go kart race track. Drawing by the author after Alex MacLean.*

FIGURE 44 *Movement protocols in (a) Ludic and (b) pedestrian practices. Photos by the author.*

Topography

Terse, devoid of inflections, the level field predominates. Its horizontality is delusionary, however, for drainage requirements induce subtle falls. Its optimal viewing scope turns it into the ultimate stage, thus epitomizing the nexus between play and spectacle. Horizontality enhances the element of chance, and guarantees equal playing conditions. It is often laconic, but as we have seen, its bareness may well conceal heterogeneous conditions and differentiated ludic values, mainly through rule prescriptions. In homologating the players' conditions, the horizontal surface seems obvious, but even if horizontality appears optimal, the insatiable ludic instinct equally values the 'accident'. Although all play rules are arbitrary, just a few demand topographic profiles.

A 'hazard', defined in the dictionary, is 'a thing likely to cause injuries', its secondary meaning is attributed to golf and is 'an obstacle such as a bunker, a sand pit, etc.' Hazards may be construed in various manners: through topographic manipulation, by means of built impediments (like steeplechase hurdles) or referring to ground material (such as mud or any other contrivance apt to the purpose of adding difficulty to the motions over a course). Their presence may become as notorious as bunkers in the landscape of golf or the *walls, triple bars*, or *oxers* in the equestrian jumping course.

FIGURE 45 *Man-made hazard. Drawing by the author after Ortner.*

Deriving their ludic potential from the accidents embedded in complex topographical ensembles, gravitational fields construe a concatenation of hazards. Ground materials sometimes act as lubricant accelerating the motions, as it happens with snow, ice or frictionless toboggan walls. But hazards are elements of resistance: a rugged field, an unstable ground, a vertical outcrop.

The ludic interfaces with gravitational forces lead players to testing the world's physical traits. In this quest, topographic 'accidents' became particularly valued: mountains thus attracted prime interest, with the fate of entire ranges ultimately determined by their embedded ludic potentials. Whether for sledging, skiing or climbing, it was just a matter of conceiving them as playgrounds. Either way, morphological properties reverberate in the ludic encounter with the site thus captured, a charged arena resonating with physical as much as psychological challenge.

If smoothness is the required condition for skiing, convoluted topographies are the staple grounds for climbing where the 'field' itself becomes just a sequence of hazards. Kwinter notes that a climber, unaided by tools or instruments, enters into subtle engagements with the mountain face: 'the mineral shelf's erratically ribbed surface, offers enough friction to a spread palm to allow strategic placement of the other palm on an igneous ledge a half a meter above'. This engagement is no longer within the order of mastering the field but rather of forging 'a morphogenetic figure in time', ever alert, an intimate and continuous interplay of every single muscle with singularities. Related to

(a) (b)

FIGURE 46 *(a) Holmenkollen ski jump, Oslo; (b) plan of Gramisch Paterkirchen ski jump stadium, Bayern.* © *Holmenkollen ski jump. Drawings by the author after Ortner.*

the single contestant, this interface substitutes the always changing figurations of field sports (Kwinter 2002, 31). Following the traditional excursion into the field, which is by its very nature remote, and also forbidding, comes the fabrication of vicarious similes, destined to be suitably grafted on urban places. Henceforth, natural fields and artefacts, the remote and the immediate, lead independent lives, as if splitting up into parallel pastimes. Climbing walls are latter day correlations to traditional climbing in the rough, their folded surfaces and protuberances a rational elaboration of the natural 'hazards'. So, whilst it stands for the unpredictable, the hazard, an accident, also forges programmed, serialized, artefacts, thus construing unprecedented ludic scenarios.

Before it became a pastime, skiing was an effective means of transportation, thus confirming that notion of ludic actions as repositories of common practices. Alpine mountain ranges were regarded as natural abominations until the concept of the sublime infused them with the mixed blessings of terror and greatness. Play was no doubt an element in their domestication as it substituted contemplative raptures for ludic challenges. Henceforth their appraisal became tactical; hills were harnessed under the aegis of leisure, with assorted elements coalescing in the 'winter resort', a complex ensemble of buildings, mechanical apparatus and earthworks, a perfect seasonal analogue of the summer resort.

Introduced into almost unassailable places, ski lifts maximized use, propelling players upwards with the ceaseless motion afforded by the industrial conveyor belt. Networks of ski lifts and fields were etched over the mountain's face, as so many scars, turning their surfaces into arenas. Following gradients, and construing particular challenges, each one set a standard. Capricious motions turned them complex, as in slalom, whilst high speed ones led onto nearly straight alignments. Turning rough nature into fields, ludic sensors were thus applied to the mountains' coarse face.

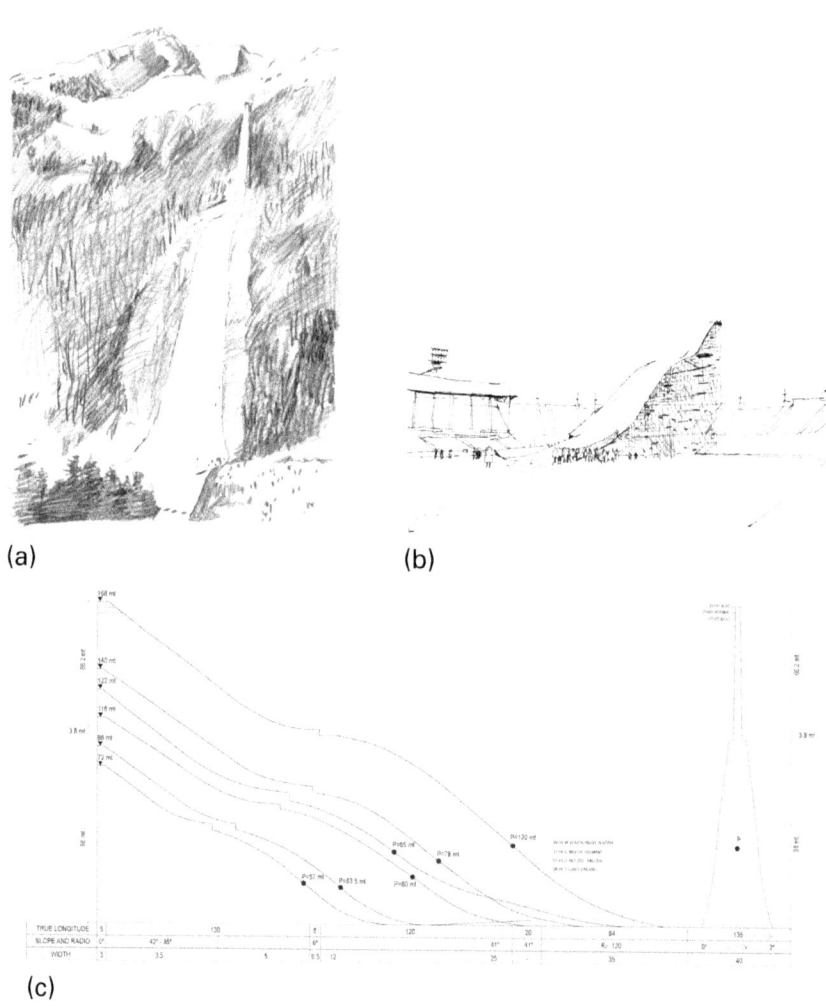

FIGURE 47 *Displacements: (a) Oberstdorf (168 metre); (b) Wembley Stadium wooden ski-jumping hill, 1961; (c) Ski-jump diagram: note that higher profile and elevation correspond to Obertsdorf. Drawings by author after Ortner.*

By the nineteenth century, Nordic countries successfully introduced ski toboggans. Reaching up to twenty floors in height, these colossal fabrications, with their alternate convex and concave profiles, set the sequence of inrun, take off, landing, and outrun, casting the skier's silhouette against the ski. Their emplacement, scale and profile turned them sculptural; their ludic analogues were much like springboards, only just so much greater. Their layouts embodied parametric considerations about form and performance, that were faithfully transcribed to design manuals.

Flanking the outrun, the bleachers construed proper – if slightly odd – mountain stadia, their peculiar bowl shape negotiating complex topographic nuances and lines of sight. In its intoxication with vertigo the experience belongs to *Ilinx*. Of broad application within the scope of children's playgrounds, the elementary principle of the toboggan found large scale industrial application before becoming a play apparatus.[4]

Symmetry

The geometric matrix is dominant within *Ludus*: it reveals that idea of the field as algorithm, a mechanism of reciprocities between the rule and the material conditions for engagement.

Like most representations of the kind, De Ferrario's eighteenth-century depiction of 'exotic' subjects about to engage in a game was emblematic of the values held by the artist: first there is bilateral symmetry because it is compositionally apt, but also because it bespeaks the agonistic encounter, a fight amongst equals. A single tree enhances it; also, body postures. A classical sense of balance beholds the composition of harmonious bodies. Whilst the recourse to symmetry and balance follows pictorial convention, it also forges the ideal of the noble savage (its Greek or Egyptian ancestry found in identical compositional ploys depicting players about to engage in games that modern interpreters class as 'hockey').

The game in question was known by the Spaniards as *Chueca* for its similarity to the Spanish game. It was played by Araucanians in southern Chile and Argentina with slightly bent sticks, over a rectangular field, measuring

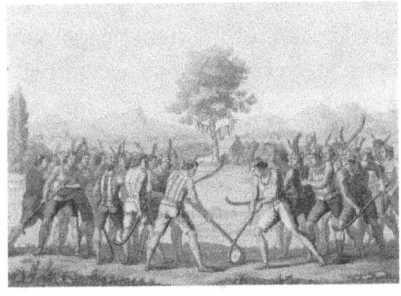

(a) (b)

FIGURE 48 *Araucanian games: (a) Guiseppe Erba, Odescalchi et al.* Indians Playing Chueca. *Image courtesy Brown University. Copyright John Carter Brown Library at Brown University, Providence, c. 1821 impression; (b) Claudio Gay, contrasting view in 1854. Image courtesy Biblioteca Nacional de Chile. Copyright Common Cultural Heritage Biblioteca Nacional Digital BNC.*

FIGURE 49 *Rodchenko chess table and chairs: one half black the other red, for a workers' club, 1925. Drawing by the author.*

about 120 x 12 metres and bounded with twigs or shallow trenches. Rules were kept by heart. Like so many vernacular games it survived through war, oppression and poverty to join the ranks of conventional sports as a token of cultural recognition.[5]

Indeed, a solemn moment of symmetry characterizes the beginning of procedures: team leaders shake hands, the arbiter sets the game going, until hostilities break. Hence it holds for just one instant. In his nineteenth-century portrayal, French naturalist Claudio Gay was closer perhaps to the facts: all hell had broken loose in the field, whilst the handling of domestic chores as shown in the foreground carried on, unabated. These were common sights, for pre-modern plays shared the casual disorder of carnivals. Elias conceived these changing choreographies as figurations, whilst Huizinga characterized them as engagement and disengagement. As if following a superior rule, games proceed from orderly beginnings to stasis in a dispute about control over terrains, things and time.

Symmetry in fields and play boards is not just a formal convention: quite to the contrary, it becomes an architectural analogue to the Agon ... *many sacred buildings ... are formed around pageants and rituals in which strict symmetry is observed* ... reflected Rasmussen, recalling the incidence of the procession in the shape of a nave, but such strict adherence of formal structure to ritual is matched in the structure of many field and table games (Rasmussen 1962, 139).

Bilateral symmetry encapsulates the agonistic principle of duality and its correlation in the two halves mirroring each other. It is not difficult to see why it became such a structural device. With its red and black elements in prefect reciprocity, Rodchenko's workers' club chess table embodies the concept;

likewise, the ones devised by Man Ray, Xenia Cage and Noguchi that celebrated this principle whilst endowing the symmetrical array with a particular expression. As with all components in the making of fields, symmetry is qualified by rules of engagement (List 2005). It expresses itself too as a physical balance that becomes yet another ludic principle, literally applied to the seesaw, an apparatus that draws inspiration from the measuring scale for weights. Carrying heraldic symbols, symmetry also features in playing cards.

When fields are split in mirrored halves players usually interchange positions, following from specific time or sets. Unlike football, however, tennis allows grass, clay, and hard surfaces. Only because players changed sides was it possible to conceive a tennis court with differentiated materials: one with grass, the other clay thus construing the so called 'battle of surfaces'.[6] Symmetrical arrays reverberate in the emplacement of umpires and judges. Medieval tournaments exceptionally set the symmetry axis tangential to the action, hence promoting oblique encounters.[7] The concealment of the bodies behind armour, the vibrant heraldry and the clank of metal must have increased the tension and drama, but the symmetrical partitioning of the field conformed to the very same ludic principles as in modern sports.

When the axis cuts across the opposite camps, players confront face to face, some rules allowing territorial invasion, others precluding it; the net enshrines the field's partition into inviolate grounds, whereas goal posts symbolize the thresholds and ultimate defensive position of a field subjected to periodical invasion. Much like a barrier and a gate, both equally enshrine symmetry, except that one is a deterrent whereas the other rather defines a threshold with the defensive and offensive positions betraying that stylized element of warfare that is present in modern sport.

Elias observed how the transformation of pastimes into sport correlated with those political mechanisms whereby English society (for it was there that these events took place first) solved conflicts without recourse to violence. Fields were incubated following those principles, likewise the House of Commons, the United Kingdom's prime debating chamber, with its distinct layout that contrasts with the hemicycle. The symmetry axis fulfils diametrically different roles in each, for in the hemicycle it follows a hierarchical relationship between the chair, or presiding body and parliament's rank and file, as if between a speaker and an audience, whereas in the House of Commons the axis bisects the space in equal camps designated as 'government' and 'opposition'. In doing so it substitutes the single focus for a median line, a virtual axis which betrays an agonistic principle, also apportioning equal grounds, as in the playing field. Its format not only *induces* but it also *embodies* face to face confrontations. Its spatial and topographic similarities to Monte Albano's pre-Columbian ball-court are striking: were one to ignore their ultimate significance they could be easily taken to embody similar agendas.

FIGURE 50 *(a) The sport arena and the axis of symmetry in Leonidov's Cultural Palace for Moscow, 1930; (b) Corbusier with Pierre Jeanneret Mundaneum in Lake Geneve, 1929. Drawings by the author after Leonidov and Le Corbusier.*

Tinged with historicism, and too academic to be embraced by modern architects, the compositional principle of symmetry was enshrined in the sports field, so that whatever their predilections, they were forced to contend with it in the organization of the outdoors. Both in structure and outline, symmetrical bodies were hard to integrate, for modern compositions largely favoured balance, yet sometimes, architects seized upon the symmetrical matrix of the field as an organizational cue. Le Corbusier's 1929 *Mundaneum* and Leonidov's 1930 *Culture Palace* in Moscow, drew compositional structure from the field's matrix. Its function was emblematic, particularly so in the Mundaneum, where it was lodged in a stadium, its oblong plan intercepting a main axis whilst also mediating between residential quarters and the monumental complex of library and university. But these efforts seemed contrived and out of line. It was certainly easier for an academic designer, like the French landscape architect Forestier, to fit sports fields within a park with its meandering paths as he did in the 1924 Saavedra Park in Buenos Aires, where the tennis courts and football ground followed a symmetrical array.

FORMAL AND RELATIONAL TRAITS 77

FIGURE 51 *Symmetrical rigours: lawn and playgrounds in Jean Nicholas' Forestier Parque, Saavedra, Buenos Aires, 1924. Drawing by the author after Forestier.*

FIGURE 52 *Classical hippodromes integrated to larger ensembles: (a) a college by Durand; (b) a royal palace over the Acropolis by Karl Friedrich Schinkel, 1834. Drawings by the author after Durand and Schinkel.*

Despite the traditional procedure, the insertion of the field in the core of the park was novel: one can follow him squeezing green wedges on the perimeter to keep the semblance of a 'natural' space.

Sports fields were not easily inscribed in parks. Similar dilemmas were present in the framing of hippodromes in institutional ensembles as attempted in the early nineteenth century: their format deriving from the classical precedent with the axial *spina* and its sharply bent track. Handled by such exponents as Friedrich Schinkel in the Acropolis palace or Durand in a college, these confirmed the pedigree of horsemanship. In comparing Durand's operation with Schinkel's it becomes evident how the inscription of the large field within the tight plateau poses different empirical challenges to its inscription over a flat terrain but besides these contextual constraints they betray contrasting sensibilities about order *vis-a-vis* an emergent taste for the picturesque.

Perspectival alignments

The perspectival field is also a ludic trope. Golf is a case where ballistics construe linear corridors yet these allow formal tolerance in the layouts of the flanking 'roughs'. Following linear sequences, fairways articulate changing vistas and naturalistic inflections with straight shots. Likewise, shooting and archery; equally classed as 'precision sports', their perspectival ranges do not necessarily construe formal corridors.

The science of ballistics impinged upon military engineering. Military engineering, it has been argued, also informed grand landscape schemes such as Versailles where the arts of Vauban were put into practice for the benefit of representation and leisure: urban historian Gaston Bardet associated urban sight lines to artillery expertise.[8]

The Hausmannian Boulevard is said to reflect upon military strategy (as with shooting ranges), also to embody crowd management principles and an efficient mechanism for the distribution of goods. We have seen how its matrix derived from French hunting grounds, with their straight rides and round-points. Most likely the Boulevard enshrines more than one design principle.

Be it as cuts in the forest, or in the building mass, boulevards and hunting rides shared precise geometric outlines. The old game of Pall Mall which was also described as a form of ground billiards was played over a lawn inscribed within the geometrically precise alee; likewise, the French pétanque where the field's format reciprocates in the orthogonal geometries of the formal garden. Modern bowling alleys follow strictly linear patterns, but their serialized ranks result in vast striated ensembles for the parallel deportment of the game.

The informal and the formless

Formality is in the essence of many a field, whereas informality belongs to the 'sportive'. It also came to be associated with rolling landscapes and their similes. Of course, biomorphic figures are not any closer to nature than formal arrays, neither are they any easier to construct. As we know, the informal was often attained in artificial landscapes at the expense of massive displacements of people and materials; it was in this respect no more than a conceit heavily propped by rules. Nevertheless, here *informal* stands for naturalistic, and the value of casualness extolled by the likes of Le Corbusier, Gray and later the Eames, Niemeyer and Bo Bardi.

Formal and informal interplays fuel the ludic imagination. Formal rules determine the validity of certain moves, the range of action of certain players, the definition of a *corner* or an *off side*, the sharp distinction between defence and offensive positions, often enshrined in simple patterns. The intelligibility of the geometric field as supplied by its regular geometries and layouts is just one of its outcomes, and yet the informal (also eventually the formless) may become equally necessary in ludic terms. Such is for example the ludic appeal exerted by the *terrains vagues*, those spaces that Sola Morales defined as . . . 'forgotten (localities), mental exteriors, urban counter images' . . . (Morales 2002) but also as . . . 'promise, space of possibilities, expectation' . . . their rampant indeterminacy, an outcome of extraterritoriality enhancing their ludic appeal. Duvignaud ranked them amongst the most privileged ludic scenarios.

Formlessness can also exert intense ludic curiosity. The adventure playground draws inspiration from it, in its quest for transforming – as in a puzzle – the initial chaos into an ordered cosmos. Beckoning the instincts of the bricoleur, it calls for the formless to be ordered, thus realizing its passage to the formal, as is common when playing with sand or snow, where the pliable material is brought into shape through modelling. These ludic dimensions did not escape the attention of architects: Frei Otto propped his discourse on 'adaptable architecture' through the evocation of the ludic process. Similar ludic overtones are present in the action-painter interplays with chance (Otto 1979).

3

Materials

In play, one activates all experiential conditions: texture, density, temperature, but also visual command, sonority, and so forth, so that one plays *with* material conditions, not just *over or by* them. As each practice beckons field conditions, play rules usually stipulate materials.¹

Aside from landscape architecture, it is not frequent to consider material textures as a relevant urban topic. With the advent of modernity, however, the wholesale substitution of hard for soft ground surfaces, reinforced by the assumption of play as a public issue, transformed cities. This was accompanied with sweeping changes in street paving. As city surfaces became harder, the park's contrast to the 'asphalt jungle' increased.

A heightened consciousness about the incidence of ground materials in play led to rationalizing their use, and distribution. Thus, Hans Wohlin's technical guideline for playgrounds in Stockholm (aimed at a community of up to 6000 inhabitants) recommended not just adequate ranges, but also precise ratios for grass, gravel, asphalt, sand and water in the making of a 'play park'. He prioritized grass, however, most probably because it so readily matched the contrasting demands of play and passive leisure. His varied ludic agenda took account of age groups. As if a cooking recipe, his precise manipulation of ingredients organized recreation in preordained morsels. Greenery was increasingly quantified within the framework of functionalist planning, but as pointed out by Belfiore, the notion of estimating surface standards for green areas dates back at least to Forestier's Buenos Aires plan. It eventually became a trend (Belfiore 2005 149,150).

Aside from its predominance in seaside resorts, sand increased its use value with the ascendancy of the children's playground. Water became fundamental to the creation of urban Lidos. Even though tainted with connotations of the Victorian school yard, concrete and asphalt played a role in the making of playgrounds; certain brutalist ones such as the one atop a Marseille block became memorable.² Snow too gained prestige with the vogue for winter sports.

The lawn

Soft, springy, resilient, easy on the eye and the body and of a neutral temperature, the lawn is ubiquitous in the sports field. It carries an element of the moist landscape where modern play originated, and because of it, it poses acute challenges when transplanted to hot climates. Charged with symbolic content, its tautness and abstraction – so in line with modern sensibilities – helped boost its landscape ascendancy (Teyssot et al. 1990).

Certain field traits seem to have incubated in the bowling green: its terse green plane substituted the gravel terrace in front of the country house, instituting a form of landscape mediation that beckoned gentile ludic action (Bale 2001). The *parterre à l 'anglaise* comes next as a possible nexus between the highly formalized lawn and the field. Greens and commons further popularized the lawn. Olmsted acknowledged the ludic element in the North America green where military drill, promenading and pasture cohabited. When migrating westwards, observes Teyssot, greens contributed to consolidate the national identity, whilst shifting meanings from the original civic conception, to the celebration of leisure in the west (Teyssot 1999).

Allied to imperial ventures, lawns became tokens of the (Anglo-Saxon) home in faraway places. They also became emblems of domination as in Singapore, Kuala Lumpur, Kerkira and Mumbai where such major esplanades were embedded in the colonial sports club.

In modern times the lawn became a favourite landscape material. Never harsh to the eye, it was equally favourable to players and strollers, whilst its amiable texture was easy on the body at rest. Simultaneously evoking idleness and athletic vigour, stillness and action, it accommodated the modern parks' contrasting agendas. It was demanding, however, for considerable technological knowhow as much as daily care were required in levelling, draining, fertilizing, and periodical cropping (Teyssot et al). Sports were active agents in this techno transformation of landscapes . . . *ever since the late 1880s . . . [supplying] particular conditions of durability, bouncing quality, and speed*. No wonder that Frederick Winslow Taylor noticed how the required turf qualities could be attained through a process similar to the manufacture of products on the industrial shop floor (Scott Jenkins 1994). As if availing his foresight, synthetic turf eventually became a by-product of sport research.

Sand and snow

The same *arena* that denotes a theatre of activity, also denotes compacted sand, which was the Roman coliseum's ground surface. We have also seen how, aside from economic criteria, the choice of earth in lieu of hard paving was a ludic one in South American squares, for material conditions are embedded in the ludic project.

In perfect seasonal counterpoint, sand and snow beckon ludic agendas, but sand was not thus always appreciated. Beaches, as Corbin points out, were considered dirty as if endless deposits of flotsam accumulated by a restless sea, which was perceived to be far too menacing for leisurely pursuits (Corbin 1993). Only gradually did these natural deposits become desirable; resorts being the main agents for their re-invention. Henceforth nothing stopped the irresistible ludic appeal of sand.

Tactile, thermal, optical and plastic properties characterize the blanket extensions of sand and snow. One warm, the other cold, both harsh to the eye, pliable and fine grained. Their pliability stimulates form-making.

Like other educational devices, the sand garden, the sand box, and the playground became initiatory spaces. In the 'Story of the sand pile', Stanley Hall recounted fine sand being hauled from the beach into a backyard, for the entertainment of children. The heap of sand spurred the creation of a miniature village with its associated trades, leading them in turn – so he tells us – to reflect upon production, commerce, legislation and so on. Although eventually subsumed within a complex ensemble, the *sand garden* triggered invention,

FIGURE 53 *Henry Barnard's 1848 school desk with a sand tray. Drawing by the author after Barnard.*

negotiation and the development of critical faculties, thus becoming a learning tool as much as a ludic space (Hall 1897).

How did sand enter the urban landscape? As seen before, artificial beaches became unprecedented collective expressions of leisure, surely the most ambitious ones. At a much subtler, even intimate level there were sand pits, a nineteenth-century invention. *Sand gardens* were created in mid-nineteenth-century Berlin through the distribution of sand heaps across public parks. These were inspired in Froebel's manipulation of natural materials, as an element in child rearing. Around the same time educator Henry Barnard conceived a 'sand desk' atop a school bench 'with a little black tray upon the rest containing a thin layer of sand in which to trace letters and crude attempts at imitating form' (Barnard 1970 1848): the magic of sand in the hands of children was augmented in direct proportion to the remoteness of beaches and dunes.

The urban presence of sand became a token for nature. In a topographic reversal of the heap, the sand box or pit entered private gardens, school yards and public settings, manmade analogues of the beach that orchestrated circumscribed theatres of action. Sand gardens seem to have led to the conception of the playground; it remains to be researched how the emergent seaside resort related to these elements that came to characterize the playground, the garden, and the school. What is certain is that the urban playground was often conceived as a public facility for deprived inhabitants who would have lacked the means for transport to the sea. The vicarious freedom extolled by playgrounds could then substitute holiday travel. As we will examine later, sand pits were at the core of the novel urban spaces created by Aldo Van Eyck in post-war Amsterdam.

Inherently unstable, fragile and easily degraded, more like a state than a material, snow yields alternative ludic opportunities, its projections highlighting the commemorative aspect of urban play for it embodies sudden change, thus also seasonal awareness. More so than any other material, snow operates a veritable urban transfiguration. These considerations led Aldo Van Eyck to criticize the phenomenological blindness of functionalism toward place time and ritual. Just for a while, snow turns cities into playgrounds whilst play, that mirror of ordinary existence, turns mere chance into events (Latouche in Zardini 2005, 94–116 and Pressman 128–141).

Water

> Despite the difficulties or the disasters it might have caused . . . the flood of January 1955 partook of festivity far more than of catastrophe . . . it is the little boat, the superlative toy of the childhood universe which has become the possessive mode of this arranged, outspread and no longer rooted space . . .
>
> BARTHES 1979

Tragedy and comedy converged in Paris. But floods were sometimes contrived, as in Rome's Piazza Navona, turned into ludic use every summer up to 1867, unwittingly recalling the former racecourse. This was aristocratic play: grand carriages turning in circles as in the carousel, the public confined to the edges, enjoying not only the suspension of civic convention but also a temperate atmosphere, until an unfortunate manipulation of the ground profiles jeopardized their ability to hold water.

Fire hydrants induced a modern, albeit ordinary, expression of these pleasures, their occasionally authorized ludic use causing impromptu festivals. Much relished by photographers, these were, in the words of Claes Oldenburg, 'public monuments, full of water and about to explode' (Ward 1990 1978, 77–78). Controlled summer flooding was implemented for recreational

FIGURE 54 *Piazza Navona flooded, Rome, 1827. Drawing by the author after Jean Baptiste Thomas.*

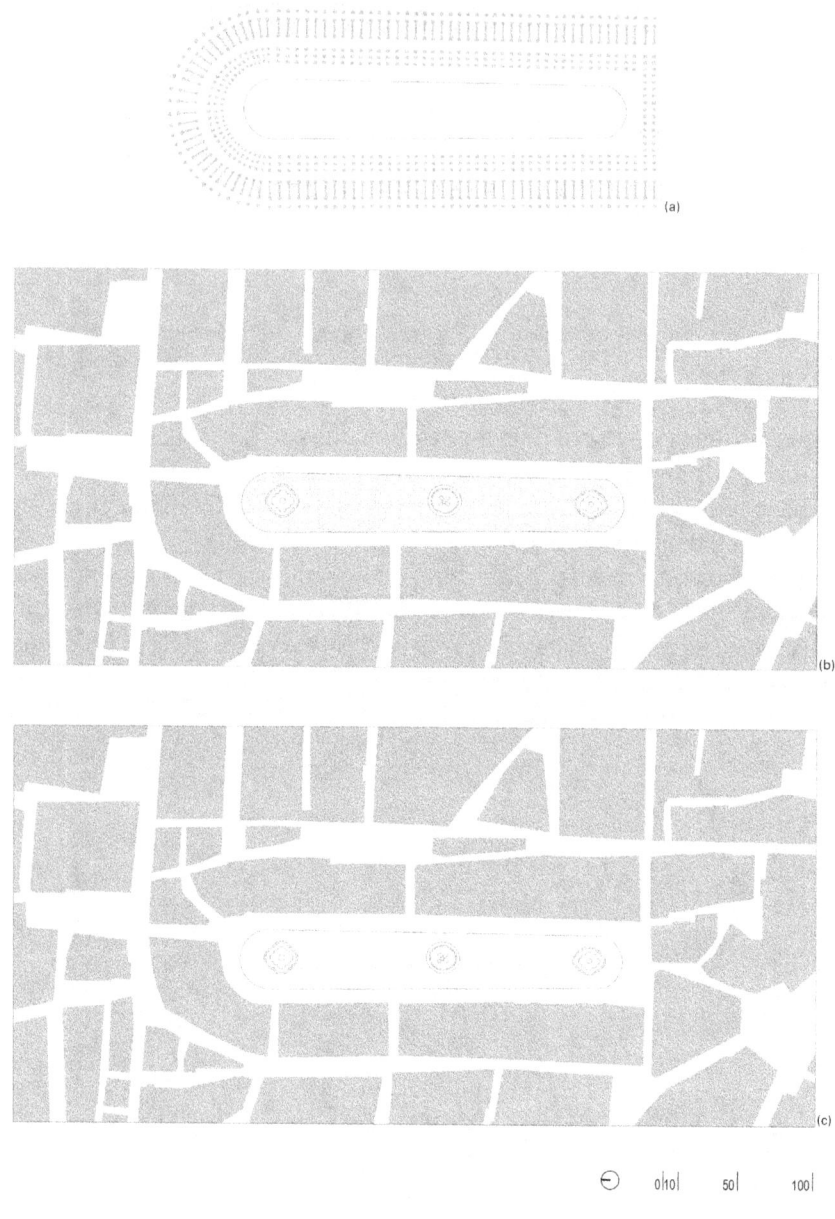

FIGURE 55 *Ludic mutations in the urban arena. Three identities of Piazza Navona: (a) as a racecourse (Campus Agonis); (b) the flooded square; (c) in its current shape. Drawing by the author.*

purposes by the Police Athletic League in 1970s New York. Water was brought into the scene unexpectedly as it were, modifying space, social behaviour, sonority and temperature, its urban presence suspending the compass of everyday life. Ward observed how similar rituals were performed in the suburbs with the aid of water hoses, but in the privacy of backyards.

These urban events faintly recalled seaside resorts, the ultimate water playground. First appreciated for their therapeutic uses and later for leisure and hedonism, beaches eventually became prime ludic arenas. Much like flotsam, their ancillary artefacts drifted between water and dry sand as the uses of the beach were reappraised: eighteenth-century bathing machines gave way to bathing in public and eventually to swimming. Beach houses gave way to tents and huts that provided seasonal shelter whilst wind and sun shades tempered the elements (their effects alternatively perceived as benign or noxious). Following mandatory holidays and improved modes of transport, multitudes reached the shores. Bathing costumes became suppler, lighter and minimal. Eventually, modern noble savages freely deported on sand and water until seaside resorts shed their conception of spas. These recreational uses were highly featured in twentieth-century urban agendas: some salient cases will allow us to examine the most relevant trends.

Public swimming pools compensated the diminishing access to clean water in such places where massive infrastructures and polluted streams inhibited recreational use. Water itself changed: Illich recalls how treatment turned it colourless, odourless and flavourless, inducing citizens to expect these properties as 'natural', where before they would have gladly accepted it cloudy (Illich 1985). Techno-manipulation of water and lawns (turned into ultra-manicured, homogenized and ultimately synthetic pastures) shared an aseptic element. Water's technical enhanced transparency was not a minor stimulus for play, as conveyed for example, in David Hockney's crystalline pools, with a perfect sight of bathers plunged in the depths, in contrast with earlier appreciations about the chromatic richness of murky ponds.[3]

Swimming changed too: Rasmussen observed that for centuries:

> swimming bore the stamp of military drill. In contrast to walking it was a symmetrical form of motion. Leisurely modes gained predominance with relaxed body postures anticipating the extraordinary fluidity of the modern swimmer who sported the rolling, uninterrupted, asymmetrical motion of the crawl introduced in the west from the South Sea Islands

Free style swimming captured that sporting dimension of the informal that rescued it from gymnastics whilst formal swimming led on to rectangular pools, with the swimmers drifting between casual and athletic demeanours.

Rhythms bore a strong impact upon architectural and urban matters. In Rasmussen's view, the frozen rhythms of Rome's Spanish Steps accounted for particular upper-class minuet-like contortions. Steps were thus tailored to a particular gait. But they too were affected by change gradually evolving 'from a rigid frontal style to a more plastic one'. Rasmussen drew parallels between painting with Tintoretto's figures that seem to float through space in a weird gliding manner and the swimming pool design by Italian architect Giulio Minoletti that seemed to encapsulate a very similar rhythm (Rasmussen 1959, 148–149).

Over the twentieth century, collective swimming pools were inscribed in parks, sports complexes, clubs, schools and shores. As prime suppliers of recreation, these overhauled former preconceptions about health and hygiene. Predominantly developed in the outdoors, they literally brought fresh air into swimming. Thus, for example, in the heyday of collective swimming, notwithstanding the notoriously unpredictable weather patterns, London featured sixty-eight public 'Lidos' (Smith 2005). Some pools were visually integrated with their surrounds; others were hemmed in stadia. There were floating swimming pools (of which Paris exhibits two) and pools embedded in sand beaches. These offered sea water and occasionally temperate baths too, as if claiming superiority over nature.

The gradual appraisal to the shore such as afforded by these encapsulated waters was in tune with evolving perceptions about sea water, with its earlier medical overtones substituted by the dominance of the ludic. When marooned

FIGURE 56 *Confined swimming in the sea-water pool at Miami, Florida, c. 1920. Drawing by the author after postcard.*

on the beach these colossal structures sheltered domesticated water in sight of the endless expanse. Differentiated localities for players and public enhanced their theatricality. Needless to say, once the open sea became the preferred bathing destination, seaside pools were largely abandoned. Replicated in quite diverse scenarios, the format included such charged urban propositions as Villanueva's 1944–1970 University swimming stadia in Caracas.

Swimming pools also betray the contrasts of *Ludus* and *Paideia*. Aside from demarcating children and adult areas, competition requirements led on to precise rectangular formats that were easily subdivided in bands. 'Free form' pools reflected casual swimming, with pleasure rather than training as the main objective.

Ever so conscious of dialectics, Le Corbusier evolved a binary scheme, which he applied to several projects: its outline featuring one rectangular side, the other kidney like, interconnected as if competition alternated with layabout swimming and splashing.

Embracing the leisurely mode, Noguchi's sculptural pool for Neutra's 1935 Von Sternberg house in Los Angeles featured soft outlines, and subtly inclined planes all washed by a thin layer of water. The aforementioned Minoletti's 1951 mosaic clad Monza pool with its viewing portholes and underwater sculpture, more a landscape than an object, displayed similar patterns. Indeed, the garden status of the pool could be just as problematic as the playing field's: concerned about their increasing spatial and programmatic impact upon private Californian gardens, landscape architect Thomas Church set himself to devise intelligent modes of integration (Church 1955: 215, 223).[4]

FIGURE 57 *Ludus and paideia in Corbusier's binary pool scheme. Drawing by the author.*

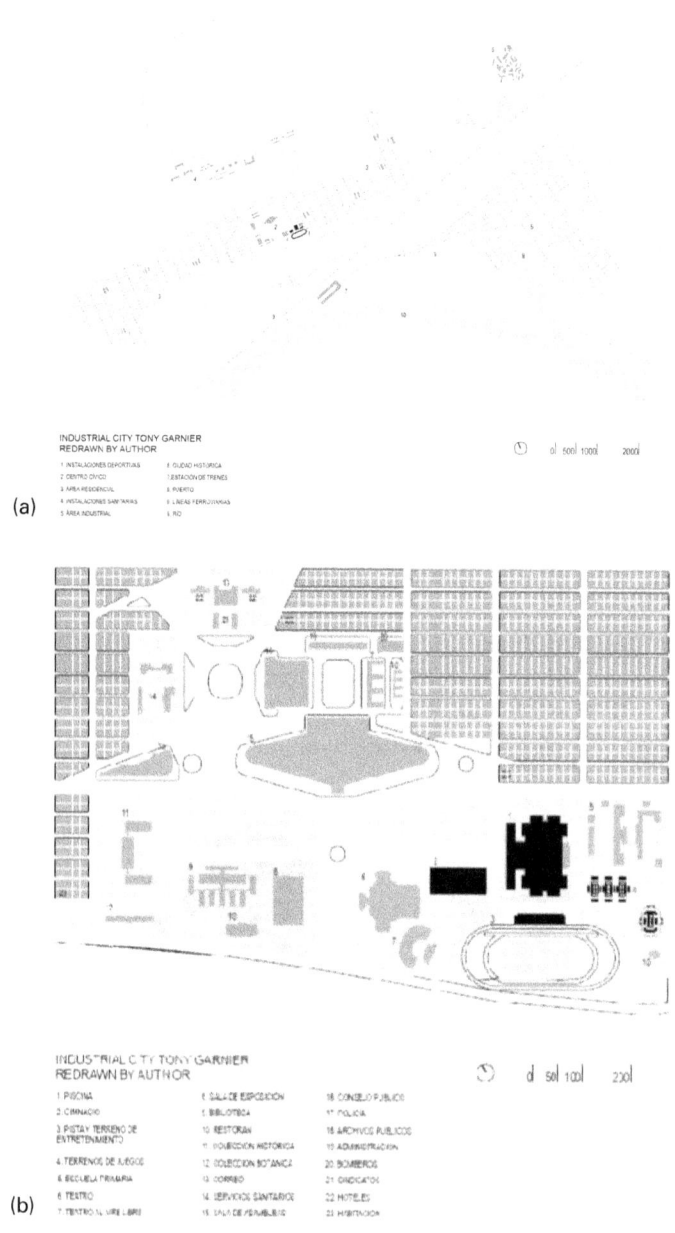

FIGURE 58 *Tony Garnier's (a) civic and (b) ludic ensemble at the Cité Industrielle. Drawing by the author after Garnier's.*

Indoor establishments also proliferated, the earlier ones exuding an impressive feel of gravitas: Garnier's 1901–1917 *Cité Industrielle* colossal baths surmounted by vast cupolas recalled imperial times.

On a lesser scale, Atelier Nikolski's 1928 Leningrad pool featured a transparent and retractable cupola conceived as if a lid over a tray; both catered for industrial labourers. No doubt, aside from their memorable spatial quality so strongly associated to ritual, scale, light and acoustics would have concurred

FIGURE 59 *Atelier Nikolsky, 1928, swimming pool, Leningrad. Drawing by the author after Nikolsky.*

FIGURE 60 *H. A. Brown: Weston-super-Mare springboard, 1937. Drawing by the author after Janet Smith's 'Liquid Assets'.*

to remarkable effect. But pools could also assume discreet urban presences: sheltered underneath stepped ranks of apartments Henry Sauvage rendered it secret in his 1912 rue Vavin housing, Paris. Owen William's 1937 Peckam Health Centre in London compressed the wet and dry areas within a tight rectangular interior, where the sight of eager parents watching the progress of their progeny from comfortable settees suggested the fusion of theatre and pool. Such enraptured attention waned as swimming became commonplace, but it held strong in the era of the public establishment, with diving boards – instruments of leisure or indoctrination – commanding all attention.[5]

Once defined as 'the art of entering the water in a graceful manner', the instinct of diving summons risk, the intoxication of the free fall, and the exercise of supreme control at the verge of chaos. It clearly belongs with *Ilinx*, yet because it admits rules, it does also fit the concept of *Ludus*.[6]

As if fusing action and form, the diving tower formalizes the hiatus that separates diver from water, the apparatus being at once an implement (that sets determined heights, organizes the performance, supports the bodies, and gives leverage to the springing motions) and a stage that highlights the drama. Its design allows formal tolerance with regard to the support structures, whilst disallowing dimensional tolerance with regard to the height, form and dimension of its springboards, thus it embodies an equation between the unique and the generic that yielded a great variety of forms. By virtue of their emplacement and scale, these sculptural contraptions enjoyed a robust presence in the landscape whilst holding minute figures as if they were just monumental plinths. Their exacting design followed performative requirements, but a diversity of supports imbued springboards with identity. However, such large and impressive structures so embedded in ritual overtones were only justified in well attended public settings.

Diving boards often loomed over collective swimming arenas, sometimes over remarkable water stadia, but these monumental structures also rose over sea beds, as if arising straight from the ocean, exuding drama in ways not altogether different to the proscenia conceived at the height of Russian Constructivism. Highly conspicuous, these vertical figures equally tested structural possibilities as if celebrating the cantilever, in itself an icon of technical achievement.[7]

This was the case with the no longer extant 1937 Icarai springboard, a magnificent tiered fabric that arose by the shores of Niteroi, in Guanabara Bay, Rio. Standing between beach and horizon its scaffold must have supported ever changing scenes. Nervi's Castel Fusano's board in Ostia was mounted over a large circular frame with comparable impact over the landscape. Most have disappeared; their destruction fuelled, no doubt, by contemporary anxieties about liabilities. Gone are the visual foci, the violent splashes, the confrontation of swimmers and idlers, and the heroic deeds by the sea.

FIGURE 61 *(a) Castel Fusano, Ostia, diving board designed by Nervi; (b) Icarai Board in Niteroi, Rio de Janeiro. Drawings by the author (a) after Ortner, (b) after uncredited photo.*

Once regarded as tokens of Hollywood's opulence, private pools were eventually incorporated in middle-class houses. Henceforth the element of theatre declined, together with the privatization of swimming. Diving towers eventually retreated from public scenarios, whilst the expert advice on pool complexes loaded them with ancillary facilities and ad hoc requirements (as suggested in mid-century manuals) until almost stifling the ludic call: Ortner's 1957 sport manual illustrated the case.

FIGURE 62 *Swimming overloaded with ancillary programmes as recommended in Ortner's manual. Drawing by the author after Ortner.*

MATERIALS 95

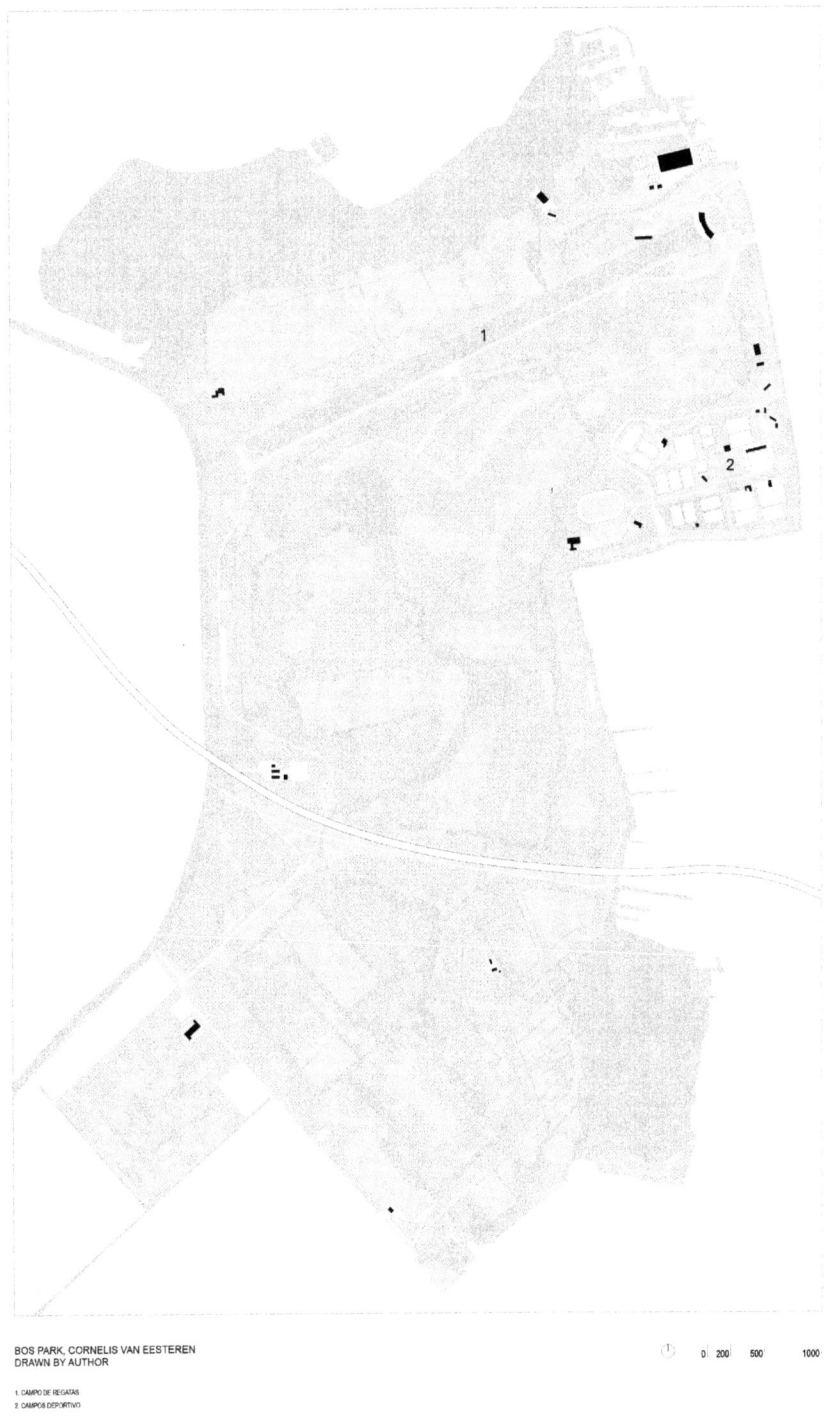

FIGURE 63 *Baroque scale in the rowing pool, Bos Park, Amsterdam (Corneus van Eesteren). (1) Rowing pool; (2) sports field. Drawing by the author.*

4

Locational attributes

Orientation

In play, orientation admits two perspectives. A practical one relates to the solar path, purportedly guaranteeing equal playing conditions, for in setting the field along a north–south axis, no matter which emplacement is chosen, excessive glare is averted (deviations of ten degrees in relation to due north are admitted). The conceptual one arises from considering orientation in itself as ludic challenge, a psychological and strategic inducement to play whose ultimate expression is the labyrinth.

Setting the field's orientation and the alternation of sides were essential to the passage from casual pastimes into sport. The ensuing urban results were noteworthy: as if trapped within a magnetic range, playing fields aligned with the compass, recalling ritual layouts, except that their Canon sprang from practical, instead of metaphysical criteria.

FIGURE 64 *(a) Instructions for orientation in football pitches; (b) the conception of a quadrangular pattern. Drawings by author after Ortner.*

In his manual, Ortner indicated tolerable deviations (prevailing winds justified departure from the norm). Moreover, he conceived an odd 'quadrangular football pitch' whose main advantage was ameliorating the degradation of the lawn. Cosmic and meteorological criteria converged with practical stewardship in defining optimal orientations (Ortner 1957).

A comparison of London's 1666 survey of the Great Fire with Le Corbusier's 1956 Meaux master plan reveals deliberate patterns of alignment. Following tradition, these accorded in London with church nave apses oriented due east. Orientation literally signified facing the Orient (sunrise, the holy lands). This regular pattern, hitherto embedded in a complex urban structure, was made

FIGURE 65 *(a) Metaphysical and secular alignments of churches after the fire of London; (b) Le Corbusier master plan for Meaux, 1956 (notice the binary swimming pools). Drawing by the author after Le Corbusier.*

visible once the fire released the masonry structures from the haphazard mass of urban matter. Had the London churches been placed upon an open field, these would have looked not unlike early modern housing blocks. Their orientation was in stark contrast with the medieval maze of streets as if they alone carried a superior principle of order.

This superior order was embedded In Le Corbusier's lyrical vision where buildings followed the course of the sun, each apartment blessed with its benefits. As with ranks of tombstones, they all shared alignments, regardless of status, hierarchy or function.[1] If one were to show its sports fields isolated in the ground, the pattern of orientation would be just corroborated for they followed identical axes.

In no time, sports fields and mainstream modern housing blocks aligned with the path of the sun, thus engendering highly structured complexes ruled by practical criteria and – in the case of the blocks – by heliotherapy, as if buildings, particularly residential, but also educational and health ones, became solar instruments.[2] Whilst these luminous principles held, fields and urban plans correlated. Their synchronicity coincided with the increasing popularity of sport and the primacy assigned to it in the conception of a new habitat. Orientation became in these ensembles both a result of layout and emplacement, for it was ruled as we have seen by the solar path and in the case of the modern project by a desire for spatial intelligibility.

If orientation fixed thus the alignment of sports fields, disorientation also became a tenable ludic principle.

In ludic terms, disorientation plays with the loss of sight or balance: it is a way of altering the familiar, releasing ludic potentials out of outworn routines.

FIGURE 66 *Principles of disorientation in a labyrinth, Pompeii. Drawing by the author.*

To this purpose it can follow diverse strategies: one can lose one's bearings in the thicket of a forest, that through its density and inherent complexity becomes bewildering; one can alternatively envision a matrix of visually unintelligible paths as with the labyrinth, or one can technically induce dense fog until occluding vision.[3] One can induce pitch darkness for ludic purposes, or one can stimulate disorientation through vertiginous movement, beckoning the dizzy effects of *Ilinx*. One can also tamper with people's sight through blindfolding for the sake of playing. Disorientation turns the ordinary hazardous, and hazards, as we have seen, easily accommodate the conceptual fabric of play.

Educator Maria Montessori devised certain exercises where blindfolding became a method for the apprehension of tactile properties. Isolating sight from tact, she activated an intimacy with objects for educational aims. Thus conceived, the loss of sight was purposeful, and circumstantial, just a game. Somewhat coinciding with her analysis and pointing into the domain of play, art critic Josipovici deemed it necessary to restore our full bearings in a world where the visual seems to reign unchallenged . . . 'What does it mean to possess a touch in the field?', he asked, 'it means possessing a distinct perception about the ball's trajectory and speed and also knowing by instinct how to place ourselves to intercept it' (Josipovici 1997). Touching and caressing were means for an understanding of the world beyond appearances. As with play, the suppression of sight stimulated an enhanced sense of the tactile, together with an arousal of a general curiosity about things felt through manipulation. Montessori blindfolding exercises were destined to elevate the understanding of things through the use of the hands. The loss of sight thus became relevant both to the acquisition of experience and the pursuit of pleasure.

Too far removed from the certainties of a rational order, the ludic principle of disorientation rarely made it into mainstream ludic agendas. Maybe it recalled undesirable experiences brought by war, poverty or dilapidation, but it surely conspired against intelligibility, a prized asset to the rational minds. Aside from the Situationists – who despised rational thought – and the captains of the leisure industry, who saw in it a powerful lure for profit as in the fairground, it gained no relevant ascendancy in the conception of the new sites for play.

The deadly effects of massive Cartesian compounds prompted Aldo Van Eyck, however, to elaborate upon the paradoxical notion of a *labyrinthine clarity*, a state of matters that without relinquishing rationality made room for accrued complexity, casualness, and even a measure of disorder: . . . 'such clarity [ally of significant ambiguity]' . . . he said, . . . 'softens the edges of time and space and transcends visibility . . . it is kaleidoscopic . . . it harbours bountiful qualities . . . [it offers] scope for. . .the right certainty, the right suspense, the right security, the right surprise'[4] (Van Eyck 2008, 402,403). This was just one shift in relation to preceding urban paradigms, eventually leading

Smithson to articulate the notion of *conglomerate order*. It is not a coincidence that in their minds the figure of the athlete and the ideals of sport, formerly so pregnant, gave way to an intense focus upon the ludic horizons of childhood. But Constant Nieuwenhuys led Labyrinths to become urban models.

Labyrinth courses are conceived so as to blur at any event the intelligibility of the field, with their horizons occluded, their ground surfaces and lateral boundaries brought to a monotonous uniformity, such as to preclude any grasp of progress, their layouts unprecedented so as to challenge the player anew. Nothing can betray orientation. As if a tightly packed knot of human intestines, labyrinthine paths banish any depth of field, for one plays in them primarily *against* the field. As each path turns upon itself, these embody a particular logic about compactness.

Homogenous and featureless, the horizontal plane – that obviates the topographic 'accident' – offers the best conditions for disorientation. Their plan, which is quite ornamental, is the harbinger of all secrets, and must therefore never be inferred.

Adaptations

Bale observed that alternate 'waves of confinement' and 'spatial release' made field, court and indoor settings change places. Play also migrated, often following colonial ventures, aside from iterating between bounded and unbounded terrains, the indoors and the outdoors. It thus encountered unprecedented ecologies, costumes and landscapes. Moreover, fields of the cultivated type were often required to retain their original planting, thus facing unprecedented ecological challenges. The nostalgia of the meadow could be distinctly perceived in many a field.

We are concerned here not so much with the internal metabolism of play such as evinced in the splitting of association football and rugby from a shared origin, as it occurred in 1860s England, but with spatial and architectural mechanisms that smooth the encounter between a given form of play and a sometimes difficult, or even downright adverse scenario. From an architectural perspective, adaptation represents the transformation of that scenario into an arena.

This mechanism accounts for a huge investment in ingenuity spent in tailoring a given field to suit unforeseen spatial and material conditions. It does not equally affect all ludic types, for as we have seen, the procedure is quite innate to *Paideia*, whose horizon nurtured by chance, assumes an always renewed contract with the here and now. But it does affect *Ludus* whose uncompromising fabric is usually described by the 'level field', a graspable condition, also a rhetorical trope that accounts for fair interchanges. Harnessed

by geometries, the field cannot but transcend particularities. Being so, its adaptation becomes a surgical procedure.

Following a seemingly teleological destiny, the global dissemination of ruled games requires the homologating of the arenas. It is one thing, however, to amplify the scope of certain competitive games according to a standard that ensures equal conditions regardless of climate, altitude, latitude, or local circumstances, and it is quite another to reconstruct the integrity of a playing field through the fabrication of a replica. The same applies to the grafting of play structures on to adverse urban sites, an occurrence that became almost normative in cities, as from the nineteenth century, with their massive retrofitting of fields. The recourse to adaptations was widespread: but adaptations in play only work within the bounds of the rule, with tolerance privative to each game; so, soccer for example, admits alternative dimensions. Not so in tennis, where alternative ground materials are admissible. However, as pointed out by Caillois, communicating vessels link *Ludus* to *Paideia*; the former reaches *Paideia* through sheer degradation whereas the latter meets *Ludus* through the acquisition of a legal corpus. These pliable frontiers eventually nurture unprecedented ludic propositions.

When limits are trespassed, the original game simply gives way to novel ludic formulae. We have seen how indoor tennis (or royal tennis as it was named), was first conceived as a kind of three-dimensional snooker, to be rearticulated around the ludic possibilities afforded by a flat ground and suppler implements. The arena turned minimal, thus consummating that trend towards abstraction that eventually became a benchmark. Play rules were accordingly adjusted.

But fields consolidate into templates, thus thoroughly excluding design. Design choices are then merely circumscribed to the manner of their mediations: how to fashion the interfaces of these generic templates with the particular spaces of 'ordinary life'. This was the scenario confronted by architects in the early 1920s, when most popular sports had already accrued stable design requirements. The inscription of these arenas atop buildings was not altogether unusual.

We have already examined how in the hunt certain ludic conventions were adapted to local conditions. At the risk of breaking the rules, either the game was adapted to suit the circumstances, or else the arena was recast to satisfy the rules. Confronted for historical reasons with a bare landscape and a menial quarry, the English gentry resorted to adaptive tactics, by adding and subtracting ingredients to and from the practice of the hunt while retaining the integrity of certain elements deemed essential to it, such as its hierarchical base, the frantic chase, the music apparel, and the pack of hounds. The game became in large measure a product of the landscape, an unusual occurrence for *Ludus*. English rural patterns characterized by subdivisions, dry stone

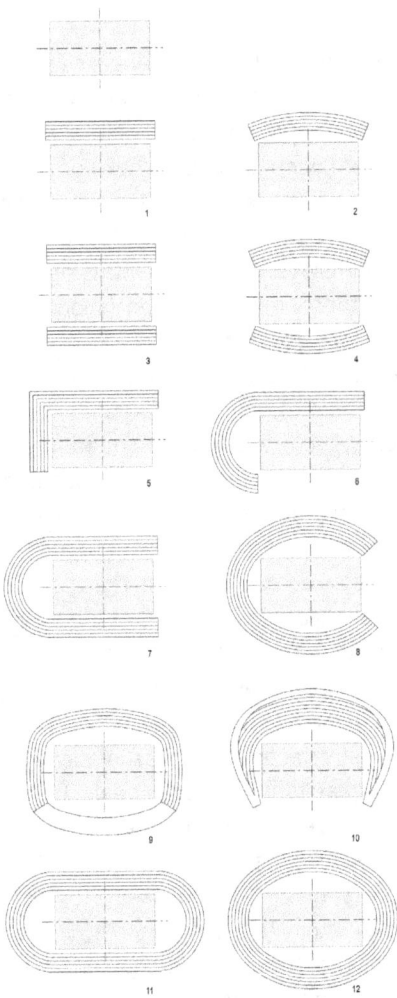

FIGURE 67 *Mediations: (a) alternative seating arrangements on stadia according to Ortner; (b) Le Corbusier's conception of a versatile stadium for 100,000 people. Drawings by the author after Otner (a) and Le Corbusier (b).*

walling and hedges led the adaptation, whereas the French adapted the field – nominally a wilderness – through surgical felling of trees until they attained a geometrical matrix of corridors and round points. Play is rarely indifferent to landscape, but its communion occurs in different guises: as an agent of landscape formation or else as a seeker of ludic potentials.

Whilst it becomes the most fertile terrain for the evolution of games, the modern city exhibits all manner of ludic adaptations. High densities and land values fuel, amongst others, miniaturization (such as implemented in baby football where accelerated rhythms and an incremented promiscuity that somewhat complicates the action compensate for a diminutive field), decomposition (for example in golf driving ranges) or geometric adjustment (such as in geometrically 'incorrect' fields). Indeed, the latter is widespread in awkward sites where the issue is neither compositional nor aesthetic, but performative. Besides empirical adjustments to site, the licence taken as regards the rules in so many popular venues suggests a reaction against an unduly over-regulated status; be that as it may, as if describing history in reverse gear, this kind of adaptation draws *Ludus* closer to a pre-rational state.

We will examine further this broad unofficial territory which challenges strict polarities (*Ludus/Paideia*) whilst infusing cities with plentiful – and largely uncharted- – 'incorrect' ludic arenas.

Something like natural selection operates in adaptive tactics, however, as any slack in the drama results in loss of appeal. Bastard progenies may not prosper unless finding an irresistible ludic cue.

Moreover, urban pressures also lead on to vertical stacking and functional mix. McKim, Mead and White's 1918 *Racket and Tennis Club* in Manhattan lodged the sports field within the gentlemen's club with squash and royal tennis courts, a gymnasium, a swimming pool, and traditional saloon games, receptions and ancillary areas, all inscribed within the compact format of the palazzo. Compositional ploys allowed the architects to conceal these arenas from the classical facades. Only the air view betrayed the attic structure of top-lit tennis and racket courts. Its multi-storey format inaugurated a compact ludic ensemble. Skyscrapers led on to radical stacking modes. In the lineage of the *Hybrid Building* (Hall 1985), Starret and van Vleck 1930s Downtown Athletic Club, which was also in New York, combined mixed ludic functions in compact clusters within the confinement of the high rise. The ensemble somewhat recalled the combinatory logics of Adolph Loos' *Raumplan*.[5] In this tower, so elevated into prominence by Koolhaas, diverse game rooms cohabited with an indoor golf course, swimming pool, squash courts, gymnasia, hotel accommodation, and assorted functions. Through grading and *trompe-l'oeil*, the golf course, that quintessential pastoral landscape, was refashioned to meet the structural, atmospheric, and dimensional characteristics of confinement. Its deviation from the normative

was inconsequential in comparison with its contribution by way of renewed vitality to the metropolitan club. For all of its ingenuity, however, the indifference towards the surroundings rendered the experience autistic. Others choose to acknowledge the environs. Conceived as a virtual acropolis, the rooftop recreation grounds in Le Corbusier's 1948 *Unité d'habitation de grandeur conforme* established sublime rapports with mountains and the horizon.

Repetition, the alternative to stratification, characterized such multi-storey playing grounds as Bo Bardi's 1977–1982 SESC Pompeia, a most effective social condenser raised amidst a dense industrial complex in Sao Paulo, with its four level fields stacked over a swimming pool, all connected to an access service and practice room tower. Bo Bardi extracted as much plastic value as possible from the dry, geometric multipurpose fields, endowing each one with a chromatic palette inspired by the seasons. Her purported agenda of 'preserving the factory image in order to subvert it' highlights the associations of sport and industrial production. By the foot of the blocks, a linear deck doubles as a synthetic beach. Its programmatic assembly of theatre, workshops, libraries and sport arenas recalls ancient Greek precedents.

If the stacking-up of fields is one answer to an economy of space, its horizontal correlation is the multipurpose field. The superimposition of diverse fields upon a shared ground through the expedient of graphic demarcations is

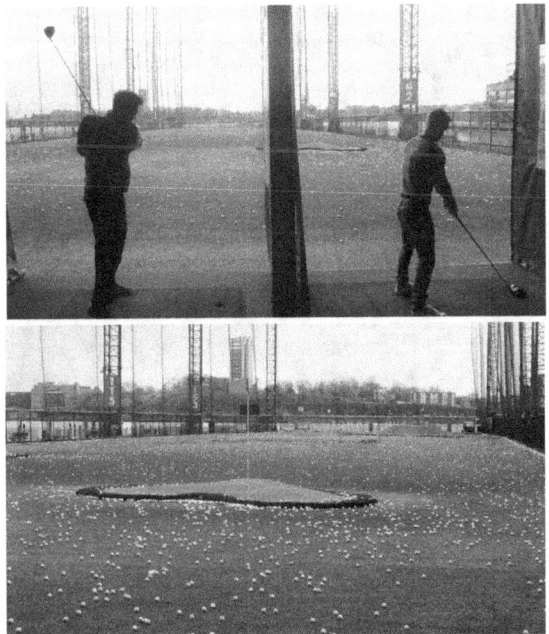

FIGURE 68 *Training at the golf driving ranges on Pier 66, Manhattan. Photos by the author.*

a remarkable modern trait. It triggers complex perceptual responses in the minds of players who must select the relevant indication in the gist of the action. These tattooed-like patterns captured the attention of Ed Ruscha. These palimpsests welcome cycles of activity, one game followed by a different one. Similar conceptions about space economy led on to drawing running tracks around soccer fields, a combined matrix that soon became a convention.

Decomposition that isolates motions, or certain parts of a game for the purpose of training, is an alternative strategy. It is true, however, that *training*, which is essentially instrumental, differs from *playing*, in the exclusion of the elements of contest and uncertainty, but probably the vast majority of practitioners find such difference inconsequential for training possess perhaps a residual-ludic interest of its own.

Golf's driving ranges construe such experiences by means of a vicarious ground. Players usually share parallel ranks on superimposed decks. Confronted with a vast and inaccessible field, they relentlessly score against a portion of air space. The air netting makes for memorable urban silhouettes whilst astro-turf carpets laid over the grounds vaguely evoke the course. Drawn toward the novelty of Tokyo's 'shameless spatial compositions', Kaijima, Kuroda and Tsukamoto revealed surprising adaptations of the driving range to extremely restrictive site conditions (Kaijima et al. 2006). Such light, airy and somewhat monumental profiles came to characterize numerous districts in the Japanese conurbations.[6]

FIGURE 69 *Domestic training in Maria Montessori's exercises on personal care. Drawing by the author.*

This sort of regressive Taylorism confines simple actions to restricted spaces whilst resorting to conveyor-belt mechanisms designed so as to aid fitness. Similar procedures led Maria Montessori on to the creation of specific tools for pedagogic reasons, such as an artefact destined to teach buttoning up, another one fastening, as if removing these daily chores from their proper context for the purpose of training. As if articulating mechanisms with methodologies, the gym gathers by-products of the fun fair, the factory and the Victorian prison, submitting them to scientific management principles. That only highly rationalized activities can be so deconstructed, confirms again the liaisons of modern sport with industrial production.

At the zenith of mechanization, a landscape of play apparatus fills the space of the gym supporting varied training needs. Solving the dilemma implicit in how to cover large stretches whilst keeping stationary, or else, how to train for summer sports in winter, contrivances were devised for swimming and rowing. Resorting to the same logic of treadmills that once served as punishing devices, these demanded all the efforts associated with motion, by a static mechanical ensemble. In strict adherence to play's unproductive principle, spent energy did not result in movement or productivity.

Current-resistance lap pools and stationary rowing pontoons recreated industrial similes. However, in terms of leisure, discipline, rhythmic motions and the principle of hierarchy reigned as much as these once did on the industrial floor.

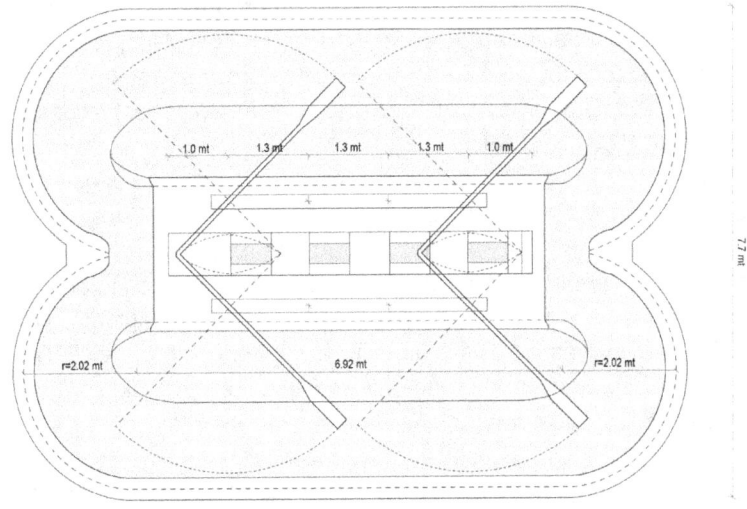

ROWING BILATERAL TRAINING POOL

FIGURE 70 *Training pontoons. Drawing by the author after Ortner.*

These endeavours that share the substitution of the field for the apparatus are characterized by earnestness rather than joy, but their ludic value can only be judged by the players.

In their kaleidoscopic variety, playing fields exhibit diverse commitments to site or landscape, for some veer towards the abstract, whilst a few embrace landscapes in all their complexity, as previously seen. Golf is unique amongst sports in claiming landscape as an element in its conception, and in begetting landscapes in the large scale (eighteen-hole courses require about sixty hectares in Neufert's estimate). In golf one plays *with the land*, for the game demands an acute tactical awareness as to the particulars of the terrain including its atmospherics. Its sequential format usually precludes a full command over the field. It is also particular in eschewing the Cartesian pattern common to so many sports, and in embracing in all propriety the aesthetic of the picturesque, one of 'accidents' instead of norms.

In its fine sensibility, this game exhibits a myriad of adaptations to geographic displacement, thus celebrating the outdoors in an almost unmatched mode.

Imbued with 'informality', its landscape idiom was in tune with the spirit of the times, and yet it never became an icon of modernity It is true, its settings were (and still are) mostly suburban, also, notwithstanding exceptions, its practice exuded privilege; moreover, it did not convene multitudes: these circumstances may account for its lack of appeal to those designers and thinkers engrossed in the collective ethos. Despite its evident appeal, the subject was largely shunned by modern urban discourses. Its rebuff can be added to those equally ignored North American products of modernity (for it was in the USA where its presence became really widespread). Koolhaas classes these as alternatives to the mostly European master narratives; innovative products of empirical minds that lacked the intellectual bearings of the manifesto (Koolhaas 1994).

Whatever its reception by the learned establishment, it gained great acceptance worldwide: a district bears its name in Santiago, Chile (first hosted in the hippodrome by 1911, the club migrated to it by 1934), whilst a course designed by the Olmsted brothers in 1928 threads smoothly through Caracas's most distinguished neighbourhood. Today, it is a global symbol of the good life as witnessed by a course in Giza (a stone's throw away from the Great Pyramids), and another one at the apex of the Lido, Venice (an unexpected landscape contribution to the archipelago). In no time, variations about golf condominiums spread wide and fast.

We have already examined the course's pliability; we will examine its particular modes of territorial and urban inscription later, but first we will assess its adaptability to soil and climate. The game, it has been stated, 'differs from [others] in not having the ground mapped out with a precise regularity'

FIGURE 71 *Augusta National Golf Club, Georgia: (a) the field as a sequential entanglement of fairways, (b) evolving patterns 1934–present. Drawings by the author.*

(Withered 1929). Its field allows for design latitude and yet its material fabric responds to moist climates. How does it accommodate adverse climatic conditions when migrating?

Golf's formal origins are credited to the shores of St Andrews, Scotland, with its striated pattern of small ridges and hollows; for it was there that the old pastime accrued rules. Described as 'link lands', these geological formations result from the gradual accumulation of blown sand by the shores in roughly parallel linear strips, with short grass growing in the hollows and long grasses over the ridges. These eventually led to the conception of 'fairways' and 'rough'. Moreover, 'links' came to represent 'a large area of open land upon which golf is played', thus keeping in memory the source: what is particular to golf is that its spatial and material schemata emerged from these natural patterns. As pointed out by Price:

> since the game of golf had developed almost entirely on coastal links land up until 1880 . . . it is not surprising that on many of the island courses at least some of the characteristics of those links were transported to inland sites. Specifically, . . . sand filled bunkers became a part of the inland golfing landscape even if . . . entirely artificial . . . A golf course . . . character is largely influenced by the physical environment of its particular location:

rocks, landforms, soil, vegetation and weather. Many of Scotland's golf courses were laid out before mechanical earth moving equipment was available, and therefore tend to incorporate . . . natural features.

PRICE 1989

To this topographic and geological description, he adds taxonomy based on vegetation, comprising *woodland, parkland, moorland* and *links.* Together these account for an extraordinary palette that lures players to choose sites with the finesse of wine-tasters. Of late development, the landscaped course became an archetype, albeit with distinct spatially sheltered sequences, in contrast to the original bareness. If the soccer field faintly recalls a common pasture, the matrix – if not the look – of the golf course recalls the landscape traits of St Andrews. But this fixation with origins did not preclude variety; quite the contrary, if in the making of the soccer field the eradication of local traits becomes a must, in the golf course these are often negotiated by landscape professionals who manage topography, water and plant material, with the fabrication of impediments thus turning each course into a unique experience, that nevertheless retains certain traits about the coastal link lands.

Introduced in the United States by 1888, golf acquired immense popularity. Games were originally played in agricultural meadows (Scott Jenkins 1994, 1999). Its post-war dissemination over vastly dissimilar territorial conditions confronted varied ecologies. What happened when confronting arid conditions?

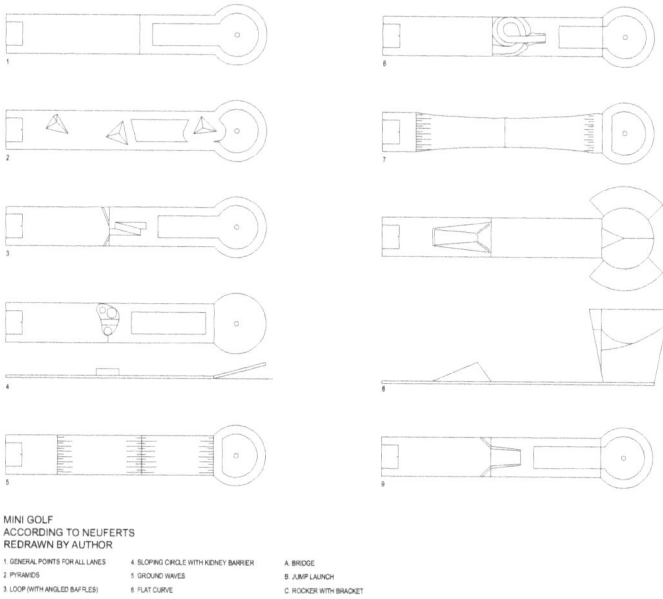

FIGURE 72 *Patterns of minigolf. Drawings by the author after Neufert.*

By the early 1920s Frank Lloyd Wright foresaw the destiny of Scottsdale, Sonora, becoming 'the playground for the United States', whilst he dreaded the massive onslaught into the unspoiled landscapes.[7] Golf's agency did in fact turn the economies of the 'sun states', supplying gradients of greenery in the making of the ludic landscape. Similarly, other latitudes required matching the atmosphere of the landscaped course with the harsh reality of water scarcity, barren ground, and poor soils.

Drought-resistant grass and drip irrigation came to the aid of golf in arid zones, its lawns becoming in great measure a technological product. The introduction of astro-turf represents another flank in the adaptations, literally materializing the 'green carpet'. Besides aesthetic considerations, all material substitutes created vicarious ludic environments with the sort of artificiality usually associated with urban conditions.

What then if vegetation was altogether banned? Certain courses in the Atacama Desert, Chile, feature none whatsoever, exposing instead a landscape of abstract figures, etched upon the naked earth. Devoid of verticality, and much like geoglyphs, these fields possess just ground surfaces. Sparse inscriptions such as ground markings or ranks of aligned stones replace planting, thus circumscribing 'ponds' or 'rough'. Smooth oiled patches stand for 'greens' or 'tees' so that metaphors effectively substitute the expected features. These unobtrusive courses hide no corners, so that in them the game's progressive stepping-stone protocol – one prospect after another – does not deliver surprises. Topography and geometric demarcations are the

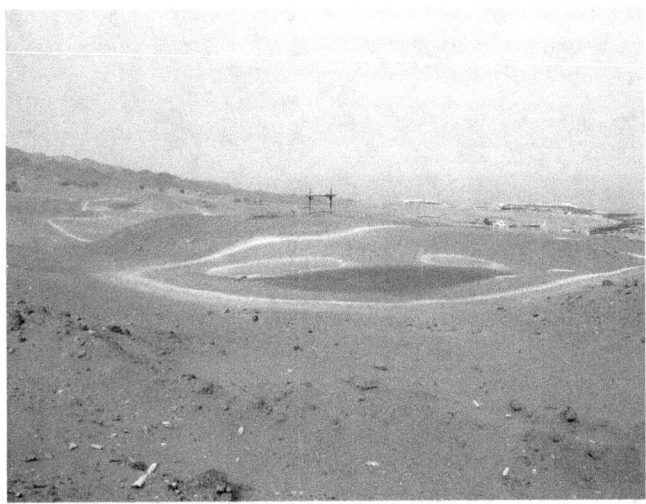

FIGURE 73 *The barren golf course in the Atacama Desert, Chile. Photo by the author.*

only vestiges retained from the landscaped course. It is useful to remember, however, that visual progression was accrued over time, a gradual displacement from the bleakness of St Andrews into the dense body of the park. Was the essential quality of the game betrayed? Or, was this particular mode of naturalizing a harbinger of a new sport? Golf's liminal experience in the desert could well inaugurate new ludic conceptions.

The worldwide production of golf courses did much in stimulating the extension of the English landscape tradition into the twentieth century: with an estimated thirty million players in Great Britain and the USA (1992), it is a robust tradition as yet to be fully considered in its urban impact (Scully 1991).

The step by step rhythm in golf is seemingly consonant with the labyrinth's sequential protocols except that they harbour hugely contrasting aims. In golf the sequence poses no mystery for it is preordained. Not so in the labyrinth, a unique figure that encapsulates both the field and a riddle, its uncertain path fraught with dilemmas, including the fate of life itself, according to tradition.

As we have seen, Labyrinths construe topological challenges. These do not preclude the exaltation of three-dimensional projections, nor mechanical potentials as with their endless variations such as mastered in Constant's New Babylon.

Such is the case too with Pezo von Ellrichshausen's *120 doors* (2003) where the in-depth repetition of doors held within an otherwise conventional Cartesian grid ensured a bewildering experience in line with Constant's explorations.

This archaic figure was subjected to material adaptations: labyrinths were crafted from clipped hedges, stone masonry, bas reliefs, or masonry thus materializing as soft or heavy constructs, as indoor or outdoor episodes; their sheer variety betraying a measure of ludic resilience. These were also recast in two-dimensional formats over certain church floors veering away from the

FIGURE 74 *Pezo von Ellrichshausen's '120 Doors': a bewildering set of paths based upon the utmost rational layout. Image courtesy of PVE Architects. Copyright Pezo von Ellrichshausen.*

ludic when understood as penitential tools; yet, when conceived as amenable games the riddle of their course beckoned amusing bodily challenges, such as, for example, manoeuvring over convoluted paths and limited spaces. Likewise, the *lusus Trojae*, or Troy game, an old English pastime, required riding a horse over labyrinthine paths.

Their mythic ascendancy leads on to the Minotaur, which awaited its victim within the seclusion of a tight space, the spatial drama unfolding within suffocating confinements, where, in contrast to bull fights, sacrifice became an intimate affair. Quite unlike the type of space we have qualified as panoptic, the labyrinth's huge psychological and evocative power derived from the mixture of fear and challenge induced by the unattainable grasp of the field. Types were attuned to particular choreographies: gentle bodily displacements, such as in certain playing fields, or minimal but highly symbolic motions, as in hopscotch. Sustained upon a formal principle, their identities beckoned drama, and precision, whilst betraying ornamental qualities from the air view.

Adaptive mechanisms such as the ones just reviewed involved materiality, site response, also planar or volumetric descriptions. Veering between the quality of symbols, penitential devices or landscape ornaments, labyrinths admitted endless declinations. Fashioned by masons or gardeners, these were either built or cultivated. A late development, the corn maze follows the cyclical renewal of annuals, growing in a season, as an extraordinary out of town proposition that awaits proper appreciation.

These ludic systems possessed no agreed rules or watchdogs; neither were they indebted to that rational spirit that transformed old pastimes into sports; labyrinths manifest rather a gradual secularization of a ritual that in the course of time gave way to a pastime. Although archaic, these impregnated the imagination of certain architects, with Le Corbusier, BBPR, Reidy, Van Eyck, Constant, and more recently Hedjuk and Scolari falling under their spell.[8] As conceptual tools, they informed Aldo Van Eyck's quest for a 'labyrinthine clarity' which anticipated the Situationists' affairs with chance and non-Cartesian patterns.

An empirical order of adaptations concurs in solving the vexing problem of outdoor play in hostile climates. The circus tent is an early example of such seasonal enclosures; an extreme one, the fully acclimatized fuselages of ski runs (an example is Ski Dubai), that shelter winter sports in hot desert climates, with its illusionistic ambiances within, and its bare exteriors clearly bereft of civic or architectonic aspirations.[9] More relevant to ordinary urban conditions, pneumatic structures shelter assorted fields from inclement weather, their soft membranes enclosing womb-like environments, infused with milky atmospheres that avert distractions. Tucked under heavy bridgeheads such balloon-like shelters add to Manhattan's stock of ludic spaces. Washed with rust and grime, and sharing prospects with the heavily weathered fabric around, these encapsulated airspaces isolate play from the street, whilst

FIGURE 75 *Soft and hard surfaces meet at Soldiers' Field, Harvard University, over the winter season. Photo by the author.*

materializing some ideas promoted by Archigram, albeit without much style or élan.

They sometimes reach epic dimensions; a massive bulge literally encapsulates Harvard University's premier sport venue, the 1903 Soldiers Field stadium, where every winter a convex skin literally emerges from the arena sheltering the players from inclement weather, in neat counterpoise with the concave container. In its radical oddness, the spheroid recalls Etienne Louis Boulee's delirious inventions, but here, in the absence of an epic agenda, suppleness prevents *gravitas*, just conveying a pragmatic response to adverse climate. Deflated and stored away by early spring, it periodically releases the arena to outdoor uses. Then, enlivened by the roaring public, the horseshoe-plan reawakens Hellenic memories so reminiscent of the reconstructed Panathinaikos stadium in Athens.

Clustering: couplings and mosaics

Fields consume space, often in large chunks. Whilst their dull expression (with exceptions made of golf and a few others) dampened picturesque aspirations, sport's boisterous component did the same to contemplative behaviours, making it difficult to inscribe fields in parks. One way out of this impasse was gathering them in large ensembles (sometimes called sport parks), a strategy that was congenial to zoning. Orthogonal formats often led on to gridded ensembles that optimized land use, rather like the *parterre à la anglaise*, with

its taut, trimmed, and monochrome lawn. Such horizontal mosaics acquired their own geometric rigour. As hinted at before, a forerunner of this odd intrusion was the emblematic case of Rousham Bowling Green, with similar destabilizing effect as sports grounds upon the pastoral mood (Bale 2001).

Although economy, rather than compositional urge, informed such mosaics, no such spatial pattern could forego an associated aesthetic, be it planned or just immanent. Running tracks conventionally cluster parallel bands creating a striated pattern which is apt for competitions, but no such convention guides the clustering of large fields. It was left to designers to draw an aesthetic from these criteria, a task that was greatly stimulated by the abstract quality of fields and grids. Nevertheless, lumping sports grounds side by side could also solve the problem of fitting together numerous fields. No master narrative informed such extended arrays as the 136 hectares of Hackney Marsh with its 110 football grounds; all laid much like carpets over the floor of a mosque. Conceived by the London County Council in the aftermath of the war, its levelling was achieved with the rubble of blitzed buildings. The park did not gain in character from such prodigious clustering; neither had it registered singular identities. Rather it was conceived as a loose arrangement, with singularities duly neutralized, over an endless tabula rasa. Likewise, the eastern *Maidan* gathers multiple fields without the recourse to geometric expression, if anything just celebrating such emptiness and functional indeterminacy as one finds in places like Lahore's Iqbal Park, where impeccably clad cricket players share the endless grounds with the public at large.

Mosaic patterns informed certain compositional ploys for the organization of territorial ensembles, however, such as Leonidov 1930s Magnitogorsk scheme in the USSR that orchestrated park, field, track, and vegetable gardens in an interplay of geometries and scales as if an outsized patchwork, all submitted to a grid, each quadrant with singular characteristics. His territorial strategy recast the elements of living and leisure (so conceived at the time as compartments) into a new synthesis which accorded with the revolutionary ethos, for times and spaces could be equally apportioned in such collectivized societies' march to progress.

Following from it, the east–west striated ranks filled up a substantial portion of Koolhaas' 1982–83 La Villette Park stimulating chance encounters. He affirmed:

> A conventional park is a replica of nature served by a minimal number of facilities that ensure its enjoyment; the program of Parc de la Villette . . . extends like a dense forest of social instruments across the site. . . . Its design combining . . . architectural specificity with programmatic indeterminacy.
>
> <div align="right">KOOLHAAS 1995, 921</div>

FIGURE 76 *The function of boundaries in a striated field pattern at Leonidov's new town of Magnitogorsk, USSR, 1930. Drawing by the author after Leonidov.*

The maximal length of borders shared between the maximum numbers of programmatic components was supposed to provoke frictions and eventually trigger ludic mutations. Ranks of trees marked some boundaries, their foliage keeping the mosaic within the concept of the park. Although it embodied no profound collective aims as in Magnitogorsk, the ensemble highlighted social agendas, for frictions were expected to affect behaviour. Koolhaas suggested affinities between the Downtown Athletic Club programmatic section of stacked ludic facilities and the park's striated layout, but these only counted at the level of representation. More substantial was the emphasis on programmatic density as a configurational principle, and the orchestration of friction as a principle of attraction. The overall enterprise was fuelled by the ludic principle of *Alea* or chance.

Like Koolhaas, Edwin Lutyens must have perceived the formal analogies of parterres and fields, for gathering ornamental and performative agendas in his Moghul-inspired 1912–1930 Viceroy Garden in Delhi he inscribed eight tennis courts within as many parterres.

On a more pragmatic note, Hans Christian Hansen's Sport Park in Copenhagen exemplifies a pattern of liveliness solely reliant upon action.[10] Following a criterion of land use efficiency, fields were deftly distributed much like cut-out boards. And yet, despite dumb repetition, the twenty-three units were not all identical, for hierarchical considerations raised one as the crowning piece. Thus, embedded in landscape, and following athletic hierarchies the central court bespoke of superior achievements. Overall it was like an industrial production line, with no room for 'nature', just an overload of 'programmes'. The pattern left significant imprints in countless settings worldwide. Bois de Boulogne and Bois de Vincennes were extensively retrofitted with sports fields, also the Ille de Puteaux with the Plaine de Jeux de Bagatelle as portrayed in Mandoul's survey of Parisian sport mosaics (Mandoul 2014).

Mosaics rely on boundaries. The issue of charging the boundary with ludic intensity rarely applied to sports fields, except when the boundary itself, the tennis net for example, became a prime ludic challenge. Yet boundaries often become ludic topics. When Casanueva increased the height of the net, he was effectively engendering a new game just by that simple expedient.[11]

Burle Marx and Affonso Reidy wrestled with the meaningful inscription of ludic mosaics in the 1960s *Aterro do Flamengo* in Rio de Janeiro, a prime

(a) (b)

FIGURE 77 *Sport mosaics: (a) 23 tennis courts in Hansen's sport park, Copenhagen; (b) in Ortner's scheme for Munich. Drawings by the author after Ortner.*

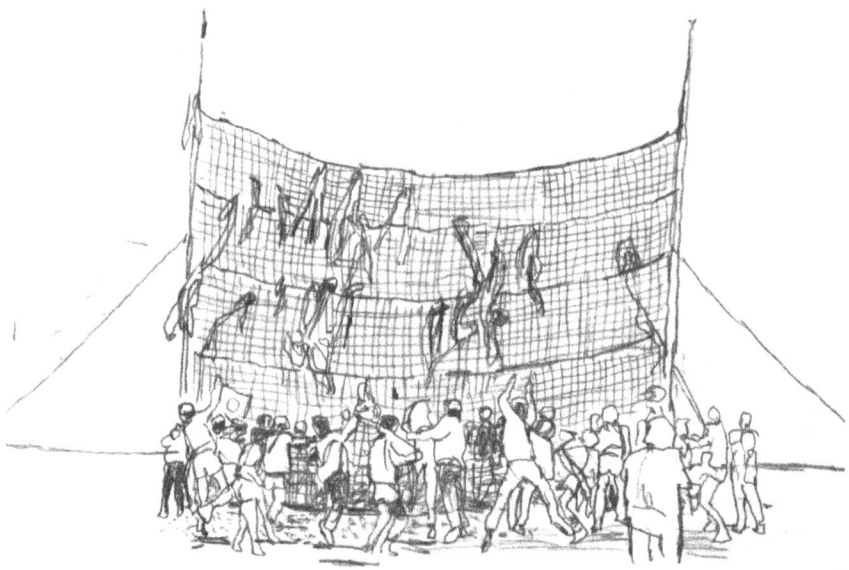

FIGURE 78 *Playing with the boundary: an overused net in Casanueva's Despelote. Drawing by the author after photo by Casanueva.*

FIGURE 79 *Organic flow and orthogonal frame: (a) Burle Marx's roof terrace at the Ministry of Education, Rio de Janeiro; (b) the dilemmas of flow vis-à-vis the field. Drawings by the author.*

urban site that mastered all interfaces between city and shore.[12] The park comprised a massive concentration of leisure venues, with airborne games, tennis, football, table tennis, labyrinths and children's playgrounds, aside from an open-air theatre and a dance platform, all edged by a beach with its leisure marina. Each geometric outline negotiated with the meandering contours, in a counterpoint of exuberant and laconic formal systems. The issue was how not to compromise fluidity whilst assembling generous sport mosaics. Soft and rectilinear forms collided with hard edges, in a perfect reversal of Burle Marx's 1945 Rio de Janeiro Ministry of Education roof garden, where a rectangle severed the biomorphic garden paths. Aside from the compositional issue, contrasting behavioural patterns were embedded in each formal system.

However, the pursuit of active leisure agendas did not compromise its spatial ambition, as the park also mastered the interfaces of city and the Guanabara shores, mobilizing to this effect landscape masses, topography, urban lighting, visual prospects and traffic flows.

FIGURE 80 *Reidy and Burle Marx playing fields at the Aterro de Flamengo, Rio de Janeiro. Drawing by the author.*

The near formal

Having observed the ingenious mechanisms of adaptation, we must stress the urban incidence of that drift away from the geometrically correct which characterizes so many adapted fields. Sports fields must keep to the Canon, lest they become unofficial, thus invalid. Meanwhile, the 'informal' sector (i.e. all agents other than official or professional) incubates prodigious adaptations, solving contextual inadequacies hence fitting ludic spaces in problematic sites, each one just a little different, all of them site specific.

Albeit in a sense unlawful, these fields foster a de-facto middle ground between *Paideia* and *Ludus*, hybrid laboratories of integration and shared uses, whose superior adaptive capacity eases the communion of play and the everyday. Their singular imprints remain largely uncharted.[13]

FIGURE 81 *Informal fields in Brazil, Joachim Schmid 'O Campo', 2010. Accreditation P420 Arte Contemporanea Bologna. Copyright Joachim Schmid.*

FIGURE 82 *The baseball arena as a public square. After Pablo Soto Caracas, Zona 10. Drawing by the author.*

Inscribing large scale geometric figures upon urbanized terrains is not easy. Non-official grounds wrestle against configurational, topographic or dimensional constraints. Their myriad of adjustments recall the typological manoeuvring which is common when squeezing well-tried types into odd or slightly inadequate sites.[14] These are 'almost all right' fields reckoning the 'as found'.

Embedded within the densely packed matrix of Latin American settlements, soccer or baseball grounds often double-up as public squares, unwillingly recasting colonial precedents, where squares were conceived as empty stages. The setting aside of valuable grounds for this purpose is a remarkable demonstration of the importance assigned to its practice by the denizens of Buenos Aires, Lima, Caracas, or Valparaiso. Likewise, in Rio de Janeiro where the informal fields largely exceed in number the formal ones.

Affluent scenarios also feature formal adaptation: the case of Manhattan is remarkable. As revealed by David Gull, tennis, football, softball and baseball arenas squeeze in unlikely sites and atop buildings enhancing the provision of sport venues all across the grid.[15]

Topographic adjustment is equally significant. Massive grading in hill towns results in veritable bastions destined to construe just terse, horizontal ludic surfaces. Built at considerable effort, terraced playing fields such as the ones common to Valparaiso, Caracas, or Rio de Janeiro, testify to the significance assigned to this unproductive pursuit. As if a communal epic, the consolidation of these significant terrains for ludic aims also betrays a celebration of free time.

FIGURE 83 *Manhattan adaptations. Drawing by the author after David Gull.*

FIGURE 84 *Flatten the site. Sewell company town, Chile. Drawing by the author from period photograph.*

Site specific

Gasping in awe at the lush Argentinean *Pampas*, an English visitor could not but imagine these as wondrous playing fields, so strong were their ludic evocations. Indeed, no effort was needed to turn those endless plains into sports fields, and yet all sites embody particular terms of engagement, for latent in every scenario lurk countless ludic potentials. As if seizing advantage from the site's natural forces, play often mobilizes innate field conditions. Hence hill towns naturally foster gravitational games. Likewise, with the seasonal ludic propensities embedded in snow-belt and waterborne cities, or with the playful challenges posed by urban wastelands. They bespeak a close rapport of play to site. So too does the ludic challenge posed by compact urban arrays (Venice's *Guerra dei Pugni* or the contemporary *parkour* are good examples). Inherent to sites there are embedded ludic potentials: this is exactly what drew Aldo Van Eyck to ponder about the transformation of cities into playgrounds that so magically followed from snowfalls.

A convoluted topography and persistent winds characterize the hillside formations of Valparaiso in Chile, each trait appealing to a particular ludic proposition: laying a slide on a slope, or maybe playing kites upon high plateaus. Dutch filmmaker Joris Ivens portrayed the city through play, its

FIGURE 85 *Site-specific slide on a hillside, Valparaiso. Photo by the author.*

rhythmic flights of steps, its gusts of wind, its ludic ambiances enhanced by particular sonorities, its amphitheatre-like formation and acoustic reverberations, all with particular elan.[16]

It is in the realm of the local, the available, the contingent and the immediate where *Paideia* scans the field for opportunities. After all, is it not so that children come to terms with the world through playing? Likewise, is it not so that playing with the 'as found' becomes the only tool available to the child for a dialogue with the world in his (or her) initiation into life?

Thus, it is in the flight of a thousand kites that certain people celebrate the wind forces, and likewise it is with the indescribable mayhem of rolling stock let loose on wild urban slopes that the topographic marvel of hillside towns is enlivened. With a fine eye for nuances in the field, skaters negotiate urban inflections in the same way that surfers draw their course upon liquid geometries until play literally becomes interplay. Jacobs likened such impromptu and fleeting choreographies to an art of human interaction. Likewise, Rudofsky and later the Situationists prized the act of negotiation that upheld ludic uses. Negotiation, that is, wrenching playing fields from the commonplace, seals fundamental – albeit fleeting – ludic contracts with the ordinary habitat.

5

Park and amusement park

A rural hillside partially covered in shrubbery obliterates any notion of football in Castillo's orchestrated collision of orders. It is clear that the field cannot be simply overlaid upon a landscape: by the same token, in their extraneous requirements, playgrounds cannot easily be assimilated to gardens. In the conception of the field, play seems to introduce another nature.

Like the park, mechanical fairs indisputably belong to the leisure domains: moreover, their extensive grounds circumscribe a domain of exceptions akin to Foucault's heterotopias. No doubt park and fair represent highly contrasting loci: one suggesting an escape into the country, the other an industrial landscape turned tame; one encapsulating botanical wealth, the other a wealth of artifice; one inspired in bucolic nature, the other in the industrial

FIGURE 86 *Field and topography colliding. Image courtesy of Eduardo Castillo. Copyright E. Castillo*

imagination. Equally contrived in their own ways, albeit following contrasting mandates, public parks and mechanical fairs surged roughly in parallel, the latter forged by an entrepreneurial drive that foresaw in leisure an exceptional business opportunity. Here parallels end, for whilst the park became a prime concern for modern architects, despite its engineering feats, the fair remained – at best – in the periphery of their concerns (although it was highly valued by Archigram, Price and the Situationists).

Founded in 1906, the Playground Association coincides with Chicago's Reform Park Movement with its 'recreational experts' (Cranz, 1982) and its early conception of 'playgrounds'. Chicago thus pioneered 'active leisure' enclaves, even though their character and pertinence were hotly debated. Jackson argued:

> The urban park is a newcomer to the landscape . . . medieval towns had of course a number of public places . . . but no open space in town was set aside – let alone designed – for such a vague purpose as recreation.
>
> JACKSON 107

Unwittingly corroborating the thesis about ludic functions as social templates, Rasmussen's 1934 *London the Unique City* and Koolhaas's 1994 *Delirious New York* highlighted the leisure component in the urban discourse.

The encounter between the English common, a pragmatic mindset and the ideals of *fair play*, led to London's peculiar urban synthesis with its extraordinary provision of parks. Such was Rasmussen's view. Along similar lines, the encounter of an entrepreneurial spirit and a particular imagination about mass leisure led Koolhaas to declare Coney Island a cradle of the metropolis, as if inventions first tested in the domain of leisure were later applied to 'serious life'. Collective play nurtured both urban identities.

The green patch matrix that characterizes London's disperse urban patterns captured Rasmussen's interest; he perceived in their predicament an embodiment of the sport ethos, also a concrete expression of the will to keep fit, with its inherent moral and physical dimensions that made London a mirror of its emancipated, healthy, and autonomous citizenship. Tracking down the historical role of the commons, he disclosed how certain areas had been sanctioned as sports grounds by parliament during the sixteenth century. The English landscape tradition became a product of direct engagement, he argued, rather than intellectual speculation; of cultivation, rather than design; an expression of liberalism always implicit in its contrived casualness.

Altogether, these nurtured the foundation of the public park. Indeed, London featured a staggering number of them . . . 'they might be regarded as some sort of supply service of hygienic importance just as water supply, common sewers etc' (Rasmussen, 306). Besides supplying clean air, parks

were primarily understood as opportunities for taking exercise in the open. The sportive use of the garden embodied a nineteenth-century paradigm shift, whereby sport exalted the experiences of natural space. Henceforth the landscape was increasingly conceived as arena.

The erosion of Hampstead Heath by intense trampling prompted Rasmussen to ponder how its worn out nature betrayed the prevalence of 'sport, instead of pastoral life', usage taking precedence over aesthetics. He also noted the massive conversion of parish churchyards into playgrounds as initiated in England by 1855 through the agency of the Metropolitan Gardens Association. By 1934 the process had yielded nearly a hundred cases, with an effect perhaps not dissimilar to Aldo Van Eyck's better-known insertion of playgrounds in Amsterdam. Diverse mechanisms eased the inscription of casual recreation in London's fabric.

Rasmussen furthered the urban significance of play in *Towns and Buildings* (1949) and *Experiencing Architecture* (1959). He highlighted unexpected linkages between play and certain canonical spaces in the former, whereas in the later he drew linkages between sport and functionalism. In his view, ludic programmes were formidable instruments for the modelling of the modern city (he was oblivious of the urban fair, however). His perceptions emphasized local traits, yet the alliances forged by play to site represent just one ludic possibility, for as we have seen, play requirements can equally turn sites into generic fields. Moreover, as pointed out by Koolhaas, the oblivion of place is inherent to the metropolitan ethos. Hence, the ludic impulse pulls in opposite directions: it either strives towards the generic, or else it nurtures intimate rapports with the specific. Clearly, the mechanical fair belongs to the former.

Its no-doubt hazardous lineage is interesting for it illuminates the transferences made from the domain of the useful into the ludic, as if machine civilization had gone haywire, turning tools into toys. Following the course of obsolescence, abandoned mechanisms were released into unproductive uses.[1] In it a gradual substitution of the field for the apparatus ran in tandem with the substitution of composition for clutter. Free fall, acceleration, collision, pendulum motion, high speed rotation and such extreme experiences became ludic tropes. Passively submitted, the 'players' confronted formidable forces much like surfers confront wave power. It was the domain of *Ilinx* and *Alea*, where subjects relinquished command to fate. However, the apparatus in the fun fair sometimes acquired a truly epic stature, as happened with certain roller coasters and ferris wheels; it was in cinema that its dramatic allure was best represented.[2]

Technology also magnified artificiality. In Coney Island, as Koolhaas observed, multitudes bathed under the halo of an artificial sun. Once the natural order was thus obliterated, recreation became a 24-hour concern:

massive, anonymous, variegated and endless. Clustered leisure facilities offered an incessant laboratory for the generation of fictional amusements.

Unlike the park, the fairground was alien to mainstream narratives; architects did not accord it the prestige bestowed upon railway stations, factory sheds or grain silos. It was a matter of taste as much as propriety. Things reversed around the 1960s when such collectives as Archigram drew inspiration from fairgrounds, their enhanced status furnishing thereafter unprecedented urban and leisure models.

Coney Island's liminal ludic experiences eventually succumbed to the alternative recreational mode of the park, and (according to Koolhaas) 'the urbanism of good intentions' with its sane and sunny entertainment obtained in green scenarios of the kind Rasmussen had advocated. The agent of that particular substitution was Robert Moses, the famed New York commissioner whom Jane Jacobs had denounced as prime culprit in the degradation of neighbourhoods and street life. Moses – who also doomed Kahn's and Noguchi's playground scheme in Manhattan – was a sponsor of mass recreational resorts.

Subjected to formal and material definition, orientation, encryption and adaptation, fields registered ludic activity as imprints, as much as choreographies, acquiring an enhanced presence in the course of the twentieth century, when the social mandate for recreational space and equipment became emphatic and distinctive. Much like templates, sports fields often became elements to consider in the fashioning of the outdoors. But sport just addressed the needs of a young and healthy part of the population. In parallel to the unprecedented entry of sports fields in the urban scene, other places were fashioned for children's use whilst the notion of green space broadened the scope of leisure: the ludic programme was effectively changing the way cities were conceived. Fields hosted the ludic activities of athletes, children and citizens at large: many architects immersed themselves into their respective ludic agendas. How these were qualified by the architects within their respective visions about city and landscape is the subject of the following section.

PART TWO

Players

6

The athlete

Introduction

Having examined the function of the field, the relationship of projects and players follows an almost inevitable course. Such enquiry can be accomplished by discriminating the ludic actors one by one, as represented by the athlete, the child, and the citizen at large. Why these? Each one stepped on stage, somewhat consecutively over the century. Their command was never exclusive, yet the sequence reflects upon the prevailing discourses about play issued from architecture, planning and the allied arts.[1] Their presence was embodied in projects, particularly urban ones, where play was charted in space.

If it is true to say that play practices embody societal models, it would then be plausible to consider that when society privileged the athlete, it was at the same time acknowledging the higher function of norms, rigour, discipline and the team spirit, somewhat expressing these values in the organization of space. Likewise, when it invested childhood with a privileged position, it endorsed chance, candour and spontaneity with an equivalent zeal. When the player became the citizen at large, one can imagine society assuming that the urban construct somewhat came to embody the teleological projection of the ludic. There, even the mechanisms for urban form-making became ludic propositions.

In assimilating play, modern societies articulated hygiene, recreation and instruction in a single project, whilst assigning particular roles to each age group. This was at any rate the dominant view, until the Second World War or thereabouts, so that even when the cult of hedonism and chance surged by the 1960s, the prevailing organization of space remained unscathed. Indeed, diverse or even contradictory agendas were pursued in the course of the century, but only some made it into the fabric of the real. The attempts to inscribe play in the city beckoned heterogeneous panoramas.

'Free time', that is, time released from labour, became a big topic by the early decades. Imbued with an acute sensibility about sport, Le Corbusier foresaw a great challenge in its exponential growth. Recreation was a universal

right, he pondered, yet 'free time' could be grossly misused for it was a menace as much as a gift. It had to be led away from idleness, thus green spaces ought to be conceived as colossal gymnasia (Le Corbusier 1924, 1978, 199). These objectives were endorsed in the 1933 CIAM Athens Charter (its text is largely attributed to him). Thus 'proposition 32' stated that green areas be assigned clearly defined missions, such as children's playgrounds (or parks), schools, juvenile centres, and so on. 'Proposition 38' delved into free time, with its hours catered for in specially prepared settings such as parks, forests, sports fields, stadia, beaches and so forth. The CIAM 1935 congress was devoted to 'dwelling and recreation', thus forging a lasting bond between ludic and domestic endeavours. Greenery and leisure became so forcefully enmeshed that it became almost counterintuitive to imagine alternatives.

In 'Architecture for world revolution' El Lissitzky expanded upon the benefits of sport, portraying people's parks, monumental stadia, public swimming establishments and other such facilities geared to provide Soviet citizens with recreation. These ensembles offered ample room for their deportment, whilst sport pavilions often tested the limits of cantilevering, in an uncanny parallel between programme and structural expression, as if *Ilinx* beckoned tectonics. Here, the uses of play were instrumental to the upbringing of a new subject, though El Lissitzky argued that so-called sport records are irrelevant in Soviet society (Lissitzky 1930).

We have seen how Koolhaas derided those precepts that came to be associated with the welfare state's politics of leisure. What he disliked the most was the high mindedness, the excessive onus placed upon spatial and programmatic order, the bare green environments that this well-meaning urbanism had too often conjured, but above all its conceptual remoteness from metropolitan vibrancy and hedonism. The contrast had not escaped the attention of planners like Josep Lluis Sert. He was a representative of CIAM who had decried the vulgarity of Coney Island, whilst also disclosing the utter banality of the belle époque aristocratic resorts (Sert 1949). His own views upon the subject were well represented in the 1934 GATEPAC 'City of Leisure' planned at the height of the Spanish Republic on a stretch of Catalonian shore not far from Barcelona.[2] Here, *free time* was conceived as an ethical reward. Laid between the shore and the inner sport strips, bands of greenery structured a generous and calm landscape. Facilities were distributed with an eye to equal accessibility. The lyrical mood was quite distinct from the garish and bizarre character of Coney Island and its siblings. The well-publicized scheme extolled recreation and universal leisure rights.

Conceptions of leisure were contested, however, sometimes radically so, by the various agents involved in east and west, but also by commercial or social-welfare initiatives. This was so at practically every level: thus, for example in Leonidov's Moscow's 1930 *House of Industry*, each floor in the main tower

FIGURE 87 *Sert and GATEPAC City of Leisure, Catalonia, 1934. Drawing by the author after GATEPAC.*

embraced work and leisure, so that clerical functions alternated with exercise and rest, conjoining work and leisure. Spaces were apportioned rationally: . . . 'five square meters, per person excluding walkways. . . planters with greenery (between) . . . on one side . . . a zone for relaxation and recreation exercises, structured by . . . sofas, a library, dining spaces served from below, showers, a swimming pool, walking and running tracks and spaces for guests'. Moreover, the lower floors featured sport and club rooms, a swimming pool and running tracks. Hence the scheme also enshrined a social model.[3]

Its revolutionary edge can be gauged in a comparison to the face-to-face urban encounter of the elite leisure institution and the corporate headquarters as represented by McKim, Mead and White's 1918 Racket and Tennis Club and Mies Van der Rohe and Phillip Johnson's 1954–58 Seagram Building across Park Avenue. Needless to say, the leisure facilities were restricted to senior employees. One can imagine the severance of work and leisure as if embodying the quintessential capitalist ethos, but of course no such ploy was envisaged. However, these establishments embodied well established values: cast over the Seagram glass plates, the mirrored image of the Club strongly recalled the binary constructs of work and leisure.

Huizinga published *Homo Ludens* in 1938. In the aftermath of the Second World War, alternative narratives about the subjects of childhood and

FIGURE 88 *Leonidov's 1930 house of industry: typical floor plan with gymnasia and working stations side by side. Drawing by the author after Leonidov.*

spontaneous play surged in full strength. Later, the citizen emerged as a ludic subject, revealing not only a shift in the relevance assigned to the topic, but also a new paradigm, whereby play was seen at the heart of the urban enterprise, such was at least the utopian aspiration. Although not nearly as comprehensive as its forerunners, Duvignaud's 1980 essay reclaimed cultural and political recognition of the play instinct: '[our century] has overlooked chance, the unexpected, the ephemeral and play', he stated, not without impatience, in the face of an entertainment industry that had turned play into spectacle and commodity. He was fully aware of the attempts to mobilize the play instinct for the sake of a profound renovation of the European city.

By 1972, Candilis, a member of Team Ten and former collaborator of Le Corbusier's published a portfolio of leisure resorts (Duvignaud [1980] 1982, 13). Whether as reality or expectation, the imprints of leisure were reaching by then territorial magnitudes, particularly on southern European shores, where the lure of 'sun, sand and sea' was attracting multitudes, whilst re-energizing local economies. If earlier assessments had focused upon urban access to leisure, here the accent was placed upon universal access to such out of town leisure settings as sand dunes, beaches and forests. There was the vexing question about how to preserve those landscape and territorial values from their annihilation through indiscriminate development. If in earlier times Le Corbusier had predicted the risks and potentials involved in planning everyday leisure in the city, by the latter decades Candilis was addressing the affluent societies' seasonal holiday as a potential menace.

The athlete, the child and the citizen embodied particular principles; thus, concordant with the conception of the 'new man', the athlete stood for Apollonian, rational and eminently virile traits (for it was primarily male). Children embodied Dionysian principles of spontaneity, and exuded an

unbridled imagination. It was not unusual for them to be linked to the primitive. When citizens at large were conceived as prime players, it was because the ludic was placed at the heart of the human experience, precluding discriminations by age, gender or type, whilst also renouncing territorial circumscription as if the city itself became a toy. Likewise, a certain pre-war insistence upon social discipline and health was at least partially counteracted by post-war re-evaluations of spontaneity and chance.

The sequence represents a hypothesis about the coming onto the scene of each character. The athlete and the child represent stages in life. Gender was also considered, but on the whole it did not become an issue with the urgency attached to it in more recent years. Nevertheless, the ordering of play according to age resulted in emphatic characterizations of play modes, forms, and eventually the design of discreet scenarios.

The athlete, 'one who competes for an *Athlon*' or award, embodies a physical ideal as much as a model of resilience, where pleasure and the ascetic impulse converge. Its vocational status reveals physical and psychological stamina, discipline and sustained effort. As an inheritor of the warrior's traditions, of sport and gymnastics, it left a durable imprint in twentieth-century collective scenarios.

Significant differences can be perceived between the 1560 happy mayhem of children playing and roaming about as described by Peter Brueghel the Elder, and modern ludic attitudes: the former describes a public domain overtaken by play; the latter evokes such orderly distributions of ludic space and time, so as to preclude conflicts between play and ordinary business. What kinds of institutional recognition were bestowed upon children in the twentieth century that led on to exclusive ludic targets?[4]

Playing is not a choice for the child as it is for the athlete. Whether casual, agitated, focused or expansive, it is arguably their uppermost concern. The recognition of play as a decisive aspect in the modelling of the child's personality was a modern realization, strongly inspired in learning theory and the teaching establishment, and it led to particularized scenarios.

The citizen stands for an all-encompassing category. In singling it out we like to put an accent on that urban conception that sets the ludic programme as fundamental. It was not just a question of coaxing everyone into play but rather a vindication of play as a primordial urban instinct that was to inform the conceptual and material foundations of the urban project.

Each instance seems to have privileged one of these players, relegating the others to secondary roles: the accent permeated projects as well as discourses. However, the trilogy of characters ultimately converged in all scenarios, only that whilst certain roles became dominant, others receded.

Whether materially embodied, or perhaps devised within the framework of speculative thought, play was a prime subject in the modern agenda. Be it

implicitly or expressly, the polarity of *Ludus* and *Paideia* was settled in each case with a particular slant. Was it not so that the playing field acquired in the twentieth century had unprecedented visibility and presence? Was it not so that children's playgrounds emerged then to become staple facilities associated with almost every residential scenario? Was the claim for the citizen's proactive ludic intervention in the configuration of the urban habitat not totally unprecedented? All these attempts did qualify an idea of *the public* stressing through their ludic commitment the values of freedom and universal access.

These expansive, sometimes unruly, always vital, but volatile activities were minutely planned. Age specificities suggested negotiations between *Ludus* and *Paideia*. Thus for example, the Dutch CIAM chart about leisure (Sert 1947) discriminated users (from age 2 to 50+), thus hinting at distinct ludic domains, with just a few shared ones (the park, the wilderness), whilst reinforcing the notion of exclusive ones. Their diagram neatly encapsulated

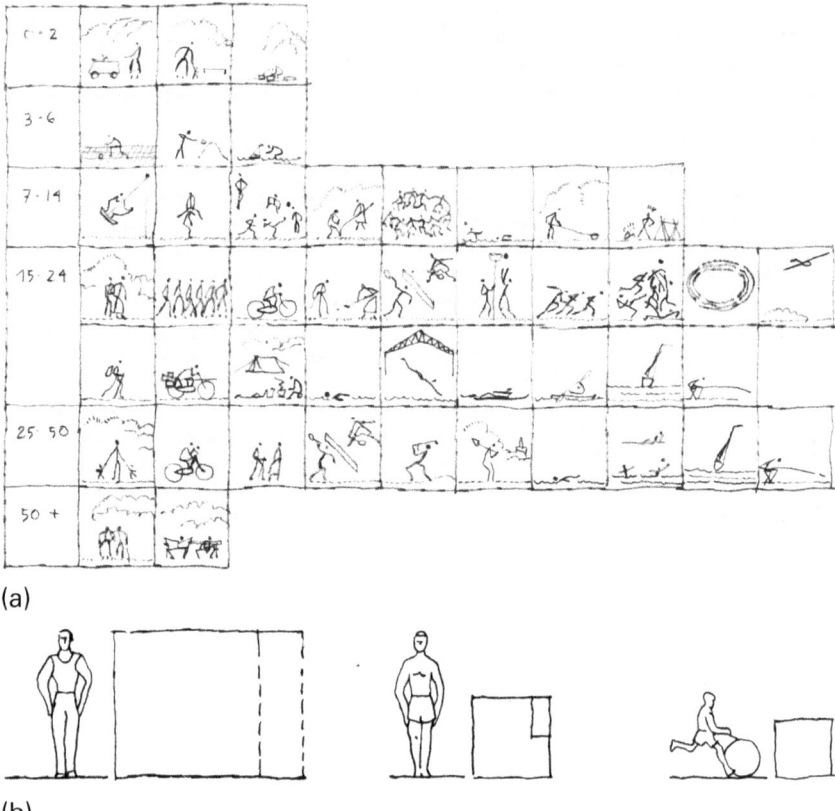

FIGURE 89 *Recreational needs classified and quantified: (a) Dutch CIAM age chart; (b) Ortner sport needs per inhabitant (adult male 3.5 m^2 plus 1 m^2; middle bathing area 1 m^2 per head with 0.1 m^2 water surface; playground 0.5 m^2). Drawings by the author.*

the kind of spatial expansiveness and contraction that results from aging, whilst also betraying an increasing recourse to data, and numerical standards.

Architectural manuals could be said to represent a twentieth-century substitute for the architectural treatise, where empiric criteria and the systematic codes of the catalogue stood in lieu of style, and the notion of the Canon. Manuals readily embraced the leisure subject, particularly sport, with its eminently rational tenets. Ernst Neufert's seminal 1936 'Architects Data' extensively covered sport and children's play facilities; the North American 'Architectural Graphic Standards' did the same, albeit in an abridged manner,[5] whilst others, like Ortner's 1953 'Sportbauten', delivered detailed field templates, layouts, and diagrams assisting the planning of complex ensembles.

Ortner typically quantified per capita needs, discriminating three types: *sport* (plus their ancillary spaces of 3.5 square metres), *sun bathing* (1 square metre of which a smaller proportion was destined for water pools) and *children's playgrounds* (2.5 square metres) thus equating metrics as an equal value to composition or performance. He extolled functionally precise ludic ensembles, their spaces clearly assigned according to age, tempo and material.

Planners often equated the universe of *Paideia* to childhood. Notwithstanding age distinctions, certain modern enclaves (particularly the beach, sometimes the park) became sites of integration. Contrariwise, ludic programmes in kindergartens, schools, colleges and university campuses were segregated from one another and orchestrated according to age.

The athlete who privileges the Agon models his Apollonian figure through *askesis*, rigorous training, sustained effort, a triumph of method over

(a)　　　　　　　　　(b)

FIGURE 90 *(a) Stepanova, 1923 Soviet sport attire; (b) athletes, Malevich, 1932. Drawings by the author after Stepanova and Malevich.*

improvisation; his well-balanced body matches neoclassical sensibilities, so distinct from the archaic expression of brute force.

Clearly dominant in the realm of *Ludus*, the modern *Agon* percolated in the conception of early modern habitats. As we have seen, sport, its prime expression, carried complex meanings, for it counted as practice, ethos, and lifestyle, while 'the sportive' evoked casualness, relaxed demeanours, also certain types of attire and goods.[6] Sport training became a referent, but the sporting attitude bespoke the informal and the casual, so that *the sportive* stood for strenuous efforts as much as extreme lassitude. Be it in its ascetic or relaxed moods, sport held nevertheless a great impact in the imagination of the period, particularly so prior to the Second World War, when it encapsulated a vision about health and vigour that acquired the status of a paradigm (one can compare it with the more recent conception of outdoor styles, with their emphasis upon rough nature). Thus, Friedrich Kiessler's 1934 'Determination, labour and play' equated the muscular worker to the sportsman, their virility, alertness, vigour, and exacting organization of time. Their bodies were equally trained except that they were tuned to opposite aims.

FIGURE 91 *Frederick Kiesler, space house. Interior view with photomural 'determination (labour and play)'; modern-age furniture company, New York, 1933. Photographer unknown. Copyright Frederick Kiessler Foundation. Accreditation 2017 Austrian Frederick and Lillian Kiesler Private Foundation Vienna.*

The sport-extensive enclaves attracted the attention of architects, landscape architects and urban designers. Accessibility often became a contested issue, but early urban schemes displayed generous openness, their green carpets hosting play and leisure. Indeed, these stood in opposition to the stadium's controlled access and severance of visual horizons,[7] the predominant criteria being about fully accessed and visually integrated arenas: sport was there not just as spectacle but for everyone to practise. The distinction was made clear by Van Eesteren (amongst others) in his 1928 lecture, 'The idea of the functionalist city', where American stadia and open fields betrayed these polar modes in vignettes that would have been unfamiliar to Europeans. Later in life he became involved in the creation of the Amsterdam Bos Park with its massive leisure facilities, as well as the commission of children's playgrounds in the same city, a task he entrusted to Aldo Van Eyck. However, his 1928 lecture devoted neither a single line nor image to the matter of children's play (Van Eesteren 1997, 1928).

In parallel to the development of the sport park, the increasing bonds that tied sport to spectacle led to the re-editing of the coliseum in the manner of modern stadia, a remarkable classical revival, that had been foreshadowed by the nineteenth-century Iberian bullring. Self-contained and inward looking, the stadium also encapsulated an institutional climax of sport, as well as the substitution of the riotous ludic feast for an orderly spectacle. As pointed out by Bale, the leisure industry that eventually captured all mass venues deprived the ordinary settings of their functions as vessels for collective play. We have, however, examined how the mobilized energies of the 'informal' sector somewhat restored the embedded field and the urban feast.

FIGURE 92 *Luigi Moretti's so-called parametric stadium with optimized viewing angles for spectators, 1960. Drawing by the author.*

FIGURE 93 *The form and its vestiges: (a) Roman amphitheatre remains in Housestead's England; (b) Roman Colosseum. Drawings by the author.*

Cells and arenas

> Whoever studies recent architecture in its connection with life styles of the mechanized society, will immediately realize that the two most successful architectural innovations in the twentieth century, the apartment and the sport stadium, were in direct relation to the two main socio-psychological tendencies in the period: the liberation of individuals through housing and media techniques . . . and the agglomeration of the excited masses through events orchestrated in large buildings.
>
> <div align="right">SLOTERDIJKT 2006 443</div>

Sloterdijkt implies that the tokens of the individual and the collective (the apartment and the stadium) embodied contrasting forms of alienation. The argument suggests the extremes of isolation and agglomeration, but the duality Sloterdijkt discloses became relevant to certain seminal projects in another way, for the direct rapport of cells to arenas became a residential goal, with blocks overlooking sport arenas, as recommended by Giedion, thus somewhat substituting apartments for spectator stands. Gropius, Sert, Le Corbusier, Van Eesteren, Lissitzky and Bakema (amongst others) pursued such goals. The novel interface became both an objective (related to a particular ethos) and the expression of a good balance about 'living' and 'cultivating body and spirit'.

The classical nexus in the modern consciousness about play was embedded in Thomas Arnold and Baron de Coubertin's visions. Classical and neoclassical models affected the perception of the modern athletic body whilst also inspiring the notion of the stadium. (Nineteenth-century athletic bodies were heavy and bulky whereas twentieth-century ones were conceived as 'balanced' and suppler.) No doubt the Roman *ludi* and Greek agonistic trials had little to do with modern sport, but what was invoked was not history as such, just somewhat selective flashes about the classical past. Wrestling with the identity of the Olympics, Coubertin had conceived 'a sport park neither distinctively English, nor French, reminiscent neither of a casino park, nor of a cemetery, with buildings neither recalling casinos nor sanatoria'.[8] He favoured grass banks for the spectators over formal grandstands.

Le Corbusier liked to stress the contrasting predicaments of Greece and Rome: 'Roman: the word has a meaning. Unity of operation, a clear aim in view, classification of the various parts'. The Roman spirit was rational, empirical, productive. As for Greece, he stated: 'the gymnasium is an essential institution in town, [where] inhabitants are not spectators but actors'. He lauded one for its logistics and the other for its subtleties about site and human experience (Le Corbusier 1978, 146).

As regards the site of sport, the message was clear: Roman logistics organized mass spectacle in impressive assemblies, but only the Greek did muster fine-tuned relationships between sport, the everyday and the landscape.

The point was corroborated some decades later by landscape architect Geoffrey Jellicoe who seized the *Altis* in Olympia as a model of integrated fields and pleasure grounds.[9] In devoting a full chapter to the issue of 'space for play', he confirmed the public ascendancy of the subject, tracing parallels between Olympia's sacred grove and London's Hampstead Heath. He was equating the relationship of stadium and running tracks to the corresponding hillsides: the key to their success being their response to 'ground modelling'. But he also endorsed Le Corbusier's earlier intuitions. He affirmed that in Greece there was: 'a harmony between man and nature which the Romans elsewhere came to destroy'. Moreover, he reflected, 'not only was this destruction in the nature of sport, which changed its character entirely, but also because of the giant built up structures that came to house spectators'. In light of this argument, it is a striking paradox that modern sport (which, despite all differences is closer in spirit to the Olympic ideals than to the Roman *Ludi*) came to be housed in Roman containers (Jellicoe 1996, 33–48).

Stadion and Coliseum differed: the former followed the race track linear pattern whereas the Coliseum's oval pattern and associated *cavea* were inward

looking and truly colossal. Often named a *spectaculum*, the latter betrayed a visual bias. One emphasized the arena with its inherent function, the other, the apparatus for mass spectacle, substituting the openness towards the horizon that so beautifully characterized the Greek conception, by self-immersion, with the spectators simultaneously registered as choir and landscape.[10]

Their ultimate fate was diverse, for coliseums were sometimes turned into quarries, sometimes built upon (as in Arles or Nimes), and sometimes phagocytized by dwellings (as in Florence or Lucca). A few were reclaimed for play (the case of Cartagena in Murcia is remarkable), sustaining thus in time their function as arena. The lesser ones simply degraded into landscape heaps, undoing strenuous human efforts, as if wrenching a Greek ideal of communion with the landscape from the Roman autonomous space; so, it happened in Richborough, Housesteads or Tomen-y-Mur in the British countryside (Wilmott 2008).

Harking back to similar sources, and bearing in mind the conception of modern leisure facilities, Sert also considered the contrasting 'organization of leisure in antique civilizations'. He was of course referring to Greece and Rome, but we have seen how he was also hinting at the conceptual substitution of massive ranks of seats for apartment blocks that integrated the arena to ordinary experience, re-editing former models in a modern idiom (Sert 1949). The formula bounded play and the everyday landscape in a Greek manner, whilst retaining the large Roman scale. Such was the synthesis offered by Le Corbusier in his own apartment, where he enjoyed the full command of the *Parc des Princes* sports ground against the magnificent

(a) (b)

FIGURE 94 *Apartments and arenas: (a) Porte Molitor, Corb's own apartment as seen from the stadium, photo by the author; (b) Ilote Insalubre nº 6, Paris, drawing by the author after Le Corbusier.*

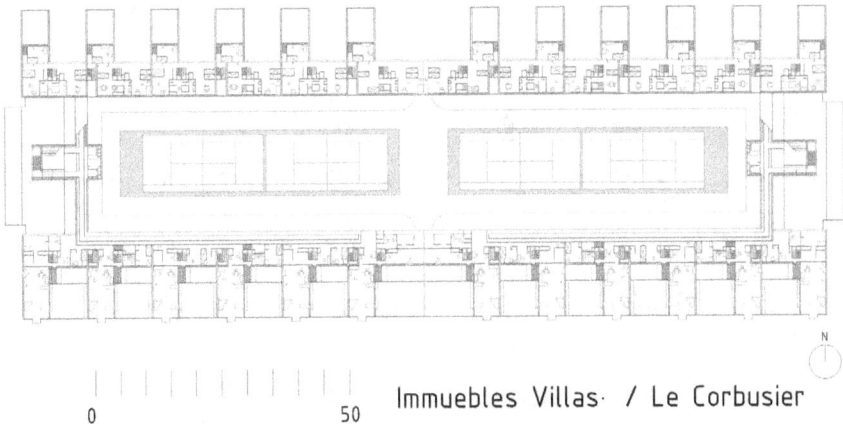

FIGURE 95 *Le Corbusier's marble villa with communal tennis courts, and hanging gardens facing outwards. Drawing by the author.*

backdrop of the Bois de Boulogne. It complied with his urban principles, only the benefits of '*sport au pied de maison*' were exceptional, rather than normative as he would have wished.

He often circumscribed arenas with apartment blocks, as in the 1922 *Contemporary City* with its plethora of fields. Following nineteenth-century precedents, he emplaced the monumental stadia and hippodromes just off bounds (likewise for example in the planned nineteenth-century cities of La Plata in Argentina, and Belo Horizonte in Brazil, also in Alphand's Bois de Boulogne). Then he delineated a park, similar in outline and layout to Central Park, whilst locating tennis courts at the core of each denominated *inmueble-villa*. Moreover; each apartment owned a 'sport room', an indoor gymnasium of sorts, located by the bathroom, where hygiene and the 'cultivation of the body' converged. Rooftops were equipped with gyms and running tracks. The notion of the city as gymnasia was quite in tune with sport's embedded hierarchies. Thus, the citizen-amateur first practised within the seclusion of the private apartment, to then compete on courts and roof decks, whilst the stadium's arena became the ultimate venue, for the celebration of outstanding athletes.

He had mobilized similar conceptions in the 1925 *lotissements à alvéolés*, a collective housing development destined for farmers newly arrived to the city. Mastering another level of reciprocity between play and architecture, it drew on the *do-mino* combinatorial potentials with parallel bands of greenery (ornamental and productive gardens) and playgrounds structuring the site. A striated pattern of sports grounds and playing fields woven with garden strips – as if a fragment of Koolhaas' La Villette *avant la lettre* – thus conjuring work

FIGURE 96 *Le Corbusier's Alveoles condominium, with alternating strips for 'play', 'garden' and 'allotments'. Allotments indicated in grey Drawing by the author after Le Corbusier.*

and play. Folding around quadrangular fields, the apartment blocks intensified the visual and aural interplays of play and domestic life. Moreover, Le Corbusier's mathematical distribution of space reciprocated a division of time in eight-hour segments for farming, recreation and rest. The much-needed restoration of nervous health, said he, required the practice of sports at every hour and in every day, at the foot of the residences rather than in specialized athletic grounds. Sport was, in his view, primarily restorative. By 1925 he turned the 12-storey hanging gardens inwards, so as to face the courtyards, thus strengthening the bound of cells to arenas. Likewise, he recast the fields to include football and tennis (the early modern architect's staple sports).

In his contemporary *Lotissements a redents*, sport arenas were located at the front and back, either toward the secluded courts, or else toward the street; but it was in the Ville Verte that these ideas were consummated. He acknowledged that much:

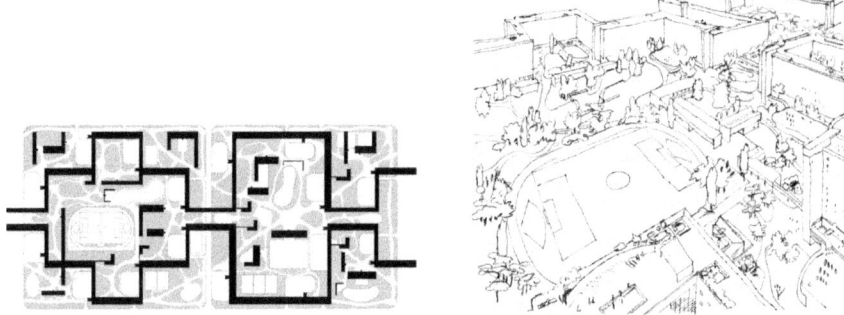

FIGURE 97 *Football, tennis and swimming in the collective grounds of Corbusier's Ville Verte. Drawings by the author after Le Corbusier.*

a complete stadium (sic) grand swimming pool with sandy beaches, tennis, children's playgrounds, play spaces under the pilotis . . . and an immense provision of sun bathing spaces over the roof gardens: sport at the foot of residences 100% of the ground. Sand beaches over the apartment blocks 12% of the ground. Grand total 112% of the ground available (for recreation).

LE CORBUSIER, 1933

The prodigious multiplication of arenas contrasted with the conception of the cell as a sealed capsule, yet – and this was the novelty – these were visually extroverted. Le Corbusier's invocation of the monastic cell is well known; he just turned it outwards, however, substituting the confinement of the cloister for the command over generous prospects. But the scheme's benefits were even greater, for the same amenities that furnished so many ludic opportunities turned out to be effective against aerial warfare: the spaciousness of its gardens and the free grounds aided the dissipation of poisonous gas, its high-density blocks were shielded against 'air torpedoes', whilst its pools and ponds became reservoirs for fire hazards (Le Corbusier 1938, Cohen 2011).

By 1942 he designed the *Mourondins*, a set of self-built provisional barracks for war refugees (Le Corbusier 1942, Cohen 2011, 61). Everything in it was elementary, including the services and amenities, some of which were shared. Their Cartesian layout contrasted with the seemingly random patterns of the neighbouring 'ville sinistrée'. Each residential unit framed a quadrant with a lawn singled out as 'pelouse jeux d'enfants'. Moreover, all courts faced on to vast collective arenas that accommodated a school, a crèche, a restaurant, a club and vast playing grounds.

As in previous cases, a crescendo of sport facilities structured the individual's ludic path, covering a range of practices from solo to the social, from the

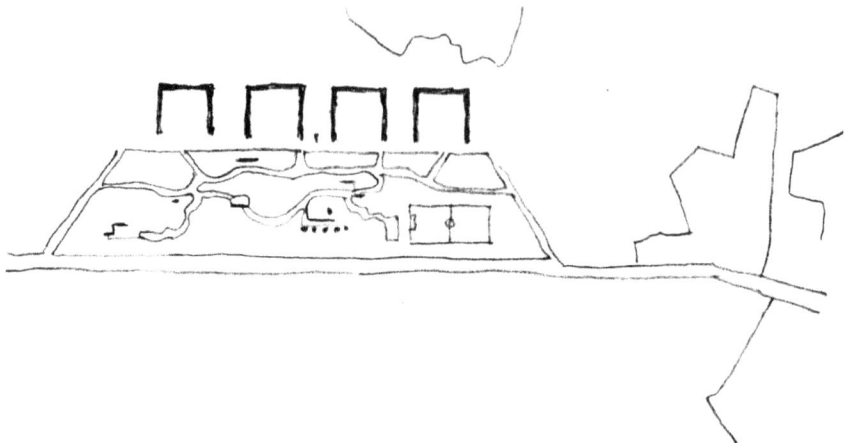

FIGURE 98 *Le Corbusier's the Mourondins, provisional housing for war refugees, 1944. Overall plan with the devastated city on the right, emergency dwellings around courts with lawns indicated as children's play areas and extensive sport facilities in front park. Drawing by the author after Le Corbusier.*

unstructured to the structured and eventually also, from the ordinary to the extraordinary. It is noteworthy that children's provisions exceeded the space allocated to *Ludus*. Just as significant is Le Corbusier's acknowledgement of the Boy Scout movement, a ludic society ushered to the rescue of a Europe in ruins, with its play leaders becoming the artifices of the new order. But the transit from the obsolescent traditional city to the modern habitat was not easy: the Mourondins were conceived as a sort of a training facility destined to show the 'opportunities for a normal expression of social relationships and (facilitate) a transition for new conceptions as to how to live in the city' (Le Corbusier). Thus, these denominated *caravanserais* were training grounds for a new habitat with its highly improved infrastructures, extensive playgrounds, clubs and sports fields[11].

The association of apartment cells, tribunes and the arena exceeded the architect's personal intention however, acquiring the status of a (declared or implicit) epochal agenda. Conscious about the radicalism of such proposition, Giedion spelled out its fundamental tenets: he affirmed that every residence should be the adequate background to leisure.. Despite ideological gulfs, his statement became a guiding principle for subsequent projects. Leisure, so conceived, was then primarily, sport-like, for as we will examine, in the course of time, children's playgrounds gradually substituted the sport arena but the principle remained unscathed.

Clearly fuelled by English practice, such intentions were akin to substituting the city of Bath's residential lawns with playing pitches. Giedion (Rasmussen too,) witnessed the actual conversion of gardens into fields in Georgian London. He also drew attention to the swift access to sport in Lubetkin and Tecton's

Highpoint housing, with its 'playgrounds at the door step' (Giedion 1941, 643). Le Corbusier had also praised the scheme in the *Architectural Review*.

The design of stadia was also topical: thus, for example, Le Corbusier's 1929 *Mundaneum* and his 1936–1937 *Centre National de réjouissances populaires de 100,000 participants* (the latter was recast in his Buenos Aires 1938 Plan) were monumental prototypes that seemed to anticipate totalitarian uses, such as contemplated in Mussolini's *Foro Italico* and Hitler's megalomaniac *Germania*. Terragni and many others engaged these epic agendas offering truly 'Roman' oversized constructs. But, as we have seen, sport and daily life mingled more productively in the conception of residential quarters.

Sports fields also featured as significant elements in Le Corbusier's 1937 International housing exhibition, as well as in the 1934–38 Agricultural Cooperative Village. He inscribed fields in diverse scenarios: amidst agricultural crops, cushioned within the rambling paths of English gardens, or more predictably within colossal stadia.

With the sole exception of Chandigarh, Firminy Vert stands as the most important urban scheme materialized by Le Corbusier, with its Olympic complex including a stadium, a field, a swimming pool, a gymnasium, running tracks, a house of culture and a church. In parallel he considered three housing blocks (of which just one was realized). These emblematic leisure agendas counteracted the mood of Firminy *Noir*, the former coal establishment, so redolent of toil and soot.

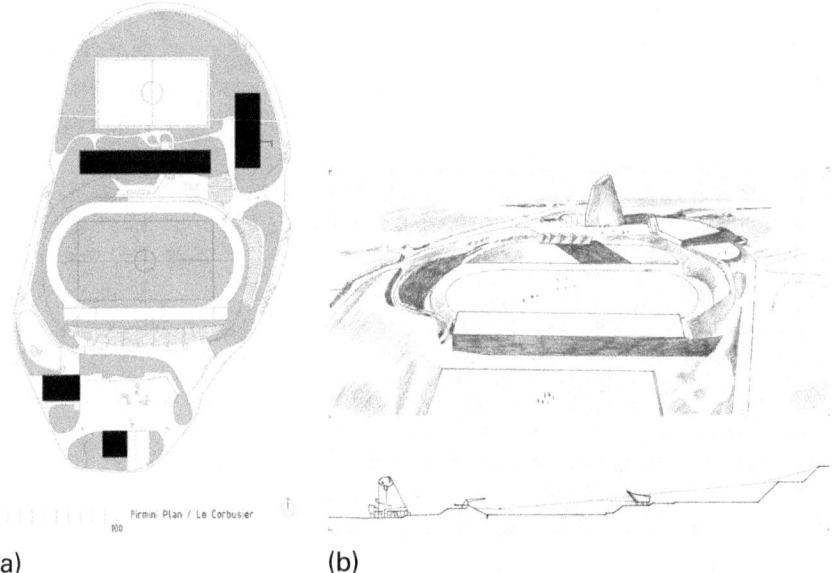

FIGURE 99 *(a) Le Corbusier's Firmini Vert sport ensemble with church swimming pool, stadium youth centre (miracle box); (b) secondary field. Drawings by the author.*

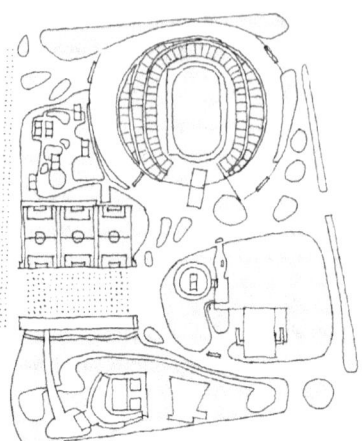

FIGURE 100 *Le Corbusier's stadium complex in Baghdad, including swimming pools, gymnasia, tennis and football. Drawing by the author.*

The complex of stadia, fields, sport facilities and church was accommodated over abandoned quarries, and a broad sequence of terraces, betraying that Greek trope about fields integrated to landscapes. Acknowledging the subtle balances of land forms and building masses, certain authors dubbed the complex an Acropolis. Perched upon a rocky escarpment, the Youth Centre (that replaced the earlier House of Culture) sheltered a concave open-air theatre. The church assumed prime spatial and symbolic roles; just as in sacred Delphi, athletics shared the space with theatre, and religion. The model was decisively Greek, as befitted the rapport of play and landscape, the concurrence of the sacred and the profane, and the direct engagement of spectators and performers. Not far away, residential quarters also sported fields, consummating the rapport of domestic cell to arenas.

Later in his career Le Corbusier designed Baghdad's sport complex, a little-known project of which only a fraction was realized, which orchestrated a stadium, gymnasium, tennis courts, swimming pools and football grounds. The 1958 plan makes evident the conceptual and compositional impasse caused by the collision of these geometric templates onto 'free' garden layouts where the modest patches of greenery utterly lacked the scale required to make credible counterpoints to the massive hulks. However, this notion of stadia set within gardens followed a well-established convention.

A radical turn was evident in Louis I. Kahn's 1961 renovation of Downtown Philadelphia. Fluvial systems were analogous to traffic, argued Kahn, articulating flow, calm waters, moorings and points of interchange. In transferring the logic of hydraulics into traffic he set himself to orchestrate speeds, tempos and intensities (the musical analogy being just as pregnant as

FIGURE 101 *Louis I. Kahn's Market Street East, Philadelphia, 1961, with arena near the town hall. Drawing by the author after model by Kahn.*

the fluvial one) whilst also smoothing the links of expressway and doorstep. Moreover, the graded architecture of viaducts framed the urban core: mastering these mega-forms: he let highways play an urban function analogous to the robust medieval defences (he liked to quote Carcassonne).

Kahn made no attempt to soften the edges of the embedded stadium. His strategy was congenial with the expressways loops whose vast turning radii also accommodated the city's reservoir. Embedding the stadium within road infrastructures was a novelty, its logic beautifully rendered in flow diagrams and a relief model where the network of expressways was described as equal to urban landmarks. Flow was tuned to topography: . . . 'the expressway bridge connects directly with the stadium and its arena', said Kahn: 'underneath the stadium there will be lodged the new institutions devoted to sport and health, as well as the entertainment centre. Over the viaduct there will be the institutions linked with swimming pools and so on'.[12] Underneath the public stands, parking and urban amenities supplied street level activities. The restricted access to the arena was conventional, not so its embedded condition that recalled Durand's arenas nested in institutional matrixes, but it was most probably inspired in models closer to Kahn, such as, for example, Piranesi and the more familiar Penn university stadium, the kind of establishment eulogized by Le Corbusier for its 'white and clean naves'.

Kahn upgraded the status of the stadium in his 1962 commission for the new capitol in Dacca, East Pakistan (now Bangladesh), an assignment charged

FIGURE 102 *The stadium at the core of the Citadel. Louis I. Kahn, Dacca, 1964. Drawing by the author after model by Kahn.*

FIGURE 103 *Louis I. Kahn's Fort Wayne fine arts centre, Indiana, 1961, 64 with stadium across railway line. Drawing by the author after model by Kahn.*

with obvious, but nonetheless elusive, symbolic resonances. He delved heavily into the notion of human institutions, and was keen to examine their relationships. He attempted to strengthen them by adjacency, conjuring up associative potentials: should the high court belong to the 'citadel' of government? Should the mosque be embedded in parliament? Critical to his thinking were the interplays of civic with ordinary affairs, and the experiential and symbolic value of propinquity.

Early on in the development, Kahn visualized two compact clusters, comprising a full range of representative buildings, each endowed with a mission. An expanse of grass and water mediated between the 'Citadel of the Assembly' and the 'Citadel of the Institutions', with the parliament chamber at the core of the former, and a sport arena at the latter. In devising the stadium as core, he was stalking its prime representative status. This was not yet another sport complex on a prime site, but rather the urban counterpoint to parliament, of equal weight and significance to the political institution at the fulcrum of the modern state. Gymnasia, market halls, auditoria and swimming pools, clustered around it, just like offices, meeting rooms and concourses did around the deliberating chamber.

Khan's vision harked back to Rome:

> It should be a place of exercise and encounter . . . [it] ought to honour the athlete . . . it is inspired in the Roman baths . . . it includes a stadium, meeting spaces, baths, exercise spaces and its own gardens, together with a school of sciences and a school of arts . . . commercial services surround this edifice.
>
> <div align="right">FECHA KAHN</div>

Not only was the stadium a magnet but its arena (usually out of bounds), was made accessible from the streets, thus suggesting a fusion of field and square similar to Sienna's Piazza del Campo, the agora-cum-arena he had so eloquently portrayed in his Italian sojourn. It matched in grandeur

FIGURE 104 *Coliseum and debating chamber in Louis I. Kahn's, Dacca, (penultimate scheme):* left *Citadel of the Institutions;* right *Citadel of the Assembly, 1964. Drawing by the author after model by Kahn.*

Garnier's colossal baths and monumental stadia devised for the 1917 Cité Industrielle.

Yet, ancient agonistic propensities such as the ones highlighted by Tzonis also resonate in modern parliaments. Perhaps Kahn pondered the shared agonistic foundation of parliament and sport, thus confronting their arenas, but this is no more than a conjecture: what is undeniable is his deliberate emplacement of these (and no other) institutions face to face, equally commanding the grounds. Alas, it was an evanescent hope, for in later versions the monumental Secretariat substituted the Citadel of the Institutions, thus diluting the interplay. Endowed with civic significance, the rituals of play enjoyed a prime setting in Dacca, only that just for a while.

However, the virtually limitless lawn stretching between the citadels ('not a single tree should disturb this surface' he admonished) suggests a vast Maidan, a vastness inherently 'modest' and 'lacking in ornament', a 'middle ground, between the uncivilized domain of the wasteland and the cultivated domain of the park; versatile, indeterminate, and apt for play' (Mathur 1999, 204, 219).

Was Kahn nesting the citadels within an expansive Maidan? He had witnessed Lahore's Iqbal Park, with its endless ranks of cricket players. In earlier times, colonial masters had seized upon the Maidan as an instrument of isolation in line with the European glacis. In Calcutta for example, it mediated between Fort William and the potentially restless 'native' populace, easily

FIGURE 105 *Ludic arenas and civic spaces in Abbas Abad, Teheran, 1974: oval square and rectangular maidan with stadium embedded on the hills on the left. Drawing by the author after model by Kahn.*

FIGURE 106 *Alison and Peter Smithson, Kuwait old city, Orangerie Maidan 1969. Image courtesy of the Frances Loeb Library, Harvard University Graduate School of Design.*

accommodating a race course. Devoid of spatial traits, its sheer vastness diluted containment, in contrast to European squares yet it was – in the eyes of Mathur – rather akin to the Anglo-Saxon Commons. Kahn took an express interest in the Maidan, however, when elaborating a preliminary scheme for a new administrative centre in Teheran's Abbas Abad hills (1973, 74). As with Dacca, the ensemble gathered major civic institutions. He articulated it on an axial sequence that linked an oval square (it followed the outline of St Peter's in Rome) with a rectangular Maidan (which exactly followed Isfahan's outline). Off centre, a stadium nested upon the hills.[13]

Developed roughly in parallel to Kahn's Capitol, the Smithsons' 1968–1972 Kuwait Urban Centre sported an Orangery Maidan lit by gas torches, conceived as a locus for national feasts and equestrian shows, also a Sports Maidan equipped with baths, gymnasia, a youth centre and clinics, promoting the good health and recreation of the urban populace. These were laid over consecrated burial grounds. These allowed for secondary uses due to the lack of permanent headstones (Smithson 2005, 137–169). Much like Kahn, in appraising a culture in so many ways beyond reach, their ludic agenda wrestled with extraordinary local conditions. Alas, the doomed scheme prevents our appreciation of these large expanses as either nondescript, or veritable 'charged voids'.

Bucolic deportments

The symbiosis of sport and urban living was innate in early modern architectural agendas, with the athlete therein impersonating a renovated citizen. Football, tennis and swimming were the preferred activities. (Although baseball, American football and others had considerable urban impact too, these were not seen as integral to urban schemes as the reviewed ones.)

Golf became critical to the North American synthesis of play and domesticity: a powerful attractor in the evolving conception of suburbia, and a

privileged engine for real estate ventures, thus re-editing that old idea of the ludic arena as communal foci.

Its idiosyncrasy accounts for the particular acceptance of such a proposition for – as we have seen – far from the meagre spatial projection of football or tennis, it construes desirable ambiances, full of imagery and character. Eminently picturesque, most courses articulate arresting sequences. Moreover, it does not beckon multitudes. Its drama unfolds parsimoniously. Smart attire, elegant equipment and superb environments add to its allure.

No doubt social, rather than bourgeois, ideals nurtured the most memorable European architectural agendas, for these were stimulated by a collective worldview, whereas in golf the aspiration was more about individual satisfaction. The conjuring up of residential landscapes through the golf course achieved such astounding acceptance, however, that the formula eventually became a template for 'gated communities' worldwide.

We have already examined the course's adaptability to layout, place and climate, but golf is also particularly adaptable to urban morphologies. The pliability of its course eases the integration with residential or business compounds, with an adjustment to site, configuration, and topography simply unknown to most other sports. This was so because of its freedom from prescribed orientation and its linear matrix of fairways allowed for topographic and geometric adjustment. However, such disembodied courses did not allow for overall visual control as was the case with panoptic fields and their stationary spectators: neither could one perceive the architectural tension between cell and arena as previously examined. Certain villas by Lewerentz,

FIGURE 107 *The urbanism of golf: ludic and residential tissues at islands.* Right *compact golf course detail. Florida, John Nolen. Drawings by the author after Nolen.*

Neutra and Mies Van der Rohe confronted golf courses, without particularly embracing ludic issues.

The critical exploration of the course's potential was assumed by planners, developers and landscape architects, notably John Nolen, a disciple of Olmsted and a friend of Unwin's who wrestled with its potential as generator of new urban (or more properly suburban) synthesis. Certain early formulae for such synthesis soon acquired the status of models.

In Belle Air (1924), Venice (1926) and Dunedin Isles Florida (1926), Nolen articulated field, residential lots and waterfronts in essentially two variants: a compact one, with the golf course wrapped by dwellings, and an expansive mode with a linear matrix of interwoven fairways and residential patches, the dismembered fairways multiplying the shared boundaries. His privileged scenario was the high-quality suburb. Whether from his influence or other sources, the imagery of the course as urban attractor soon spread. The symbolic presence of the club house at the fulcrum of such estates significantly displaced the secular, or religious, symbols for the playground. We have seen how enduring the trend was, for places like Arizona's Biltmore became foundational stones for extensive developments. The idea was so effective that several Sun Belt economies seized golf as the agent of growth. 'Play to live; live to play' spelled the *Arizona Monterrey Homes*. With no trace of irony, the senior citizen condominium sponsored a late return to childhood. But these were powerful real estate engines, as palpably demonstrated by the wholesale substitution of the field for the urban square in so many suburban developments.

So why was golf not considered worthy of that marriage of sport and residence so cherished by modern architects? Unlike mass sport, with its epic scale and the communion of players and public – sometimes homologated to that ancient Greek complicity of actors and choir – golf was perhaps too parsimonious, its practice too expensive, its outlook most probably too bourgeois for it usually exuded privilege. Whatever the reasons, it did not fire the early modern imagination. As with the fairground, its parallel narrative was largely ignored in mainstream discourses. It was effective but it did not touch utopian thought.

If such was the potential of *Ludus* in the making of novel urban scenarios, what was the situation with *Paideia?*

7

The child

Introduction

*P*aideia, the classical Greek education, was redefined by Caillois as a mode of play that drew from childhood's impulsive character and relentless improvisation but was by no means circumscribed to childhood. Nevertheless, it was from children's play that modern architects envisioned their scenarios of unbridled action. Whether wrestling with an oxymoron or not, they attempted such synthesis with increasing impetus in the aftermath of the Second World War; henceforth, they often substituted sports fields for children's playgrounds as social cores, particularly so in residential compounds.[1]

Childhood play is both informal and devoid of stable rules. Stimulated by its sheer exuberance, modern architects and fellow artists found in it a call for abstraction, yet however abstract their responses, these could also nurture from rich analogies. Playground designs often bespoke desirable urban scenarios; their distinct formal sets frequently conceived like correctives to mundane building forms, with their bizarre and memorable identities displayed against the excessively serialized mass housing estates. Quite unlike the average arenas devoted to *Ludus*, the universe of *Paideia* was plentiful in associations; whilst it offered great design freedom, moreover, its designers could literally invent the arena anew. Unlike the hyper rational hygienist correctives introduced into the city in the form of public parks, modern educational ensembles, certain infrastructures, and the solar orientation of buildings, the scenarios emanating from *Paideia* were primarily drawn from the imagination. Projects were short lived, however, often because they were so defined from the outset, also because of demographic change, diminishing demand, or a gradual loss of aura.

In looking at *Paideia* we shall consider primarily the issue of visibility as a token of social priorities, and also the discursive overtones, for architects often invoked play in order to touch upon other primary issues.

Disney's vision has coloured modern perspectives about childhood ever since the 1955 creation of *Disneyland* in Anaheim, California. Although hugely

FIGURE 108 *Size dilemmas: (a) Prouvé's 1936 miniature desk; (b) Rietveld helps the child to reach the adults' table. Drawings by the author.*

relevant, its corporate perception about childhood was insular and condescending. In looking at the child at play we will review instead cases where the subject was treated with due dignity, where the ludic did not become an excuse for puerility, the sentimental or the insubstantial, and where architectural quality was beyond question.

In his extensive enquiry about childhood, Philippe Aries distinguishes two paradigms: in one the child is understood as an imperfect creature essentially lacking in skills and resources, in the other it is perceived as the very emblem of innocence, thus morally superior to any adults (Aries 1962). He makes it clear that as a cultural construct, the notion of childhood is prone to contradictory interpretations.

The conception of children's furniture exemplifies the case: as if correcting an inherent handicap, Rietveld's 1923 wood and leather stool assisted the child in reaching the adult's table. Conversely Prouve's 1936 miniature nursery desk and chair submitted the scale of all elements to the child's body. Whilst the former accelerated the child's integration into adult ways, the latter delayed it for a determined period of time. The design consequences of these alternative outlooks were widespread.

Modern thought soon reckoned play as a vital tool for the forging of the individual personality. This conception led on to the modelling of schools and specialized urban playgrounds. It also reached the residential sphere, for it was thus that increasingly the playroom, the sand pit, assorted outdoor playing equipment, together with the domestic swimming pool became staple

residential elements, particularly so in the North American middle-class scene. In these scenarios, certain criteria about supervision, autonomy and freedom merged with adult ploys about keeping chaos under control, much like in the aforementioned Robbie House with its specific ludic domains but at other scales, *Ludus* was sorted out from *Paideia* in domestic and urban terms.

Outdoor amenities such as 'play yards' were soon added to the playroom. Marcel Breuer's MOMA 1949 house defined highly particularized outdoor domestic settings such as a car port, a terrace, service yard, and a play yard with a sand pit, plus of course, a garden. *Creative Playthings* supplied the ludic implements. The differentiation of usages according to age and function henceforth characterized the suburban house in the USA, thus betraying changing attitudes about childhood and play in general. These exercises reinforced the notion of play as something to be sheltered, whilst its collective dimensions were extensively researched in Europe. In 1957, Dennis Lasdun famously re-articulated the row-house communities of tenants in Bethnal Green in a Cluster Block. Fully conscious about the ludic role of the yard, he recast it as aerial patios with a shared use for laundry and play that were understood as collective amenities.

Childhood became emblematic of a new order of things as pointed out by Stan Allen when observing the way children were featured in the architectural media, as subjects totally relieved of the weight of history, convention and tradition, with suggestive parallels to be drawn between childhood and the condition of the ex-novo habitat (Allen 2000, 23).[2]

Arguably, urban places must be relevant to the child's initiation into public life, but the issue was vehemently contested. Should their environments be

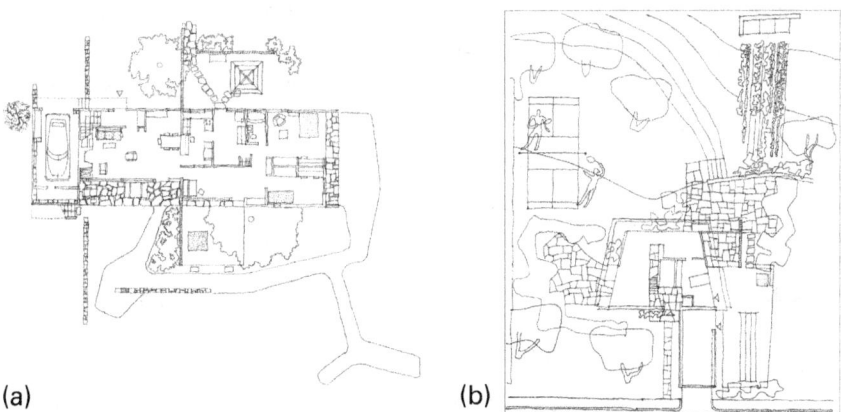

FIGURE 109 *Play-oriented traits in the post-war house: (a) Marcel Breuer's Moma House, 1949, with playroom next to children's bedroom and children's court with sand pit in the garden; (b) Louis I. Kahn's sun house with tennis court. Drawings by the author.*

generously supplied with 'greenery? Or should the hard and overly exposed public square be more appropriate? Should streets become playgrounds? And which should be the appropriate scale assigned to children's spaces?

Playground design followed certain criteria for the aforementioned initiation rites, albeit often just implicitly. Their emplacement, distribution and character were indicative of general ideas about urban ordering according to the citizen's age, gender and kind, just a modest quantum in the territorial and hierarchical ordering of things brought about by modernization: they thus posed relevant dilemmas. How were these addressed by architects?

There was no consensus for they reached the most diverse conclusions: thus, the air space, the street, topographic ensembles, miniatures, junk yards, lush gardens and the public square characterized so many valid options, each one casting a particular ambiance. Their descriptions were topographic as much as topological for they betrayed all manner of urban rapports which represented contingent viewpoints. Le Corbusier, the Smithsons, Van Eyck, Pikionis, Sorensen, Kahn, Noguchi Rossi, Burle Marx, Breuer, and a host of artists and architects partook of this quest. Whenever circumstances permitted, they also envisioned very particular and sometimes odd locations, whilst the idea of play was persistently reviewed.

The sky

> If you want to raise your family in seclusion . . . place yourself among 2000 persons . . . your houses will be 160 feet high . . . there will be parks for the games of children . . . adolescents and . . . adults. The city will be green. And on the roof, you will have amazing kindergartens.
>
> LE CORBUSIER 1965, 208

Such were the thoughts gathered by the architect when accounting for the *Unités* (of which he had already built five). Their functional structure was stratified: parks were for all, but rooftops were mostly reserved for children.

Robin Evans pointed to the way in which building plans mapped human relations. Sections which are dependent on the plane of projection are perhaps less eloquent in this respect, but when a social system becomes subordinated to a stratified system, sections map them just as efficiently. Such is of course the case with *Unité* with its programmatic stacking of uses. Marseille (1947–1952), that led the experiment, was by common consent the most accomplished one. Its children's play areas spread over its summit, 56 metres above the ground.

 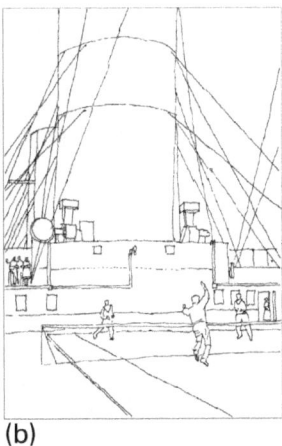

FIGURE 110 *Play on decks: (a) a school in Islington, London, photo by the author; (b) the Empress of Britain tennis deck 'here in the middle of the ocean, tennis and swimming pool, sunbathing ... and enjoying the boat's girth ... dimensions apply to the ville radieuse' (Corbusier), drawing by the author.*

Roof deck recreational uses date back to earlier design strategies. Certain urban schools featured rooftop play yards long before the modern movement, but these propositions surged from logistics rather than doctrine. As early as 1930, Walter Gropius foresaw their uses for solaria, gymnastics and children's playgrounds: likewise, following the observation of passenger cruise ships, and also inspired by the increasingly fashionable seaside resorts, Le Corbusier's 1930s Ville Radieuse assigned solariums and sand beaches to the rooftops. Sheltered behind high parapets, these enjoyed an exclusive communion with the sky.

It was in Marseille that these goals first materialized. Other than a swimming pool (which could have provided an element of identity if it hadn't been aborted in the early design stages) the layouts of its grounds were rather generic, yet its 24 by 125-metre deck was truly memorable, with the 300-metre running track's sharp bends folding around a gymnasium, a solarium, an elementary theatre, a crèche, a paddling pool and play spaces. The roof deck was not exclusive to children but its vitality owed much to children's play.

Following Marseille, Le Corbusier pursued the subject in Nantes Rezé (1952, 1953), Briey-en-Foret (1957), Berlin (1957) and Firminy Vert (1967), all described – at least in intent – primarily as the domain for *Paideia*. He also reviewed the subject of collective children's facilities in a booklet entitled *Les Maternelles* (Le Corbusier 1968). Whenever required, he expanded the facilities to the floor below the upper deck, but all in all he preferred the ground and summit for leisure and play: extensive carpets of interconnected gardens below, for urban interfaces, and insular roof terraces above where these were precluded.

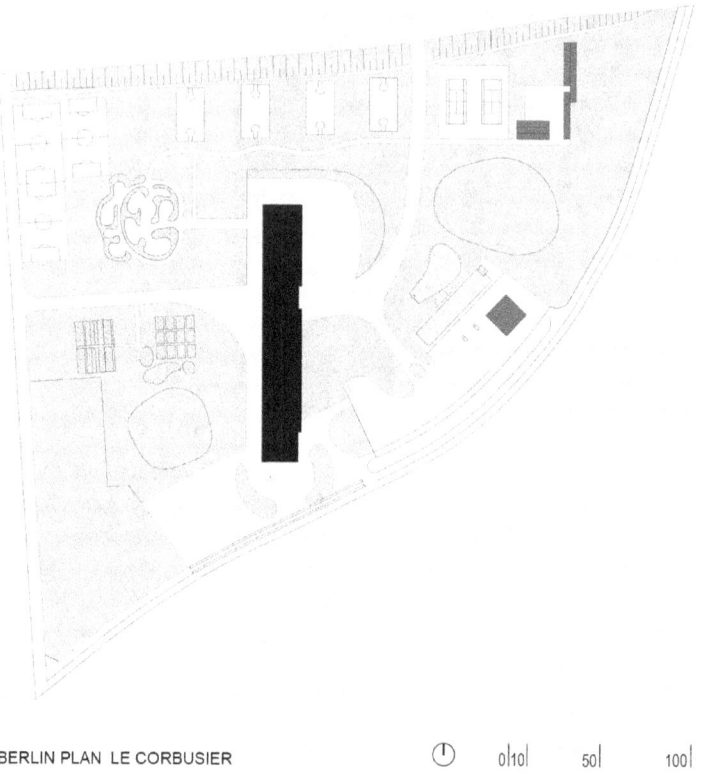

BERLIN PLAN LE CORBUSIER

FIGURE 111 Unité *Berlin grounds and rooftops for play and leisure. Drawing by the author after Le Corbusier.*

All buildings embody specific visual strategies; some relate to supervision, some to concealment. Le Corbusier singled out the unprecedented appeal of the air vision, in *Aircraft* (1935), whereas his *Unités* construed alternative fields, so that panoramic prospects were commanded from its apartments and loggias, whereas a highly contrived prospect was offered in the collective roof terrace, with its 1.8m high parapets concealing the objects of human toil, just framing distant summits and the sky.

Visual command was often guided by an idea of control: Le Corbusier often represented his large blocks with one cyclopean eye, thus turning them into optical apparatuses; simultaneously a result and motivation of the design process, the optical attribute was high on his agenda; we will see how the Smithsons reacted to the same.

Attracted to the horizon, the *Unité*'s residential cells opened to the landscape with the park, the streets, the city and the horizon unfolding at some distance, whilst high up and beyond visual reach, children played in communion with the sky: therefore, in designating one as visible and the

other as invisible, Le Corbusier established a crucial distinction. Their material distinctiveness may be just as relevant, for he designated one as 'soft' and the other 'hard'. Moreover, as if following a lopsided reasoning, he turned the ground 'naturalistic' and the rooftop 'urban like', each appealing to specific sources: the former to the English landscape tradition, the latter a synthesis of Greek classical tradition and cruise liner's decks.

The secluded rooftop also recalls domestic backyards; equally divorced from the street, these traditionally delayed the children's entry into public life, but in Marseille domestic chores were banished from the collective space. Conversely, the communication of *Paideia* with great landscape and cosmic events suggests relations of a different order, not urban, but lyrical, such as the ones so vividly evoked in *Towards a New Architecture*. This initiatory space confronted children with cosmic dramas before releasing them to face harsh, ordinary experiences. Adding to the tactics of invisibility, a deliberate acoustic ploy must have prompted the setting, a likely option when considering the architect's stated search for fully insulated residential interiors conceived as he put it, tranquil *as a crypt*.

The Marseille terrace was also an athlete's domain. Subtle devices such as rockeries, planters, slanted planes, labyrinths and windbreaks separated the riotous children ambiances from the sprint track. Unlike the Fiat Lingotto rooftop which had had such an impression on the architect, here the athlete's only visual prospect was an austere and monolithic space that formally recalled compact urban settings. There, amongst monumental chimneys, concrete carcasses, rocailles, labyrinths and a paddling pool, children socialized among equals, for everything was offered to them, other than condescending designs and the contact with strangers. The logic of the *Unite* dictated that at a later stage they would descend to join school ranks and sport clubs, and to be thus initiated into the athlete's domains.

Rooftops were sometimes developed for the exclusive use of athletes as in Le Corbusier and Leonidov's entries for the Centrosoyuz cooperative building competition in Moscow (1928–1931) but whether atop buildings or on the ground, play was sheltered, away from the street, to which it had been associated from time immemorial. The trend had been incubating for some time: 'no children's playground and no public garden should lie open to the street' stated Camillo Sitte as early as 1900 (Sitte [1889] 1965 179–182). He advocated the withdrawal of leisure into the park.

Withdrawal could be attained either through horizontal or vertical segregation. Play's removal from the street was by no means an after-thought, for it accorded with notions of safety, welfare, health and efficiency. Wrestling with contradictory functions, chaotic, physically dangerous and spatially untenable, the traditional street could obviously not be considered a recreational space any longer.

FIGURE 112 *Tennis court above the Centrosoyus building in Moscow by Le Corbusier. Drawing by the author after Le Corbusier.*

The street

In the early stages of modernism, the commonplace urban street was perceived as an anachronism, particularly so with regard to the independence of traffic from pedestrians. More ambivalent opinions surged in the decades following the Second World War: Jacobs re-evaluated the traditional 'corridor street' as a messy mixture of roles on the face of wholesale redevelopment; Kahn sought to redefine it in the face of massive traffic onslaught, whilst Team Ten architects perceived it both as symptom of urban malaise and as prime instrument for urban regeneration. The iconography they displayed was often drawn from play.

Jane Jacobs reckoned in street play an index of the urban system's efficacy and social health. Kahn concurred through personal mementos: 'when I was a child', he recalled, 'we never went to specially designed play spaces; . . . play was inspiration, not organization' (Kahn, 2002, 1998). In a somewhat

similar spirit, Ivan Illich likened the old-fashioned street to the commons: 'like any true commons, the street itself was the result of people living there and making that space liveable' (Illich 1983).

The Smithsons took a keen eye into neighbourhood street play. Perceived by them as *arenas*, these scenarios were charged with allusions to the ludic and the agonistic as in Nigel Henderson's Chisenhale Road photos, where streets doubled as playgrounds.

The photographic essay was part of an anthropological research about London's East End deprived quarters. Conducted by his wife Judith, it was understood by the Smithsons as 'a shift to the specific', one that would influence their orientation. In their view the Hendersons' work 'had begun to emerge from the rain forest to the street', making the commonplace as fascinating a subject as the exotic; the pictures revealed 'a microcosmic world in which the street games change with the seasons and the hours are reflected in the cycle of street activity' (Walsh 2001, 150). Their collating of the Henderson pictures in the 1953 entry for the Aix-en-Provence CIAM congress is well known: it is also indicative of the value they assigned to *Paideia*, and their belief in children's play as a general model of social behaviour. They stated in 1967: 'in the uninhibited organization of the children's games, we are seeing a valid pattern, and this is an indication of a freer sort of organization' (Smithson 1967, 10).

Alison Smithson encapsulated such views in diagrams: 'Child association pattern in a street' showed twenty houses facing on to impromptu arenas. Little eyes indicate views across and along the street axis, the former a token for supervision, the latter associated perhaps to the players' control over the field. 'Diagram of streets with scratching indicating the zones of social contact' showed rambling paths criss-crossing the street, designated as *arena space*. Wiggly lines represented neighbour contact across boundary fences. Like a social mechanism, the commonplace street was subjected by the Smithsons to enquiries about scale, critical numbers and structure.

The multiple eyes contrasted with Le Corbusier's massive cyclopean one, drawn from the housing block, as we have seen. Likewise, the East London riotous children contrasted with Le Corbusier's disciplined sportsmen; their random patterns with the rational ones sported by athletes at play; the gestures and expressions of *Paideia* with those of *Ludus*.

Although the Smithsons' evaluation of the traditional English street was deeply ambivalent, they gave it due prominence: 'the street in the late nineteenth century and early twentieth century' asserted Peter Smithson, 'was the arena of life. To perceive that the invention of another sort of house was the invention of another kind of street, of another arena, or maybe not an arena, wasn't exactly . . . a question of saying the street must be revived' (Smithson).

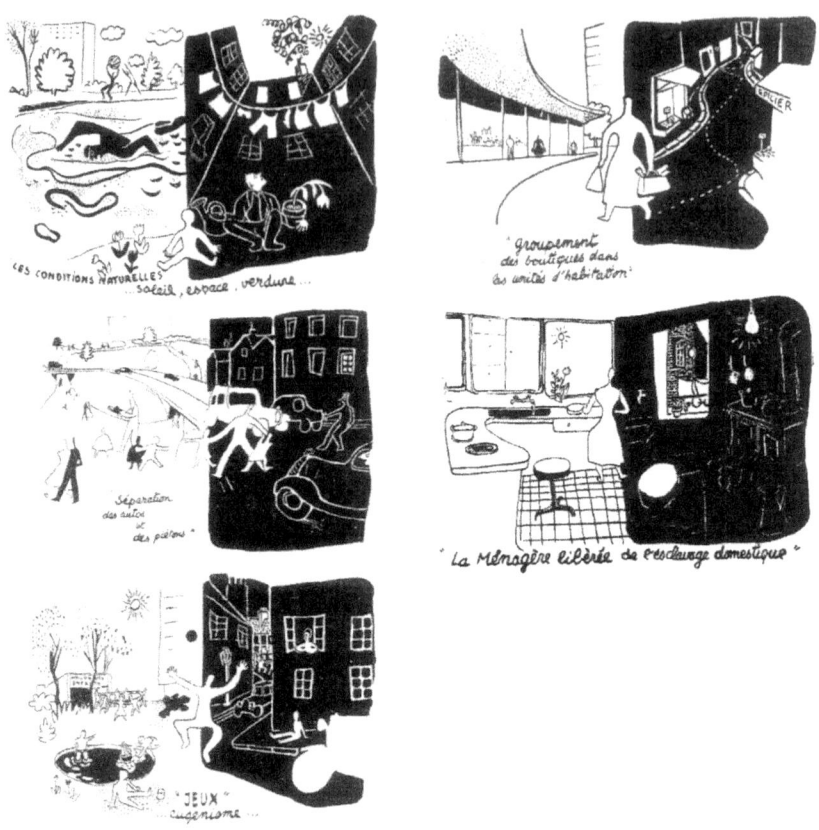

FIGURE 113 *Ludic counterpoints, sunshine and urban misery, according to Corbusier's, Jeux Eugenisme, c. 1940. Copyright FLC / ADAGP Paris and DACS London 2017.*

Human associations that took into account human interchange, as well as territorial criteria, were their substitute for the CIAM definition of the four functions, where play had been subsumed within the concept of a cultivation of body and spirit. Le Corbusier's own vignette entitled *Jeux; eugénisme,* rendered these differences sharply for it gave not even the slightest consideration to the traditional street as a subject of interest and even less so as a locus for leisure.

The Smithsons' 1952 Golden Lane scheme famously introduced streets 'in the air', with its decks widely open to the landscape. Because the blocks were (at least notionally) expandable, these could thread veritable urban networks. Play was expected to unfold in these spaces, and as such it was displayed by the architects; but when it came to collective leisure amenities, they reverted to convention, laying the playground and community centre amidst lawns at street level. 'Going down to the ground' they affirmed, 'will be a small event, like going

FIGURE 114 *Play facilities at street level in Smithson's Golden Lane scheme. Drawing by the author after A. and P. Smithson.*

to the cinema, to school, to the office or to play tennis . . . a special journey for a particular purpose' (Smithson 1970, 59). Field games were obviously to remain as episodes in the park much as Le Corbusier had envisioned.

However, *Paideia* furnished them with a desired alternative to the urban formulae, which was by then, Canonical. Embracing *Paideia* was akin to accepting chance in the design process. Chance which was present in accidental encounters could also become a procedure: Dubuffet and Pollock's paintings were *discovered* within the process of making, they reasoned, not *prefigured*. In the same vein, the *as found* 'shifted the creative moment from design to selection'.[3] It valued the chance element, as purists did with the *objet trouvé* and the Surrealists with the *exquisite corpse*, but it also nourished from empirical criteria, the everyday and the commonplace. Chance patterns were explored by the Smithsons both at the urban and domestic levels.

A *poupe à habiller*, a cut-out print with the purpose of dressing out a figure with alternative outfits, supplied them with another ludic model, inspiring this time the 'select and arrange' technique. It was a topological game about choice and fit, greatly influenced by the Eames whose design appraisals and lifestyle the Smithsons much admired.

Related to *interplay,* a 'reciprocal and mutual action and reaction', the notion of leeway is often associated with mechanisms. The free jottings they sometimes

published to account for particular urban concepts (and which so offended Colin Rowe)[4] betrayed an idea of fit which was more open ended, less contrived than Rowe's contextual figure–ground interlockings. If the Smithsons sponsored a measure of dimensional and figural tolerance, largely based on a loose-fit principle, Rowe's exact fit represented its counterpart. Fit, leeway, adaptability, interplay were recurrent: their *Play Brubeck* diagram seized upon Jazz as a metaphor, its dynamic entanglements of theme and variations suggestive of adaptable design ploys that seemed congenial to fluid urban scenarios. It was ultimately a counterpoint to Le Corbusier's *Modulor:* closer to *Paideia*, the former sponsored a general idea to be interpreted according to the contingencies of the here and now; whereas based on strict metric and proportional rules, the latter accorded with the highly structured domains of *Ludus*.

The street was resilient, however. This 'relic of bygone eras' was still, and against all odds, a prime constituent of the present. Despite its resilience, its imminent demise was a subject of intense debate, with street play often considered in its defence.

In *Streets for People: a primer for Americans*, Bernard Rudofsky challenged North American urban habits, highlighting street play, and chastising the hostile local environments and the puritanical ethos that underpinned American urbanism; his diagnosis was sombre (Rudofsky 1969).

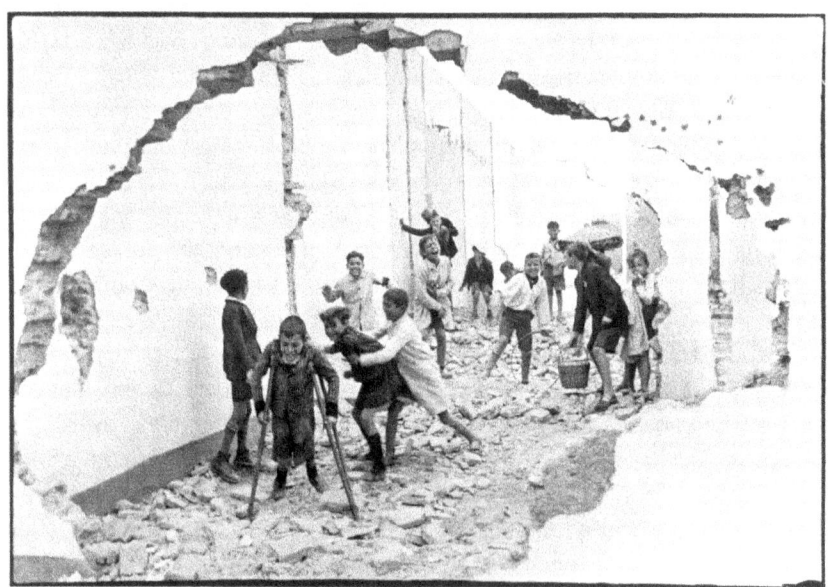

FIGURE 115 *Playing among ruins at Seville, 1933. Photo by Henri Cartier Bresson. Copyright Magnum Photos.*

THE CHILD

Unlike such robust street cultures as the ones that engendered the Moroccan Zouq or the arcaded Bologna networks, American cities, he reasoned, did not welcome informal interchanges. In his view, the removal of children from streets represented an enforced mode of deprivation but he was scathing too about playgrounds, for he saw in them repressive tools of indoctrination, their architecture of 'metal cages and concrete bunkers' particularly aggravating, even more so when considered as urban premonitions (in line with Caillois, play anticipated 'serious life'). Quoting Jacobs, Rudofsky denounced the playground's paradoxical contribution to urban violence.

Like Jacobs, he valued the indisputable credentials of corridor streets as loci for ludic and ritual functions, a role these spaces shared with alternative ordinary duties.[5] He recalled how, long before hippodromes were implemented, Roman streets accommodated horse racing. No doubt he would have appreciated contemporary urban marathons.

The ludic subject stuck in Rudofsky's critique: he quoted Schiller: 'man only plays when in the full meaning of the word he is a man, and he is only completely a man when he plays'.[6] Also T.S. Eliot, for whom the separation of work and play destroys culture, questioned the modern misunderstanding of play, its unimaginative outlets and instrumental manipulations. He was scathing about Froebel's 'passion for cubes', favourably contrasting certain

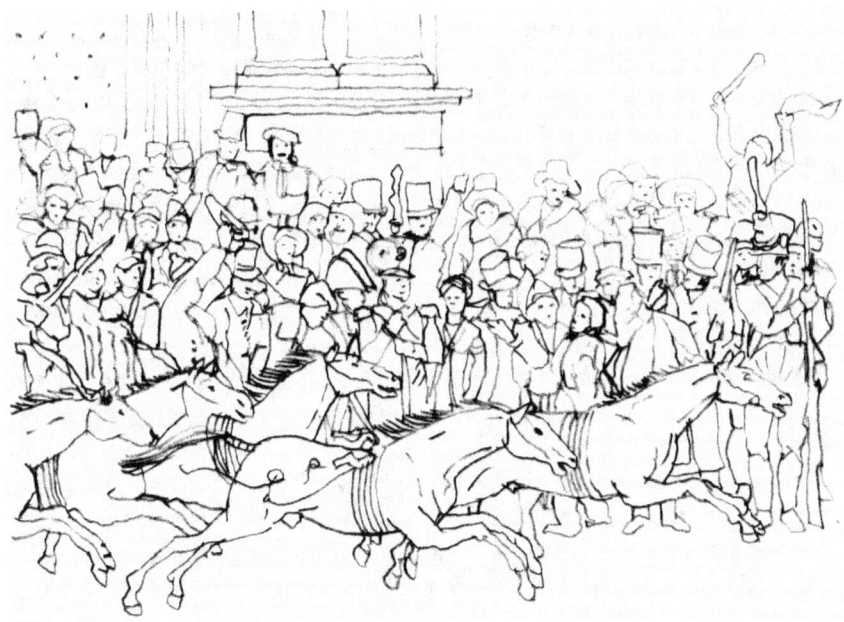

FIGURE 116 *19th-century horse stampede in Roman streets. Drawing by the author after Rudofsky's 'Streets for people'.*

FIGURE 117 *Plastic sensibility and crass insensibility according to Rudofsky: (a) the wonderful imagination of Ethiopian children against (b) Froebel's passion for cubes. Drawings by the author after Rudofsky's 'Prodigious Builders'.*

makeshift toys with such 'impoverished vision' as embodied in a Froebel 'gift'. Toys were in his view just as potent an index of play's worldview as playgrounds, and modern society was failing on both accounts.

Rudofsky's intuition about the function that toys and games fulfilled as anticipation of matters of architecture and planning was not wrong, however. As demonstrated by Brostemann, the Froebel method profoundly influenced the avant-gardes. It can even be seen as an accurate anticipation of certain Bauhaus iconographies and methods, with striking linkages between the early training of such figures as Klee, Kandinsky, Gropius and a host of others and their latter practices (Brostemann 1997). Uncanny resemblances match certain Froebel 'gifts' with Bauhaus studio exercises. Frank Lloyd Wright's debt to Froebel is well known. Le Corbusier, also a Froebel child, applied – perhaps unconsciously – certain compositional principles first tried in his infancy (Max Vogt 1998). The Froebel Gifts did indeed nurture urban propositions, compositional ploys and particular aesthetics. Linkages such as the ones denounced by Rudofsky were very plausible: modern urban choices had a lineage in play forms.

Thus, perceptions about streets were contradictory. Everyone agreed, however, upon the heavy burden exercised by heavy traffic upon them, and its negative effect upon play or loitering.

The ever-increasing car usage caused city officials to teach children to reckon traffic risks and protocols so that the idea of 'traffic playgrounds' emerged from this conundrum, their concept involving vicarious networks safely lodged within parks, thus safeguarding children from real traffic whilst instructing them in elementary protocols. Withdrawn into safe havens, they would learn how to face crude 'reality' later. Traffic playgrounds consecrated an instrumental view of play, and a conception of traffic as something isolated

from the street's convivial functions. In severing children from urban hazards, these shared the shortcomings of zoning: like most playgrounds they became specialized retreats, ultimately embodying an idea of apartheid. Their elaborate patterns also represent a brief episode in landscape history.

The 1938 *Lordship Recreation Ground* in Tottenham, London, comprised assorted traffic challenges. Its loops and circuits accommodated peculiar English quirks with all the paraphernalia associated with traffic management, yet its roads obviously led nowhere, so that learning about the street missed urban engagement and traffic purpose. The recourse to miniature was extensive: certain *traffic playgrounds* featured a miniature pump station and assorted 'street facilities'.

The other outcome of the street's ludic dilemma was the 'play street'. A permanent reversal of street usages was tested in Copenhagen, temporary ones in many other places, holding urban pressures at bay, just for a while. Roadways were sometimes furnished with playground equipment. Either way, street play forfeited a whole host of urban usages. Thus, deprived of their traffic functions and free from unpredictable events, play streets became highly selective. The removal of undesirable mixes ultimately rendered them reductive as conventional playgrounds. However, the experiences led on to programmed street usages, with selected days devoted to jogging, skating, cycling and so on.

No doubt – with the exception of shanties – modern streets became less and less amenable to children. How could an architect redress such an anomaly? How could a devolution scheme be envisaged such as to bring children back into the nitty-gritty of life in cities? Of all architects Aldo Van Eyck was the one who took the subject closest to heart, framing his (ideal) answer in a beautiful metaphor.

(a) (b)

FIGURE 118 *(a) Play supplants traffic in Copenhagen 'play streets'; (b) traffic playground at Lords' recreation ground, London. Drawings by the author after Lethermann and Traschel.*

Anywhere

> The city without the child's particular motion is a malignant paradox. Edged towards the periphery of attention, the child survives an emotional and unproductive quantum . . . when snow falls on cities, the child, taking over for a while, is all at once Lord of the city. Now if the child, thus assisted, rediscovers the city, the city may still rediscover its children, If childhood is a journey, let us see that the child does not travel by night.
>
> VAN EYCK 1956, 199

But the figure of snow was too evanescent. . . 'where there is some room', he pondered, . . . 'something more permanent than snow can still be provided as a modest correction. Something, unlike snow, the city can absorb; and not altogether unlike the many incidental things already there the child adapts anyhow to its own needs at its own hazard' (Van Eyck, 1956, 199).

More so perhaps than any of his peers, Van Eyck embraced the childhood agenda. Artists and children were, in his view, harbingers of imaginary worlds. He envisioned people of all ages intermingling, with children thus reclaiming the city. His vision of snow as something that obliterates habits, dampens noise, and utterly subverts the spatial, material and configurational qualities of a place was a brilliant way of conveying their 'return' to the city.

Pliable like sand, inviting like water, snow beckons play. It overwhelms in its sheer capacity of transfiguring places, but not for long, as it easily degrades into slush.

The metaphor had a tangible counterpoint in the hundreds of playgrounds designed by the architect in Amsterdam. The urban effect must have been formidable, albeit subtle in its local impact, for it was triggered by modest events. The transformation of bombed sites into playgrounds and the ensuing re-emergence of joy in these devastated places must have acted like a balsam, a modest statement of hope against the grim aftermath of war and occupation. Siegfried Giedion reckoned in them a sort of an 'urban vitamin' . . . capable of invigorating the whole urban complex (Giedion).

City commissioner Van Eesteren sponsored the infusion of fresh life into decayed urban cores. The novelty was the agency of *Paideia*: one can clearly detect the receding figure of the athlete so grossly tainted with totalitarian overtones – its significance fading in contrast to the infant, the very emblem of innocence. This was a radical turn, for Van Eesteren's former agendas had considered athletics a token of urban health.[7] As it happened, almost inadvertently, sports fields immersed in parks gave way to playgrounds. Like snowflakes, these spread all across Amsterdam, setting up new public foci and betraying that *corrective measure* of devolution to the formerly

disenfranchised children, who could now claim their rightful place on the urban stage. The action worked both on the small scale, for playgrounds were never too extensive, and on the large one because these modest insertions affected the entire city.

As shown in recent surveys, these proved to be short-lived, however, but being prescient about their function, Van Eyck conceived many of them as stop-gap measures for urban renewal, ways of reactivating an injured city before reconstruction, a provisional status that did not escape John Volcker's attention about the function of time in the urban project. Grand plans could thus be anticipated by ephemeral events. As we will see these perceptions were shared by others.[8]

Traffic islands, public gardens, wide pavements, housing estate gardens or war-ravaged voids were seized by Van Eyck for the purpose. Sites could be awkward, vestigial or simply ordinary, their commonplace existence and wide distribution fitting the idea of *something unlike snow the city can absorb*. Such incredible variety called for firm design strategies: his choice was for a restricted set of precast concrete and tubular steel items. Grading, paving, textures and planting engaged the nuances of each site. Nourished by abstraction and equipped with industrial items, his playgrounds contrasted with the amicable play environments endorsed by Rudofsky, but there was irony too in these 'concrete bunkers' and 'steel cages', for when creating empty plinths, Van Eyck was mocking traditional statuary, its entrenched sense of gravitas and its conveyance of social hierarchy with children hopping about as if dancing sculptures. Such was the function of the concrete pads he placed in Amsterdam's Zaanhug playground.

Much like the harsh play landscapes in Corbusier's *Unité*, there was no concession in Van Eyck's design to cosiness. His tubular steel elements drew on nineteenth-century gymnastic apparatuses, also on the kind of modern tubular furniture that had introduced this cold material into the domestic setting. Tubular chairs had aided relaxation whereas Van Eyck's devices conjured up perpetual restlessness. Woven into reticular structures, like filigree sculpture they construed virtual interiors in a substitution of urban mass for linear texture. They harboured no figurative associations, recalling instead such archetypes as domes and vaults.

Precast concrete was equally alien to the prevailing notion of 'softness' associated with childhood. Moreover, the muted hues departed from the expected cheerfulness conveyed by primary colours, for Van Eyck's playgrounds shared that resilient quality that is often associated with hard-paved yards. Nevertheless, as if opening small windows into the remote domain of the beach, sand pits were the heart of most playgrounds. In contrast to the robustness of concrete and steel, sand invited manipulation so that in these tiny coliseum-like theatres the *arena* itself incited play, fostering a new kind of focus.

FIGURE 119 *Aldo Van Eyck sand pits with modular concrete sets. Drawings by the author after Aldo Van Eyck.*

Tubular furniture, bicycle structures and gymnastic apparatus were significant precedents. It took no time, however, for the tubes' inherent quality as ducts to be reckoned in their ludic potential. Such was the idea behind Noguchi's conversion of reticular ducts into water spraying devices

Van Eyck's efforts were intended as an effective turning from the abstract category of *space* into the factual quality of *place*, through site specific decisions, but in the eyes of most authorities playgrounds were increasingly subsumed within the logics of urban infrastructure: more systemic, closer to the notion of such amenities as bus stops or public phones than place-making,

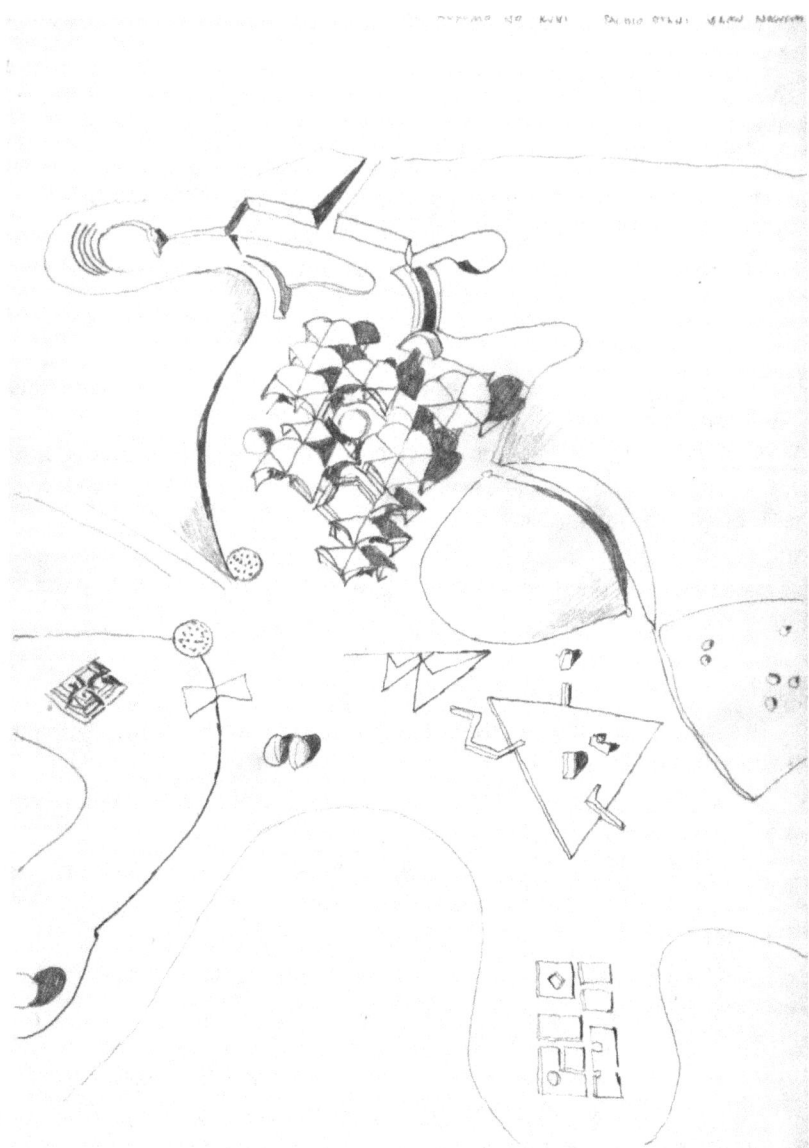

FIGURE 120 *Isamu Noguchi's topographic playscape in Yokohama. Drawing by the author after model by Noguchi.*

becoming as such undifferentiated urban tools aimed at keeping children busy.[9] Yet as from the 1930s, an alternative strategy was incubated whereby playgrounds were conceived as conveyors of urban identity: such was the case with the idea of mobilizing topography in the aid of play. These were to be site specific and formally unique.

Tumuli

> At the new city scale, making a garden should be like making a range of hills . . . today one might make contour relief of the same earth shifting equipment that opencasts coal . . . 'Capability' Brown raised eyes from the parterre to rove among fine silhouetted trees . . . we would be lowering our eyes to look down from our street decks and homes . . . the bulldozer that has been employed to ruin quickly can be employed to make quickly.
>
> <div align="right">SMITHSON 1972 562</div>

Such were Alison Smithson's thoughts about the potential of artificial topographies. She was then confronting the challenges posed by the realization of the Golden Lane urban principles in Robin Hood Gardens. It was as if embracing the English landscape tradition with a new agenda, one which was urbane, democratic in spirit, and technically updated. Topographic manipulation – which had not been part of the Golden Lane landscape – became site specific for, faithful to their doctrine of the 'as found', as in Rome's Testaccio where the accumulation of stacked clay vessels had formed a mound, they gathered the spoil of buildings and wartime shelters in two mounds. Flanked by 'play pits', these filled the garden space; a sunken pitch was also carved by the southern end making room for sports grounds. Topography was thus charged with ludic intent. Two slightly bent blocks flanked the mound garden, with the streets in the air facing outwards, so that domestic spaces overlooked the arena.

Residents did not focus any longer upon the street as in Alison Smithson's diagrams, for their prospects led them now to the sheltered garden. Acoustics had something to do with it, because the attainment of a stress-free environment was also a result of the local authorities' statutory noise thresholds. Aided by noise deflecting ribs on the facades, as well as the perimeter wall's bent profile, the blocks sheltered the garden acoustically. Internal distribution was also organized in view of acoustic criteria, but also play was explicitly assessed in accordance; for, as explained by Peter Smithson, the mounds were: 'a way of preventing noisy football games from spoiling the quiet of the sheltered garden . . . the ground is modelled upwards to discourage people from playing football'.[10] In determining ludic uses upon acoustic criteria, he was unwittingly following Le Corbusier's relegation of play – and riotous noise – to the rooftop in Marseille.

Just a modest inflection sufficed to obliterate the pitch, sending players away: Smithson lifted the lawn, so to speak, as one would do with a carpet, disabling structured games, and welcoming *Paideia*: in welcoming *Paideia*, it ruled out *Ludus*. By the same token, its monumentalized ground, that was so

reminiscent of Celtic mounds, so pregnant with ritual overtones, charged the genteel (but also bland) imagery of its acknowledged forerunner, with gravitas.

Such monumental ludic scale was first envisaged by Isamu Noguchi in the 1933 Play Mountain. Conceived for a city block in New York, it articulated play with topography in an ensemble that conjured up performance, for it was conceived as a sculpture to be 'used' or more properly interplayed with, one that awakened reactions well beyond mere visual contemplation; an unlikely arena in the heart of the metropolis. Noguchi had previously engaged stage and costume designs; he was now orchestrating a performative arena devoid of a script. Moreover, players were expected to engage the field directly; this was in no way a stage prop or a backdrop. They were to play *with* rather than just over – or in front of – the sculpture. Body, motion, matter and form interplayed.

Play Mountain articulated three different fields. Like Van Eyck, Noguchi also considered seasonal change, with the effects of snow, light and moisture somewhat augmenting ludic performance. There was a cascade for summer games and a slide for the snow season.

As in Robin Hood Gardens, topography beckoned gravitational games. This principle was further explored by Noguchi in propositions such as *Contoured Playground*, also in singular elements like the 1940 *slide mantra*, a spiral shaped toboggan. One attractive quality of contoured playgrounds was the manipulation of the ground itself for ludic incitement: but there was more, for topography enabled the sculptor to do away with the play implements altogether. Players could roam about freely.

The manipulation of contours resulted either in single mounds or polycentric fields: either way these provoked sequential exploration, so contrasting with the level field's all-at-once visual possession.

The evident articulation with architecture which resulted from these ideas prompted Noguchi to invite Kahn to partake in the elaboration of the Adele Levy Memorial Playground emplaced in the Riverside Drive Park, by the Hudson, in Upper Manhattan. Kahn had already explored the subject of playgrounds and recreational centres. He also harboured powerful childhood memories of street play in Philadelphia; moreover, the street subject was a recurrent topic.

He had designed a memorial playground with Oscar Stonorov in 1946, for an orphanage, that featured a shelter, a fireplace, some trees and one mural over a large party wall. It looked as if assembling the elements constitutive of home. Of greater complexity were his proposals for Mill Creek (1952, 1962), a low-cost housing development with two significant arenas. He emplaced a grass circle amidst high point apartment blocks, and attached a playground to the community centre. The latter was tight, highly formalized, and urbane. Structured in quadrants, it echoed the building's structure, each court a

FIGURE 121 *Isamu Noguchi's slide mantra, preliminary study, c. 1940. Drawing by the author after model by Noguchi.*

FIGURE 122 *Louis I. Kahn's community centre and adjoining playground, Mill Creek housing, Philadelphia, 1953. Drawing by the author after Kahn.*

variation within the theme of precincts, as if a concatenation of traditional squares. The attachment of play to the communal core betrayed Kahn's confidence about the subject's relevance.

The Trenton Community Centre that occupied Kahn for several years (1954–1957) was a suburban country club that comprised a swimming pool, a day camp, sports fields, extensive gardens and a large complex of gymnasia, play and meeting rooms.

Kahn had previously studied a compact urban club whose mission was to help integrate Jewish immigrants to the USA. The country club, its Arcadian counterpart, responded to the community's suburban drift, its greater affluence and demand for better leisure spaces; immersed in greenery, it celebrated the outdoors. Aided by a landscape architect, Kahn shaped the grounds as if defining precincts within a meadow, inscribing small playing fields within circular planting areas with the exception of the softball diamonds that were accommodated in the open lawns. Tree phalanxes interspersed with lawns and freer formations. Together with the swimming pool, its famous pavilion and the main block, these construed a significant leisure ensemble for all ages.

Kahn's ludic itinerary was followed by the *Adele Levy Memorial playground* which was jointly undertaken with Noguchi. It was a topographic conception wholly dedicated to *Paideia* with a complex array of mounds, slanted planes, and sculptured figures. Each form appealed to some ludic use, most of them profiting from the potentials of the gravitational pull. Sadly, despite five fully developed alternatives, in an episode that bespeaks the ludic programme's political overtones, the project was halted by a coalition of neighbours concerned about the influx of outsiders, with the legendary Robert Moses credited with its final downfall.

Located within Riverside Park by the shores of Manhattan, the playground confirmed the leisure agenda's increasing hold on water edges, an agenda that unleashed a momentous process of urban reconversion in most

FIGURE 123 *Louis I. Kahn's ludic patterns at the Jewish Community Centre in Trenton, NJ, 1954–1959. Drawings by the author after Kahn.*

FIGURE 124 *Louis I. Kahn and Isamu Noguchi's Adele Levy Memorial Playground in Riverside Drive, New York, 1960–65, third proposal. Drawing by the author after cast model by Noguchi.*

waterborne cities. Children and the old were to be prime users, with special access and shelter. The expedient of lodging all indoor facilities below grade enables the smooth inscription of this alien element within the park . . . *There is nothing here that does not speak of park* . . . said Kahn.

The five schemes ascribed a prime ludic function to topography, sharing also the conception of multiple foci and varied circuits that stimulated exploration a non-hierarchical and non-consecutive matrix validated by the restless patterns of *Paideia*. Unlike Play Mountain's unique geological disturbance within the regular block pattern, the riverside playground was more like a formation of rippled, slanted and warped surfaces. Although its edges would have smoothly merged with the adjoining grass carpet, its archaism and its theatricality would have infused the place with drama and expectation, at odds with Olmsted's sedate design, its somewhat solemn air recalling Agamben's ruminations about play and ritual. In their abstraction, Noguchi's bronze casts somewhat highlighted ritual. The impression was partially redressed in Kahn's sketches where the urban horizon seen against a background of trees with a glimpse of skyscrapers further afield, collided an archaic foreground to a modern metropolis.

Kahn also designed two memorials along the shores of Manhattan: The *Four Freedoms Park*, realized posthumously, was devoted to Frank Delano Roosevelt's legacy; the Jewish Memorial (which remains inbuilt) was dedicated to the martyrs of the Holocaust. He conceived the Park as a solid mound; its slanted faces as if the skin of a fortress, guarding the tip of Roosevelt Island. Emplaced in Battery Park by Castle Clinton, the Jewish Memorial was an array of glass cubes distributed on a grid over a granite plinth overlooking the Liberty statue and the arrival paths of immigrants to the USA. Like many leisure establishments, these

memorials colonized portions of the shore formerly dedicated to industrial activities: remembrance, leisure and play substituting toil and hard labour in these liminal areas. But distinctions between these institutions were not so clear. Indeed, twentieth-century playground identities were too varied.

The issue about distinctions was posed by Karl Krauss in a much-celebrated quote:

> Adolf Loos and I – he, literally and I, grammatically – have done nothing more than show that there is a distinction between an urn and a chamber pot, and that it is this distinction above all that provides culture with elbow room . . .[11]

Such was his concern about proper use and formal identities, for urns and chamber pots could share roughly similar outlines. What could then be the essential difference between a children's playground and a memorial? What is it that draws an essential distinction between Play Mountain, the Adele Levi Memorial Playground, Robin Hood Gardens' tumuli, and Four Seasons' Park? How could a future archaeologist discern use and meaning from such ambivalent forms?

When topography with its associated grand gestures and intimations about timelessness and permanence became the issue in the making of playgrounds, functional and semantic frontiers became elusive. With hindsight, it would require quite a precise contextual knowledge to discern the difference between a playground and a memorial when both exuded gravitas in equal measure. Impregnated by ritual, and especially funereal associations, the mound is critical to Kahn's strategies for the playground – and the Roosevelt Memorial. Both layouts share that key. Consequently, nothing will keep a future archaeologist from inadvertently interpreting the Adele Levy Playground as a funereal compound. By the same token, nothing, outside of the force of habit (and its taboos) will keep someone from playing on the slopes at the Roosevelt Memorial. Nothing, that is, in the material or even conceptual order, except for dissuasive measures: 'to preserve its sanctity', its 'rules of use' state: '. . . leave your bicycle, roller skates, scooters, skateboards . . . at home. (. . .) Enjoy Nature but no tree-climbing . . . no climbing is allowed on embankments, or walls'. Abstaining from play at the memorial is now more evident than abstaining from ceremony at the playground. The rules just show the inherent difficulty about shaping volatile ludic impulses. Also, for quite different reasons, they make evident our bewilderment about how to confront secular commemoration (when we are unguided by codes or formal models) through architectural form.

Unstructured play can easily turn a memorial into a field. In Paris, children traditionally played over burial places. As recalled by Rasmussen, countless English burial grounds were converted into playgrounds. (Such seems to also

be the fate of Peter Eisenman's Jewish Memorial in Berlin.) What all this highlights is not so much the considerable latitude allowed in the formal definition of memorials, but rather how unprecedented the modern proposition about supplying stable structures for informal play was.

Displacements

The gradual retreat of play away from the street was widespread. If anything, it intensified over the years, with gated communities repelling outsiders, as much as chance and the unexpected. The ideology of zoning anticipated this method of discrimination, as it was based on efficacy and economies of scale. But zoning did not only entrench exclusions, for it also dealt with distribution and optimal distances, as if the city was a precise mechanism in need of fine tuning.

Children were led away from streets, towards garden spaces such as the ones featured in Marseille, Chandigarh, Brasilia, Golden Lane, Robin Hood Gardens or Lafayette Park, conceived as collective grounds, with public rights of way. Garden networks were woven into extensive pathways running

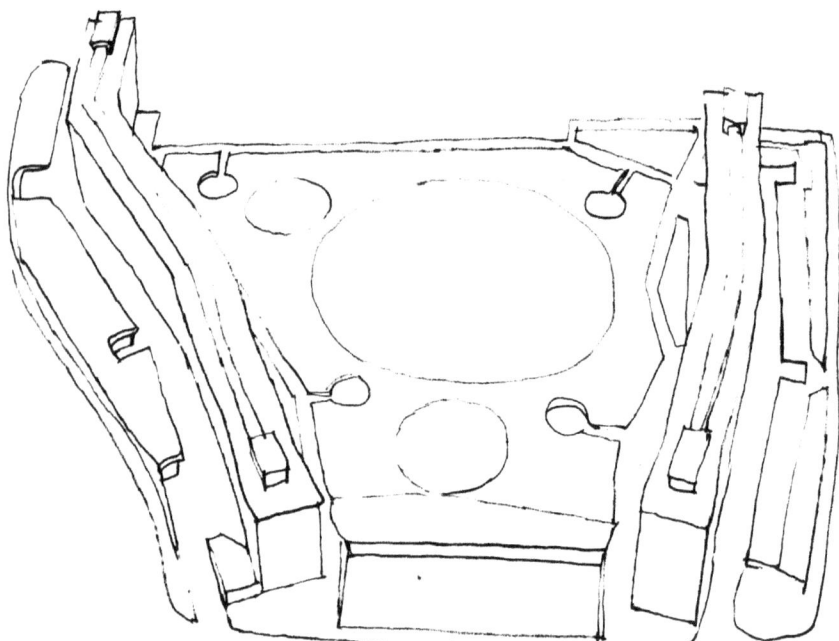

FIGURE 125 *Alison and Peter Smithson, Robin Hood Gardens scheme with mounds and sport yard. Drawing by the author after model by A. and P. Smithson.*

parallel to the streets. Facilities such as nurseries, schools, and playgrounds could then be plugged at regular intervals, according to optimal 'walking distance'.

In Robin Hood Gardens, the Smithsons sponsored differentiated ludic ambiances according to age. Earlier in *Scatter* (1959) they had discriminated precise ludic domains. The scheme featured two parallel bars facing each other across a meadow. Turned away, the individual patios were designated as one-year-old play areas, whereas the meadow served the two-to-six-year contingent. Further afield the seven-to-fourteen-year turf was in a public park, detached from the security of home. Children – they argued – required increasing space as they grew up: . . . 'space to safely close by until seven years old or so, and space for wild running and little excursions until eleven . . . and then places to go and do things in until they are almost grown up'. In one variant, the housing terraces articulated around an 'anonymous communal space' good for 'sledging, bonfires' (Smithson 1970 160–165) and so on. Incremental ludic spheres responded to the child's evolution with play scenarios changing from stage to stage. Each step foregrounded the next, until the time came to leave home and face the city, in its full roughness, each one allowing for particular exposures to the seasons. Incremental autonomy resulted in incremental leisure time to be spent away from home.

Scatter suggested chance and loosely arranged patterns. Although the diagrams depict row house patterns, the model pointed to a complete reversal of the situations formerly observed in Chisenhale Road. However, they shared strong concerns about children's play as much as a pronounced disinterest about the figure of the athlete.

Although the substitution of the sports field for the children's playground was not at all universal, it was nevertheless significant. The case of Marcel Breuer is revealing. His 1931 *sportsman's house* doubled as a fully equipped gymnasium. Its austere interiors exuded precision and functionality, describing a very particular residential ambiance whereby action and rest were equally accommodated. Its sparseness was congenial to the idea of the arena. The scheme celebrated the athlete, an early modern hero. About three decades later, he sponsored other priorities in the Fairview Heights residential compound in Ithaca, upstate New York, a family-based scheme with all dwellings facing a single playground. The arrangement aligned (whether consciously or unconsciously) with the *Neighbourhood Unit* concept, in its embracing of children as privileged subjects, for their arena became the prime locus for social interaction.[12]

Conceived by Perry, the Neighbourhood Unit was imagined as almost a self-sufficient urban entity that accommodated all facilities for education and recreation within a core that was sheltered away from traffic and strangers. The safety of playgrounds is said to have been at the origin of his concept,

and his way of making them safe was to turn them away from streets, a criterion that percolated far and wide until becoming a convention. Breuer was not innovating in the Fairview apartments but applying mainstream social concepts.

Ludic cores

Thus, although in the eyes of modern architects play spaces had become significant cores, their nature shifted as demonstrated in a comparison between Fairview Heights and Le Corbusier's own apartment building in Paris: Corbusier's block faces onto a sports field whereas in Breuer's it is children, not athletes, who play. It is spontaneous, not structured games that unfold, and it is around playground equipment, not sports fields, that everything happens. The same applies to Robin Hood Gardens.

In drawing recreational lots and schools away from streets, neighbourhood units effectively excised the street from childhood experience. They eventually led to the conception of the urban superblock and the proliferation of the type of cul-de-sac patterns that Albert Pope has characterized as Ladders (Pope 1996). Even though the conception of green cores had many other precedents (the Victorian English terrace for one), its morphological novelty was well illustrated in Ludwig Hilberseimer's urban diagram about selective demolition, where a sizable area of housing was cleared with the purpose

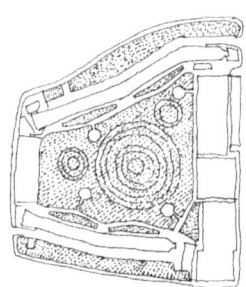

(a) (b)

FIGURE 126 *Ludic counterpoints; (a) horizontal grounds for games in the Ville Verte; (b) mounds as arenas for Paideia in the Robin Hood Gardens. Drawing by the author.*

FIGURE 127 *Urban leisure cores carved out of the grid: (a) Chicago market park, Hilberseimer, c. 1950; (b) European housing blocks before and after intervention. Drawings by the author after Ludwig Hilberseimer and Joseph Luis Sert.*

of accommodating green networks. These soft cores were devoted almost exclusively to leisure and predominantly to children.

Such reconversions were also realized on smaller scales: formerly cluttered backyards gave way to spacious gardens and playgrounds as illustrated by Sert in Berne; and Traschel in Copenhagen. 'Slum clearance', predicated Sert, 'should provide new recreational space'. The strategy was comprehensive, for it comprised play lots, larger playgrounds and athletic fields covering all needs. The process, reasoned Sert, could be managed in stages so that the sports fields which required larger spaces could eventually substitute play lots. In his dynamic process, ancillary amenities were easily relocated. Such goals could be advantageously attained in ex-novo schemes (Sert 1947, Traschel 1960).

The urban pattern of green ways clearly distinguished a quiet and safe green heart from a periphery of traffic arteries, likely to be polluted, noisy and unsafe. Hence, as if within a cocoon, without confronting chance or hazards, children could roam freely between home, playground and school. Designated as leisure areas, these seldom met traffic; conversely as streets became depleted of urban functions other than transport, they turned mono-functional. The model was widely applied. This conception entailed a new initiation of children into urban life. The contrast between green corridors and corridor streets transcends mere spatial issues, foregrounding questions about ambiance (one soft, the other hard; one calm, the other restless), conviviality (one sponsoring encounters amongst equals, the other a confrontation with strangers) and the acquisition of tactical skills oriented to territorial negotiation (space as freely given in one but negotiated in the other). It also contrasted an arcadia of peace and greenery with prosaic urban sets. In removing children from streets, society was sparing them potential dangers whilst by the same token depriving them of the preparation for risk.

A *street child* came to denote crass abandonment or else an altogether negative drift towards the margins of civilized society. Be it for traffic

intolerance, dogma, changing lifestyles or other reasons, it is a truism that the modern street banishes play and children. But streets are compelling ludic scenarios. Derived from surfing, the practice of skating drifted from empty swimming pools, to street kerbs, and paved surfaces. *Street* and *bowl*, the prime 'skate-park' constituents, betray its urban origins but also its banishment into innocuous and controlled ludic enclaves.

Future imperfect

Hermann Hertzberger observed how when the renovation of public utilities resulted in the removal of pavements, the uncovered grounds became extensive sand pits. It is a common situation: once the normal flux of events is interrupted, either drama or play flourishes (Hertzberger 2008, 326). Demolition unprecedented, ludic scenarios inspired the Parisian invocation in the heady days of May 1968 . . . 'dessous les paves c'est la plage!' Beckoning revolutionary conviviality, it pleaded the release of the ludic soil, from the thin crust of asphalt that had hitherto kept it entrapped, guaranteeing the absolute sovereignty of play. It followed the reverse logic with respect to accumulative snowfalls, or earthworks. In this process of undoing, all products of human labour were dismantled, revealing a profoundly anti-urban ludic utopia.

Urban play environments alternate between soft and hard; modern doctrine clearly favours the former (the Kindergarten concept consolidates it), but the reality of play is by no means univocal. As we have seen, the ludic instinct looks to the world itself as if an expectant field for the eruption of a festive mode.

The idea of the adventure or 'junk' playground (as it was first known) was nurtured from the observation of children playing with the spoils of war, or building sites. These scenarios appealed because of the suspension of customary norms, in itself an arresting call to play (almost as if a ludic revenge against convention), indeterminacy, which also beckoned play, and freely available debris that nurtured a potent horizon of possibilities. Derelict sites, ruins, *terrains vagues,* equally compel playful reactions: such was Duvignaud's acknowledgement. The ethos of the junk playground was far removed from aesthetic raptures: for it was essentially a space for and about action. In this instance, it was clear that space itself was the ludic matter.

Its first delineations were drawn, against all expectations, by landscape designer Carl Theodor Sörensen. Although he crafted quite impressive gardens, he also stated – not without irony – that children's playgrounds represented his best urban plantations. He fully acknowledged the function of parks in play and leisure, but was fascinated by the spell that building sites exerted upon the child's imagination. He thought it worthwhile disposing of

FIGURE 128 *An odd landscape: Sorensen's inaugural adventure playground in Copenhagen; a barren site sheltered behind mounds and foliage. Drawing by the author after Sorensen.*

junk in empty lots for children to play with, a conception that was closer to an idea of a workshop than 'landscape'. Junk playgrounds (for that was the way he christened them) were clearly destined to make another kind of nature. Much like streets, they exuded artificiality: some critics perceived in them street similes such as a certain atmosphere, urban grit, colour, movement, sound, and danger.[13] There, through the practice of building construction, children would muster boundless creativity, technical and managerial skills, aside from a collaborative spirit whilst also nurturing early interests in architecture and engineering.

The concept behind junk playgrounds was closer to a procedure rather than a design, for it involved no formal agenda. It just sponsored large, unencumbered, and preferably flat lots stocked with tools and as such, devoid of aesthetic aspiration.

His much publicized first scheme was inaugurated in wartime Copenhagen, by 1942. Earth banks and a line of trees concealed the grounds. Rasmussen, who occasionally collaborated with Sörensen, featured it in his book about the experience of architecture. Right in the middle of the city, the arena was forever in flux. Except for its heterogeneous stock of materials, it recalled the sandbox, with which it shared the stubborn, and in a sense, futile effort involved in shaping the formless.

FIGURE 129 *Heuried recreational centre, Zurich; overall view with adventure playground against cultural centre. Drawing by the author.*

These fabrications could not conceal imperfections, fragility, and the absence of foresight. All these evoked the shanty town. The analogy held at least as regards the tactical choices that fuelled the fabrication of shanties and adventure playgrounds alike. The dilemmas posed by making do with elementary tools also recalled the trials of Robinson Crusoe, except that they were for play. Moreover, dirt, which was in fact appealing to players, furthered the associations with squalor; removing the experience even further from the modernist ethos.

Sörensen's conception was enthusiastically endorsed by Lady Allen of Hurtwood, also a landscape architect, who realized how junk playgrounds could inject life and purpose to otherwise wrecked environments. They came to be known in Britain as adventure playgrounds (Robinson Crusoe was the Swiss variant). Entrenched in well-established urban scenarios, often within modern housing estates, these precarious fields of exception awoke memories of underdevelopment amidst increasing affluence, as probably elicited by the Independent Group's perplexing Patio and Pavilion. (Was it a representation of a nuclear holocaust?) By the time *Planning for Play* was published in 1968, it

was clear that aside from revitalizing urban space, the agenda involved supplying equipment for those children raised as the first generation in high rise blocks, thus pioneering the unprecedented habits of collective living. The seeming contradiction about landscapes of progress and deprivation was perhaps not so unexpected from the perspective of Team Ten, given the interest they had displayed in the subject of shanty towns: there it was their enthusiastic response to the Algerian delegation's meticulous renderings of squalid domestic interiors in the 1953 CIAM congress at Aix en provence Congress, and the Smithsons' keen interest in the ordinary. There it was Aldo Van Eyck's eulogy of the squatter's ability to make 'so much from so little' (Van Eyck 2008 450 453). When considered from the perspective of human ingenuity, shanties, as much as adventure playgrounds, became precious sources of creative thinking, and a sort of medicine against the perceived menace of that species of bureaucratic planning that had led astray the liberating promises of modernity: 'the slum has gone', warned Van Eyck, 'in some privileged parts of the world – now behold the slum edging into the spirit'. (Jacques Tati evoked similar sentiments in 'Mon Oncle' (1958) and 'Playtime' (1967)).[14]

His contrasting images of a shanty, (designated as 'somewhere'), and dumb housing blocks (which he subtitled 'nowhere') made the point. As if by default, the landscapes forged by adventure playgrounds alleviated the housing estate's heavy-handed mood; the 'somewhere' impregnating with character, identity, vitality, and charm the bleakness of the 'nowhere'. One was dynamic and formless, the other static and overbearing. These capsular enclaves accorded with Huizinga's conception of a ludic *Temenos*. They were as odd and removed from the commonplace as anyone could fathom. If it wasn't for their lesser status these could rightly be confused with the ancient regime's *follies*.

FIGURE 130 *(a) Memories of underdevelopment: a counterpoint of formal systems in Copenhagen's adventure playground; (b) the informal surrounds the formal field in Buenos Aires Villa 31. Drawings by the author.*

These 'creative, anarchic, children-led spaces' (there was a protracted debate as to the role of supervision by 'play leaders') were often contrasted with their 'municipal cousin', a domain of 'inflexible ironmongery, unattended climbing frames and swings' (Norman 2003). Despite Van Eyck's celebration of spontaneous action, his conception was far removed from the adventure playground spirit, with its affinities somewhere closer to *arte povera* or the deranged machinist inventions of Jean Tinguely.

Fuelled by the spoils of war, the principle spread successfully. Whilst visiting devastated areas of the Ruhr, Traschel observed how barefoot 'children of the debris' who played with wreckage, blessed the sad landscapes with a semblance of humanity (Ledermann 1960, 21). Widening the scope of Sörensen's model, he affiliated the playground to comprehensive clusters with sports fields, playrooms and cultural facilities for all ages: this model became the *Robinson Crusoe* playground. More than just a ludic enclave, it was conceived rather as a laboratory for human interactions that included, for example, a debating chamber destined to air major issues. In so doing he stressed that propaedeutic element of play as initiation into 'real life'. His compendium *Creative Playgrounds and Recreation Centres* with a format aping Corbusier's *Oeuvre Complète* (jointly edited with Ledermann) soon became a fundamental reference. The Robinson Crusoe idea suggested an affinity with the trials of the 'primitive'. Such informality was at the same time liberating, in its capacity for infusing the 'as found' with new meanings.[15]

The most significant alternative to the idea of construction as play had been on offer with the Meccano set, that particular turn-of-the-century invention that introduced steel components into the child's domain. Based upon industrial production, standard elements and highly rationalized assemblages, these predicated an eminently technical approach to the built environment with an engineering slant: no wonder the recognition bestowed upon this toy by high-tech architects. The contrasting figures of the bricoleur and the Meccano player anticipated architectural form through play, each providing a particular worldview, one about collecting and recombining and the other about assembling building components according to prescribed methods.[16]

Building blocks, Meccano pieces, toy towns, dolls' houses and playground huts share the quality of the miniature but their sources range from the primitive to the technological. Inspired by the primitive, Dimitri Pikionis devised a peculiar playground in the Filothei neighbourhood, Athens (1961–1964): a fenced garden, appraised through a wooden propylaeum. Within, assorted pavilions followed varied cultural models, their structures handcrafted in timber and reeds, their joints woven. In contrast with their seemingly casual quality, the general layout followed a strict criterion of thresholds and sightlines directly inspired in Constantine Dioxiadis' enquiry into the subjacent order of

FIGURE 131 *Dimitri Pikionis's playground in Philotei, Athens. Drawing by the author.*

classical sites (Dioxiadis 1972, 1937). Thus, lurking behind picturesque casualness, Pikionis was calibrating the site by subtle landscape ploys learned from the ancients so that each ambiance visually unfolded from each threshold in highly contrived ways. Nothing in it was condescending, for Pikionis accorded the playground a serious status.

Stillness and the miniature

Reviewed under the light of history and precedent, traditional European streets and squares made a comeback in the heydays of postmodernism. Such urban critique could not miss the subject of play for if all major urban

activities were to converge again on streets and squares these would reinvigorate the integration of play to urban life.

Aldo Rossi valued the formal status of the city. He was impressed by Giorgio de Chirico's laconic imagery of colonnades, and emblematic objects – a classical sculpture, railway viaducts, an industrial furnace – bathed in a harsh Mediterranean light with buildings shown empty and in splendid solitude. These highly charged spaces galvanized a collective memory so that the persistence of urban mementos, either banal or exceptional, was aided by the timeless presence of monuments[17] (Rossi 1984).

Rossi's imagery invoked other topics, however, including the small, the perishable and the fragile, embodied in such items as fairs and beach huts, confessionals, architectural models and dolls' houses that imploded the urban model, betraying its smallest particles. His fascination with seaside resorts revealed that fragile but nevertheless recurrent quality of cities on the sand, such as Ostia, Rimini or Venice's Lido: a 'dramatic city of the summer holidays, a time of vacation, ... perhaps even tedium ... the mobile terrain of a temporary city, which the seaside promenade separates from the other, permanent city' (Rossi 1981).[18] These charming establishments exuded playfulness whilst also sharing the empirical condition of Huizinga's 'space apart' where a gregarious culture, a strong urban tradition and a vigorous formal discipline converged. Rossi's Teatro del Mondo raised the subject one step further, blowing up the scale of the miniature, as if an enlarged toy, to confront face to face Venice's iconic monuments. Mounted upon a barge, its bouncing movement confounded the inherent sense of stability attached to the very notion of the monument: stone and wood, the venerable and the evanescent confronted each other across the embankments.

Memories of childhood lurked just behind stern urban edifices. Fragments and ruins did play a part too. 'It may be', Rossi stated, 'that only ruins express a fact completely ... photographs of cities during war, sections of apartments, broken toys' (Rossi 1981, 8). These resurfaced, both for the part they played in the formation of an historical consciousness, and also for the juvenile attraction felt for things undone. The expectancy of vacations rather than the energy released by particular ludic actions was perhaps his strongest nexus with the ludic spirit.

The reinstatement of the urban square received a significant impulse with Piñon and Viaplana Plaza Sants in Barcelona (1979–80). Realized eight years after Gallaratese, it was soon recognized as a landmark of the much-publicized urban renaissance. Although probably stimulated by Rossi's acute perceptions about the status of the public space, it was truly original. Catalonian philosopher Eugenio Trias celebrated its void, so clearly attuned to the empty stage of the Plaza Mayor, that guaranteed the possibility for civic expression. Just a handful of elements populated its ten thousand square metre expanse; yet unlike the taut horizontality of the Plaza Mayor, a subtle topography of fractures played

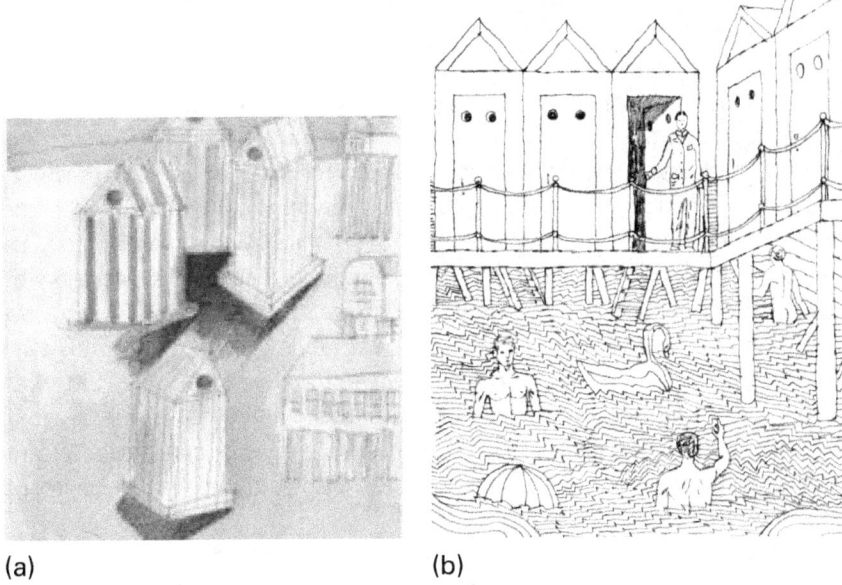

(a) (b)

FIGURE 132 *Thrills of the miniature in: (a) Aldo Rossi's* Le Cabine dell Elba, *Image courtesy of Fondazione Aldo Rossi, copyright Eredi Aldo Rossi; and (b) Giorgio Chirico's* Evocations about Life by the Italian Seaside. *Drawing by the author after De Chirico.*

an active role in it. A rank of pillars of decreasing heights spouted water over the granite base; slight inclines leading the streams to run smoothly to vanish in a neat crevice. Incited by water, children soon took to play in that spot. This was no children's playground, however; it was just a laconic setting that provoked discreet ludic reactions, but it was precisely the contrast of its stern design with play that made it so memorable. Deprived of ceremonial, excised from the built edges by heavy traffic, the Sants Square was a pale relation to its traditional siblings. Its almost desperate site rendered civic gestures futile. With hindsight, it became all too clear how the vibrant atmosphere of urban spaces could not just be recreated through sheer formal will. Squares had often hosted play, but such theatrical propensity did not persist over time, as their voids became increasingly populated with public symbols or planting.

Statuary: action and the immobile

The critical emplacement of statuary was reviewed in Camillo Sitte's seminal *City Planning According to Artistic Principles* (1889). Inspired by ancient precedent, he advocated 'that the centre of plazas be kept free' (such was also the title of chapter II). He concurred with Vitruvius who 'had observed

how the centre did not belong to the statues but to the gladiators'. Yet he did not give much thought to the ludic usage. He made an interesting aside, however: 'it is significant that when children at play follow unhindered their own artistic instincts ... what they create bears a resemblance to the unsophisticated art of primitive peoples'. For, when modelling snowmen, children inadvertently reckoned ancestral patterns of emplacement: these, he observed, 'stand on the same spots where, under other circumstances and following the old method, monuments and fountains might be expected to be located'. The explanation was to be found in the availability of clean snow by the edges. Only there could children find pristine material for their fabrications, thus unwittingly following the emplacement rationale of ancient times with statues aligned to the edges such as not to interfere with the action. Sitte was also interested in the relationship between static and dynamic areas within squares, not in their particular significance as *arenas*, a concept so clearly conveyed by Vitruvius (Sitte 1965 20, 22), but both appraisals converged around clearance.[19]

In discussing size and shape, however, he alluded to drill grounds such as the *Champs de Mars* in Paris, the *Campo di Marte* in Venice (mentioned in our introduction) and the *Piazza d' Armi* at Trieste and Turin, just pointing to their disproportion. In his view, these were debased spaces, but as we have seen these were in fact forerunners of the sports field.

The emplacement of statuary and ornamental objects in squares was not innocent, for urban sculptures often constrained use, particularly so with those emplaced in the geometric centre. Sitte objected to the way these obliterated the unique visual command over the field, but these also acted as impediments against ludic usage. We have seen how as if through *detournement,* Aldo Van Eyck's 'stones for jumping' restored to the square the primacy of play. There was another way in which to reconcile statuary with the playground, however.

Sculptures in squares often conspired against play, but they could also beckon it as long as they became in themselves ludic attractors, a common – but not exclusive – occurrence with figurative sculptures. The almost irresistible urge to touch sculptures – as museum curators know – is conventionally repressed such as to keep art and life at due distance. But the play instinct is persistent: what if sculptures were envisaged to be touched and played with? This kind of interaction led to the conception of 'play sculptures'. Noguchi's Play Mountain, United Nations, and Adele Levy Memorial playgrounds were sculptural conceptions, but his interpretation led to the expansive spatial domain of landscape rather than the concise one of statuary. The play modes he beckoned were equally expansive.[20]

Play sculptures were there to incite play directly, mainly through climbing. Sculptors devised cavities large enough for children to crawl; exploring their

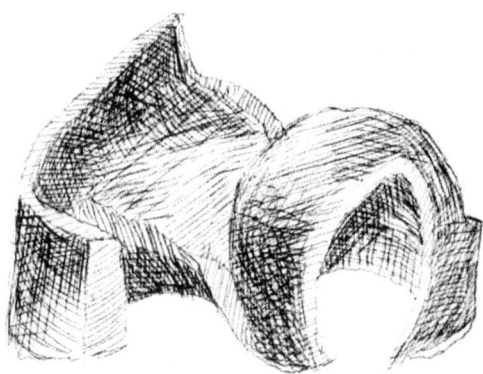

FIGURE 133 *Play sculpture by Julliette de Jeckel. Drawing by the author after cast model by de Jeckel.*

entrails involved tactile experiences about surface, texture and temperature. These uterine voids conveyed corporal rather than visual stimuli.

Play sculptures rather re-signified traditional sculpture formats and as such they often alluded to urban origins even though obliquely, for they were largely installed in parks. Although the denomination was soon extended to commercial items, certain artists reckoned their potential. Egon Möller Nielsen's hollowed structures became renowned. Others rose to the challenge such as Pierre Jeanerette, with a climbing sculpture in Chandigarh, setting up somehow a standard for the playground in the new city, Enzo Mari, Jolliet de Jekel, and Anthony Caro, whose Child's Tower Room tight interior contained a spiralling path.[21]

Ledermann and Traschel's *Creative Playgrounds and Recreational Centres* embraced the idea. The subject was slippery, however; for aside from the taboo that precludes touching art there was no substantial difference between Nielsen's 1952 *Egg* or Henry Moore's (or Barbara Hepworth's) hollowed sculptures. Clearly, if allowed to do so, children would play in any of them. But as it took hold the idea fuelled corporate initiatives such as David Aaron's *Creative Playthings* shifting the emphasis from art to design. The play sculpture spatial interest was also grasped by the French *Group Ludic* whose suspended spheres and tumuli articulated a varied landscape against the background of mass housing so that through their agency, play forms devolved intimacy and identity to the environment; their little clusters were 'playful' even when not in use.

The subject's performative potentials engendered varied propositions. Giulio Minoletti's 1951 submerged hollowed sculpture supplied Rasmussen with a good argument about rhythm in architecture. The exceptional setting was counterintuitive for the piece was submerged; swimmers slid in and out of its bone like forms: their fluid performance was in contrast to the

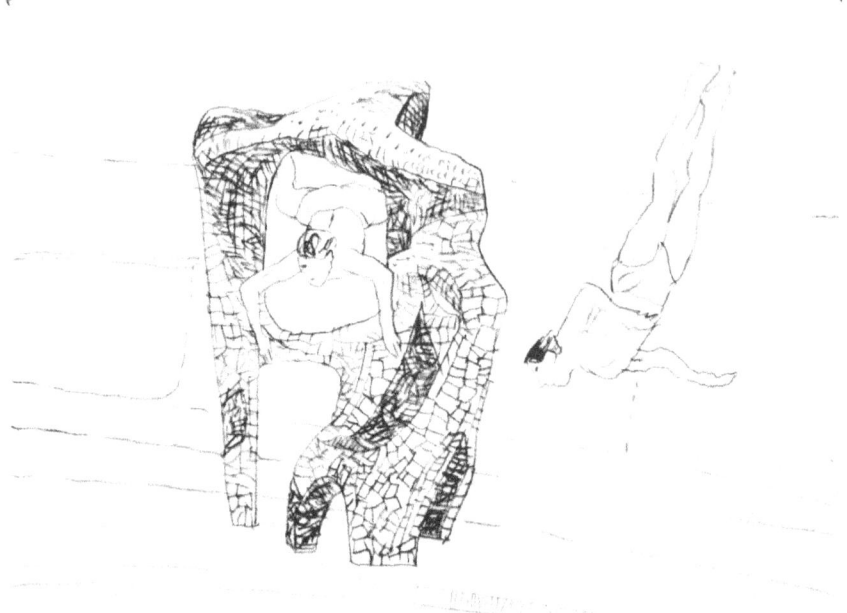

FIGURE 134 *Gulio Minoletti's submerged sculpture. Drawing by the author after Rasmussen.*

cumbersome crawling expected in *play sculptures*. In Rasmussen's view these embodied enhanced forms of architectural experience (Rasmussen 1975,147–150). His phenomenological appraisal could not but regard play as a privileged interface between body and matter, for which Minoletti's summoning of formal elegance and performative potentials represented a masterful example. Rising above the water datum, the springboard failed to capture his interest, however, even though aside from its formal quality, it embodies a particular synthesis about display and deportment, as we have seen.

There were other notable exponents too: far out in California, Adaline Kent's seemingly levitating soft contour piece echoed Thomas Church's kidney-shaped basin in the Donnell Garden, Sonoma (1948, realized in association with Thomas Halprin).[22] Much as in Monza, Sonoma was all for *Paideia*, free style swimming and hedonism. As we have already seen, magazine editors like Elizabeth Gordon and landscape architects like Thomas Church extolled private leisure and play with great effect in these self-sufficient paradises which were a world apart from the collective spirit that animated the housing estate.[23]

The toboggan and the swing were subjected to revision with similar sculpture oriented insights. Noguchi explored the toboggan's formal potentials

in the monolithic *Slide Mantra*, its static form conducive to the acceleration of the slide. Le Corbusier deployed it as a link between roof garden and swimming pool in the 1951 Sarabhai House, Ahmedabad.[24]

As it beckons pendulum motion, the swing encapsulates reiteration and rhythm, ludic traits that were singled out by Huizinga and Gadamer. Noguchi, David Aaron and others explored the potential of cantilevered supports linking structural prowess to ludic challenge.

Play sculptures orchestrated cadences and choreographies: some agitated, others calm; they stimulated ludic ploys about exploration, balance, or chase, and they aimed for a primeval rapport of art and life. Strongly inspired in the integration of the arts, these soon populated public parks, and as such they embraced that old association of statuary with gardening. Climbing structures often acquired the upright stance of public statues.

If adventure playgrounds often served as counterpoints to the barren monotony of serialized environments, play sculptures were also perceived as capable of animating the dull background of vast housing ensembles: such was the counterpoint sought by Emile Aillaud in 'La Grande Borne' at Grigny (1965) where undulating floors and climbing structures furnished little theatres of action, urban foci expected to alleviate the otherwise overbearing surroundings. Just as in the Smithsons' Robin Hood Gardens, these grounds privileged the hazardous practices of *Paideia* whilst clearly averting the performance of field games.

Lacking in rules, oblivious to the measurement of time and space, indifferent to the notions of training or ranking, prone to amnesia and without the benefit of hindsight, *Paideia* simply made of each instance a fresh experience. In its most public expression the setting was not home, but the city, as seen in the cases previously examined.

Pestalozzi, Froebel and Montessori seized on free play as a fundamental pedagogic tool. It was valued for instilling social and creative skills, equity, and an active imagination. These values were soon acknowledged at institutional levels: in playgrounds, these often bizarre scenarios became standard urban amenities; conventional adjuncts to neighbourhood centres, modern spaces of initiation for momentous rites of passage.[25] Noteworthy were those that came to supply ludic outlets to the high-density estates of the welfare state. Siegfried Gideon visualized them as elements of the urban core.

Ranging from rooftops as in Le Corbusier's Marseille, to secluded gardens as in Pikionis Filothei, the most varied places accommodated the infant's initiation into life through play: it is not coincidence that the ludic space became so fundamental in a dominant trend about displacing children from the domestic into the communal sphere. Other approaches, notably, Aldo Van Eyck's, strove to keep alive the spirit of the street in playgrounds, even when local urban conditions did not sustain much social interchange. The idea of

devolving streets to children was compelling, however, stimulating diverse attempts to administrating roadway uses to ludic aims. Such were the intentions behind the aforementioned 'Play Streets'.

The stewardship of playgrounds was varied: sometimes in turns, sometimes independently, landscape architects, architects and planners, designers and social agents, took charge of their programme, design and implementation. Playgrounds were either embedded from the outset in public spaces or retrofitted in them. Whichever their origin, the impact was considerable as they supplied a new species of space, which was not quite like the square or the park, but somewhat different, sometimes oddly so. Should one attempt to recast Sitte's typological series of urban squares in the format of urban playgrounds the results would be particular, for these followed no formal precedent, even when loaded with urbane associations.

The often-invoked 'asphalt desert' equated the bareness of the modern metropolis to the starkness of the play yard. But these sentiments did not necessarily accord with matters of play, for as often happens, veiled behind social critique, there was a powerful element of aesthetic preference. Indeed, under certain circumstances the picturesque approach construed appealing ludic environments, but the dead flatness of the yard did also appeal to equally compelling ludic agendas. Sequential views and panoptic visual fields engendered equally fertile play conditions: they just drew upon contrasting ludic agendas. Material choices were equally open, for as we have seen, nothing stopped children from enjoying Le Corbusier's rooftop with its abrasiveness becoming an enticement – not a deterrent – to play; so, it was expected in Park Hill, Sheffield, and Goldfinger's Balfron tower in Poplar, London. After all, if children happily played over rocks, why not on concrete (Terry 2015)?

Scale is another issue that paradoxically works both ways, for in *Paideia*, the huge and the small have a place, each for its own merits, as attested by Le Corbusier's minute rocailles at Marseille and the Smithsons' oversized mound in Robin Hood Gardens. One was good because of its cosy intimations of shelter, the other for its ludic call to adventure. It was as if complicit with architectonic variants *Paideia* searched in each one appropriate condition for its consumption. 'I grew up in a city built on solid rock', said Krier,' 'its main features are defensive: *escarpes, contrescarpes*, crevasses and viaducts . . . they were the playground of my childhood. . . . provided its inhabitants are sympathetic the most monumental architecture will become the object of an extravagant sentimental attachment' (Krier). He was, of course, validating monumentality.

Ludic grounds are often contested; the institutional form accorded to them by society (or the state) contrasts with claims for free access to urban space. Such political claim over the non-productive use of public space is perhaps

FIGURE 135 *Oscar Niemeyer, 1983, Zambodromo, Rio de Janeiro. Drawing by the author after Niemeyer.*

best represented by the carnival. We have seen how Duvignaud ranked it as a supreme expression of the ludic instinct, a Dionysian outburst he admired in its capacity for shaking up the commonplace and defying established rules. Away from architectural manipulation, the carnival turns the banal turf of everyday existence inside out; essentially subversive, it is therefore prone to be banned or else emasculated, when cajoled into purpose built scenarios. Oscar Niemeyer's 1983 *Sambodromo* in Rio de Janeiro is one example of such institutional counterclaim where the carioca parade turns into a formal spectacle with dancers flanked by fifteen thousand spectators seated on bleachers. In countering spontaneity and chance, it ultimately denaturalized the event. The case is interesting, however, as an example of eradicating play from the everyday arena to the specialized domain of stadia.[26]

We have already reviewed how in a process that gained momentum as from the nineteenth century, playgrounds and sports fields consolidated into distinct, structured, and often durable forms. Ludic demands were increasingly embraced at every scale and level, and this included the elusive *Paideia* for which, against all odds, stable settings were also supplied.

Where were these inscribed? The residential enclave, the educational establishment and the park became prime locations; for sure there were other alternatives, but it was primarily in housing ensembles, schools and parks where play in its diverse manifestations became recurrent, readily accessible and conspicuous, and it was through them that the State delivered public recreational facilities.

8

Back to order

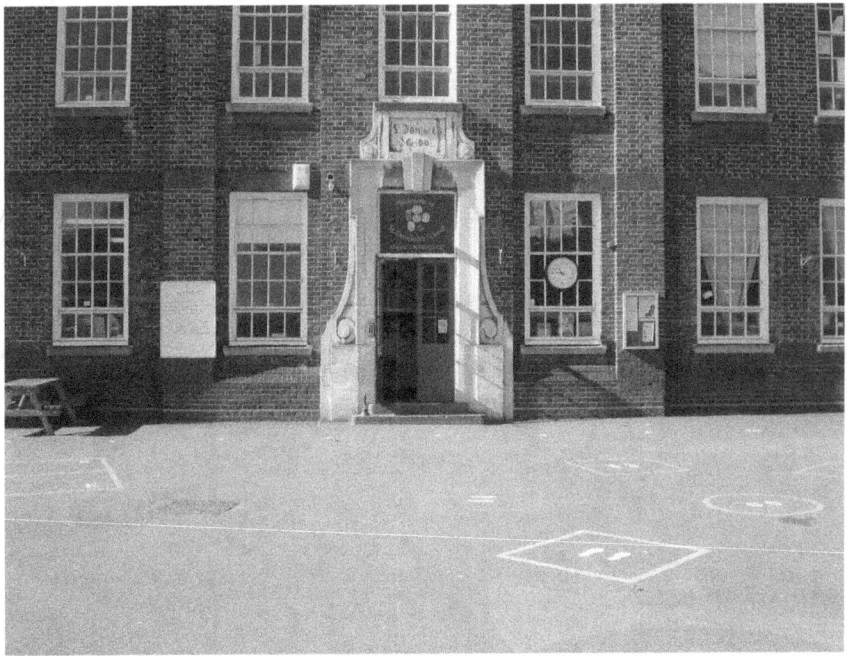

FIGURE 136 *A stern approach to school, hard-paved yard in Camden Town, London. Photo by the author.*

The school

Schole denotes leisure, as if schools surged from an unhurried pursuit of knowledge (Piper 1952). In any event, these active ludic incubators forged purposeful relations between play and learning: it is well known how a selected few, led by Rugby and other English 'public' ones turned old pastimes into structured sports, whilst German and Scandinavian Gymnasiums with their intimation of the Greek Palaestra placed their emphasis on physical training.[1] Little by little, physical training and playing became structured

components in schooling; the uses of *Ludus* and *Paideia* turning increasingly central to a modern understanding of education, thus demanding vast swaths of space. The higher the formal level of education on offer, the higher the expectation about team games: secondary schools and colleges vied for fields and gymnasia. University campuses – particularly in the USA – competed for the best sport facilities in a process that grew exponentially.[2] Faintly evoking the Roman *Campo de Marte*, these derived the Latin denomination *Campo*, from the level ground and the field.[3]

We have seen how in *The American Vitruvius,* Hegemann and Peets paraded university clusters as significant tokens of civic achievement. Many of these possessed sports grounds, just a few, proper stadia, but that was in the 1920s. These were just early symptoms of a general trend. A few decades later, most campuses in the USA displayed impressive athletic infrastructures.

Le Corbusier's Greek precedents were mainly centred on the Palaestra and the Olympic sites, the Roman ones on the Coliseum. Always alert to alternative models, he also drew lessons from the East Coast University Campus white stadia and lush environments that were so conducive to healthy experiences. Their generous provision of outdoor facilities ratified his

FIGURE 137 *A Scout leader explains the Murondins to his companions in Le Corbusier's conception about the reconstruction. Copyright FLC / ADAGP Paris and DACS London 2017.*

view about sport, greenery and 'living' converging in a perfect mix, which was applicable to residential quarters.[4]

But schools do more than just incorporate play into their curriculum and material fabric: together with the guidance they provide for the passage from childhood to adolescence, schools actually master another kind of passage, leading students from the pre-eminence of *Paideia* on to *Ludus*, from instinct to strategy, from individual search to team effort, setting also their aims in aiding youngsters to acquire the tools and skills of athletes.

Their discrimination of groups according to age and gender, de-facto institutionalizes early rituals of passage. Such predicament lends itself to neat spatial strategies; it also results in a particular attention lavished on the arena where collaborative efforts such as the ones mustered by team games can be usefully fostered. Such social goals were broadly shared by Baden Powell in his turn of the century foundation of the Boy Scouts with its emphasis on team effort, a sporting attitude and life in the outdoors. Although he privileged experiences in the rough, the institution became increasingly urban. By the 1940s, the movement had acquired sufficient visibility for Le Corbusier to reckon its potential as active agent in the reconstruction of France. Considering his keen endorsement of sports, it must have been quite natural for him to see them as apt potential managers of the Mourondins scheme.[5]

The binary rhythms of teaching and recreation, stillness and action, time and halftime, indoor and outdoor, rule over conventional schooling. Together they are expected to model well-balanced personalities. School spaces are accordingly construed, so that their basic kit requires a classroom and a yard (or playground). In early schools the yard was a perfect tabula rasa; albeit lacking in visual interest, it afforded unrestricted freedom to roam about as well as optimal surveillance conditions. As early as 1824 the playground was understood in England as a laboratory, an urban simulacrum, and a microcosm of the effects of the educational process upon children (Markus 1993). By 1825, Durand conceived a school with a court 'for exercising the spirit', gardens for recreation and leisure and an arena for corporal exercise. A play yard already features in the 1835 Wilson Primary School in England, with its counterpoint the classroom. Henceforth these embodied divisions of time and purpose were regarded as critical to the acquisition of experience.

'The [school] building [should] be surrounded with a yard, of never less than half an acre, protected by a . . . substantial enclosure. This yard should be large enough in front, for all to occupy in recreation and sport', recommended North American educator Henry Barnard by 1848. He advised the front yard to be planted with shady trees, and the back one to be split in two: one portion for boys, the other for girls, such as to attain 'the most perfect neatness, seclusion, order and propriety'. The playground was an 'uncovered classroom . . . where the real dispositions and habits of the pupils . . . can be more easily trained'.

FIGURE 138 *An elementary ensemble: an aexedra, classrooms and the playground in Wilson's Primary School, England, 1825. Drawing by the author.*

Ample enough to hold athletic games, the grounds were equipped with swings (Barnard 1848, 80, 81).[6] They were best placed in pastoral landscapes and away from streets. Hygienist concerns led him to hold a deep conviction about nature as a better educator than men. These principles (most probably inspired by Rousseau) became modern paradigms.

In the course of time, the single school yard gave way to a dual system of playgrounds that unequivocally catered to the differentiated impulses of *Paideia* and *Ludus*, their respective identities clearly discernible in the paved *court* and the cultivated *field*.[7] Here the agendas of educational experts and modern architects converged. Embedded in the structure of modern schools, the binary system became a trait.

Formal playgrounds were incubated little by little. As early as 1889, Sitte made reference to them. The *Playground Association* was created in the United States by 1906. Universal schooling became a prime objective in modern democracies, and its reach was expanded further and further to early childhood. As a result of this predicament, diversified playgrounds became stock elements in schools.

Paved yards were derided by almost everyone concerned with modern conceptions of childhood. The critique was amplified by CIAM member Alfred

Roth in *The New School* (1958), a sort of primer about new models. In his view, old style schools were often beset by 'unfunctional' (sic) ponderous and out of scale settings. He favoured softer ambiances, a friendlier scale and a decided presence of 'nature' together with a more casual, less disciplinary vision of the educational process.[8] Such links between infancy and greenery were endorsed by most leading architects. The immersion of schools within parks or gardens was decisive, for the issue was not just about character but also about appropriate ambiances. All in all, greenery substituted the hard-built urban fabric as the optimal locus, whilst pedestrian-only access favoured integration with residential communities.

Three main precepts embodied such aspirations: the value of the outdoors for the educational experience, the value of nature to the same end, and the value of sheltered, tranquil, even bucolic scenarios for the upbringing of children and youngsters. Green buffers sheltered the residential enclaves from undue noise.

Roth underpinned his promotion of playgrounds with numerical data about optimum sizes and distances from home (relative to children's ages), all related to 'neighbourhood units' of about 5000 people. In his estimates, Americans led their provision with a stunning 160 square metres per student, which reflected the sharing of school facilities with neighbouring communities. Seen this way, schools were suppliers of playground space.

Reaching out to the seaside, the mountains, or the rough country, holiday colonies further extended this liaison between early education, greenery, the outdoors, sun therapy and collective indoctrination (Wall 1988). But in urban schools the outdoors were carefully apportioned to each age group. Thus, small gardens were often devised for infants. The more resilient yards, so reminiscent of the hard-paved square, were for just about everyone else. Proper playing fields were for grownups. The transit from the amiable setting of the garden to the barren court and field became topical. Yet within these graded scenarios, only the field strictly conformed to a priori formal rules, for only there such structural traits as measure, orientation, material, and topography embodied absolute value. Yards were designed, whereas fields were just inscribed.

Expected behaviours were also quite specific to each scenario. In contrast to the prevailing immobility in the classroom, a riotous melange prevailed in the yard, whilst the orchestrated logics of *esprit de corps* characterized the mood in the field. Schools conducted children progressively through domains of increasing scale, whilst operating an almost inadvertent substitution of *Paideia* for *Ludus*.

Described as a geometric dispositive destined to regulate behaviour, a site of silence, obedience and attention, the standard classroom is also the site of immobility (Vigarello, Holt). Classrooms and playing fields make a conceptual

FIGURE 139 *Contrasting technologies and traditional patterns of twin stools: (a) Jean Prouvé, 1951; (b) high school, Providence (19th century). Drawings by the author.*

pair. Even though modern schools substituted the grim monumentality of Victorian establishments for friendlier environments, disciplinary assumptions often lingered. One example is Jean Prouvé's 1951 paired stools attached to a single desk that harnessed students to their stations (desks were often fastened to the floor). Aping nineteenth-century practice, his scheme enforced immobility so that, albeit technically advanced, it was conservative in behavioural terms.

Such was also Hermann Hertzberger's dispute about early modern schools, where, despite the evident gains in natural light and hygiene, the old pedagogical principles seemed to go substantially unquestioned. Without mentioning Roth, he seriously challenged the underlying principles espoused in *the New School*, although he revisited many of its examples.

Inspiration was to him more relevant than efficiency. He argues that nothing was gained by moving the classroom into the outdoors, when the pattern of relations between pupils and teachers was undisturbed: 'even so-called outdoor classrooms were in fact indoor classrooms placed outside' (Hertzberger 2008). Informality and spatial in-determination, rather than health and hygiene were critical; hence he prioritized *Paideia*'s less structured ways, the value of exploration over stamina, discipline, and muscular coordination. Needless to say, he was intellectually motivated by Montessori's conception of unstructured play. Notwithstanding his concerns about the informal and his predicaments about the value of the in-between, Hertzberger (like Van Eyck) failed to value the status, quality and programmatic overtones of sport.[9]

It was generally accepted that classrooms ought to relate to yards. Such propinquity was facilitated by single storey arrays, where the comings and goings between lecture and 'recreation' could be as fluid as desired. Counterbalancing the yard, gardens often flanked classrooms too, so that

sandwiched between bucolic spaces and the arena, these enjoyed contrasting prospects: such guiding principles informed the pavilion type.

However, notable exceptions were construed: Hannes Mayer and Hans Wittwer's 1926 multi-storey Peterschule in Basel strove for optimum intakes of light and fresh air within a small square. Its play yard was located on a cantilevered deck above the ground. There were ground and rooftop gymnasia. One can imagine the thunder over the covered square: even though these concerns were probably not within the architect's scope, sound rather than vision would have affected public experience, just as with Le Corbusier's cloistered playground atop the Marseille block.

Jan Duiker and Vijvoet's 1937–38 'first school for healthy children' in Amsterdam, another modern classic, also conformed to the multi-storey format. Concerns about heliotherapy led to linking each classroom to a balcony yard. A roof terrace doubled as classroom. Expansive games were played in the grounds, amidst residential blocks. The two-storey linear format of Beadouin and Lods 1935, 1936 *Ecole à Plein Air* at Suresnes vastly amplified the roof terrace potentials. Its grounds were subdivided according to age and gender. Despite overtly hygienist priorities, its washing facilities were also thought out in ludic terms.[10]

Notwithstanding the interest in multi-storey layouts, single storey types were clearly favoured, for only these afforded equal access to all facilities. The formula was not always applicable, but two-storey became a second-best

FIGURE 140 *Swimming and field games at Le Corbusier and Prouvé's 'portable schools for refugees', 1939–1940; note the binary pool. Drawing by the author after Le Corbusier.*

option for the integration of indoor and outdoor, and the distribution of differentiated ludic domains.

By the 1940s Le Corbusier and Jean Prouve's lavishly provided the 'portable school' for war refugees with youth centres, sport arenas, swimming pools, gardens and orchards: 'in many villages the school is . . . old, dismal, and the classrooms do not lend themselves to modern teaching methods . . . the sports field will be five or ten minutes away . . . one may as well accept [moving] the school building there' (Le Corbusier 1946, 96). As in the Mourondins, the ludic agenda was totally assumed even if in wartime. The school's emblematic function was also highlighted by his former assistant Kunio Maekawa in a striking conception for a new town in occupied Manchuria c.1940, with the sports grounds featuring as geometric and symbolic core.[11]

Almost a decade later, in Nagele, a new town built over reclaimed land in the Zuiderzee (1954, 1959), Aldo Van Eyck teaming with the 8-Opbow strove to organize 'a physical, social and plastic scenario' for some two and a half thousand people. Reflecting Dutch religious tolerance, its programme contemplated three schools and up to five churches. School outlines were

FIGURE 141 *Two settings for play at the new town of Nagele: (a) football by the edge of town; (b) playgrounds sheltered within thick groves. Drawings by the author after Aldo Van Eyck.*

identical so as to minimize potential rivalries. These shared with the churches an emplacement on the village green.

A thick forest protected Nagele against the polder's somewhat hostile expanses, also making an effective windbreak. Ludic arenas were sheltered in forest clearances whilst playgrounds were emplaced in each school, with communal sports fields spreading by the south-western edge. Following from a geometric armature, fields and schools shared strict alignments, the fields set over the north–south axis and the schools facing due north. Echoing the figure-ground schema, thick foliage sheltered the sand pits. The master plan thus defined central and peripheral ludic settings, as much as exposed and concealed ambiances, together with a range of arenas.

Sports fields were increasingly inscribed within schools, however, and as such they featured prominently in the 1949–1954 Smithsons' Hunstanton scheme. What makes the case poignant is their stance about integration, for they finely attuned the grounds to the site composition. Two fields flanked the main block symmetrically, thus reinforcing the formal parti. Neatly cut against an expanse of gravel, these green patches shared the overall geometric rigour and certain starkness, much in line with the Miesian interplay of steel, glass, brick, gravel and the lawn. The original photos render the ensemble against the largely featureless rural landscape. Drawn from industrial imagery, the stark mood reflected no sentimental concessions to childhood.

A *Greek Temenos* was the Smithsons' description of the layout, a rough stone plinth and ha-ha demarcating the grounds against the road. In the integration of fields and gardens, performance and landscape, the overall

FIGURE 142 *Hunstanton School, East Anglia: the main block flanked by symmetrical sport fields that mediate between school and the rural hinterland. Drawing by the author after A. and P. Smithson.*

conception was similar to Rousham House, also in the notion of playing fields as devices of separation and control.

Children were purposefully excluded from the inner courts: 'no doors open to the green courts', said Alison Smithson, 'just hopper windows for ventilation as no children's movement is to be there ... the green courts are light areas free of noise'. Similar acoustic criteria would inform, decades later, the Robin Hood Gardens scheme. Nothing could offer a greatest contrast than Nagele with respect to Hunstanton: where Van Eyck deployed well calibrated thresholds between domains, the Smithsons split the grounds sharply as in the agricultural patterns further afield. Of course, Van Eyck (or maybe his

FIGURE 143 *Stadium and orphanage in Amsterdam. Drawing by the author after Aldo Van Eyck.*

patrons) banished all sport facilities from the school grounds, whereas the Smithsons gladly assumed their impact upon the overall layout.

These schemes were developed between the late 1940s and 1950s. Aldo Van Eyck made another significant contribution to the subject with the Amsterdam Orphanage (1955, 1960) that lodged over a hundred children of various ages (they attended kindergartens and schools elsewhere). Its horizontal texture of precincts and patios embodied the principles of the Mat Building of which it became emblematic. All efforts were placed by Van Eyck in interweaving the domains of the individual with the collective. Seizing on its rapport with the nearby stadium, he drew parallels between geometry and behaviour: 'fifty thousand packed together in a huge oval cheering and quite close lots of little domes with children protected under them chattering, laughing . . . lots of domes in a multiple pattern and a single oval – a little less little now' (Van Eyck). The message was reiterated in the site plan that featured the stadium, an aircraft bound for nearby Schiphol, and the orphans' citadel: *Ludus* informing the stadium, and *Paideia* a compelling ingredient for the orphanage. Alas, children did not stay long, for changing criteria about care led them to be removed to urban venues. All that remains of their ludic responses are pictures, particularly the ones captured by Violette Cornelius. Her much celebrated vignettes of playing in the Orphanage became almost as powerful as Henderson's, and Burris. In this dense scenario columns became ludic totems, mirrors were embedded in floors and walls, sand pits were emplaced outdoors and indoors; there were little stages, all recalling Van Eyck's playground sets. Much bleaker in contrast, the grounds outside just featured three circular arenas inscribed within a vast and otherwise undifferentiated lawn. Despite the presence of older children (up to twenty years old, according to the architect's account) no formal sports ground was featured in the published drawings. However, the whole strategy was imbued with ludic intent. An active, even complicit and therefore ludic interface between child and form filled these buildings with life, but the architect's inspiration was clearly drawn from free play.

Some five decades after Roth, with sufficient hindsight over early modern schools, Hertzberger made a plea about extending the notions of school and playground to the city at large. In line with his mentor Van Eyck, he sponsored convivial urban situations for all ages.[12] In his view, such urban ambiances did not require much planting; the issue was in fact more to do with impromptu encounters. Such was the ultimate conclusion he drew in the idea of 'the city as a macro school'. The thesis could have been readily endorsed by Jacobs, Rudofsky and Ward, whose views about play also hinged upon the mingling of unstructured jovial outbursts with the relative chaos of streets. 'Soothing as rural life may be', reflected Rudofsky, 'it is the city that stimulates the brain. No other environment, least of all the classroom, tickles the senses as much as the street', These views were far removed from the spirit that hitherto animated pedestrian

greenways.¹³ Street roughness was also preferable to garden cosiness in that it supplied much greater extracurricular challenges. Negotiating the passage to school through obstacles was a source of experience superior to rambling through uneventful landscapes; risk taking was, at bottom, a better choice. Hard-paved patios and sports fields made the backbone of many a school, however. One can imagine these contrasting domains reverberating with memories of the hard-paved plaza and the common, as if embracing alternative urban traditions, except that they were removed from the urban bustle. This institutional Canon about segregated play was so entrenched that despite their radical stances about 'leisure', architects from different persuasions conformed to it.

Each play mode stakes particular claims upon space, but higher learning institutions generally excluded *Paideia*. Moreover, the notion of the University Campus embodies a particular composition of gardens and fields, with the almost total exclusion of play yards. Despite their classical overtones, the sportive use of university grounds in England was decried by nineteenth-century scholars (Lewis Carroll, amongst them). The issue was not so much formal, for given the minimalist markings required, the grafting of sports fields over the extensive meadows did not cause major spatial upheavals. It was rather to do with propriety, for these new usages did modify expected behaviours. The grounds charged the outdoors with an agenda for strenuous physical action that seemingly antagonised expected academic deportment, but as we know, nothing stopped sport from being introduced into these refined environments, a task that was increasingly entrusted to architects and landscape designers. The modernist mindset expected sports grounds to counteract academic fatigue, foster self-discipline, a collaborative spirit, the ethics of fair play and the cultivation of resilience. Last but not least, green extensions supplied clean air.

The campus

There was another classical precedent, however, for, as if following a teleological path, the *Campus* gathered something of the martial Roman spirit, particularly so in North America, where military training is often brought in line with university goals. The synthesis of classrooms and arenas soon became a staple one, to the extent that in a short span of time the ludic programme transcended cultural and climatic chasms. Whilst it fitted hygienist agendas, it was quite consonant with modern principles about the city in the park. Facilities often included stadia and large buildings, but unlike the unassailable coliseums surrounded by endless parking grounds, campuses offered a nuanced and much friendlier approach to sport.

We have seen how a single principle of orientation governed the Ville Radieuse where the housing blocks folded at right angles around the playing

fields. Likewise, it was seen in Walter Gropius's 1925–1926 Bauhaus Dessau, where the teaching and studio blocks folded around sports fields.

The Bauhaus educational programme embraced play and sport. Aside from football fields and tennis courts, the premises possessed a gymnasium and a terrace (atop the Pellerhaus dormitory block often used for exercise). The dormitory balconies were sometimes seized by students to jump into the void, as captured in Moholy Nagy's 1926 pictures, with the structural trials of the cantilever somewhat encapsulating the fearful trials of vertigo.

It can be safely assumed that the field's mathematical precision and minimalist character accorded with the Bauhaus design ethos, yet the school's broad ludic agenda also hosted remarkable carnivals that were integral to its academic calendar. Affording opportunities for plastic creativity and the subversion of hierarchies, these pursuits counterbalanced the earnest rationality of sport, until Hannes Mayer reinvigorated the values of perseverance, rigour and self-control found in sport against the comparatively unmanageable ways of *Paideia*.[14]

The sport agenda spread far and wide, regardless of stylistic preferences. Thus, for example, notwithstanding its neoclassical lines, Joseph Solomon's 1917 University of Cape Town mustered sports fields as primary landscape

FIGURE 144 *Bauhaus blocks and sport fields, Dessau. Drawing by the author.*

FIGURE 145 *Athematical gambits at the Illinois Institute of Technology by Mies van der Rohe (intermediate scheme). Drawing by the author after Mies van der Rohe.*

devices. Massive terracing was deployed to accommodate a rank of aligned rugby fields, their terse expanse configuring a graded forecourt, an extensive parterre to the classicist acropolis that arose against the magnificent bulk of Table Mountain. Combining the starkness of a Greek site (one recalls the graded stadium at Delphi) with the lushness of a garden, this memorable arena embodied the principle of *mens sana in corpore sano*, the ludic plateau infusing scale and character to the site's pervading gravitas. The terraced campus loomed over exuberant garden districts with its fields matching landscape and functional requirements. A cluster of gymnasia was added to the northern flank by Uyterbogaart in the late 1970s, which consolidated the original agonistic agenda over a period of several decades.[15]

Of course, the way sports fields fitted a university campus varied greatly. Thus, for example, Mies van der Rohe's IIT gridded layout was laid upon Chicago's platted surface, betraying a mathematical criterion. In situating the military tactics pavilion over the sports grounds, Mies unwittingly revealed the agonistic commonality of sport and warfare. Although not a final layout, the gridded scheme was perhaps closer to the overall ideal than the somewhat compromised built one. In it one recognizes not only the source of an austere constructional idiom of steel, glass and bricks, but also a landscape principle about flatness, geometric outlines, and orthogonal blocks. Such was the inspiration that fed the Hunstanton layouts.

The considerable challenge posed by the sport agenda to the making of gardens was reflected in such site strategies as the 1958 Churchill College competition, Cambridge, where the Smithsons confronted Stirling.[16] Despite the quality of Stirling's conception, as regards the ludic issue, his pragmatic appraisal contrasts with the Smithsons' critical stance. Their jagged-edged pond-cum-skating-rink mediated between lawns and fields. Its sharp outline was a landscape oddity. Whether fully conscious or not, they were fostering an element of integration of playing fields and gardens, whilst also reckoning in the landscape certain behavioural patterns that ranged from the contemplative to the active, from the planned to the hazardous and from the

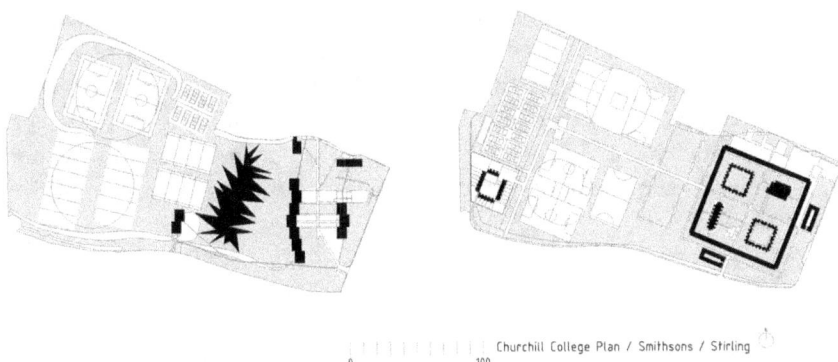

FIGURE 146 *Smithson and Stirling's competing visions about a Cambridge college in its relation to its grounds. Drawings by the author after submission drawings by A. and P. Smithson and J. Stirling.*

jovial outbursts of Paideia to the earnest patterns of Ludus. Both in outline and ludic potential, their pond-cum-skating-rink was a hybrid. Ludus was indeed the prevailing mode in University Campuses; a predominance that came to formally assimilate these to military academies, reflecting the uncertain boundaries between playing and indoctrinating. It was easy for military establishments to turn parades into sports grounds, but large university clusters were close to the mark in devoting extensive financial and spatial resources to the same: Harvard Soldiers Field and MIT Briggs Fields are just significant tokens of a generalized trend. Fields and athletic facilities came to form tightly locked patterns of grounds, stadia and gymnasia such as the ones we observed earlier where planting became subservient to ludic ends.

Not surprisingly, such clustering informed the Valparaiso School's 1954 Naval Academy competition scheme.[17] Its windswept coastal plateau adjoined a public stadium and an extensive parade ground that gathered the largest sport facilities in town. The scheme was particularly innovative in the deployment of wind deflectors. The extensive terracing required for the fields together with the wind deflecting walls yielded a highly geometrized pattern of horizontal and slanted elements cast against the open sea, adding interest to what would have otherwise been a standard sport park. Universities did not lag behind: Carlos Raul Villanueva's 1944–1970 Central University campus in Caracas, and Mario Pani's, Del Moral and Garcia Ramos 1947–1952 UNAM campus in Mexico City contemplated significant sport areas. Unlike most pioneering North American campuses where the arenas often evolved piecemeal, these were guided by cohesive master plans. If Villanueva's campus shows a remarkable parti as regards the integration of the institution to the city, the Mexican team elevated the sport ensemble into a formidable sequence of elements cast against rough nature.

Sport arenas and coliseums were smoothly integrated in most educational establishments. Not so in cities where, with the exception of some remarkable examples (Boca Junior stadium in Buenos Aires for one), urban stadia were usually isolated. Such was the critique Lewis Mumford levelled against these giant bulks usually stranded in vast parking plateaus. University sport ensembles often made better neighbours: Villanueva's decision on emplacing

FIGURE 147 *Topographic devices for wind control in a sport cluster at the Naval Academy, Valparaiso. Competition entry by architects of the Valparaiso School. Drawing by the author after model by Valparaiso group.*

FIGURE 148 *Epic scale and pre-Columbian associations at Alberto Taray's 1952 Hai Jalay play courts in Mexico's university city. Drawing by the author.*

the University stadia at the tip of the campus, flanking Caracas' prime thoroughfare, made these, rather than the library or other element, into the institutional icon: his strategy was not very different from Kahn's embedded stadium in Philadelphia's, for as if following Roman precedent, both became metropolitan hotspots, and visual landmarks.

Educational establishments first instilled the values of *Paideia*, to later turn children in favour of *Ludus*. Play was reckoned to be an agent for the acquisition of skills, also for the fostering of collaborative efforts and moral values. No doubt it was also valued as a harmless outlet for dissent, particularly so because playtime dissipated the energy accumulated through the enforced stillness of study time. In a sense these institutions sequestrated the ludic agenda for instrumental purposes; but what if, once divested of moral or altruistic aims, play's creative potentials and rewarding experiences were redeemed? How could such assumptions inform urban space making?

9

The citizen

The rebirth of *Homo Ludens*

Constant Nieuwenhuys, the Situationists, Yona Friedman, Archigram and Cedric Price endorsed the ludic impulse as a prime urban engine. However, nothing could be further away from their respective quests than the mythology of sport. Even less so the earnest conception of play as a tool for the infant's progression into adult life. Neither did they subscribe to the social agendas embraced by their peers in the heroic period. Tenuous lines connect their somewhat disparate thoughts, but all in all they mistrusted the welfare estate (Price being somewhat ambivalent in this respect). They endorsed the ideas about *Homo Ludens* as a modern agent, also state of the art technology as a liberating tool, with an early awareness about cybernetics in the fields of human relations and space management.

Most of them rated fun over play, although to different degrees. Constant, his fellow Situationists and Friedman shared a special interest in Huizinga's *Homo Ludens*. Friedman was also conversant with Caillois. Archigram rated boredom as a social malaise. Similar thoughts led Gordon Pask and Cedric Price to craft algorithms conductive to obliterate interactive computer programs subjected to either low demand or excessive reiteration. Agile and transitory, these computer aided scenarios would avert this most paralyzing mood.

There would be Fun Palaces, Instant Cities, atmospherics and interactive environments for the fruition of the denizens of advanced societies, who were about to reach a full emancipation from industrial toil (at least, such was the expectation). The heavy cultural baggage associated with architecture, urbanism and landscape did not find outlets in their discourses. Aside from singular Victorian items that infatuated Price and Archigram, historical precedent was inconsequential. Unmoved by the poetics of gravitas, they rather pursued light, changeable, responsive scenarios. Impatient with inertia, they wanted to accelerate time: Price, Archigram, Friedman and Constant conceived provisional environments; mutant, short lived, allied to an expanding

consumerism, 'expendability' was a catch word. Far removed from brutalism, they phased out concrete in favour of steel, glass, plastics, fibres, and new alloys. A progressive disengagement from site led their schemes to rise free from the ground, sometimes drift or move impelled by mechanical contrivances, rendering futile any concerns about locality. A renovated nomadic experience now fostered by technology became a common ground. Fun and hedonism were far removed from earlier concerns about how to productively fill 'free time'. Leisure thrills could now be attained by interacting with disposable software.

One would be hard pushed to find sports fields, scout clubs, children's playgrounds, let alone schools, in Constant's *New Babylon*, Friedman's *Ville Spatiale* or Archigram's *Instant City*. You just needed plentiful and adequate room for leisure in the Corbusian scheme of things, whilst greater doses of individual choice, plus heavy technological inputs were required within the new vision. Peter Cook argued:

> The city . . . [is] a network of incidence . . . [destined]. . . to respond to situations rather than to incarcerate events . . .
>
> COOK 1967

Inert masses of concrete in Brasilia, Chandigarh and countless lesser settings embodied the kind of 'incarceration' alluded to by Cook.

The ludic instinct turned political as soon as *Homo Ludens* became the role model, for in doing so, it set forth unquestionable urban priorities. The ludic ethos that affected all civic matters was far removed from the educational establishment's instrumental view of play as a tool. It was equally removed from the medical establishment's view of play as contributor to wellbeing. It was, needless to say, at odds with the military establishment's view about play as training. Play was postulated as a prime urban pursuit only because the ludic was understood as the citizen's prime objective. Moreover, the substitution of working time for playtime claimed freedom as a supreme value: freedom from toil, from the regulated uses of time, from habits, also from the constraints of reason or production.

Paideia's revenge

Paideia was the mode of play that best suited such agendas. Of course, its practice was not circumscribed to children (who were seldom mentioned) but to everyone. Citizens' play was seen no so much a compensation for work, or a tool for social or physical improvement. It was seen as a prime endeavour, a celebration about newly attained freedoms, the ones afforded by a

post-industrial, affluent, fully mechanized society. Such was the message relayed by Constant.

But *Paideia* was also seen as the means by which to mould the citizen's urban habitat in a kind of one-to-one Lego game, which was intended to cast massive conglomerates, whilst aping vernacular practices. These were indeterminate, ever changing, and participatory. The price to pay was of course the mega structure with its (undeclared) master designer, its purported flexibility and indeterminacy attainable through the exercise of considerable centralized power. Such views run counter to business oriented leisure initiatives (Disneyland was established in Orange County by 1955) where the ludic was increasingly commoditized, although flirtations with the leisure industry were not at all rare.[1] They were equally removed, however, from that branch of the leisure industry that dealt with organized sport, an activity estimated by Guy Debord as 'at least as repugnant as tourism and credit transactions'.[2] It was more like *Paideia's* revenge against countless modes, whereby the human instinct of play had been made instrumental, commoditized and eventually denatured. If there was an urban model behind this rebellion it was far removed from those ludic considerations that had borne the foundations of modern projects. Hygienic and rational design parameters were ignored. The social, pedagogical, philanthropic considerations that had thereto guided the criteria for ludic spaces were equally abhorred. Closer to Duvignaud than Huizinga, despite all differences between the respective actors, this particular vision of play redeemed its impromptu character, its Dionysian promise and its rebellious nature.

The agenda did find institutional outlets, however. Conceived in Price's words as 'a toy', a 'university of the street' and a 'laboratory of pleasure',

FIGURE 149 *A pleasure machine: Cedric Price and Joan Littlewood's fun palace, Lea Valley, London. Worm's eye perspective, 1964. Copyright Cedric Price fonds. Canadian Centre for Architecture.*

London's Fun Palace was an attempt to break down conceptual, psychological and physical barriers of the kind that hold leisure and learning activities apart, whilst inaugurating novel forms of urban intercourse as afforded by advanced technology. The scheme's patron, Joan Littlewood, brought her experience as theatre director and social reformer to bear in the programme of this cultural institution which was aimed to break new ground in relating theatre to the public. Price devised a fixed structure to which moveable elements, services and equipment could be freely attached, placing the emphasis upon performance over aesthetics, tuning building and spatial relations simultaneously, as much as the events and modes of encounter generated by each set. Each temporary scenario was to express volatile social desires. His numerous diagrams attempted to foster the kind of choices deemed essential for the materialization of the idea: he liked conveying the notion of a menu as essential to the spirit of the enterprise. Price visualized in play primarily a potential for intercourse. Ludic interfaces between citizen and structure and the direct intervention upon the urban habitat were aspirations he shared with Constant and Friedman. The full-scale Meccano was in a sense the best analogue for his ludic conception that betrayed technological infatuation, the ludic potentials of form making and the ludic challenges posed by tectonics.

Nevertheless, other than in garden sheds and adventure playgrounds, direct action of the sort was rare in advanced societies, stifled as they were by regulating bodies and massive environmental and planning legislation. With an emphasis upon urban mechanisms rather than form, the strategies summarized as 'Non-Plan' (1969) gathered a bunch of critics and professionals around a principle of space management that challenged planning criteria. Non-Plan enforced an idea of direct action to be tested in selected patches of exception in Great Britain, not unlike the Chinese enterprise zones created in the post-Mao era.[3] Launched by magazine editor Paul Barker, it aspired to unleash the suppressed forces of creativity, chance and spontaneity long removed from urban matters. Reiner Banham, Peter Hall and Cedric Price were collaborators. Colin Ward, who was an active sponsor of adventure playgrounds (and who later authored books devoted to children's experiences in city and country, with a considerable emphasis upon the issue of play), reckoned in it a significant model for emancipated management of space.[4] In their view, the expressions of individual desires were stifled by overregulation, yet lurking behind direct expression and the protocols of action and reaction there was an undeniable ludic element.

Non-Plan substituted established urban practices which could be closer in spirit to *Ludus* (for example those that drew their meaning from expressed rules and regulated frameworks such as found in building regulations, treatises or manuals) with the uncertain creativity of *Paideia,* its celebration of chance and the unforeseen. We have seen how the Smithsons had already nurtured

an urban syntax from the spontaneous outbursts of *Paideia*. Nonetheless, their ultimate aim was to replace one large scale planning mode for another equally heavy one, whereas Non-Plan defied such overall prospective visions as enshrined in planning practices. It was definitely concerned with the here and now.

According to Yona Friedman, leisure and play accounted for the driving force applied to city making. Following from Huizinga, his expanded ludic framework also accounted for the theatrical, the political and the religious, but in his view, only the social basis of such pursuits guaranteed stable human groupings. He reasoned that the history of cities was no more than a protracted struggle to avoid boredom and inanity. Collective recreation required organization, hence work; work produced fatigue, fatigue called for repose, and repose led into boredom which in turn awoke desires for amusement and distraction: such an extraordinary – and at the same time predictable – cycle accounted in his view for much of the experiences of all urbane civilizations.

In his view, Team Ten had failed to face the unprecedented challenges posed by 'development', 'mobility' and 'change'.[5] With a generous emphasis on participation, his conception of a mobile architecture would channel those leading forces, productively. The essentially adaptive organism of the Ville Spatiale (1958, 1961) found in the ludic instinct a core concept. He derided

FIGURE 150 *The old in the new: Yonna Friedmann's Ville Spatialle, collated to a Mediterranean village. Image courtesy of Yona Friedman. Copyright Yona Friedman.*

agonistic games. These were tainted by lingering memories of ancestral – and now meaningless – fights for food, also by totalitarian appropriation. He favoured adaptive and imitative games and particularly creative ones, such as do-it-yourself or amateur painting, which he deemed fertile in urban place making. Friedman made unsuccessful appraisals of Caillois, and it is clear that his vision of the ludic was impregnated with Huizinga's overarching notion of play, as much as from Caillois' distinction about ludic modes and their respective social connotations.

The three-dimensional armature of the Ville Spatiale was conceived as an enabling structure to be spatially manipulated at the small, medium or large scale with the purpose of formalizing a living habitat. It aspired to mobilize the ever so latent forces of individual initiative in order to retrofit a high-tech chassis with a new vernacular; such was the game Friedman proposed, espousing his vision in photomontages where lattice structures supported tight dwelling ensembles that could have easily been extracted from Rudofsky's 'Architecture without Architects'. Neither shade nor any other effect tarnished the interplay of the suspended over the grounded. Rudofsky reciprocated, portraying the *Ville Spatiale* as a visionary project that was somewhat in tune with tradition.[6] Living up within lattices must have also awoken the thrills of the tight-roper.

Homo Faber the fabricator thus became *Homo Ludens* the player, for in this vision the utilitarian merged with the ludic, the fabrication of dwelling space (the emphasis was upon dwelling) engaging creative formal games of the kind devised by Froebel. It was as if amplifying Sörensen's fusion of fabrication with play. But as we know, it was only in small ludic installations where the closest similes to Friedman's vision were ever enacted, for the expected epic scale was never attained.

Hovering above the crust of the earth, over cities or oceans, unencumbered with hazardous soil conditions or topography, the Ville Spatiale offered ample possibilities for formal invention, albeit always constrained by the fixed three-dimensional lattice. Largely undisturbed, the grounds hosted agricultural space, large scale industrial infrastructure and occasionally, as hinted by the author, massive stadia.

Friedman did in fact test the concept in the Milan stadium with the mega structure hovering over the bowl, its tiny dwelling clusters in command of the spectacle. Years later he visualized retrofitting such places as Place de la Concorde for the Olympics with demountable bleachers and impromptu arenas. Whether conscious or not, he was simply re-editing ancestral common practises.

The substitution of the principle of production for the ludic principle led to the conception of buildings and cities as veritable toys as exemplified in Constant Nieuwenhuys *New Babylon* (1953–1965).

FIGURE 151 *Friedmann's bid for the Paris Olympics 2004, with a demountable stadium at Place de la Concorde. Image courtesy of Yona Friedman. Copyright Yona Friedman.*

Nieuwenhuys and Debord abhorred the Corbusian city and its debased expression in French Grand Ensembles such as Sarcelles, with its multi-storey blocks and extensive grounds of 'captive nature' devoted to recreation and play. The construction of situations promoted exploration, accident and an immersion in the guts of the metropolis, with passion, desire, and a full awakening of the senses its main instigators, whilst the principle of Unitary Urbanism radically countered zoning and its deleterious experiences. But aside from the ex-novo situations lodged within New Babylon, the Situationists' agenda embraced the ludic subversion of cities through ploys such as the nocturnal use of underground infrastructure, the interconnection of rooftops, the elimination of cemeteries and museums, (their contents were to be distributed to bars all over the city), the suppression of street names, and the provision of switches in traffic lights for the individual control over flows. Eminently tactical, and much in the spirit of *Paideia, detournement* was unconcerned with building new realities as it turned the everyday upside down.

Homo Ludens was expressively embraced by the Situationists, yet Huizinga had fallen short of the real scope of play, they argued, for in his views it accrued value only in contrast to work, as *Homo Faber*'s alter ego.[7] Moreover, Huizinga had paid too much attention to the mores of (Veblen's) leisure class. New Babylon's ludic agenda would surge from a classless society once automatic production had overhauled human labour. The scheme culminated in a protracted exploration of the ludic subject, initiated by Constant in

FIGURE 152 *The play board as a sculpture constant. Neienhuis's Ambiance de Jeu, 1956. Drawing by the author after Constant.*

collaboration with Van Eyck. His fellow Situationists had taken part in the Cobra Group with which Van Eyck had also collaborated. As noted, New Babylon urban patterns derived from the Smithson Golden Lane diagrams: thus, it was at certain levels nurtured from Team Ten.

The urban layouts supplied a fluid and open system in lieu of the dialectics of 'urban fabric' and singular landmarks. 'Units of Ambiance' rather than districts characterized the urban sectors: these were of course fleeting and unstable as they embodied evanescent conditions. The relentless assault on the senses aligned with Constant's references to psychological and erotic games.

Interaction was critical to New Babylon, as it was with Price, Archigram and Friedman, with the citizens tuning its particular urban effects. The labyrinth supplied another conceptual model, except that it was conceived as mechanical and transitive. Evoking the nomadic life of gypsies and circus troupes, the ceaseless drift in search of novelty would prevent the inhabitants from putting down roots, or forming habits (the latter were deemed undesirable by Constant). In utter contrast with the Enlightenment traditions of intelligible forms of order, Constant's unfathomable designs induced loss of orientation and memory. But there were other consequences too, derived from the strenuous physical effort required in shaping its scenarios, a point highlighted by Sadler, who equates it to the demands of gymnastics for in an unwritten agenda, the citizenry would require optimal health in coping with their duties of city making (Sadler 1998).

The New Babylon web of interlinked bridges had capsular units clipped on to its levitating urban bulk that reached the ground mainly through some massive load bearing elements. Infused with a spirit best described as immersive, it offered a cloistered experience. The combination of a fully synthetic environment and an overwhelming feeling of enclosure led Alan

FIGURE 153 *Strenuous efforts: a late Victorian gymnastic apparatus. Drawing by the author.*

Colquhoun to draw comparisons with the shopping mall. As is customary in gambling casinos, the removal of play indoors would have led on to a suspension of time, depriving it of the kind of renewed expectation derived from the natural cycles. The relentless derive from one unit of ambiance to another, the fluid and ungraspable nature of the mechanical labyrinth, the absence of landmarks nurtured those feelings that Caillois had classed as *Ilinx*, claiming the value of subjectivity against rationalist expectations. Of all the authors who delved into the ludic subject, Duvignaud comes closest to its spirit.[8]

Chance and the unpredictable were underpinned by a robust technological hardware. Specialized software aided the production of ambiances where colour saturation ('yellow sector', 'green sector'), sound, moisture, temperature and spatial arrays construed very particular experiences. The heavy (although largely undeclared) technological reliance did not preclude an equally emphatic call for citizen's action in the making of what one could term (borrowing from Rudofsky) non-pedigree architectonic formations. Whether disguised or in full view, the mechanical apparatus allowed *Homo Ludens* to confidently enjoy leisure, but such routine matters as the ones CIAM classed as 'Living', and Team Ten with the more inclusive concept of 'Habitat', were derided or at least absent from the argument. Bereft of a residential agenda, its plan departed from core modern concerns. Another fundamental distinction in relation to

modern precedents was its neglect of the grounds. New Babylon's programmatic and aesthetic indifference to the grounds applied to their expansive ludic programmes, conceived as prime propellers of its urbane experience. Needless to say, sport arenas and agonistic contests were simply not held within its conceptual horizons.

The aforesaid indifference to the grounds contrasts with the Situationists' '*dérivé*', however, with its endless roaming about streets with its pedestrian foundation nurtured from rich European traditions, thus congenial to the urban values so passionately sponsored by Rudofsky, Rasmussen, Rykwert and Jacobs (also shared by countless photographers, writers and filmmakers). Streets and alleyways were the *dérivé's* predominant arenas, whereas in New Babylon, such structures were not contemplated. Its robust urban experience was supposed to grow indoors and up, divorced from the traditional urban matrix. Ancestral pastimes were equally ignored.

Invoking pagan ancestries, however, it offered saturated ambiances for the satisfaction of *Homo Ludens*. Stimuli saturation removed the experience from the ascetic rigours of Ludus. Founded upon the uncertain trails of *dérive, detournement*, chance and nomadic impulses, the society that emerged from this conundrum would be unable to forge stable forms.

The May 1968 events in Paris were generally considered a turning point. It was the time when Henry Lefebvre extolled 'the right to play'. The substitution of the everyday for a new order of barricades construed a veritable set of situations destined 'concretely and deliberate for the organization of a unitary ambiance and a play of sensations', as defined by the Situationists. Duvignaud equated these episodes to the carnival.[9]

Leaving aside all considerations about their scope, and political consequences, the network of Parisian blockaded streets reveals a strategy not altogether different to the Danish play streets. Just for a while these exhibited a form of order circumscribed in space, and ruled by particular considerations, as if delineating a ludic space, although with other aims. These nevertheless highlighted certain ambiguities about drama and play. Thus, it is only fitting to close this enquiry with a statement that looked upon play – mainly through its artefacts – in relation to memory and drama: such was John Hedjuk's 1983 competition idea for the Memorial to the Gestapo Victims on a site tainted with gruesome memories.

A tram circuit enfolded a vast field populated with assorted objects such as a labyrinth, a ferris wheel, a sand box, tramways, sixty-seven items in all, each one assigned to a user and a particular agenda, all of them immersed in a grove. One by one, the objects were put in place, removing trees as required, the overall process guided by public consultation.

The children's playground and the fairground were well represented in the scheme, together with other idiosyncratic units drawn from the author's

FIGURE 154 *A field of ludic objects: John Hedjuk's memorial for the Gestapo victims, Berlin. Completion stage with 67 items. Drawing by the author after John Hedjuk.*

sometimes bizarre mental stock. Time was to unfold in slow motion, in contrast with Price and Archigram's accelerated tempo, for Hedjuk drew significant parallels about growth, with trees aging together with the citizen's passage from childhood to old age.

Referring to the dry orthographic representations and technical mood of 'Neufert's' or the 'American Graphic Standards', Hedjuk displayed the full inventory, including sandbox, seesaw, swing, a tram, and the aforementioned fairground wares. Children were clearly expected to fill the memorial with joy, but the impression conveyed is one of a profound foreboding. The ferris wheel offered privileged overviews of the wooded landscape. The absence of clearances in the woods left the space without open 'arenas'.

There was no technological celebration, certainly nothing approaching a modern vision about technology. Building procedures were simple, if not archaic. No software was summoned, and no techno atmospheres, even though a brooding mood would most probably have pervaded the whole complex. Like Price, Hedjuk supplied a script, except that not as a deadpan

'menu', but an ideal one, with a preordained protocol for the assembly of the artefacts. Associated with each pavilion there were characters as in fiction. As regards building materials, timber was favoured above metal, and of course the overwhelming presence of trees bespoke 'garden' or 'forest' rather than fairground.[10]

We may ask at this point, why equip a war memorial with ludic implements? Or else, again, what is it that differentiates a playground from a memorial, as we did in relation to the Adele Levy playground. The issue is not innocent, for Hedjuk deliberately conjoined play and reverence.

Citizens could indeed seize the world as playground. Such was the 1960s' inebriating expectation. But culture had steadily eroded the formal distinctions of the ludic and ritual sites. A similar mindset had impelled Kahn to cast the unpredictable outbursts of free play in solid, inert and durable configurations so that play and ritual met their common origins. Players, the field and instruments (as required) make the necessary ingredients to the ludic event. Each particular player: the child, the athlete and the citizen, captured the imagination of architects who then engendered distinct ludic scenarios that embodied certain notions about society and the city.

The 'field' is often a given (or rather the product of a sophisticated evolutionary process), frequently a construct, and sometimes an elusive figure: It is for the most part authorless and X-games obviate it. This late trend suggests a momentous shift away from the architecture of play. When instruments likewise become fields of action, such as an inflatable which is set to roll or glide through human action, no room is offered to architecture. Only under certain circumstances does ludic need lead on to architectonic formulation, however elementary. But as we have seen, even within this constrained framework, the production of architecture of play in the modern period was nothing less than prodigious.

FINAL REMARKS

Futile pursuits: play and the production of space

Unburdened with practical obligations, play belongs to the domain of delight. As we have seen, a decisive nineteenth century legacy supplied modern sport, the conception of children's playgrounds, and the implementation of people's parks. The latter became a privileged locus for play, quite in tune with its increasing convergence with 'nature'. With lesser ascendancy, the mechanized fairground or amusement park, made a ludic counterpart to the industrial shop floor. Ludic arenas were attached to educational establishments.

Like many nineteenth-century gridded cities, Aarao Rei's 1895 plan for the Brazilian *Cidade de Minas* (later christened Belo Horizonte) featured distinct 'recreational' enclaves cast over a super-rational grid: an arabesque-patterned park was encrusted in its very heart, with its meanders adding to pleasure, for here – as in play – the inverted uses of time reigned.

'The principle of the longest path', affirmed Nathan Rogers, 'is the basis of the art of the garden'. Paths thus conceived delayed time, infusing the garden with certain grandeur (Rogers 1965, 133). The race course was the other enclave. It was emplaced toward the eastern fringes, its precise outline following measured distance and turning radii, its ludic imperative aiming for efficiency, albeit with no productive goals in sight. Both denote identifiable ludic forms.

Just over three decades later, Le Corbusier's synthesis of the urban and the ludic ensnared similar meandering paths with dead straight arteries, whilst relegating the race course to the fringes, as in Belo Horizonte. In his *Urbs in Orto*, sports grounds and swimming pools were inscribed in the arabesque, even at the risk of disturbing the precarious equilibrium of the bucolic and the Cartesian. No longer exceptional, the park became coextensive with the urban plan.[1]

The Athens Charter consolidated the triad, park, play and sunshine in a synthesis that found an expression worldwide, however fragmentary; but the

privileged rapports between the ludic and the 'natural' were soon questioned when challenging the radical artificiality of the playground, whilst the notion of the playground itself became increasingly contested.

The mid-1960s brought the issue of play to a climax, when the city itself was conceived as a monumental ludic mechanism. Then, the bearings of leisure upon the urban matrix became overwhelming, but as we know, this unexpected synthesis failed to materialize, for reality pushed things in quite other ways.

Neither heroic in imagery nor in intent, suburbs were tainted with ludic overtones: 'an asylum for the preservation of illusion' in the words of Mumford, (illusion brings us to *in ludere*, to be *in the game*), these heavens of domesticity, he argued, were not merely child-centred but based upon a childish view of the world in which reality was sacrificed to the pleasure principle.[2] Thus emasculated, *Paideia* posed no political threat, just urban inanity, for the big game was to be played elsewhere, in 'human scaled' towns.

A big bang impregnated all urbanized lands with playgrounds, except that without a grand plan. These were nevertheless intended as significant nuclei, hence much like in old traditions about play in the square. Entangled, the theatres of *Ludus* and *Paideia* evolved: abandoned fields accounted for ludic fads gone out of fashion, whilst new configurations sprang up unexpected. Later, X-games superseded the notion of the field.

Over time, landscape patchworks interwove contrasting leisure traditions: thus, for example, in Chantilly, Ile de France, long past the baroque climax, the progressive overlay of race course, golf courses, and training grounds substituted courtesan etiquette and hunting. Whilst enmeshing Le Notre's imprints with embodied figurations of action, hazards, risk and speed, these novel grounds consumed about as much space as the baroque ensemble.

Embedded in greenery, the new lexicon of leisure spaces was in keeping with precise ludic mandates, whilst the various ways in which society catered for *Paideia* were simultaneously registered. Nearly-proper 'unofficial' fields took advantage of urban opportunities across the board.

This was a distinct lexicon of precincts, landscapes, spaces and objects, for, within the logic of play, a park could become a garden for projectiles (as in golf), a matrix of platforms (as in sport complexes), a network of impediments (as in steeple chase), whilst a room could become a bouncing apparatus (as in squash), or a climbing device (as in gymnasia), and even a table could be construed as a sliding device (as in billiards) or a bouncing one (as in ping pong). Assuming the agenda wholeheartedly, the twentieth century delivered manifold ludic enclaves, including a considerable amount of green landscapes of a sort that was bereft of ecological variety, with such artificiality and abstraction as one ascribes to industrial materials. These became ingredients of the modern habitat.

FIGURE 155 *Leisure ensembles at Chantilly le Notre's garden with hunting grounds, the hippodrome and a golf course. Drawings by the author.*

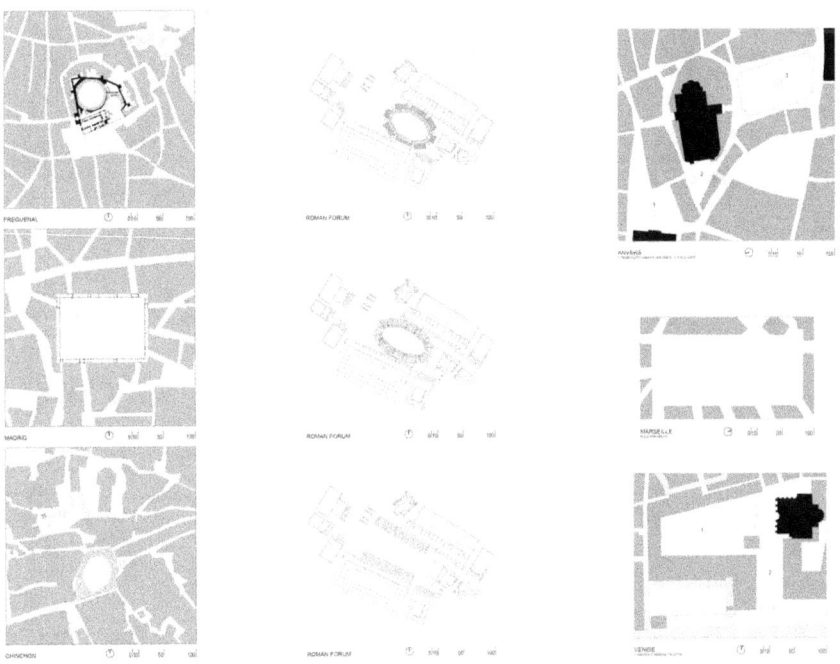

FIGURE 156 *Fields and squares. Drawings by the author.*

Alternatively perceived as menace or as the ultimate deliverance from toil, newly attained leisure posed new architectonic, urban, and territorial challenges. All these were guided by ludic (that is, entirely arbitrary) propositions; play was seriously considered in the making of cities and neighbourhoods.

Play is above all a way of reckoning with the world. It is not impelled by material gain, nor by spiritual yearning, but rather by surplus vitality and the pleasure principle. Its assault upon reality is so comprehensive that the ludic instinct affects our relation to plants, animals, minerals, the environment and society in highly specific ways. We have examined how the perception of mountains shifted when these became playgrounds as in winter resorts, but ludic objectives also change our conception of other creatures. So, for example, the mapping of a carcass with an eye for the best cuts, as conceived by the butcher, follows precise culinary traditions, but when play comes to the scene it brings other considerations altogether. Born of rural practices, the Chilean rodeo involves a couple of riders seeking to trap a calf against a circular palisade, so that its arena is mainly used by the perimeter. In this trial, certain body sections (which are mapped as parallel strips denoting areas of body contact) relate to 'good points', hence indexing performance. If the butcher's empirical logic ultimately draws from taste, the ludic one – even within the

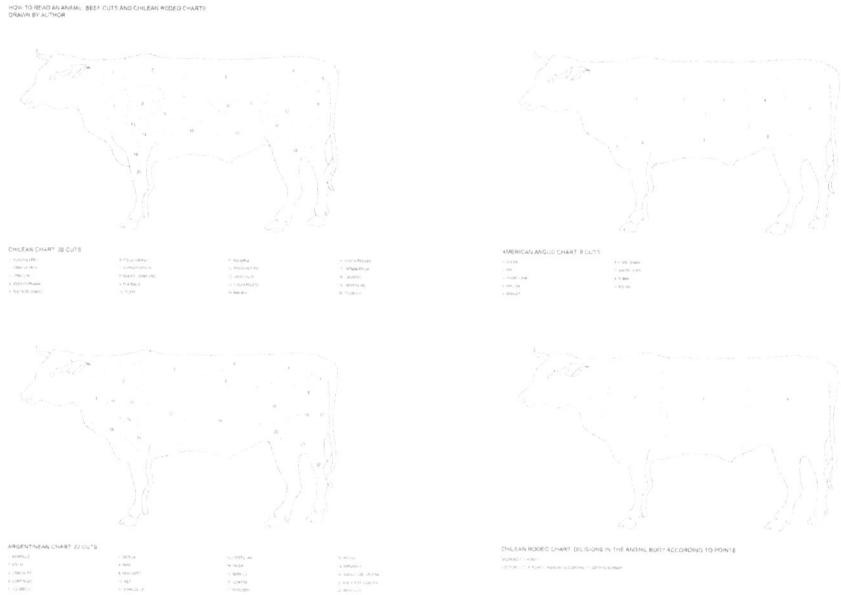

FIGURE 157 *Mapping the body for food or leisure: Chilean beef chart 28 cuts; American Angus 9 cuts; Argentinean 22 cuts; Chilean rodeo points 4 sections. Drawing by the author.*

relative coarseness of rural games – conjoins dexterity with deportment. To the player, the animal represents a challenge as much as an opportunity, hence his (her) ludic appraisal.

But ludic aims are insatiable. Just as the animal is mapped in view of arbitrary goals, so we thoroughly map the world we inhabit with ludic intent, only that for the gist of it. Seizing it for play unleashes actions that may or may not last, for not all ludic forms do. Following ludic calls manifold fabrications cater for players and spectators alike, whilst setting the conditions for play. A constant flow of initiatives pushes play into streets and ordinary spaces whilst opposite forces draw it into specialized enclaves. At stake are individual desires and institutional objectives, freedom and control. The issue is compounded by strict differentiations between amateur and professionals, but it is fair to conclude that overall, the twentieth century represents a period of setting play apart rather than fusing it with the flow of ordinary life. Was it a parenthesis or the beginning of a long-lasting trend? It is impossible to hazard a guess but there is one important consideration: if common urban spaces were once possessed as ludic arenas why not try such integrative strategies again?

FIGURE 158 *A lexicon of urban spaces. Drawing by the author after Sitte and Sport Manuals.*

Notes

Introduction

1 Huizinga, 1972 (1938). His seminal essay on play was preceded by a presentation at the University of Leyden on the limits between ludic and 'serious' concerns in culture. Although sometimes criticized for its somewhat excessive scope, this text profoundly altered the perceptions about play and its cultural function to the extent that most subsequent serious writings on the subject made reference to it.

2 Huizinga does not delve much in the distinction; if anything, his interest lies closer to the spirit of *Paideia*. He regarded modern sports as grossly overregulated. Caillois' critique distinguished *Ludus* from *Paideia* (Caillois 1986 (1967)). Their perspectives also reflect upon the appraisals of the historian and the sociologist. Caillois who was associated with the surrealist movement and who befriended Bataille was also aware of such architectural developments, as the landscape architecture of Roberto Burle Marx.
 No such distinction as play and game is acknowledged in French, Italian, or Spanish.

3 Far from waning, the symbolic status of urban squares is made evident at times of uncertainty. This was confirmed in recent events in Tahir, Cairo, Gezi, Istanbul, or Plaza del Sol, Madrid, all massively seized for democratic expression between the years 2012 and 2013. One may reckon that these retain the significant function of representation of a people. These momentous political events captured worldwide attention.

4 Unconcerned with good or bad, play exists beyond ethics, and yet ethical dimensions are often associated with it. Indeed, one reason for the late nineteenth-century upsurge of modern sport was its perceived usefulness for inculcating values allied to a team spirit, which was also instrumental to the training of managerial cadres. Confirming the vision of Huizinga (who esteemed modern sport as exceedingly regulated) and Caillois (who held it in more positive esteem), play supplied templates for social intercourse. Ortega asserted that it was play, before practical endeavours, that inaugurated social organization, the club representing a cradle of the political institution. And yet, play values are contingent on particular social mores, as shown for example in the exclusionary rules often attached to membership. Ominously the appeal of sport is prevalent in modern totalitarian agendas. Moreover, the often-restrictive access to playtime confirms Veblen's indictment of the

'leisured society' privileges which was a direct consequence of its member's abstinence from industrious (i.e. productive) occupations (Veblen 1994, 1989).

5 For a detailed facsimile see: Romanelli 1982. The Ansart plan is available at www.archivovisual.cl/plano-de-Santiago–2 (accessed 15 August 2017).

6 Like many of the original features, this radical encounter between building and sand was lost in subsequent refurbishments: today the Excelsior's sea front is bedecked with an unimaginative front garden.

7 Girouard (1975, 109) describes how Venetian rivalries were channelled through competitive games. For a more thorough description see Molmenti, 1905. The author lists regattas, bridge contests and field games (such as *forze d' Hercule* and *caccia dei tori*): earth, water, and their mediating elements were somewhat recast in spectacular manner for ludic ends. Like Giacomo Franco, in the eighteenth century Gabriel Bella portrayed the celebrated carnival, and ludic activities such as bear baiting and bullfights performed in such unlikely settings as the Piazzetta, the Doge's palace courtyard, and the Chiovere di san Giobbe. He also depicted bulls being chased over the Rialto in paintings now housed at the Querini Stampaglia. Simmel characterized Venice as a city of false appearances, a stage for theatrical performances (Simmel 2007 (1907)).

8 Although many other foundations predated the Laws of the Indies, the principles enshrined in these were largely concordant.

9 Recent scholarship validated this Vitruvian agenda. See: Welch (2007, 49). Although temporary seating facilities in the Forum often resulted in angular layouts, Roman amphitheatres eventually settled for the familiar oval configuration. Explains Welch: 'a circular structure such as the Spanish corrida (sic) would have been an ideal space in terms of all the spectators getting a good view of the show. But egalitarian seating arrangements were not a Roman concern, nor would circular structures maximize the viewing space for gladiatorial spectacles within the forum. The ellipse fits well . . . and it supplies commanding spaces of the kind liked by the Romans'. Hemmed in between existing structures, the ellipse became an optimal compromise between the ideal and the possible.

The temporariness of these structures reflects a republican prohibition against spectators' buildings in Rome. 'The lack of a permanent amphitheatre in Rome until Augustus . . . is not connected with the kind of moral prohibitions that were applied to the theatre. Theatre spectacles were alleged to be enervating and corrupting, while the gladiatorial combat that took place in the forum was thought to harden people . . . and promote military discipline. No moral stigma was attached to gladiatorial entertainment. Impermanence is less the result of moral policing than of force of considerable habit . . . the situation is roughly comparable to the idea of football games being regularly held in (Washington DC) on the Mall' (Welsh).

10 An exception must be made for the famous Mayan ball courts, but these belonged to a culture where play, ritual and sacrifice liaised, quite in contrast with the modern agendas of sport. Colonial towns in Latin America sometimes also featured ball courts, but these were of northern Spanish (not indigenous) provenance.

11 Sitte's treatise became an important source for Le Corbusier. No so amongst Team Ten members who moved on to altogether different sets of referents. Sitte's insistence upon the subject of the urban square is evident as it is his almost exclusively compositional approach.
12 Alone in Team Ten, Candilis seems to have foreseen the menace and opportunities present in mass leisure, to the extent that much of his housing agenda was effectively channelled toward the making of resorts.

1: The whereabouts of play

1 Play 'transforms structures into events', observed Agamben, whereas ritual makes 'events into structures'. If the sacred instinct united myth and rite, he argued, play either translated myth into words, or else rites into action, but never binding one to the other (Agamben, 2001).
2 He makes special reference to the nunnery of Santa Catalina in Arequipa, southern Peru, an extraordinary monastic village. Why such a place should have counted as a ludic site was unexplained, but his vision of the ludic phenomena embraced atmosphere, irrational expense (as in the baroque conception of architecture), as well as the quality of otherness.
3 No doubt non-British sports also acquired broad acceptance. All in all, it is true however that the main practices were disseminated by the British, with the worldwide dissemination of the lawn following that source.
4 'Thus, sport which began originally perhaps as a spontaneous reaction against the machine has become one of the mass duties of the machine age', argued Mumford. Sport was for him just a compensatory function (Mumford 1934, 303–307).
5 Artificial lighting was another feature at this stage, says Bale, with the effect of expanding play time into the night. Such was the case in many European scenarios, where the stadium was often conceived as monument.
6 Huizinga drew parallels across scales: 'the stadium, the table for games, the magic circle, the temple, the (theatre) scene . . . they are all in form and function playing grounds' (Huizinga, 1994, 23, translated by the author). He did not delve into the formal or spatial subject however. Other authors link boards to fields, thus highlighting the commonality of their formal principles and the quality of abstraction that eased the passage through scales.
7 (Ortega 1962). In his view the hunting ground differs from others such as the tourist's, the farmer's or the military, as all of them show signs of a significant recasting through human agency.
8 Early photographers shared the excitement too, such as for example Edward Muybridge's 1880s 'explorations about the Human Figure in Motion'. See also Leni Riefenstahl's 1936 Berlin series, Harold Egerton's 1944 'Gussie Moran tennis performance', and George Rodger's 1949 'Korongo Nuba wrestlers', amongst many others.
9 The argument was about the beauty and precision attached to functional items: 'there are certain categories of everyday objects that already possess

most of the qualities of good design but which are not recognized as categories in which the question of design enters, because their qualities have been acquired self-consciously' (Richards, 1935: 225, 226).

10 See also, Le Corbusier, 'L'art décoratif d'ajour' hui', 1925, for a description of sportive, lightweight functional items.

11 Says Schama: *forest* replaced the older Latin terms *saltus* or *sylva* that signified a particular form of administration, independent from the Roman or common law. (Schama1995: 144). Landscape researcher Donadieu reaffirms the idea of the forest as a space apart, looking also into the various ways in which these have been conceived (Donadieu 2006: 66–77).

12 Forests were often managed. See for example, Spirn (1998: 171–173). According to the author, the management strategies for Chantilly reveal a comprehensive control over the grounds over time which could be extended to similar cases.

13 Older sources such as the radiating avenues in Rome are also acknowledged, but only the hunting forest construes veritable networks of *allées* as visualized by Haussmann for Paris.

14 Cosgrove (1988) and Rykwert (2000, 26) concur in relating the upsurge of the aristocratic hunt to the episode of the enclosures and its momentous effect in the uses and prospects of the land.

15 This extraordinary liturgy has been characterized as a *barbarous ritual surrounded by extraordinary and fantastic taboos*, and also as a *highly structured and dramatic form of social communication*.

16 The subject was further elaborated through school assignments by Casanueva often submitting established sport practices to significant modifiers, such as the scale or weight of the elements or the nature of boundaries (Casanueva, 2009).

17 The subject of the square was topical for Sitte, Stubben, Hegemann, later, Rasmussen, Korn, Zucker, Bacon, and others who traced its European lineages, sometimes stressing the central and northern contributions, sometimes the Mediterranean ones. The CIAM group addressed the subject as a main topic in its 8th congress entitled 'The heart of the city' (1951), but the ludic subject was seldom addressed.

18 Like many playing fields in historic towns, this esplanade was originally devised for security: the case is similar to colonial Calcutta, Bombay and Madras. According to Mathur, the conception of these esplanades, such as the reclaimed Maidan in Calcutta that supplied a clear range of fire, followed defensive criteria. (Mathur, 1999; 212, 213).

19 Ortega, quoted in Rowe and Koetter (1978; 50). A keen supporter of bullfights, Ortega drew parallels between the urbane sacrificial ritual and the hunt. He emphasized the contrasting southern and northern Spanish traditions. Barthes too was enthralled by bullfights observing how the bullfighter transformed a trail into a graceful act. (Barthes 2008).

20 'Tauromaquia o el arte de torear a caballo o a pie'. 1804 Obra escrita por el célebre profesor Josef Delgado (vulgo) Hillo, Madrid MDCCCIV, en la imprenta de Vega y Compañía, Calle de Capellanes. For a comprehensive

survey of Spanish bullrings with a discussion about the evolution of the type see Diaz y Recasens 1992.

21 Picasso signed the plans together with Matador Dominguin and Catalonian architect Bonet. On some occasions he proudly dressed up as a matador.

22 For a full account see: Carduch Cervera Juan et al., 'Architecture without plans, La Petatera'. polipapers. upv. es/index. php/EGA/article/view File/1038/1088 (accessed 15 August 2017).

23 Scholarly attributions are contradictory however, for others have also been singled out as possible authors. The urban scene depicted in the Cassone painting ca. 1500, presently in The Walker Art Gallery Baltimore, features a commanding triumphal arch, a stadium to its left, and a baptistery-like building to its right, all framed by two nearly symmetrical palazzi in the foreground. The amphitheatre is both an anachronism, for no such structures were built in the Renaissance, and a classic revival.

24 A noteworthy example is Colombian architect Rogelio Salmona's 1968–70 brick clad *Torres del Parque* that overlook Bogota's prime bullring, the same building that Le Corbusier had sketched in one of his visits to the city.

25 Bear baiting and such activities, not to speak of the ancient Roman *venatio* where beasts were induced to kill each other, or else to confront fighters on a life to death struggle, that was staged for massive audiences. For a full account see: Dupavillon (2001).

26 The amphitheatres in Nimes and Arles, southern France, present similar characteristics, except that only in Lucca did the former arena space become fully accessible to the public as it turned into a square. In Cartagena, Murcia, Spain, a bullring was mounted over the amphitheatre.

27 Morrison (2011) stresses the authorship of John Wood the Elder. She also points to an emphasis upon layout, geometry and numerology, as concordant with Wood's emphasis upon the decisive influence of early Britons in the foundation of the city. A slightly different version appears in Gravagnuolo (1998). See also Summerson (1963), who regarded Wood's musings as mental digressions.

28 Giedion was quite explicit about the reciprocity of domestic and leisure spaces: 'the combination of movement and surprise and openness make [Bath's Lansdowne Crescent] exactly what every residence should be: the adequate background for leisure' (Giedion 1941). Bath was evoked to validate alternative urban models. Hilberseimer's exemplified with its crescents the harmony between city and landscape (Hilberseimer, 1955; 188, 190). Smithson referred to the way the countryside came into the town as it did in eighteenth-century Rome. Clearly Bath represented for him a model for a sober, genteel and poetic urban establishment (Smithson, 1971).

29 For a contrast between templates, and the notion of the identical, see Carpo (2011). Although he does not discuss the ludic field, he enquires into the mechanisms and conceptual effects of identical reproducibility in architecture.

30 It became a significant cluster of sport facilities in Rome.

31 So they were described by Auciello who relates field to board games. Table Tennis played a momentous role in the thawing of the Sino-American conflict that brewed over the Cold War. A contest between Chinese and North American champions became a prelude to negotiation between the belligerent parties. Ludic Agon released political tensions.

2: Formal and relational traits

1 Casanueva (2009). What made his experience original was not only the inventiveness lavished on each game but also its inscription within the framework of the Valparaiso school curricula. The institution showed particular proclivities towards the idea of play and chance. See (Rispa et al., 2003), also (Pérez de Arce 2003; 18–31).

2 The 2014 Tour de France is reported to have covered an overall circuit of 3,664 kilometres of flat, hilly, and mountainous terrain. Lacking in material or formal mediation, the Tour turns 'ordinary spaces' into ludic grounds.

3 For a discussion about the idea of the large park see Czerniak and Hargreaves (2007), a thoroughly documented enquiry, although biased toward Europe and North America (no mention is made of remarkable cases such as Sao Paulo *Ibirapuera*, Rio, *Aterro de Flamengo*, Buenos Aires *Palermo* or Caracas *Parque del Este*). An account of the transformation of the Bois de Boulogne from hunting ground into public park is offered in the same volume (Hargreaves 2007: 132, 139).

4 Largely ignored in landscape circles, these were highlighted in the MOMA review on modern engineering. Drexler, 1964. The exhibit featured the 1962 Olympic ski jump stadium in Innsbruck by engineers Peyerl and Heinz and architect Klopfer. Drexler classed it as *Earthworks* but its effect upon the mountain profile relates better to the celebrated 1962 solar observatory tower by SOM in Arizona that was featured in the same exhibit.

5 *Palin* as it was known to its original practitioners, the Araucanians (from southern Chile and Argentina) the game was eventually classed a *National Sport* in a process of institutional control that accords with Elias' thesis about the transformation of pastimes into sport.

6 As arranged for Federer and Nadal's so called 'battle of surfaces' which was played over a half clay half grass court in Palma de Mallorca in 1997.

7 *Basque ball* or *jai alai* is another rare case of the action following a lateral axis roughly in parallel to the audience.

8 (Schama,1995). Also, (Scully, 1991; 275, 289), drew attention to the nexus between French baroque landscapes and the military arts of fortifications, one that became evident in the collaboration of Vauban and Le Notre in Chantilly. The construing of visual fields through geometric alignments, and the shaping of the land on a grand scale through recourse to geometry were shared. As aforementioned, another nexus of sport and military requirements was present in certain Maidans.

3: Material attributes

1. Although it is not as common to highlight the function of materials in the urban discourse as it is in landscape, the issue seems to be increasingly redressed. See for example Teyssot et al. 1999 and Zardini et al. 2005; where the lawn, asphalt and snow are discussed as fundamental ingredients to the urban experience. The notion of landscape urbanism conflates 'urban' and 'landscape' appraisals with a bias toward the organic, fluid and changeable aspects.
2. 'The Brutalist Playground', (RIBA, 2015) curated by the collective Assemble and the artist Simon Terrill, registered noteworthy British playgrounds built in abrasive materials.
3. As conveyed by Monet in his own garden in Giverny. Also, of course in Tanisaky's (1977) eulogy of shadow, light, colour nuance, and dense water bodies.
4. Church's manual betrayed an idea of domestic leisure in contrast with the collective ideals we have examined. 'Which will survive, the children or the garden?' he asked, favouring in his words a collaboration between the garden and the playground' (Church, 1955; 19).
5. Garnier labelled the complex *'grande piscine hydrothérapie'*, showing a health bias. It comprised a monumental public bath, hot and cold baths, a fencing room and training track, all next to field games for tennis, soccer and cycling. Turn of the century Sutro Baths in San Francisco was another extraordinary case of a monumental (albeit light built) ensemble with an amphitheatre with a seating capacity of 3,700 and a holding capacity of 25,000 (*P.G.&E Magazine* September 1912). Typical of these establishments was their formal distinction between onlookers and swimmers, as in stadiums. Atelier Nikolski's scheme was echoed by Alvaro Siza's 1979 Gorlitzer Bad in Berlin Kreuzberg, thus re-editing the notion of a monumental bathing space. Kahn drew inspiration from the monumental Roman Baths for his lofty bathing establishments.
6. As defined by the *British amateur diving association* (1903). Smith (2005).
7. There were numerous cases in the UK, such as for example, Blackpool 1923, Southport 1928, Finchley 1931, Hastings 1933, as portrayed in Smith (2005). Italian cases such as Castel Fusano or Venice's Lido feature the kinds of miniaturized citadels largely made of beach cabins which Rossi found so enthralling.

4: Locational attributes

1. A rule which he broke in the 1932 *Obus Plan* Algiers, where the lie of the land rather than solar orientation became the guiding criterion.
2. The rule does not apply to all modern experiences that embrace multiple traditions, but orthodox views gained ascendancy particularly in housing, as witnessed by countless schemes worldwide.

3 As in Diller and Scofidio's 2002 *Blur*, media pavilion, at the Swiss expo in Neuchâtel.
4 *Labyrinthine* (sic) *clarity* was published in 1963, 1965, 1966, 1967, each time with slight changes.
5 Hall, 1985. Aside from the 1931 *Downtown athletic club*, he listed the 1928 *New York Christidora House*, the 1916 *Missouri Athletic Club*, the 1928 *Penn Athletic Club*, all of them 'fabric hybrids' (i.e. such high-rise structures 'characterized by the . . . subsequent relegation of programme to an inconspicuous status in the appearance of the building') the *Downtown Athletic Club* belonged instead to the 'graft hybrids' with an outward expression of programme. With a combined programme of offices, commerce, and athletic facilities, New York's 1976 *United Nations Plaza* belonged to the category of 'monolith hybrids' with a greater emphasis on a singular expression. Koolhaas' review of the athletic club was made in 1994.
6 'Made in Tokyo' lists such urban adaptations as swimming or diving pools, fairgrounds and golf practice ranges fitted atop structures for other uses in a city with little green space for expansive sports (Kuroda et al. 2006).
7 See Neil Levine, *A utopian space between tourism and development, Frank Lloyd Wright architectures for the deserts of the American Southwest*, in: Picon Lefevre and Chaouni, et al. (2011).
8 See for example the Italian BBPR team's 'labyrinth', a spiralling trefoil wall structure for the X Milano triennial that featured a mural by Steinberg, and a mobile by Calder.
9 Ski Dubai, the 2005 capsular, fully acclimatized 400-metre-run ski range was construed as if a field fitted within the fuselage of an airship. For inflatables see McLean and Peter, 2015. In Graham Stevens' 1970s *Atmosfields*, St Katherine's Dock, London, the minute figure of the artist holds a huge inflated beam. In Stevens' *Transmobile*, human engagement was activated through the manipulation of the inflatable structure from within.
10 Ortner (1957), Mandoul (2014). Following the linear structure of a dictionary, Mandoul's remarkable survey looks at the fabric of the city of Paris through its sport places. It features significant examples of sport mosaics.
11 Casanueva (2009: 139, 145) portrayed eighteen such inventions. '*Despelote*' (a pun on pelota (ball) meaning chaos) was based in the manipulation of just one element in such traditional games as tennis, badminton, or volleyball, namely the net, which he radically increased in height. The tempo was regulated by drums; motions followed sound, stillness followed silence. The formal care and the music accompanying the action accorded with the ancestral festive ethos of the ludic activity.
12 Established on reclaimed land, the *Parque Brigadeiro Eduardo Gomez*, otherwise known as *Aterro do Flamengo*, was initiated in 1951 and completed in 1961 (Soares et al. 2003: 143 144); (Bonduki (ed.) 2000).
13 Photographers like Joachim Schmid (with the Brazilian series 'o Campo') and Leonardo Finotti (with the Paulista series 'Pelada') portrayed this remarkable phenomenon.

14 It touches upon an issue of a more general character as it is the fitness of site to composition, and in broader terms the issue of the commonplace as a source of architectural consideration. Serlio has often been credited as the first treatise author to include explicit reference about fitting a residential ensemble within an inadequate site.

15 The issue was explored at various seminars conducted by the author at Cornell, GSD and Santiago.

16 In the documentary film *A Valparaiso* released by Dutch filmmaker Joris Ivens in 1963 the pulse of the city is portrayed mainly through play.

5: Park and amusement park

1 In amusement parks and fairgrounds, mechanics substitute the organic materials usually associated with parks (Braithwaite 1968). Sica likens the process to a picturesque estrangement of the signs of industrial civilization (Sica 1981: 905). In the course of the century certain leisure compounds such as Las Vegas evolved towards the creation of immersive environments of greater effect than the average fairground. The incisive analysis of Venturi and Isenour becomes now (much like Koolhaas' narrative about Coney Island) a sort of archaeological description about a no longer existing scenario.

2 See for example the dramatic role assigned to the Viennese ferris wheel in Carol Reed's 1949 film, 'The Third Man'. Carnival is often made into a setting for drama as in Marcel Camus' magical portrayal of Rio in 'Black Orpheus' (1959).

6: The athlete

1 The emphasis on play allows us to differentiate significant initiatives such as for example the 1930s Italian children colonies with their emphasis upon fascist indoctrination, from others led by recreation. The tension between play and indoctrination, its inherent freedom and its instrumental manipulation is examined in the following sections. See Wall and De Martino 1988.

2 GATCPAC: group of Catalonian architects and technicians for the progress of contemporary architecture (Grup d'Arquitectes i Tècnics Catalans per al Progrés de l'Arquitectura Contemporània). The city of leisure may be contrasted with the contemporary Italian Calambrone with its massive children colonies (mostly built between 1933 and 1935) and neighbouring Tirrenia, a planned headquarters for the film industry over the seaside. See Wall and De Martino 1988.

3 Ivan Leonidov, quoted by S. Kahn-Magomedov in: *Institute of Architecture and Urban Studies 8 Ivan Leonidov* (1981), Rizzoli, New York. 20, 56–59. In a twist of fate, such ideas about combining leisure and work in the office environment became fashionable as the concept of 'wellness' gained acceptance in the advanced corporate environments of late capitalism.

4 Aries (1960). Childhood, we are reminded by Aries, is above all a social construct and as such, contingent on cultural views and sensibilities. Aries explains how a concept of a very brief childhood was long lasting and how age groups in our societies are organized around institutions, the modern concept of childhood being related to the modern concept of schooling.

5 The *Architectural Graphic Standards* was first published in 1964. Its 1988 eighth edition featured forty pages about sport.

6 Berger argues that, as from the nineteenth century, the upper classes evolved certain patterns of male fashion such as ironed trousers and jackets that made more apparent their sedentary work and their abstinence from strenuous physical effort. 'The suit as we know it today . . . is the first ruling class costume to idealize pure sedentary power.' The 'sport style' instead allowed for vigorous motion (it also gets soiled in action) (Berger 2013: 35, 42).

7 Bale (2001) makes reference to the way in which as a format, the saucer type stadium reduces the landscape elements that belonged to the incrementally built English stadium. The process reached a literal closure with the inward looking all-enclosed sky-dome type.

8 He seems to have grasped the unprecedented qualities arising from a modern sport ensemble. *Olympic Architecture,* Barclay F. Gordon, John Wiley and Sons, London.

9 Jellicoe generously quotes Rasmussen.

10 Miller (2004). See also Hersey, 'The colosseum the geometry and the spectaculum', *Chora* 4, Mc Gill (103–126). The Latin *Spectaculum* is the alternative denomination in mass spectacle to the Anglo-Saxon *auditorium*.

11 This idea of provisional housing as propaedeutic for modern living habits was tested in Rotterdam's 1923, 24 'white village' where the poor and disenfranchised learned how to manoeuvre in the unprecedented habitat of pristine blocks with their angular precincts bathed in sunlight and equipped with modern utilities, before reaching their new apartments. Unprecedented ludic habits were also nurtured in these modern scenarios.

12 As in the aforementioned urban scene attributed to Luciano de Laurana. The stadium rubs shoulders with assorted institutions in a spirit akin to Kahn's idea about bringing the stadium to the core of Philadelphia and Dacca.

13 For a description of the scheme's political and cultural framework see Mohajery, Sima (2013) 'Louis I Kahn Silent space of critique in Teheran'. San Rocco 6, Collaborations.

7: The child

1 The point was clearly stated by Giedion who introduced Aldo Van Eyck's Amsterdam playgrounds in his debate about the city core.

2 In this highly suggestive essay Allen indistinctly looks at children as captive performers (as in Terragni's orphan asylum in Como for example) and other

cases where the presence of children derives from the photographer's explicit choice. In contrast with the images of children at free play see the period photographs about children submitted to collective discipline in Wall and De Martino (1988).

3 'As Found' draws from a certain value of the real above the imaginary, of ordinariness and imperfection also of chance. See, for example, the visually saturated Paolozzi's scrapbooks where heterogeneous images collaged together trigger unexpected chance readings. (Lichtenstein et al 1993).

4 'For Team X bears the weight of what is supposed to be the apostolic succession; and though it often endeavours to compensate for this elevated predicament with insubstantial graphics and verbal infantilism . . . one senses in their invariably cautious performance the consciousness of almost ecclesiastical responsibility' (Rowe 1978: 41).

5 The point was further emphasized by Rykwert, Vidler and others.

6 J C Friedrich von Schiller, 'Letters upon the Aesthetic Education of Man', *Literary and Philosophical Essays*. The Harvard Classics 1909–14, Letter XV.

7 As becomes evident in Van Eesteren's 1928 lecture, he emphasized the function of sport in leisure to the detriment of play in general. An isolated football pitch served him as an illustration of 'an element of the modern city plan that must be completely understood if it is to be correctly placed', quoted by Van Rossen (Van Eesteren 1997: 29). See also recreation (pp. 39–50).

8 Voelcker, (1955: 94). 'Through a playground and similar simple urban function existing urban associations – hitherto isolated streets for example – may be extended . . . observing its use the urbanist will be guided . . . to future, more extensive socially more complex tasks . . . this is research. . .'.

9 Lefaivre recalls how Van Eesteren 'who had made no provision for playgrounds in his extension plan for Amsterdam', changed his approach, largely influenced by Van Eyck's, not just as regards play types, but also as regards the primacy of a site-specific urban appraisal that capitalized on local nuance (Lefaivre 2002: 24, 49).

10 The point was raised by Peter Smithson in his 1970 BBC2 film on housing and recalled by Alan Powers in *Robin Hood Gardens: a critical narrative* pp. 239–240 (Risselada, 2011).

11 Krauss, Karl, 1913.*Nachts*. In *Die Fackel*. Jg 15, Heft 37 as quoted in Nassir Zarrin Panah pp1 www.cloud-cuckoo.net/journal 1996 (accessed 15 Aug 2017)

12 Breuer designed the 1963–1964 Fairview Heights housing scheme in partnership with Hamilton Smith. Perry's 'neighbourhood unit' was based upon an idea of relationships between family life and social equipment arranged in blocks with arterial roads circumscribing residential quarters and their ludic and educational equipment situated within green cores away from traffic.

13 Drummond Abertheney, head of the children play department at the NPFA, Britain, quoted in Norman (2003: 19).

14 In *Jour de Fête* (1949) and *Les Vacances de Monsieur Hulot* (1953) Jacques Tati also addressed play and recreation.

15 Frei Otto et al. (1979). In this colloquium on adaptable architecture, Yona Friedman, Konrad Wachsmann, Gunter Nitschke and others embraced vernacular form, pilgrimage sites, funfairs, emergency dwellings, and play. Mietke's 'building construction as play' (230, 233) drew parallels with 'primitive' practices, noting the subject's relevance as regards elementary technologies, appropriateness of building to material, self-build strategies, and the social dimension of building.

16 *Lego*, the Danish invention, followed, with its open-ended interlocking plastic modules.

17 For Rossi the amphitheatre was a remarkable case of formal persistence and functional adaptability as enshrined in Rome, Florence, Nimes and Arles. Except for Rome's, once considered to be made into a wool factory (1590) and later to include a memorial church (Carlo Fontana 1707), the others became citadels and were later cleared of invasive structures. Arles is an occasional venue for bullfights. Lucca is particularly apposite to our subject for it had its arena turned into a square.

18 Others shared this fascination: see for example Summerson (1963: 1–3). Cosiness and ceremony are two aspects Summerson relates to play, the former present in the child's domain, the latter in 'serious' adult play 'which is intertwined with religious and social custom'.

19 Vitruvius' remarks were slightly different (as quoted by Sitte on page 6): he was referring to the arrangements around the public space made to facilitate the enjoyment of gladiatorial contests performed in the forum.

20 An exception should be made of Noguchi's *play mantra*, a monolithic slide that conforms to the object-like quality of Nielsen's play sculptures.

21 See for example: *Architecture d' Aujourd'hui*, L'Architecture et l'Enfance (February-March 1971) where hollowed sculptures by Enzo Mari (En toute liberté) and Juliette de Jekel were featured. Other pieces featured, by Mitsuru Senda and *Group Ludic* could also rate as 'sculptural'.

22 See for example: Van Leeuwen (1998). The author traces a broad description of the Californian swimming pool culture. He also quotes Rasmussen in relation to the Minoletti swimming pool. The Sonoma pool is extensively reviewed in Church (1955: 231, 235).

23 See for example Thomas Church and Dianne Harris, 'Making your private world: modern landscape architecture and House Beautiful', 1945 (1965). In Treib (2002).

24 Carsten Holler monumentalized the former in his stainless-steel *Test Site*, for the Tate Modern Turbine Hall (2007), subverting the museum's vertical linkages by way of a swift connection between top and ground. With it, this archetypal apparatus made an entry into the art institution. Holler also thought of using slides as high rise escape routes. See Tate Trustees (2006: 38,53). Roy Kolzlovsky traces the technological origins of slides to such sources as indigenous Canadians (as betrayed by the word toboggan), Russian ice slides (precursor of the Russian mountain and the roller

coaster). The amusement park was in his view the medium where this leisure apparatus thrived.

25 Political agendas were no doubt also involved as several authors claim, playgrounds contributing to appease the always volatile instincts of the working class, in the eyes of the ruling class.

26 Another source of interest is Niemeyer's use of the under croft of the tribunes as school classrooms, endowing the structure with everyday usages. Seen this way, the operation was similar to the underside of Kahn's stadium seat ranks accommodating secondary uses in Philadelphia.

8: Back to order

1 According to Norbert Elias, the English Public School with its ethical emphasis on fair play and collaborative efforts, and the Nordic Gymnasium with its emphasis upon discipline and endurance equally appealed to Greek precedent. Other authors point to the neoclassical overtones of such a relationship.

2 See for example the cases of Soldiers Field Harvard and Briggs Field MIT with their associated gymnasia and facilities: lavish grounds that compare to the scale of the oriental Maidan.

3 *Campo* is also Spanish for *countryside*.

4 Not just in 'Towards a new architecture', but foremost in his excursion into the USA as described in 'When the cathedrals were white', Mc Graw Hill Paperbacks 1964.

5 As regards the entanglement of organized play and political matters, said Fergusson (2003, 260–263) 'the British empire of the 1890s resembled nothing more than an enormous sports complex . . . hunting continued to be the favourite . . . of the upper classes, (but) it was team games however that did most to make a reality of the ideal of Great Britain . . . Baden Powell . . . boy scout movement . . . another highly successful recreational export which aimed to generalize the team spirit of the games field into an entire way of life'.

6 Barnard illustrated three models: a 'Roman Revival School House' immersed in extensive pastoral grounds, an 'Urban grammar school house', with a planted front yard, and separate playgrounds for boys and girls, framed by a shaded grove, and an 'Infant school' with a single yard that contained a few trees.

7 One may recall the significance of the *Kinder Garten*, a garden for infants in the conception of the differentiated outdoor scenarios.

8 Alfred Roth decried those traditional monumental schools, pointing to their lack of scale, functional indifference and absence of creativity. Roth pledged that the modern school had to embrace pedagogic and psychological considerations together with environmental, technical and functional principles (Roth 1958).

9 Not at least in their discourse, as it was in le Corbusier's. (He devoted just one spread to 'the space of gymnastics and sports'.)

10 Cases abound: Roth (1948) dedicated ample space to the Suresnes school. He also featured the Amsterdam Open Air school (1948, 207–210).

11 Maekawa was a former Corbusier assistant. The scheme is portrayed in Treib (2002, 272).

12 Hertzberger advanced many of these points in conferences and magazine articles compiled in his previous book *Lessons in Architecture,* 1981.

13 Rudofsky (1969, 327–336). Conversant with Jane Jacobs's arguments about street life, and coinciding with her critique about the North American planning malaise, Rudofsky also thought of vandalism as a form of negative play.

14 Several Authors, 2005, *La Bauhaus de Festa 1919–1933*. Fundación La Caixa, Barcelona. The intense ludic calendar followed by the Bauhaus is displayed as much as the tensions built between the carnivalesque activities and the sportive ones.

15 How far the scheme was instrumental to the ideological agendas of apartheid is another matter.

16 The prize was awarded to Chamberlain Powell and Bon.

17 For a more detailed account see: *Naval Academy* in: Rispa (Ed) 2003, 28–31.

9: The citizen

1 There was an element of indictment but also wonder about it, as an expression of the huge territorial incidence of tourism and leisure. Asked Smithson about *Cité Lacustre*, Port Grimaud, the fake Provençal village-cum-resort: 'why are we so disturbed about Port Grimaud?' As in Disneyworld, the urban mess that was common to large conglomerates was left outside (Smithson, 1973).

2 Guy Debord quoted by Simon Sadler (1998, 91).

3 Sadler (2000). As pointed out, the ideology of Non-Plan matched the extensive deregulation applied later by Thatcher and Reagan.

4 Ward (1979) and (1988), See his essay 'Anarchy and architecture, a personal record' in Sadler (2000).

5 Friedman attended the CIAM X congress in Dubrovnik where he became disenchanted with the propositions of the younger generation.

6 Reckoning a common ground with Friedman, Rudofsky portrayed the Ville Spatiale as a visionary projection of the vernacular tradition (Rudofsky 1969: 197). Walks up in the air did indeed awake ludic reactions, as would have been the case with Constant's three-dimensional urban matrix too.

7 As recollected by various authors, the relations woven within the International Situationists (1957, 1972) were short lived and riddled with disputes. Just for

a while Constant and Debord shared each other's insightful ideas. Debord is credited with the invention of the *Dérivé*.

8 He did in fact publish some of Constant's writings. See Sadler (2000).
9 The point is made by Thomas y Levin, in Andreotti (1996: 136–138), who note how these criteria were summed up in the *International Situationists* first issue.
10 It is interesting to compare John Hedjuk's competition entry to Alvaro Siza's, who covered a large portion of the site with a shallow dish with a replica of Adolph Loos's Herald Tribune column-tower arising from its centre. It would be fascinating to imagine the possible ludic occupations of such an austere memorial.

Conclusion

1 Similar patterns can be examined in the new town of La Plata in Argentina, south of Buenos Aires, originated by public competition in 1881, also in the aforementioned 1974 Ansart plan of Santiago de Chile.
2 Mumford (1966: 563): 'In breaking away from the city, the part became a substitute for the whole, even as a single phase of life, . . . childhood, became the pattern for the seven ages of man . . . As leisure generally increased, play becomes the serious business of life, and the golf course, the country club, the swimming pool and the cocktail party become the frivolous counterfeits of a more varied and significant life. Compulsive play fast becomes the acceptable alternative to compulsive work'. In metropolis and suburb, Mumford observed, 'mass production, mass consumption, mass recreation produce the same kind of denatured environment'. Implicitly endorsing Caillois's conception about play as an index of social trends, he identified them with 'playful emptiness'.

Bibliography

Aaron, David. 1965. *Child's Play, A Creative Approach to Play Spaces for Today's Children.* Harper and Row Publishers, New York and London.
Agamben, Giorgio. 2001 (1978) *Infancia e historia.* Adriana Hidalgo Editora, Córdoba and Buenos Aires.
Andreotti, Libero; Costa, Xavier. 1996. *Theory of the Derivé and Other Situationist Writings on the City.* Museu d'Art Contemporani de Barcelona, ACTAR Barcelona.
Andreotti, Libero. 2001. *Pratiche ludiche dell urbanistica situazionista.* Lotus 108, Electa. pp 40–6.
Archetti, Eduardo. 2001. *El Potrero, la Pista y el Ring, las patrias del deporte argentino.* Fondo de Cultura Económica, Serie breves, Buenos Aires.
Arendt, Hannah. 1958. *The Human Condition.* The University of Chicago Press.
Aries, Philippe. 1962 (1960) *Centuries of Childhood.* Penguin Books, London.
Arnau, Joaquín. 2000. *72 voces para un diccionario de arquitectura teórica.* Celeste Ediciones, Madrid.
Atelier, Bow Wow. 2009. *Echo of Space, Space of Echo.* Inax Publishing, Tokyo.
Auciello, Fernando. 1997. *Juegos Jugadores, Juguetes. . . .* Alción Editora, Córdoba.
Augé, Marc. 1994 (1992) *Los "no" lugares, Espacios del anonimato. Una antropología de la sobre modernidad.* Gedisa Editorial, Barcelona.
Bale, John. 2001 (1993) *Sport, Space and the City.* The Blackburn Press, New Jersey.
Barthes, Roland. 1979. *The Eiffel Tower and Other Mythologies.* University of California Press, Berkeley.
Barthes, Roland. 2008. *Del deporte y los hombres.* Paidós Barcelona.
Belfiore, Emanuela. 2005. *Il verde e la citta: Idee e progetti del settecento a oggi.* Gangemi editori, Rome.
Benjamin, Walter. 1974 (1969) *Reflexiones sobre niños, juguetes, libros infantiles jóvenes y educación.* Ediciones Nueva Visión, Buenos Aires.
Bengtsson, Arvid. 1973. *Parques y campos de juego para niños.* Editorial Blume, Barcelona.
Bernard, Jeu. 1998 (1987) *Análisis del deporte.* Ediciones Bellatierra S. A., Barcelona.
Bourdieu, Pierre. 2000. *Cuestiones de Sociología.* Itsmus, Madrid.
Bonet, Antonio. 1990. *Fiesta Poder y Arquitectura aproximaciones al barroco español.* Ediciones Akal.
Brostemann, Norman. 1997. *Inventing Kindergarten.* Harry N. Abrams, Inc. Publishers, New York.

Brownlee, David; De Long, David G. 1992. *Louis I Kahn in the Realm of Architecture*. Rizzoli, New York.
Burkhalter, Gabriela. 2016. *The Playground Project*. Kunsthalle Zürich.
Caillois, Roger. 1986 (1967) *Los Juegos y los Hombres, la máscara y el vértigo*. Fondo de Cultura Económica, México.
Carpo, Mario, 2011. *The Alphabet and the Algorithm*. MIT Press, Cambridge, Mass.
Casanueva, Manuel. 2009. *Libro de torneos*. Ediciones Universitarias, Valparaíso.
Church, Thomas. 1955. *Gardens Are For People*. Reinhold Publishing Co., New York.
Cohen, Jean Louis. 2011. *Architecture in Uniform, Designing and Building for the Second World War*. CCA, Montreal.
Colomina, Beatriz. 1997. *The Medical Body in Modern Architecture*. Daidalos 64, Rhetoric.
Corbin, Alain. 1993. *El territorio del Vacío: el occidente y la invención de la playa, 1750, 1840*. Mondadori, Barcelona.
Corbin, Alain. 1995. *Avènements des Loisirs 1850, 1960*. Champs Flammarion, Paris.
Corbin, Alain; Courtine, Jean Jacques; Vigarello, Georges. 2005. *Historia del Cuerpo (II) De la Revolución Francesa a la Gran Guerra*. Taurus, Santillana, Madrid.
Corbin Alain; Courtine, Jean Jacques; Vigarello Georges. 2006. *Historia del Cuerpo (III) El siglo XX*. Taurus, Santillana, Madrid.
Corner, James. (Ed) 1999. *Rediscovering Landscape, Essays in Contemporary Landscape Culture*. Princeton Architectural Press, New York.
Cosgrove, Denis E. 1984 (1998) *Social Formation and Symbolic Landscape*. The University of Wisconsin Press, Madison, Wisconsin.
Cranz, Galen. 1989. *The Politics of Park Design, A History of Urban Parks in America*. The MIT Press, Cambridge, Massachusetts.
Crary, Jonathan; Kwinter, Sanford, (Ed). 1992. *Incorporations*. Zone Editions, New York.
Crosas, José. 2004. *Le Corbusier y las razones del deporte*. Massilia, Barcelona.
Czerniak, Julia; Hargreaves, George. 2007. *Large Parks*. Princeton Architectural Press, New York.
Dannatt, Trevor. 1960. *Architect Year Book 9*. Paul Elek, London.
Dattner, Richard. 1969. *Design For Play*. Van Nostrand Reinhold, New York.
Debord Guy, 1983 (1967) *Society of the Spectacle*. Black and Red, Detroit, Michigan.
De Martino, Stephano; Wall, Alex. 1988. *Cities of Childhood, Italian Colonies of the 1930s*. AA Publications, London.
De Certeau, Michel. 1996 (1990) *La Invención de lo Cotidiano. 1, Artes de Hacer*. Universidad Iberoamericana, México.
Díaz y Recasens Gonzalo; Vásquez Consuegra Guillermo. 1992. *Plaza de Toros*. Sevilla, Conserjería de Obras Públicas y Transportes, Junta de Andalucía.
Diller, Elizabeth; Scofidio, Ricardo. 1999. *The American Lawn, Surface of Everyday Life*. pp 116–131 Lotus International 101, June 1999.
Dioxiadis, Constantine. 1972 (1937) *Architectural Space in Ancient Greece*. MIT Press, Cambridge, Mass.

Donadieu, Pierre. 2006. *La sociedad paisajista*. Editorial de la Universidad de la Plata.
Duvignaud, Jean. 1982 (1980) *El Juego del Juego*. Breviarios, Fondo de Cultura Económica, México.
Dupavillon, Christian. 2001. *Architectures du cirque: des origines à nos jours*. Editions Le Moniteur, Paris.
Eco, Umberto. 1988. *De los Espejos y Otros Ensayos*. Editorial Lumen, Barcelona.
Ehrenreich, Barbara. 2007. *Dancing in the Streets, a History of Collective Joy*. Holt Paperback, Metropolitan Books, Henry Holt and Company, New York.
Eichberg, Henning. 1986. *The Enclosure of the Body on the Historical Relativity of Health, Nature and the Environment of Sport*. Journal of Contemporary History, vol. 21, no. 1, January.
Elias, Norberto; Dunning, Eric. 1995 (1986) *Deporte y Ocio en el proceso de la civilisación*. Fondo de Cultura Económica, México DF.
El Lissitzky. 1970 (1930) *Russia: Architecture of World Revolution*. Lund Humphries, London.
Evans, Robin. 1986. *Il mito dell'informalità*. in Teyssot, George (Ed.) *Il progetto domestico: la casa del uomo archetipi e prototipo*. Electa Milano.
Farina, Ferruccio. 2001. *Architetture Balneari tra Europa e Americhe nella Belle Époque*. Federico Motta editore S.p.A.
Ferlenga, Alberto. (Ed) 1999. *Dimitri Pikionis 1887–1968*. Electa Milano.
Fusaro, Florindo. 1985. *Il Parlamento e la nuova Capitale a Dacca di Louis I Kahn, 1962–1974*. Officina Edizioni.
Gadamer, Hans Georg. 1999. *Verdad y Método*. Ediciones Sígueme, Salamanca.
Gadamer, Hans Georg. 1988. *The Relevance of the Beautiful and Other Essays*. Cambridge University Press, Cambridge.
Garnier, Tony. 1989. *Une Cité industrielle, étude pour la construction des villes*. Princeton Architectural Press, New York.
Giedion, Siegfried. 1941. *Space Time and Architecture: The Growth of a New Tradition*. Harvard University Press, Cambridge, Mass.
Girouard, Marc. 1985. *Cities and People: A Social and Architectural History*. Yale University Press, New Haven.
Grassi, Ernesto. 1994. *The primordial metaphor*. Centre for Medieval and Renaissance Studies, State University NY at Bingampton.
Hall, Steven. 1985. *Hybrid Buildings*. Pamphlet Architecture 11, New York, San Francisco.
Halley, Charlie. 2009. *Camps: A Guide to Twentieth-century Space*. MIT Press, Cambridge, Mass.
Hedjuk, John. 1986. *Victims*. Text I, Architectural Association, London.
Hedjuk, John. 1985. *Mask of Medusa*. Rizzoli, New York.
Hegemann, Werner; Peets, Elbert. 1988 (1922) *The American Vitruvius: An Architect's Handbook on Civic Art*. Princeton Architectural Press, New York.
Hertzberger, Hermann. 1991. *Lessons for Students in Architecture*. 010 Publishers, Rotterdam.
Hertzberger, Hermann. 2000. *Space and the Architect, Lessons in Architecture 2*. 010 Publishers, Rotterdam.
Hertzberger, Hermann. 2008. *Space and Learning*. 010 Publishers, Rotterdam.

Hobsbawm, Eric; Ranger, Terence. 1983. *The Invention of Tradition*. Cambridge University Press, Cambridge.
Holler, Carst. 2006. *Test Site*. Tate Publishing, London.
Hoskins, William G. 1970 (1955) *The Making of the English Landscape*. Pelican Books, London.
Howe, James. 1981. *Fox Hunting as Ritual*. American Ethnologist Vol 8 no. 2, May.
Hughes, Jonathan; Sadler, Simon. (Ed) 2000. *Non-Plan, Essays on Freedom, Participation and Change in Modern Architecture and Urbanism*. Architectural Press, Oxford.
Huizinga, Johan. 1972 (1938) *Homo Ludens*. Alianza Editorial libro de Bolsillo, Madrid.
Huizinga, Johan. 2014 (1933) *De lo lúdico y lo serio*. Casimiro libros, Madrid.
Jackson, John Brinkerhoff. 1980. *The Necessity for Ruins and Other Topics*. The University of Massachusetts Press, Amherst.
Jackson, John Brinkerhoff. 1984. *Discovering the Vernacular Landscape*. Yale University Press, New Haven and London.
Jackson, John Brinkerhoff. 1985. *A Sense of Place, A Sense of Time*. Yale University Press, New Haven and London.
Jackson, John Brinkerhoff. 1997. *Landscape in Sight*. Yale University Press, New Haven and London.
Jacobs, Jane. 1993. *The Death and Life of Great American Cities*. Random House, New York.
Jellicoe, Geoffrey. 1966. *Studies in Landscape Design; Vol II*. Oxford University Press, London.
Jellicoe, Geoffrey; Jellicoe, Suzan. 1975. *The Landscape of Man: Shaping the Environment from Prehistory to the Present Day*. Thames and Hudson, London.
Josipovici, Gabriel. 1997. *La Terapia de la Distancia*. Editorial Andrés Bello, Santiago.
Kahn, Louis. 1998. *Conversations with Students*. Architecture at Rice 26, Princeton, New Jersey.
Kaijima, Momoyo; Kuroda, Junzo; Tsukamoto, Yoshiharu. 2006. *Made in Tokyo*. Kajima Institute Publishing Co., Tokyo.
Kant, Inmanuel. 1991 (1803) *Pedagogía*. Ediciones Akal, Bolsillo, Madrid.
Kassler, Elizabeth B. 1984 (1964) *Modern Gardens and The Landscape, Revised Edition*. Museum of Modern Art, New York.
Koolhaas, Rem. 1994. *Delirious New York*. The Monacelli Press, New York.
Koolhaas, Rem; Mau, Bruce. 1995. *S M L XL*. The Monacelli Press, New York.
Kopp, Anatole. 1969. *Ville et révolution architecture et urbanismes soviétiques des années vingt*. Editions Anthropos, Paris.
Kostof, Spiro. 1992. *The City Assembled: The Elements of Urban Form Through History*. A Bullfinch Press Book, Little Brown and Company, Boston, New York, London.
Lady Allen of Hurtwood. 1968. *Planning for Play*. Thames and Hudson, London.
La Regina, Adriano. 2003. *Nikke Il Gioco e la Vittoria*. Mondadori Milano.
Le Corbusier. 1925. *L'Art décoratif d ajour d'Hui*. Editions Cres Del Esprit Nouveau, Paris.
Le Corbusier. 1933. *La ville Radieuse, éléments d'une doctrine d'urbanisme pour l'équipement de la civilisation machiniste*. Editions d'architecture d'aujourd'hui.

Le Corbusier. 1948. *Cuando las catedrales eran blancas, viaje al país de los tímidos*. Editorial Poseidón, Buenos Aires.
Le Corbusier. 1978 (1927) *Towards a New Architecture*. The Architectural Press, London.
Le Corbusier. 1999. *Precisiones, Respecto a un Estado Actual de la Arquitectura y el Urbanismo*. Ediciones Apostrophe, Barcelona.
Le Corbusier; Jeanneret, Pierre. 1934. *Œuvre complète 1929–1934*. Editions d'architecture, Zurich.
Le Corbusier; Jeanneret, Pierre. 1938. *Œuvre complète 1934–1938*. Girsberger Editions d'architecture, Zurich.
Le Corbusier. 1946. *Œuvre complète 1938–1946*. Les Editions d'architecture, Zurich.
Le Corbusier. 1965. *Œuvre complète 1957–1965*. Editions d'architecture, Zurich.
Le Corbusier. 1968. *Les maternelles vous parlent: Les carnets de la recherché patiente # 3*. Editions Gauthier, Paris.
Le Corbusier. 1988. *L'avion accuse . . . aircraft*. Universe Books, New York.
Ledermann, Alfred; Traschel, Alfred. 1960. *Creative Playgrounds and Recreation Centres*. Frederick A Praeger, New York.
Lefaivre, Liane; De Roode, Ingebord. (Ed) 2002. *Aldo Van Eyck, The Playgrounds and the City*. Stedelijk Museum Amsterdam, NAi Publishers, Rotterdam.
Lefaivre, Liane. 2005. *Puer Ludens*. Lotus International 124 June: Electa pp. 72–85.
Lefebvre, Henri. 1966. *Writing on Cities*, Translated and edited by Eleonor Kofmann and Elizabeth Lebas. Blackwell Publishers, Oxford.
Le Floch'moan Jean. 1966. *La Génesis de los Deportes*. Nueva colección Labor, Editorial Labor, Barcelona.
Ligtelijn, Vincent. 1999. *Aldo Van Eyck, Works*. Birkhauser Publishers, Boston, Berlin, Basel.
List, Larry (Ed.) 2006. *The Image of Chess Revisited*. The Isamu Noguchi Foundation and Garden Museum, George Braziller Publishers, New York.
Lodder, Christina. 1983. *Russian Constructivism*. Yale University Press, New Haven.
MacLean, Axel S. 2006. *The Playbook*. Thames and Hudson, New York.
Maldonado, Tomás. 1979. *Sul Sport?*. Casabella 445, Marzo.
Mandoul, Thierry (Ed.) 2014. *Sports portrait d'une métropole*. NP2F Pavillon de l'arsenal, Paris.
Manu, Alexander. 1995. *Tool Toys: Tools with an Element of Play*. Danish Design Centre, Copenhagen.
Markus, Thomas A. 1993. *Buildings and Power. Freedom and Control in the Origin of Modern Building Types*. Routledge, London and New York.
Martinez, Andres. 2005. *Habitar la Cubierta / Dwelling on the Roof*. Editorial Gustavo Gilli, Barcelona.
Mathews, Stanley. 2007. *From Agit-prop to Free Space: The Architecture of Cedric Price*. Black Dog Publishing, London.
Matthews, W H. 1970 (1922) *Mazes and Labyrinths, Their History and Development*. Dover Publications Inc., New York.
Max Voght, Adolph. 1998. *Le Corbusier the Noble Savage: Toward an Archaeology of Modernism*. MIT Press, Cambridge, Mass.
Miller, Stephen G. 2004. *Ancient Greek Athletics*. Yale University Press, New Haven.

Mujica, Felipe. (Ed.) 2014. *Jugador como pelota, pelota como cancha, torneos 1974–1992, Manuel Casanueva, Escuela de Valparaíso*. Museo Experimental del Eco, México.
Muller, Thomas; Schneider, Romana. 2002. *Montessori, Teaching Materials, 1913–1935, Furniture and Architecture*. Prestel, Munich, Berlin, London, New York.
Mumford, Lewis. 1934. *Techniques and Civilization*. Harcourt Brace and Company, New York.
Mumford, Lewis. 1961. *The City in History*. Penguin Books, London.
Nilsson, Sten. 1975 (1973) *The New Capitals of India, Pakistan and Bangladesh*. Curzon Press, New York.
Norman, Niels. 2003. *An Architecture of Play: A Survey of London's Adventure Playgrounds*. Four Corners Books, London.
Obrist, Hans Ullrich. (Ed.) 2003. *Re: CP by Cedric Price*. Birkhauser, Basel.
O'Connor, Aidan; Kinchin, Juliette. 2012. *The Century of the Child, Growing by Design 1900–2000*. The Museum of Modern Art, New York.
Ortega y Gasset, José. 1962. *La Caza y Los Toros*. Espasa Calpe, Colección Austral, Madrid.
Ortega y Gasset, José, 1965. *Meditación de la Técnica*. Espasa Calpe, Colección Austral, Madrid.
Ortner, Rudolf. 1957. *Construcciones deportivas*. Editorial Ahr, Barcelona.
Otto, Frei. (Ed.) 1979. *Arquitectura Adaptable*. Editorial Gustavo Gilli, Barcelona.
Pannerai, Philippe; Mangin, David. 1999 (2002) *Proyectar la Ciudad*. Celeste Ediciones, Madrid (1st edn Marsella 1999).
Parcerisa Bundó, Josep; Ruber de Ventós, María. 2000. *Hechos del Urbanismo: La Ciudad no es una Hoja en Blanco*. Ediciones ARQ.
Pereira Salas, Eugenio. 1947. *Juegos y alegrías coloniales en Chile*. Editorial Zigzag, Santiago.
Perez de Arce, Rodrigo. 2005. *Valparaiso Ludens*. Lotus International 124, Milano.
Pérez de Arce, Rodrigo. 2006. *Hacer nada*. Revista ARQ 62, Santiago.
Pieper, Josef. 1952. *Leisure, The Basis of Culture*. Pantheon Books, New York.
Pineda, Mercedes; Ochoa de Zabalegui, Teresa. (Eds.) 2014. *Playgrounds: Reinventing the Square*. Museo Nacional Centro de Arte Reina Sofia, Siruela, Madrid.
Pollack, Linda. 1999. *Fountains, Space of Flows, The Fountain as Apparatus*. Lotus International 102, Sept. Electa. pp 6–33.
Pope, Albert. 1996. *Ladders*. Architecture at Rice 34, Princeton Architectural Press, New Jersey.
Price, Cedric. 1984. *The Square Book*. Wiley Academic, England.
Ramirez Camilo César, (Ed.) 1992 (1990) *Enciclopedia Ilustrada del Deporte Vols. I y II*. Editorial Voluntad, Santa Fe de Colombia.
Rasmussen, Steen Eiler. 1951 (1949) *Towns and Buildings*. MIT Press, Cambridge, Mass.
Rasmussen, Steen Eiler. 1959. *Experiencing Architecture*. MIT Press, Cambridge, Mass.
Rasmussen, Steen Eiler. 1983 (1949) *London the Unique City*. MIT Press, Cambridge, Mass.
Risselada, Max. (Ed.) 2011. *Alison and Peter Smithson: A Critical Anthology*. Ediciones Polígrafa, Barcelona.

Risselada, Mark; Van den Heuvel, Dirk. 2006. *Team Ten 1953–81, In Search of a Utopia of the Present*. NAi Publishers, Rotterdam.
Rohner, Heinz; Jhaven, Sharad. 1978. *Louis I Kahn Complete Works 1935–1974*. Birkhauser Books, Basel.
Rossi, Aldo. 1981. *A Scientific Autobiography*. MIT Press, Cambridge, Mass.
Rossi, Aldo. 1984. *The Architecture of The City*. MIT Press, Cambridge, Mass.
Roth, Alfred. 1948. *The New Architecture*. Les éditions d'architecture, Ellerbach, Zurich.
Roth, Alfred. 1957. *The New School*. Frederick Praeger, New York.
Rowe, Colin; Koetter, Fred. 1978. *Collage City*. MIT Press, Cambridge, Mass.
Rudofsky, Bernard. 1969. *Streets for People, A Primer for Americans*. Anchor Place, Doubleday, Garden City, New York.
Rudofsky, Bernard. 1988 (1997) *Constructores prodigiosos, apuntes sobre una historia natural de la arquitectura*. Editorial Concepto SA, México.
Rykwert, Joseph. 2000. *The Seduction of Place, The History and Future of the City*. Vintage Books, New York.
Sadler, Simon. 1998. *The Situationist City*. The MIT Press, Cambridge, Mass.
Scully, Vincent. 1994. *Architecture: The Natural and The Manmade*. St Martin's Press, New York.
Schama, Simon. 1996. *Landscape and Memory*. Vintage Books, Random House, New York.
Sechner, Richard. 2002. *Performance Studies, An Introduction*. Routledge, London and New York.
Sennett, Richard. 1991. *The Conscience of the Eye, The Design and Social Life of Cities*. Faber and Faber, London.
Sennett, Richard. 1996. *Flesh and Stone, The Body and the City in Western Civilization*. WW Norton & Company, New York and London.
Sert, Josep Lluis and CIAM 1947. *Can our Cities Survive?*. Harvard University Press, Cambridge, Mass.
Sica, Paolo. 1981 (1977) *Historia del Urbanismo del Siglo XIX, 2*. Instituto de Estudios de Administración Local, Madrid.
Sitte, Camillo, 1965 (1889) *City Planning According to Artistic Principles*. Phaidon Press, London.
Sloterdijk, Peter. 2006 (2004) *Esferas III*. Ediciones Siruela, Madrid.
Smith, Janet. 2005. *Liquid Assets, The Lidos and Open Swimming Pools of Britain*. English Heritage, London.
Smithson, Peter and Alison. 2001. *The Charged Void, Architecture*. The Monacelli Press, New York.
Smithson, Peter and Alison. 2005. *The Charged Void, Urbanism*. The Monacelli Press, New York.
Sola Morales, Ignasi. 2002. *Territorios*. Editorial Gustavo Gilli, Barcelona.
Solomon, Susan G. 2000. *Louis Khan's Trenton Jewish Community Centre*. Princeton Architectural Press, New Jersey.
Strauven, Francis. 1998 (1994) *Aldo Van Eyck, The Shape of Relativity*. Architectura en Natura, Amsterdam.
Summerson, John. 1963. *Heavenly Mansions and Other Essays on Architecture*. WW Norton and Company, London.

Sussmann, Elizabeth (Ed.). 1991. *On the Passage of a Few People Through a Rather Brief Moment in Time: The Situationist International 1957–1972.* MIT Press, Cambridge, Mass.
Tate Trustees. 2006. *Carsten Höller Test Site.* Tate Gallery, London.
Tanisaki, Junichiro. 1994. *El elogio de la sombra.* Siruela, Madrid.
Terán, Fernando (Ed.). 1997. *La Ciudad Hispanoamericana, El Sueño de un Orden.* CEHOPU Centro de Investigación de Obras Públicas y Urbanismo, Madrid.
Teyssot, Georges (Ed.). 1999. *The American Lawn.* Princeton Architectural Press, New Jersey.
Teyssot, Georges. 1999. *The American Lawn, The Spectacle of Suburban Pastoralism.* Lotus International 101, June. Electa. pp 92–115.
Treib, Mark. 2002. *The Architecture of Landscape 1940–1960.* University of Pennsylvania Press, Philadelphia.
Tzonis, Alexander; Giannissi, Phoebe. 2004. *Classical Greek Architecture, The Construction of the Modern.* Editions Flammarion, Paris.
Unwin, Raymond. 1984. *La práctica del urbanismo.* Editorial Gustavo Gilli, Barcelona.
Van Eesteren, Cornelius, 1997 (1928) *The Idea of the Functional City, A Lecture with Slides.* Nai Publications, Maryland.
Van Leeuwen, Thomas A. P. 1998. *The Springboard in the Pond, An Intimate History of the Swimming Pool.* MIT Press, Cambridge, Mass.
Veblen, Thorsten. 1989 (1899) *The Theory of the Leisure Class.* Penguin Books, London.
Venturi, Robert; Scott Brown, Denise; Isenour, Steven. 1972. *Learning from Las Vegas: The Forgotten Symbolism of Architectural Form.* MIT Press, Cambridge, Mass.
Waldheim, Charles (Ed.). 2006. *The Landscape Urbanism Reader.* Princeton Architectural Press, New Jersey.
Ward, Colin. 1990 (1978) *The Child in the City.* Bedford Square Press, London.
Ward, Colin. 1988. *The Child in the Country.* Bedford Square Press, London.
Whiston Spirn, Anne. 1998. *The Language of Landscape.* Yale University Press, New Haven and London.
Wigley, Mark; De Zegher, Catherine (Eds.). 2001. *The Activist Drawing; Retracing Situationist Architectures from New Babylon to Beyond.* The Drawing Centre New York, MIT Press, Cambridge, Mass.
Wigley, Mark. 1998. *Constant's New Babylon, the Hyper Architecture of Desire.* 010 Publishers, Rotterdam.
Wigley, Mark. 1998. *The Construction of Atmospheres.* Daidalos 68.
Williams, Amancio (Ed.). 1957. *La carta de Atenas.* Editorial Contempora, Buenos Aires.
Williams Goldhagen, Sarah; Rejean, Legault (Ed.). 2000. *Anxious Modernisms, Experimentation in Post-war Architectural Culture.* Canadian Centre for Architecture, Montreal, The MIT Press, Cambridge, Mass.
Worpole, Ken. 2000. *Here Comes the Sun: Architecture and Public Space in Twentieth-Century European Culture.* Reaction Books, London.
Wrede, Stuart; Adams Williams, Howard. 1991. *Denatured Visions, Landscape and Culture in the Twentieth Century.* The Museum of Modern Art, New York.

Wycherley, R E. 1962. *How the Greeks Built Cities: The Relationship of Architecture and Town Planning to Everyday Life in Ancient Greece.* WW Norton, New York.
Zinger, Tamar. 2015. *Architecture in Play, Intimations of Modernism in Architectural Toys.* University of Virginia Press, Virginia.
Zucker, Paul. 1973 (1959) *Town and Square from the Agora to the Village Green.* MIT Press, Cambridge, Mass.

Index

Page numbers followed by n refer to notes.

accessibility 134, 136, 138
acoustic properties 27, 55–6, 59, 176, 210
active play 21, 40, 81, 126
adaptations
 apparatus 106–8
 climate 108–12, 113–14
 golf 106, 108–12, 154–5
 labyrinths 112–13
 Ludus 101–6
 topography 71, 177
 urban spaces 18, 104–6, 120–1, 186–91, 244 n.6
Adele Levy Memorial Playground, Manhattan 177, 179–80, 181, 194
adventure playgrounds 79, 188, 222
aerial performances 49, 68
age distinctions
 play 135–7, 183
 schools 203, 205, 207, 246 n.4
Agon 23, 74, 137–8
agonistic principle 67, 165
 games 28, 29, 73–4, 214, 224
 hunts 33, 37, 41
 parliaments 75, 151
Agricultural Cooperative Village (Le Corbusier) 147
Ahmedabad, Sarabhai House 197
Aillaud, Emille 197
Alea 23, 49, 116, 127
alee 7, 78
alignment 97, 99

Allen, Marjory, Lady Allen of Hurtwood 26, 188
Allen, Stan 159
amenities 145, 149, 159, 166
amphitheatres 51, 52, 241 n.26, 248 n.17
Amsterdam
 Bos Park 139
 playgrounds 84, 127, 172–5, 247 n.9
 schools 207
Ansart, Ernesto 7
apartments 46–7, 142–5, 184, 189
apparatus
 play 107, 158–9, 227
 training 107–8, 127
Aranjuez, Spain 36–7
Archigram 52, 114, 128, 219–20, 226
arenas 25, 45–52, 102, 139
 bullfights 43, 45
 campuses 212, 214
 classical world 29–30, 140–2
 Kahn 148–52
 Le Corbusier 141–8
 schools 203
 Smithson 153
Aries, Philippe 158
aristocracy. *See* privileged classes
Arnold, Thomas 23–4
arrays 58, 123, 180, 206
 hierarchies 22
 symmetrical 74–5, 76
Ashley amphitheatre, London 52
asphalt 81, 198

astro-turf 106, 111
Atacama Desert, Chile 111
Aterro do Flamengo, Rio de Janeiro 118–19
Athens
 CIAM charter 132, 231–2
 Filothei playground 190–1, 197
athletes 131, 134–5, 163, 183
 Apollonian athletes 23, 135, 137–8

Baghdad sports complex (Le Corbusier) 148
Bale, John 3, 25, 43, 52, 101
Balfron Tower, Poplar, London 198
ballistics 53, 54, 78
balls 65
Banham, Reiner 222
Barcelona, Sants Square, Barcelona 192–3
Barnard, Henry 84, 203
baseball grounds 121
Basque ball 54–5, 56–7
Bath, England 50–1, 146, 241 n.28
Bauhaus 170, 212–13, 250 n.14
beaches 9–10, 83–4, 87, 89, 137
 artificial 10, 105, 145, 161
Beaudouin, Eugène 207
behaviour, influence of architecture 211, 212
Belle Air (Nolen) 154
Belo Horizonte, Brazil 143, 231
Berlin
 Jewish memorial (Eisenman) 182
 sand gardens 84
Berne 185
Bethnal Green cluster block, London 159
Bijvoet, Bernard 207
billiards 58, 59–60
Biltmore, Arizona 155
bleachers 25, 43, 64–5, 72
Bo Bardi, Lina 105
boards 26, 58, 63–4
 games 58–9, 68, 74
Boca Junior Stadium, Buenos Aires 216
Bois de Boulogne, Paris 67, 143, 242 n.3
Bologna, arcades 169

Bonet, Antonio 43, 45, 47
Bos Park, Amsterdam 139
boundaries 75, 116–17, 119
bowl shape 50, 72
bowling 78, 82
Boy Scout movement 146, 203
Breuer, Marcel 159, 183–4, 247 n.12
bridge (game) 59
Briey-en-Foret (Le Corbusier) 161
Britain
 development of sport 23–4
 hunting 37–8
 public schools 23–4, 201, 249 n.1
brutalism 81, 220
Buenos Aires 81, 147
 Boca Junior Stadium 216
 Saavedra Park 76
bullfights 39, 113
bullrings
 South America 15
 Spain 41–7, 64
burial grounds 153, 180

Caillois, Roger 2, 6, 224
 Ilinx 227
 Paideia-Ludus 4–6, 23, 30, 36, 157, 237 n.2
Calle de Cristo, San Juan Puerto Rico 7–8
Campo di Marte, Venice 7
campuses 137, 202, 212–17
Candilis, Georges 17, 134, 239 n.12
Caracas, Venezuela
 Central University campus 215, 216
 golf 108
 swimming stadia 89
 terraced playing fields 121
carnivals 23, 198–9, 213, 228, 238 n.7
Caro, Anthony 195
Cartesian layouts 108, 112, 145
Castel Fusano board, Ostia 92
cells 140, 142–6
Centre National de Réjouissances Populaires (Le Corbusier) 147
Centrosoyuz cooperative building competition 163
chairs 158, 173–4, 206
chance 6, 69–70, 101, 116, 131

INDEX

in design 166–7, 183
chess 58–9, 68, 74
Chicago, Reform Park Movement 126
childhood 2, 5, 101, 131, 134–7, 157–60
 paradigms 158, 159, 183, 246 n.4
children 3, 89, 134–5, 159, 183, 205, 246 n.2
 behaviour 211
 furniture 158, 206
 indoctrination 245 n.1
 instinct of play 25, 124, 190
 playgrounds 2–3, 26, 53, 81, 83–4, 137, 145–6, 163, 228–9
 supervision 159, 162
Child's Tower Room (Caro) 195
Chisenhale Road, London (Henderson) 165, 183
Chueca (game) 73
Church, Thomas 89, 196
churches 208
Churchill College, Cambridge 214
CIAM. *See* Congrès Internationaux d'Architecture Moderne (CIAM)
circuits, racing 65–7
circuses 49–51, 68, 113
Cirque du Faubourg du Temple, Paris 52
Citadel of Institutions 150, 151–2
Cite Industrielle (Garnier) 91, 151
cities 2, 223, 226
 adaptations 102
 displacement of playgrounds 182–4
 as ludic mechanism 232
 parks and gardens 126–8, 143, 176–82, 211–12
 for play 5, 6, 23, 121, 123, 134, 164–71, 186–93
 playgrounds 10–17, 143, 158–9, 172–5, 197–8
 related to rural spaces 25, 28
 resorts 10, 119
 rooftop playgrounds 160–3
 urban renewal 172–3, 184–5
 See also urban practices
citizens 131, 134–5, 219–20, 230
classical architecture 7, 28–30
classrooms 203, 205–6, 212

climate 108–12, 113
climbing 70–1
clubs 8, 24–5
 country clubs 17, 40, 179
 urban 40, 105, 133, 179
clustering 114–19, 128, 150
Cobra Group 226
cockfight pits 47–8
coliseums 25, 47, 83, 139, 141–2, 202
colonial world 82
 South America 13, 39, 40, 121
Colquhoun, Alan 226–7
commodification 134, 221
commons (Anglo-Saxon) 15, 82, 152, 164–5
concrete 173–4, 220
condominiums 155
Coney Island, New York 126, 127–8, 132
conglomerate order 101
Congrès Internationaux d'Architecture Moderne (CIAM)
 charter, Athens 132, 231–2
 congress, Aix-en-Provence 165, 189
 four functions 1, 166
 leisure chart (Sert) 136
connectivity 68, 71
Constant (Constant Nieuwenhuys) 1–2, 26, 52, 101, 219, 222
 New Babylon 112, 220, 224–6, 228
Contemporary City (Le Corbusier) 143
Contoured Playground (Noguchi) 177
control 74
 panoptic control 40, 41, 64, 194
 physical 92
Copenhagen 185, 187
 Sport Park (Hansen) 117
Cornelius, Violette 211
Corralejas, Sincelejo, Colombia 46
corridor streets 164, 169, 185
Coubertin, Baron de 141
country clubs 17, 40, 179
courts 101, 203–4, 209–10
creativity 2, 4, 187, 189, 224
cricket 25, 40, 115, 152
Culture Palace, Moscow (Leonidov) 76
cycling tracks 66

Dacca, Bangladesh (Kahn) 149–52
Dakar Rally 66–7
decomposition 104, 106
Delhi, Viceroy Garden 117
dérives 228, 251 n.7
deserts 111, 113
détournement 37, 194, 225, 228
Dionysian play 23, 45, 135, 199, 221
discipline 131, 135
Disneyland 157–8, 221
disorientation 99–100, 226
displacement 182–4
diving (swimming) 92–3
domestication 24, 71
Donnell Garden, Sonoma (Church and Halprin) 196
Downtown Athletic Club, New York 104, 116, 244 n.5
drama 21, 31, 48, 75, 92, 104, 113
Dromenon 23
Duiker, Jan 207
Dunedin Isles, Florida (Nolen) 154
Durand, Jean-Nicolas-Louis 76, 78, 149, 203
Duvignaud, Jean 2, 23, 26, 79, 134, 221, 227, 228

Ecole a Plein Air, Suresnes 207
El Lissitsky 26, 132
Elias, Norbert 24, 74, 75
Elliot, T.S. 169
elliptical formats 49, 211, 238 n.9
emplacements 72, 92
 arenas 45, 151
 orientation 97, 99
 playgrounds 160
 statuary 193–4
 symmetry 75
enclosure 25, 37, 43, 226
 fields 52–61
 schools 203
 seasonal 113
England
 development of sport 23–4
 hunting 37–8
 public schools 23–4, 201, 249 n.1
equestrian sports 76, 113
 hazards 69–70
 settings 7–8, 13, 25, 52, 64–7, 169

ethics 6, 237 n.4
etoiles 34–5
Eton fives 54
Evans, Robin 160
Explanada de España, Murcia 7
expressways. *See* road networks

fabrication 224–5
fairgrounds 68, 100, 126–8, 228–9, 231
Fairview Heights, New York 183–4, 247 n.12
fencing 56
fields 5–7, 15, 25, 79, 101
 of action 26–32, 230
 arrangement 52–61, 65, 75
 hazards 69–71
 multipurpose 105–6, 115–16
 playing fields 2, 7, 9, 114–17, 166, 205
 scale 63–4
 schools 204
 shapes 39–52, 74
 templates 102
 topology 68–9
Filothei playground, Athens (Pikionis) 190–1, 197
Firminy Vert (Le Corbusier) 147, 161
football 25, 101, 102
 grounds 31, 65, 106, 115, 121, 144
Forestier, Jean-Claude Nicolas 76, 81
forests 33–5, 134, 209, 240 n.11
form 32
 formlessness 79
formality 10, 23, 63, 78–9, 120–2, 157
Foro Italico (Mussolini) 147
Forum, Rome 13, 238 n.9
Four Freedoms Park, Manhattan (Kahn) 180
France, hunting 34–7, 78
free time 2, 6, 131–3, 146, 251 n.2
Friedman, Yona 219–20, 223, 226
Froebel, Pestalozzi 197, 224
 Froebel gifts 169–70
Fronton Recoletos, Madrid 55
fun 21, 219, 220
Fun Palace, London (Price) 219, 221–2
functionalism 31, 84, 127

gambling 6, 10, 58
games 4, 28
 board games 58–9, 68, 74
 See also sport
gardens 40, 143, 186
 playgrounds 176–7
 public 182–3
 schools 203, 205, 206
 university campuses 214
 See also parks
Garnier, Tony 91, 151, 243 n.5
gated communities 154, 182
GATPAC (Grup d'Arquitectes i Tècnics per al Progrés de l'Arquitectura Contemporània) 245 n.2
Gay, Claudio 74
gender divisions 60, 135, 203, 207, 212
geometry
 adjustments 104
 of *Ludus* 22, 73
Germania (Hitler) 147
Giedion, Siegfried 51, 140, 146, 172, 197, 241 n.28
Golden Lane scheme (Smithson) 1, 166, 226
golf
 courses 68, 104, 153–5
 driving ranges 106–7
 hazards 69–70
 landscaping adaptations 108–12
Gorlitzer Bad, Berlin (Siza) 243 n.5
grandstands 25, 43, 64–5, 72
graphic markings 68–9, 105–6
gravitational games 70, 123, 177, 179
Greek civilisation 28–30, 141, 202
greenery 15, 68, 110
 for children 160, 184, 205
 courts 209–10
 gardens 40, 143, 176–7, 182–3, 186, 203, 205, 206, 214
 green corridors 185, 211
 lawns 40, 82, 145, 152, 179, 239 n.3, 243 n.1
 in modern cities 2, 8, 81, 126–7, 132–3, 139, 148, 202, 232
Gropius, Walter 161, 212
Group Ludic 195

Grup d'Arquitectes i Tècnics per al Progrés de l'Arquitectura Contemporània (GATPAC), City of Leisure 132
Guerra dei Pugni, Venice 12
gymnasia 51, 107, 143, 161
gymnastics 24, 87

Hackney Marsh, London 115
Hall, Peter 222
Hampstead Heath, London 127, 141
Hansen, Hans Christian 117
hazards 69–71
health 51–2, 126–7, 138, 220
 public health agenda 88, 243 n.5
 See also hygiene
Hedjuk, John 228–30
Henderson, Nigel 165
Hertzberger, Hermann 3, 186, 206, 211
Highpoint Housing (Tecton) 146
Hilberseimer, Ludwig 184–5
hippodromes 7, 40, 66, 76, 169
Holler, Carsten 248 n.24
Homo Faber 30, 224–5
Homo Ludens 1, 2, 219–20, 224–8
hopscotch 113
horizontality 69
horses. *See* equestrian sports
House of Commons, Britain 75
House of Industry (Leonidov) 133
housing developments 157, 177, 188, 189
Huizinga, Johan 74
 Homo Ludens 2, 134, 219
 play 4, 6, 22–3, 192, 223, 225
 regulations 237 n.1
 reiteration 30
 scales 239 n.6
 Temenos 22, 189
Hunstanton scheme (Smithson) 209–10
hunts 32–9, 67, 78, 102, 104, 239 n.7
Hurtwood, Lady Allen of 26, 188
Hybrid Building 104
hybrid spaces 8, 120, 214
hygiene 131, 204, 206–7, 212, 221
 See also health

Icarai springboard, Rio de Janeiro 92
ice 68, 70
Ilinx 23, 49, 73, 92, 127, 132, 227
Illich, Ivan 87, 164–5
immersive environments 245 n.1
implements 31, 64, 65, 177
Independent Group 188
indoctrination 17, 169, 205, 215, 245 n.1
indoor tennis 53–4, 102
indoors 101, 104
 fields 55–61
 integration with outdoors 207–8
 play 2, 10
industrial production 105, 107, 117, 190, 231
inflatables 58, 230
informality 79, 120–1, 157
Instant City 219–20
instinct of play. *See* ludic instinct
institutions 149–51
integration 75, 88
 Ludus and *Paideia* 89, 120, 137
 play and urban life 192
 schools within residential communities 205
 urban space and ludic areas 235
intelligibility 7, 79, 101
International Housing exhibition 1937 (Le Corbusier) 147
interplay 167–8
Iqbal Park, Lahore 115, 152
Irish handball 54, 56–7
Ivens, Joris 123

Jacobs, Jane 26, 128, 164, 169, 228
jai alai (game) 54
Jeanerette, Pierre 195
Jekel, Jolliet de 195
Jellicoe, Geoffrey 141
jeu de paume 53–4
Jeux: eugénisme (Le Corbusier) 166
Jewish memorials 181–2
Johnson, Phillip 133
Jorn, Asger 31
junk playgrounds 21, 25, 186–91

Kahn, Louis I. 148–52, 164, 177–80
Kent, Adaline 196

Kiessler, Friedrich 138
kites 123–4
Koolhaas, Rem 104, 108, 115–16, 126, 127, 132
Krauss, Karl 181
Kuwait Urban Centre (Smithson) 153

La Grande Borne, Grigny (Aillaud) 197
La Petatera, Colima, Mexico 46
La Plata, Argentina 143
La Villette Park (Koolhaas) 115
labyrinths 68, 226–8, 244 n.8
 ludic challenge 97, 100–1, 112–13
 See also paths
ladders 184
Lahore, Iqbal Park 115, 152
landscapes 27, 66, 112, 119, 125, 232
 adaptation for golf 108–12
 effects on play 104
Las Vegas 2, 245 n.1
Lasdun, Dennis 159
Latin America 15, 47, 238 n.10
 squares 13, 39, 40, 121
Law of the Indies 13
lawns 40, 82, 145, 152, 179, 239 n.3, 243 n.1
 See also greenery
layouts 99
 Cartesian layouts 108, 112, 145
Le Corbusier 1, 26, 67, 203, 231
 apartments 46–7, 142–5
 arenas 141–7
 Centrosoyuz cooperative building competition 163
 Firminy Vert 147, 161
 International Housing exhibition (1937) 147
 Jeux: eugénisme 166
 lotissements 143–4
 Meaux master plan 98–9
 Minotaur 45
 Modulor 168
 Mourondins 145–6, 203
 Mundaneum 75–6, 147
 Nantes Rezé 161
 playgrounds 160–3
 Sarabhai House 197
 schools 208

sports facilities 17, 89, 105, 131–2, 141, 148, 160–3
 Unites, Marseille 105, 160–3, 176, 197, 198
 Ville Radieuse 10, 17, 161
Le Notre 232, 242 n.8
learning tools 84, 197
Ledermann, Alfred 3, 195
Lefebvre, Henry 228
Lego 221, 248 n.16
leisure industry 17, 134, 221
leisure spaces 119, 232
 in cities 121, 126, 220–3
 resort development 9, 51, 234
leisure time 2, 6, 131–3, 146, 251 n.2
Leningrad Pool 91
Leonidov, Ivan 17, 76, 115, 133, 245 n.3
 Centrosoyuz cooperative building competition 163
lidos 9, 81, 88
lighting 55–6, 59–60, 206, 239 n.5
Lissitsky, Lazar 26, 132
Littlewood, Joan 222
Lods, Marcel 207
London 7, 51, 88, 126–7
 Ashley amphitheatre 52
 East End 159, 165, 198
 Great Fire survey (1666) 98–9
 Hackney Marsh 115
 Hampstead Heath 127, 141
 Lordship Recreation Ground 171
Longchamp race track 67
Loos, Adolph 104
Lordship Recreation Ground, London 171
lotissements (Le Corbusier) 143–4
ludic areas 6, 183, 198
 See also playgrounds; sports facilities
ludic challenges 22, 70, 117, 123
 animals 234–5
 labyrinths 97, 100–1, 112–13
 psychological 32, 58
 tectonics 222
ludic instinct 21, 27–8, 134–5, 223, 235
 children 25, 124, 190
ludic principles 5, 65, 224

Alea 116
disorientation 99–100
gravitational forces 177
physical balance 74
reiteration 30–1
Ludus 4–5, 12, 23, 63, 232
 adaptations 49, 71, 101–6
 contrast with *Paideia* 89, 120, 136, 168, 176–7, 211, 214
 fields 26, 73
 progression from *Paideia* 30, 183, 203, 205, 217
 transition to *Paideia* 102
 university campuses 214–15
 See also Paideia; play (activity)
lusus trojae (troy game) 113
Lutyens, Edwin 117

Madrid, Fronton Recoletos 55
Maekawa, Kunio 208
Magnitogorsk scheme (Leonidov) 115–16
Mah-jong (game) 59
Maidans 115, 152–3
Manhattan, sports grounds 121
manuals (architectural) 136–7
Mari, Enzo 195
Marseille, Unites 105, 160–3, 176, 197, 198
Marx, Burle 119
materials 112, 243 n.1
Mayan civilization 238 n.10
Mayer, Hannes 206, 213
mazes. *See* labyrinths
McKim, Mead and White 104, 133
Meaux master plan (Le Corbusier) 98–9
Meccano 190, 222
mechanical energy 65–6, 126, 245 n.1
medieval tournaments 75
memorials 180–2, 228–30
Metropolitan Gardens Association 127
Milan stadium (Friedman) 224
military training 212, 214
 role of play 220
 spaces 7, 78, 82, 194, 215
Mill Creek (Stonorov) 177
mimicry 23, 49
miniaturization 104, 190

Ministry of Education Roof Garden, Rio de Janeiro (Marx) 119
Minoletti, Giulio 88, 89, 195–6
Minotaur 113
mobile structures 36–7, 43, 46, 52, 60, 223
modernism 164, 188, 212
Modulor (Le Corbusier) 168
MoMA (Museum of Modern Art), 1949 house (Breuer) 159
Montessori, Maria 100, 107, 197, 206
mosaics 114–19
Moscow
 Culture Palace 76
 House of Industry 133
Moses, Robert 128, 179
motor racing 65–6
mountains 70–2, 123, 234
Mourondins (Le Corbusier) 145–6, 203
Mundaneum (Le Corbusier) 75–6, 147

Nagele, Netherlands 208–9
Nagy, Moholy 213
Nantes Rezé (Le Corbusier) 161
National Reservations, United States 33
nature 205, 231
neighbourhood units 183–4, 205
Nervi, Pier Luigi 92
networks 71
 green 182–3, 185
 roads 66–7, 148–9
Neufert, Ernst 137
New Babylon (Constant Nieuwenhuys) 112, 220, 224–6, 228
new man 5, 134–5
New York 113
 Adele Levy Memorial Playground, Manhattan 177, 179–80, 181, 194
 Coney Island 126, 127–8, 132
 Downtown Athletic Club 104, 116
 Fairview Heights 183–4, 247 n.12
 Four Freedoms Park 180
 Jewish memorial Manhattan 181
 Play Mountain 177
 Police Athletic League 87
 racecourses 30
 Racket and Tennis Club, Manhattan 104, 133
 Seagram Building 133
Nielsen, Egon Möller 195
Niemeyer, Oscar 199
Nieuwenhuys, Constant. *See* Constant (Constant Nieuwenhuys)
Nikolski, Atelier 91, 243 n.5
1949 house (Breuer), MoMA (Museum of Modern Art) 159
Noguchi, Isamu 89, 174
 Adele Levy Memorial Playground, Manhattan 179, 180
 Play Mountain, New York 177, 194
 slide mantra 177, 196–7
Nolen, John 154–5
non-Cartesian patterns 113
Non-Plan 222–3, 250 n.3
North America 82, 159
 golf 108, 153–5
 schools 205
 university campuses 202
 urban spaces 168
 See also New York; Philadelphia
notations, encrypted 64

Olmsted, Frederick Law 180
Olympics 141, 202
120 doors (von Ellrichshausen) 112
orientation 97, 98–101
ornamental features 66, 113, 117, 194
Orphanage, Amsterdam 210–11
Ortega y Gasset, José
 bullfights 43, 47, 240 n.19
 hunts 28, 32–3, 239 n.7
 play 2, 4, 237 n.4
 squares 41
orthogonal fields 64, 114–15
Ortner, Rudolf 98, 137
Otto, Frei 79
outdoors 101
 integration with indoors 207–8
 landscape adaptations 108–12
 play 2, 10

Paideia 4–5, 12, 23, 28, 124, 232
 adaptations 101
 children's play 137, 157–8, 161, 165

contrast with *Ludus* 89, 102, 120, 136, 168, 176–7, 211, 214
 in design 157, 166–8, 180, 196–9, 206, 225
 leading to *Ludus* 30, 67, 203, 205, 217
 re-emergence 26, 58, 172, 220–2
 See also Ludus; play (activity)
Pall Mall (game) 78
Pall Mall, London 7
Pani, Mario 215
panoptic control 40, 41, 64, 194
Parc des Princes stadium, Paris 142–3
Paris 1, 35, 78, 92, 117, 228
 Bois de Boulogne 67, 143, 242 n.3
 Cirque du Faubourg du Temple, Paris 52
 Parc des Princes stadium 142–3
 Paris Plages scheme 10
 Place de la Concorde 224
Park Hill, Sheffield 198
Parkour 53, 123
parks 15, 34–5, 137, 231, 232, 242 n.3
 mixed use 67, 115–16
 North America 3
 public 8–9, 17, 126–8, 132, 183
 schools 205
 sports fields 114–17
parliaments 75, 150–1
parterre à l'Anglais 82, 114
partisanship 64–5
partitioning 25, 75
Paseo de la Corredera, Cajamarca de la Cruz 7
Pask, Gordon 219
passive leisure 81, 82, 137
pastimes 75, 97
 See also sport
paths 34, 68, 231
 meandering 119, 147, 165, 231
 See also labyrinths
Penn University stadium 149
performance 2, 32, 49–51, 92
Perry, Clarence 183
perspective 78–9
pétanque 78
Petersschule, Basel 206–7
Philadelphia, Downtown renovation (Kahn) 148–9

photography 165, 239 n.8, 247 n.2
Piazza del Campo, Sienna 151
Piazza Navona, Rome 85
Picasso, Pablo 45, 241 n.21
Pikionis, Dimitri 190–1, 197
Place de la Concorde, Paris 1, 224
play (activity) 2, 21, 131, 134–5
 and fabrication 190, 224–5
 functions 6, 220, 237 n.1, 251 n.2
 segregated 212
 types 4–5
 See also Ludus; *Paideia*; recreation
Play Mountain, New York (Noguchi) 177, 194
players 5–6
 See also athletes; children; citizens
Playground Association 126
playgrounds 3, 17–18, 21–3
 adventure playgrounds 79, 188, 222
 Amsterdam 84, 127, 172–5, 247 n.9
 children 26, 228–9, 231
 formal 204
 junk 21, 25, 186–91
 memorials 180–1, 230
 play parks 81
 play sculptures 194–9
 rooftops 160–3
 safety 183
 schools 205, 208–12
 Stockholm 81
 streets 160, 164–71, 182
 urban 2–3, 10–17, 143, 158–9, 172–5, 198
playing cards 74
playrooms 2, 158–9
Plaza de Armas, Latin America 13, 39
Plaza Mayor, Barcelona 192–3
Police Athletic League, New York 87
polo 24, 64
Pope, Albert 184
portable structures 36–7, 43, 46, 52, 60
postmodernism 191
Powell, Baden 203
precincts 26, 52–3, 232
Price, Cedric 219, 221–2, 226
primeval play 10, 22, 32–9

privileged classes 85, 102
 bullfights 43
 golf 108, 155
 hunts 33, 34–8
Proposition 38 (CIAM charter) 132
Prouvé, Jean 158, 206, 208
provisional environments 219
purpose-made venues 55

quadrangular platforms 52

racecourses 7, 8, 30, 65–6, 67, 231
Racket and Tennis Club, Manhattan 104, 133
Radiant City (Le Corbusier) 10, 17, 161
Rasmussen, Steen Eiler
 formal structures 74, 87–8, 195–6
 implements 31–2
 urban play 26, 53, 126–7, 187, 228
Raumplan 104
recreation 2, 17, 131–2, 223
 See also play (activity)
Reform Park Movement, Chicago 126
Rei, Aarao 231
reiteration 30–1
repetition 105
resorts 9, 128, 132, 134
 seaside 9–10, 87, 134, 192
 winter 71–2, 234
rhythms 64, 88, 195, 203
Rietveld, Gerrit 158
Rio de Janeiro
 Aterro do Flamengo 118–19
 Icarai springboard 92
 Ministry of Education Roof Garden 119
 Sambodromo 199
 terraced playing fields 121
rituals 74, 180–1, 230, 239 n.1
 labyrinths 113
 layouts 97
 in play 22
 water 87
road networks 66–7, 148–9
Robbie House (Wright) 60
Robin Hood Gardens (Smithson) 176, 177, 182–3, 184, 198, 210

Robinson Crusoe playgrounds 188, 190
Rodchenko, Alexander 74
Roman *Ludi* 141
 See also coliseums
Rome 2, 53
 forum 13, 238 n.9
 Spanish Steps 88
rooftops 163
 beaches 161
 gardens 119
 playgrounds 160–3
 sports facilities 18, 105, 143
 terraces 207
Roosevelt, Franklin D. 180, 181
Rossi, Aldo 192
Roth, Alfred 204–5
Rousham Bowling Green 115
Rowe, Colin 168
Royal Crescent, Bath 50–1
royal tennis 53–4, 102
rubber 31
Rudofsky, Bernard 26, 168–70, 211, 224, 250 n.13
rue Vavin housing, Paris (Sauvage) 92
rugby 101, 213
rules 4–5, 6, 24, 74, 79, 102, 181–2
 bullfights 43
 effect of play 31, 38
 lack of 113, 157, 222
running tracks 106, 115, 141, 143, 161, 163
rural spaces 37–8, 102, 235
 related to urban spaces 25, 28
Rykwert, Joseph 228

Saavedra Park, Buenos Aires 76
safety, playgrounds 183
Saint Andrews, Scotland 109–10
Sambodromo, Rio de Janeiro 199
sand
 artificial beaches 10, 105, 145, 161
 beaches 9–10, 83–4, 87, 137
 golf bunkers 69, 109–10
 for play 22, 79, 81, 83–4, 158, 173–4, 186–7, 211, 228–9
 surfaces 10, 43, 83
Santa Catalina nunnery, Peru 239 n.2

Santiago, Chile 7, 39
　Field of Mars 8
　golf 108
　hippodromes 40
　racecourses 30
Sants Square, Barcelona 192–3
Sao Paulo 105
Sarabhai House, Ahmedabad (Le Corbusier) 197
Sauvage, Henry 92
scale 26–7, 32, 63–7, 160, 198, 205, 239 n.6
Scandinavia 72
　Gymnasia 201, 249 n.1
Scatter (Smithson) 183
Schinkel, Karl Friedrich 76, 78
schools 137, 158, 161, 201–8, 246 n.4, 249 n.6
　classrooms 203, 205–6
　English public schools 23–4, 201, 249 n.1
　fields 17, 204
　gardens 206
　playgrounds 205, 208–12
　yards 203–4, 205, 206
sculptures 193–9
sea water 88–9
Seagram Building, New York 133
seasonal changes 84, 107, 177
security 240 n.18
select and arrange technique 167
Sert, Josep Lluis 26, 132, 136, 142, 185
SESC Pompeia (Bo Bardi) 105
settings 21–3, 25–6, 38
shanty towns 171, 188–9
shoreline 119, 123, 132, 179–80, 215
Sienna, Piazza del Campo 151
sight
　loss of 58, 99–100
　panoptic control 40, 41, 64, 194
Sitte, Camillo 17, 239 n.11
　playgrounds 15, 163, 204
　squares 193–4, 198
Situationists 100, 113, 124, 228, 250 n.7
　Homo Ludens 219, 225–6
Siza, Alvaro 243 n.5, 251 n.10
skiing 24, 70–1, 113, 244 n.9

ski jumps 242 n.4
sledging 70
slide mantra (Noguchi) 177, 196–7
slides 123, 177, 248 n.24
Sloterdijkt, Peter 58, 140
Smithson 26, 153, 176, 182–3, 209–10
　forms of association 1, 165–6
snow 22, 79, 81, 83–4, 172, 194, 243 n.1
　hazards 70
　snow-belt areas 123
Soane, John 50–1
soccer 25, 101, 102
　grounds 31, 65, 106, 115, 121, 144
social models 131, 133, 160
　organized sport 23, 25
　templates 126
softball 179
Soldiers Field stadium, Harvard University 114, 215
Solomon, Joseph 213
Sörensen, Carl Theodor 186–8, 224
sound 27, 55–6, 59, 176, 210
Soviet recreation 17, 132
space 21–2, 137, 232
Spain
　bullrings 41–7, 64
　GACTPAC City of Leisure 132
　hunting 36–7, 38
　public recreation agenda 17
Spanish fronton 54–5, 56–7
Spanish Steps, Rome 88
spectacle 37, 41, 69, 134, 139, 141
spectators 50, 64–5, 235
spheres of action 26–7
Spianada, Corfu 40
spontaneity 58, 131, 134–5
sport 138–9, 212, 247 n.7
　benefits 132
　development of 23–5, 75, 97
　See also games; pastimes
Sportbauten (Ortner) 137
sports facilities 17, 145–6, 231
　fields 32, 76–8, 120, 183, 209, 215
　parks 139, 141–53, 179
　terraced fields 121, 213–14, 215
　universities 202
sportsman's house (Breuer) 183
springboards 92–3

squares 83, 121, 237 n.3, 240 n.17
 focus of play 5, 13, 28, 39–45, 191–3
squash courts 54
stacking 104–5, 160
stadia 72, 76, 139, 141, 246 n.7
 Boca Junior Stadium, Buenos Aires 216
 as monuments 239 n.5
 universities 202
Stadion 29–30, 141
stands 25, 43, 64–5, 72
stately homes 60
statuary 193–4
Stonorov, Oscar 177
stratification 104–5, 160
streets
 corridor streets 164, 169, 185
 culture 128, 168–9
 ludic scenarios 185–6
 for play 191–3, 198, 211–12, 228, 235
 playgrounds 160, 164–71, 182
 traditional English 165
suburbs 18, 232
sun bathing 137, 161
supervision 162, 203
surfaces 26–7, 64, 68, 75, 79, 81
 bouncing effect 53–4
 hazards 69–70
surfers 124
surveillance 25
swimming 87
 domestic pools 93, 158–9
 pools 9, 87–94
 See also water
swings 196–7
symbolism 22
symmetry 73–8

table tennis 58, 60
tables 26, 58–60, 63
Tate Modern Turbine Hall installation (Holler) 248 n.24
Tati, Jacques 189, 248 n.14
Taylor, Frederick Winslow 30, 82, 107
Team Ten 134, 164, 189, 223, 226, 227, 239 n.12
teams 64, 131, 202, 203

technology 220, 222, 224, 227, 229
tectonics 132, 222
Teheran administrative centre (Kahn) 152
Temenos 21–2, 189, 209
temporal limits of play 21–2
temporary scenarios 222
temporary structures 36–7, 43, 46, 52, 238 n.9
tennis 31, 102, 144
 courts 10, 32, 52, 53–4, 75, 117
terraced playing fields 121, 213–14, 215
territory 26, 75, 134–5, 166
Teyssot, Georges 3, 82
Tinguely, Jean 190
toboggans 68, 70, 72–3, 196–7
topography 69–73, 119, 123–4
 adaptations 108–12, 121, 123–4, 154–5, 175
 artificial 176–82
topology 68–9, 112
Tour de France 66–7, 242 n.2
tracks 63–6, 68
 hippodromes 76
 running 106, 115, 141, 143, 161, 163
traffic 170–1, 185
training 106–8, 137–8, 146
 military training 7, 82, 194, 212, 214, 215, 220
 physical training 201–2
Traschel, Alfred 3, 185, 190, 195
Trenton Community Centre (Kahn) 179
Trias, Eugenio 192

Unites, Marseille (Le Corbusier) 105, 160–3, 176, 197, 198
universal access 134, 136, 138
Universidad Nacional Autónoma de México (UNAM) campus, Mexico City 215
university campuses 137, 202, 212–17
University of Cape Town (Solomon) 213
Unwin, Raymond 15–16
urban practices 135, 220, 222, 224
 carnival 198–9, 228
 See also cities

urban spaces. *See* cities
urbanism 2, 225
 Unitary Urbanism 225
USA. *See* North America

Valparaiso 123
 Naval Academy 215
 terraced playing fields 121
Van der Rohe, Mies 133, 214
Van Eesteren, Cornelius 26, 139, 172, 247 n.7, 247 n.9
Van Eyck, Aldo 226
 Amsterdam 127, 139, 171–5, 210–11, 247 n.9
 functionalism 84
 labyrinthine clarity 100
 Nagale 208–9
 playgrounds 26, 171–5, 190, 194, 197
 shanty towns 189
vandalism 250 n.13
vegetation. *See* greenery
velodromes 50, 66
Venice 192, 238 n.7
 1845 plan 7, 11
 golf courses 154
 Guerra dei Pugni 12
 Lido 9, 108
Venturi, Robert 2
vernacular games 24, 73
Viceroy Garden, Delhi (Lutyens) 117
Vienna 15
Villa Rosenberg 32
Villanueva, Carlos Raúl 89, 215, 216
Ville Radieuse (Le Corbusier) 10, 17, 161

Ville Spatiale (Friedman) 220, 223–4, 250 n.6
Ville Verte (Le Corbusier) 144–5
violence 24–5, 75
visibility 157, 162–3
visual fields 242 n.8
Vitruvius 13, 193–4, 238 n.9, 248 n.19
von Ellrichshausen, Pezo 112

walls 52–5
Ward, Colin 222
water 81, 85–95, 174, 179–80, 193
 networks 148–9
 play sculptures 195–6
 See also swimming
Welles, Orson 45
Wilson Primary School, England 203
wind 123–4
 deflectors 215
Wittwer, Hans 206
Wohlin, Hans 81
Wood, John the Elder 51
Wright, Frank Lloyd 60, 111, 170

X games 27

yards 159, 206
 schools 203–4, 205

Zaanhug playground, Amsterdam 173
zoning 10–11, 26, 114, 133
 children 60, 159, 171, 182–4
 urbanism 225
Zouqs, Morocco 169

www.ingramcontent.com/pod-product-compliance
Lightning Source LLC
Chambersburg PA
CBHW072126290426
44111CB00012B/1801